PHOTOGRAPHING BUILDINGS INSIDE AND OUT

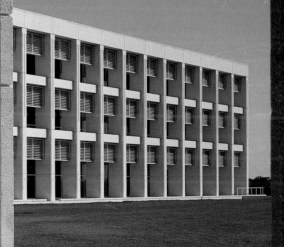

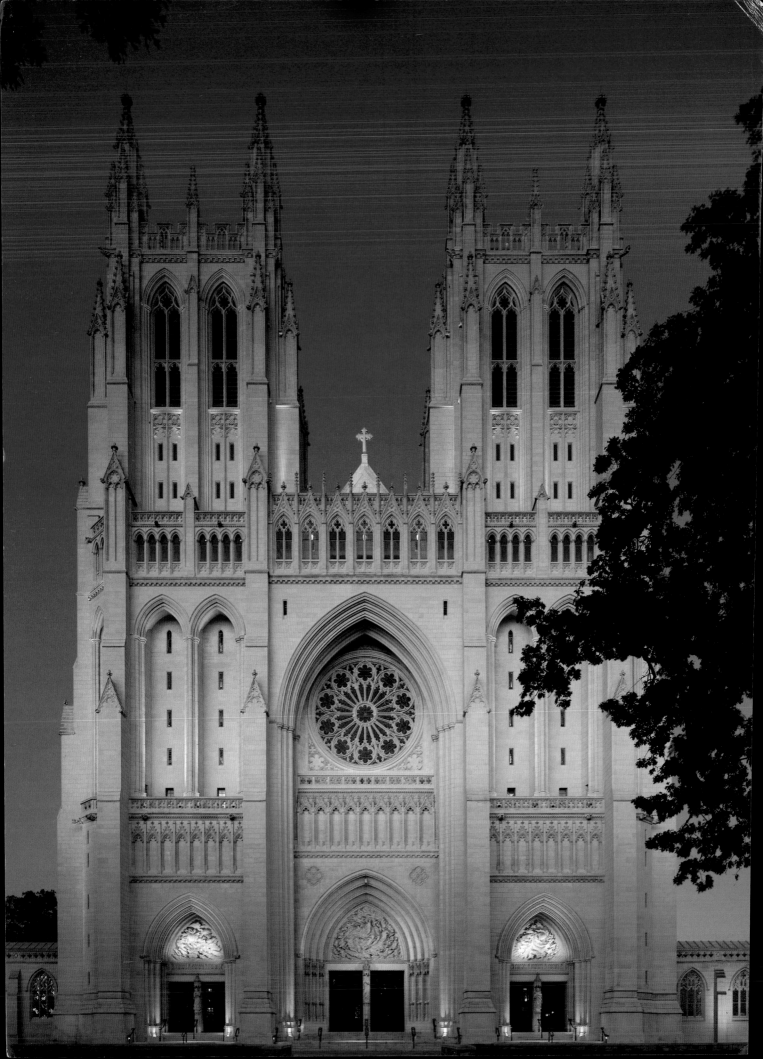

PHOTOGRAPHING BUILDINGS INSIDE AND OUT

REVISED AND EXPANDED 2ND EDITION

NORMAN McGRATH

WHITNEY LIBRARY OF DESIGN
an imprint of Watson-Guptill Publications

I would like to dedicate this second edition to Harry Stein, sculptor, designer; the personification of the great talents whose lives have been cut short in their prime by AIDS.

All photographs in this book are by the author unless otherwise noted.

Page one: The American Automobile Association (AAA) Headquarters in Orlando, Florida. Architects Spillis, Candela.

Page two: The National Cathedral in Washington, D.C.

Page six: The Atlantis, Coral Gables, Florida, designed by Arquetectonica.

Revised edition
Senior Editor: Roberto de Alba
Assistant Editor: Sue Shefts Traub
Designer: Bob Fillie
Production Manager: Ellen Greene

Revised and expanded edition first published in New York in 1993
by Whitney Library of Design
an imprint of Watson-Guptill Publications,
a division of BPI Communications, Inc.,
1515 Broadway, New York, NY 10036

Library of Congress Cataloging-in-Publication Data

McGrath, Norman.
 Photographing buildings inside and out / Norman McGrath. —
[Rev. and expanded 2nd ed.]
 Includes index.
 ISBN 0-8230-4017-8 (cloth) — ISBN 0-8230-4016-X (paper)
 1. Photography of interiors. 2. Architectural photography.
I. Title.
TR620.M37 1993
778.9'4—dc20 92-42306
 CIP

Manufactured in Singapore

Revised Edition
First Printing
2 3 4 5 6 7 8/00 99 98 97 96 95

ACKNOWLEDGMENTS

For the second edition of this book I would particularly like to thank my editors at the Whitney Library of Design: senior editor Roberto de Alba and my nuts-and-bolts editor, Sue Shefts Traub. The original idea for the first edition came from Stephen Kliment, former senior editor with Whitney. Julia Moore was my editor for the first edition. Many thanks to them both.

Special thanks to the following photographers who let me use examples of their work in this edition: Ezra Stoller, Julius Shulman, Cervin Robinson, Jaime Ardiles-Arce, Lizzie Himmel, Peter Aaron, and Judith Turner.

The following manufacturers were very helpful: Olympus, Canon, Pentax, Schneider, and Arca Swiss (Tekno). In addition, Ken Hansen lent equipment and Hirsch Photo was always ready with film at short notice. Good advice came from Lens & Repro, Kodak, Fuji, and Polaroid.

Useful reference material came from *Architecture Transformed* by Cervin Robinson and Joel Herschman, *Photography of Architecture* by Akiko Busch, *Travel Photography* by Susan McCartney, *Photography and Architecture* by Eric de Mare, *Photo District News*, and many others.

Thanks, also, to all my architect and designer clients for so much wonderful subject matter, and to *Architectural Digest* for permitting me to use a good deal of its material in this book.

Finally, to Georgia Griffin and Max Strycharske, who did much of the "typing" and organization.

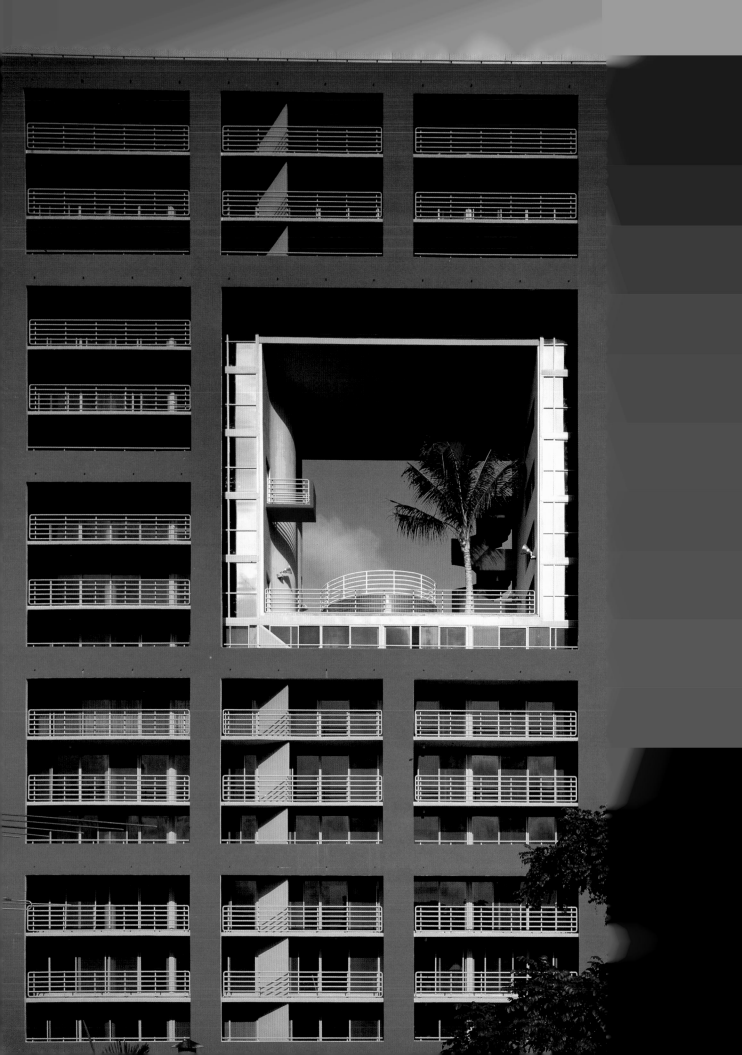

CONTENTS

PREFACE

A precise definition of architectural photography is more complex than might be supposed. As soon as rigid criteria are established, exceptions arise. A photograph in a particular context might be considered "architectural" and in another situation, not.

A reasonable approach suggests that if the primary objective of the photographer is the straightforward documentation of a subject—be it an interior or exterior—conceived or designed by an architect, then the result will be an "architectural photograph." The photograph per se is not what is important here, but rather the clarity with which the design is recorded.

The wide interest in architectural photography today is reflected by the enthusiastic reception of the first edition of this book, published in 1987, and now updated and expanded here. I have been pleasantly surprised by this success and encouraged to enlarge and explore more fully the themes covered in the original edition.

Technology marches on, sometimes simplifying our lives but also introducing new challenges. Electronics is changing the photography profession. I do not foresee a direct threat to architectural and interior photographers, but the techniques they apply and the tools they use will certainly change. New films and equipment may make the task easier, but the facility of duplication and dissemination of pictorial images via electronics pose problems for the photographer.

This still unique and demanding field must ultimately depend on a real love and understanding of architecture. I was lucky enough to inherit this from my father, Raymond McGrath. Two houses dating from the 1930s remain the roots from which my interest sprang: St. Anne's Hill in Sussex, England, designed by my father in 1937, and Serge Chermayeff's own house in Surrey, England, from 1934.

After a brief foray into structural engineering, it was to architecture that I was drawn, not as a creator but as an interpreter. Many architects, as well as photographers such as myself, sooner or later want to direct their cameras at the built world created around us. If you are one of these, this book may help you along this path and make your efforts more productive and rewarding.

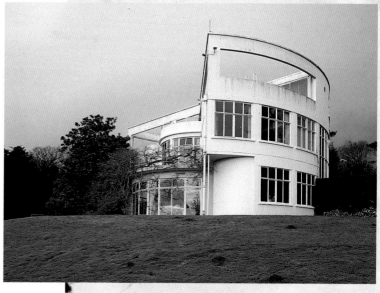

St. Anne's Hill, in Chertsey, Sussex, England, designed by Raymond
Inset photograph by the author was taken January 1992.

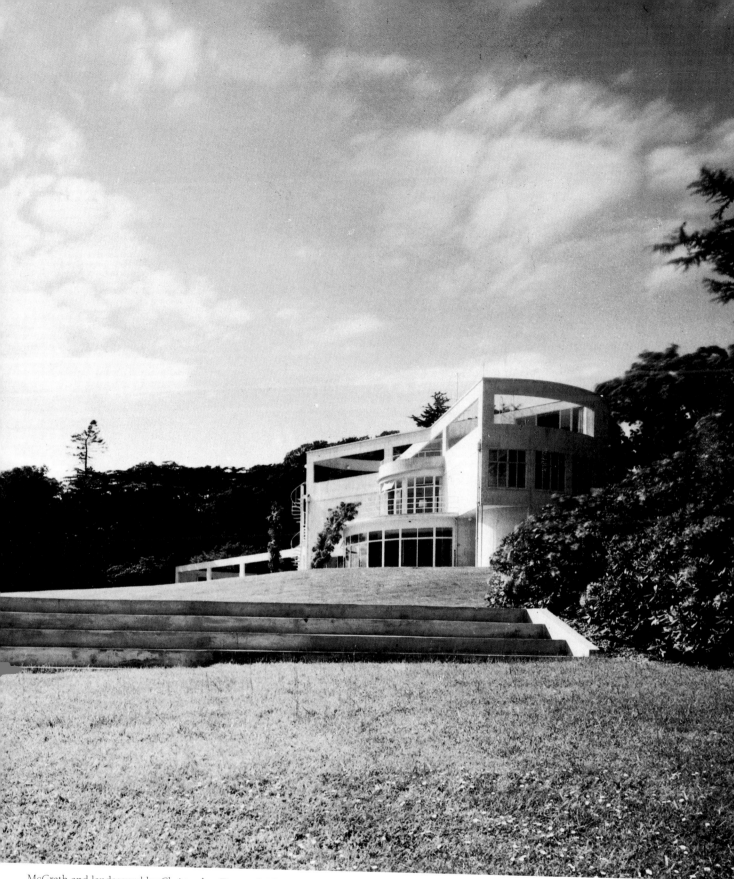

McGrath and landscaped by Christopher Tunnard. This 1937 photograph was taken by Herbert Felton.

WORKING WITH THE PROFESSIONAL

Ideally, the photographer-client relationship is a close professional arrangement based on mutual trust and respect. Frequently, the client is the architect or designer. Other clients can be public relations firms, development companies, property owners, contractors or builders, advertising agencies, corporations, and magazine and book editors. To be truly successful, the photographer must fully understand the needs and objectives of the client. Conversely, the client should appreciate the problems and difficulties that a photographer may have to overcome to complete an assignment to the satisfaction of everyone involved.

FINDING THE RIGHT PHOTOGRAPHER

Once the various objectives for an architectural photography project have been carefully analyzed and clarified, the client must decide whether or not to retain a professional. (The alternative is to do the photography on one's own.) If the project demands a professional, there are several ways to find a good photographer. Noting the credit line of photographs that catch your eye is one way. Gathering referrals from a friend or a respected associate is another way. If no leads appear, you can call a publication you admire for recommendations. Avoid using the yellow pages directory, as you may end up with a photographer more suited to photographing weddings than working with architectural subject matter.

Another means of locating a photographer is through the American Society of Magazine Photographers (A.S.M.P.), which has a membership directory available for $18.00. (A.S.M.P. is located at 419 Park Avenue South, Suite 1407, New York, N.Y. 10016.) Worldwide in scope, the directory lists the addresses and telephone numbers of 400 member photographers specializing in architecture. Arranged by region, the directory includes 48 architectural photographers in California and 56 in New York City and state. Membership in A.S.M.P. is dependent on the attainment of a certain level of competence in conjunction with recognized publication for a period of not less than three years, and many of the world's leading photographers are members. There are A.S.M.P. regional chapters in a number of locations in the United States.

Some groups, such as Esto Photographics, Inc. of Mamaroneck, New York, for example, have more organized back-up service than others and are very businesslike in their dealings. They also have a stock photo service with architectural emphasis, as I do. This can be a factor when hiring a photographer. It's nice to be able to call up many years after the completion of an assignment and find access to old material. I was able recently to provide a client with photographs of a job shot more than twenty-five years ago, before I was a full-time professional.

After a photographer has been selected, the client and photographer should meet, if they haven't already. Personal contact should be established to ensure and promote mutual understanding. This will also present a good opportunity for everyone to examine a portfolio of the photographer's work that relates directly to the upcoming project. Much time and effort will have been expended completing the project so the client should feel confident that the right photographer has been chosen to document it.

TIMING AND SCHEDULES

Availability of the photographer may be a crucial factor. The more time allowed for photography, the more likely that the many variable conditions and everyone's schedules will synchronize, thereby promoting the least stressful completion of an assignment. When tight timetables dictate the scenario, compromises must frequently be made. These may adversely affect the results, leaving everyone unhappy. Therefore, as much time as possible should be allowed for the photographer to produce a quality job. This leeway will enhance the photographer's goodwill toward the project.

When a really good set of photographs is produced in spite of unavoidable deadlines, the designer should be particularly appreciative. A photographer may have to juggle schedules and a client may have to exercise much

patience in order to complete a project successfully. So my advice is to plan ahead, anticipating when the best conditions for such a project are likely to prevail.

Here are two timing scenarios that any architectural photographer would recognize. One: A new hospital facility is scheduled for completion on a certain date. The architect's client does not officially take possession for a week after completion, allowing the hospital staff members to familiarize themselves with the new facility before patients are admitted. This is probably a good time to take photographs. The new quarters will be in top condition, and miscellaneous items have not yet appeared to sully the clean look of things. The photographer can take liberties that would be impossible once full operation has commenced. Two: A new house has been completed for a client who is out of the country. Some last-minute compromises on furnishings have disappointed the architect, but the client has agreed to permit photography before the offending items arrive or else to substitute others chosen by the designer for documentation purposes.

Depending on their function, certain types of buildings or interiors quickly lose their fresh appearance and should be recorded as soon as possible after completion. On the other hand, many projects rely heavily on landscaping, which is frequently one of the last-completed aspects of a design. If a building's budget has become a problem, there may be insufficient funds available to accomplish the original landscaping. Only time will make up for the reduced outlay. A house or a suburban corporate center may look a lot better a year or two after plantings have had a chance to grow and fulfill the landscaper's objective. All these factors should be considered. Alerting the photographer to this kind of situation can avoid embarrassments all around.

There are certain seasons when an architectural photographer may be highly in demand. For me, these times tend to be in the spring and autumn. The brief period in spring when things begin to look green, but before full leaves appear, can be critical in exterior photography. The winter look has gone, and the hint of green is flattering. These ideal conditions may prevail only for a short time. The autumn also produces nice in-between situations when the leaves are brightly colored and their density makes visible hitherto unseen portions of the subject. Autumn coloring can produce very dramatic photographs. Fallen leaves blanket the ground, perhaps concealing incomplete landscaping. So I find that September and October are particularly busy for me, and clients have to book well in advance to avoid disappointment.

The other major seasonal consideration is the angle of the sun. When the sun is lower in the sky, shadow details may be more flattering. On the other hand, a critical location may only receive full sun during summer months when the shadows of adjacent structures don't interfere. An exterior facade with few projections may not need sunlight to record it effectively. A highly articulated facade will probably require a certain angle of light to best describe it. A tall building on a narrow city street is particularly difficult to record, especially in winter, even when the right vantage point can be found, because the building's illumination probably varies tremendously from top to bottom. If the building's facade is also dark in tone, the problem is even more critical. The photographer must try to solve such problems within a given time frame. An experienced photographer will warn the client if the documentation is likely to be compromised by an insufficiently flexible schedule.

The weather is the one factor over which no one has control, and therefore a certain amount of luck is involved. Schedules with more leeway enable the photographer to wait for just the right conditions. Regarding rain dates, photographers have various policies. Once a mutually agreeable shooting date has been set, some photographers will charge a cancellation fee if the shooting date is changed at the last minute. A rain-date policy should be established when scheduling the shoot, so there is a clear understanding that if weather or other conditions are unfavorable and require rescheduling, a fee will be charged.

Typical postponement fees vary depending on circumstances. Some photographers may not charge when a client gives forty-eight hours notice, but most probably will if only twenty-four hours (or less) warning is given. During busy seasons in particular, this is not unreasonable when you consider that a photographer's time is much in demand and a last-minute cancellation means a lost fee unless a substitute assignment can be scheduled.

Does the decision to go ahead and shoot rest with the architect or the photographer? An architect assigning a project may have enough deadline flexibility to permit the photographer to wait for ideal working conditions. If the assignment then has to be rescheduled, there may be fees involved. Weather forecasts are more reliable in certain parts of the country than in others. A photographer may have to depend on a client at the location to make the final decision on out-of-town work.

An experienced photographer can come up with satisfactory results even without ideal conditions. Direct sunlight is not always desirable. A house set in the woods may look better in soft light than in bright sunlight. Trees and foliage may cast distracting shadows that destroy or compromise the design's forms.

Weather conditions are generally less critical for interior photography. However, before the designer or client

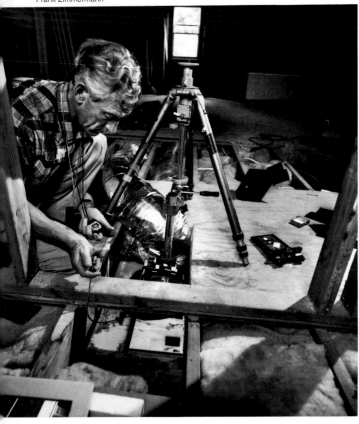

Frank Zimmermann

Author setting up to shoot down through a small ceiling opening.

cancels an interior shoot, the photographer should be consulted; there is often more control over the scene than is at first evident. With the careful balancing of strobe-lit interiors, the "outside" can be made to appear much brighter than it actually is. With appropriate lighting, even sunlight can be simulated indoors. When adjusted, Levolor, or similarly louvered blinds, can act as neutral-density filters for the exterior view. Also, the photographer can adjust the blinds to control the amount of light admitted into the space.

If the photographer is shooting both interiors and exteriors, and if more than one day's work is involved, then the weather won't be quite so critical. Invariably, interiors take longer to photograph than exteriors, so careful planning of the exact sequence of shots helps to avoid wasting time.

COSTS, FEES, AND CONTRACTS

Assuming that the architect or designer has determined that everyone's schedules are mutually compatible, the next matter is cost. The basic fee a photographer charges will vary according to the type of rights the client requires. (See the information on rights in this section.) These rights should be determined in advance so there are no misunderstandings. When "all rights" or exclusive rights are essential (this is unusual, I might add), the cost can be double that for the normal limited rights most designers need. Although some photographers quote rates for particular jobs, most have daily rates. These can vary substantially according to both location and reputation. A photographer with experience in this field is unlikely to charge less than $750 per day, and a range between $1,000 and $2,000 is currently more typical.

The architect or designer should have certain points clarified before working with a photographer. The policy regarding overtime, for example: What constitutes a photographer's day? And, what flexibility there is, if any? What about postponements or cancellations? How is travel time charged? What are the photographer's rates for driving his or her own car? What happens if bad weather delays or prevents a shoot? What do the reimbursable expenses include, and how are they billed?

Does the day rate include an assistant? If not, how much will the assistant cost? Who makes necessary travel arrangements? What is the per diem for out-of-town standby when no photography can proceed? Does the photographer provide the client with originals or duplicates? Does the fee include a basic number of photographs in the required format? Will negatives, either color or black-and white, be released to the client? If so, is there an extra charge? Are materials included, or will they be billed as an extra? Does the photographer require an advance to cover out-of-pocket expenses? Perhaps

many of these situations will not arise, but it's important to a good working relationship to know how you stand if they do.

Some photographers nowadays require a portion of the fee to be paid in advance. This is by no means universal and may only occur for first-time assignments, until payment procedures are established. Bills outstanding for more than thirty days may also be subject to an interest charge. This is not unreasonable when you realize a photographer may have to expend considerable monies to complete an assignment and there may be some time lapse before billing is possible.

I charge strictly on the basis of time, but my day may be quite long. If the job is local, I may scout the project ahead of time without additional charge. Other photographers may charge for preliminary site visits and consultations, but this varies according to circumstances. I charge extra for an assistant, a normal practice that is well worth the extra expense and is really essential, except, perhaps, when requirements are limited to small-format equipment. Even then, an assistant is likely to improve productivity.

My method is to charge for materials at cost plus a percentage for overhead and handling. The designer is informed in advance what the overhead and handling will probably run and how they are worked out. Time getting to the job may or may not be included in the basic rate, but when substantial distances are involved, a half-day rate for travel time is used. Out-of-pocket expenses are added, and when required, receipts are furnished. These expenses include transportation, meals, and accommodations when necessary. The present cost of running a car is pretty high, particularly in big cities. I charge fifty cents per mile when I use my own car, and I think that barely covers my costs, but it is probably less expensive than an equivalent rental.

When the architectural photographer works for a client other than the designer or architect, the rate charged may be different. Publicity and promotional photography is deemed to be somewhat more commercial in nature and therefore worth higher rates than documentation done directly for the architect or designer or for straight editorial use. (Assignments done for the design press are considered similar to work done directly for design professionals. Thus when fees are split between an architectural magazine and an architect, there is usually no complication with variable rates.)

The American Society of Magazine Photographers publishes an excellent, regularly updated guide, *Professional Business Practices in Photography*, for $29.50 plus postage and sales tax where applicable. A comprehensive guide, it includes valuable information on suggested rates for use of photographs in books and for a variety of other purposes. The society takes pains to point out that these are general guidelines since it is not their policy to establish rates or fix terms.

How many pictures can a photographer shoot in a day? This is a difficult question to answer and ultimately depends on how fast a photographer works. The complexity of the project, the experience of the photographer, and the client requirements are other factors. Some lighting situations require time-consuming solutions. Advance preparation and propping of the space can take hours. A photographer who takes one shot an hour with a large-format camera is shooting quickly and many professionals shoot at half that pace. Exterior-only photo shoots tend to go faster. Productivity, even among experienced photographers, does vary widely.

Most photographers restrict the distribution of their photographs to third parties not sharing in the original assignment. Thus a subcontractor, consultant, or other interested party wishing to use photographs must first check with the photographer and will likely have to pay a negotiated "use fee."

Fees for architectural photography done directly for corporate clients and for advertising agencies will almost invariably be negotiated on an individual basis and will almost always be in a considerably higher range than previously mentioned. So the value of photographs depends largely on the use to which they will be put.

Sales Tax

Both client and photographer need to be aware of local and state sales tax regulations. Photographers for New York City-based clients, for example, are obliged to charge and collect sales tax on both their services and expenses. The rate depends on the client's location, not the address of the project. Even though the expenses include some items on which a state tax has already been paid, the sales tax must be calculated on the total billed amount. When airline tickets and hotel bills are paid directly by the assigning client, these items will not be included among the photographer's overhead expenses.

Further, a completed assignment delivered to a New York City-based agent for an out-of-town client will also be subject to city sales tax. When uncollected, the photographer will be liable for the tax. In New York City, the only exception to the above occurs when the client has a legitimate resale certificate, and the number of this resale certificate must be provided to the photographer for his or her records. New York City-based photographers have resale certificates that enable them to purchase materials and equipment needed without sales tax, thus avoiding double taxation of these items.

Contracts

Some architectural photographers have contracts, which they require their clients to sign before they undertake an assignment. Personally, I don't favor this approach but prefer a certain degree of trust and flexibility. While the relationship between a photographer and a client may be strictly business, ideally it may be something more. The subtle interpretation of a sophisticated design goes beyond some legal document. Many architectural photographers, especially those with established reputations, work without contracts for the same reason. This custom is certainly an exception to many photographer-client arrangements and would probably horrify most lawyers. But the fact that most commissions are accomplished without involving elaborate legal documents would indicate that the system works.

RIGHTS

Most architects and designers have predictable objectives in mind when photographic assignments are being considered. Likewise, the majority of professional photographers are familiar with these needs. Although the details of the rights offered will vary from one photographer to the next, the typical client uses are likely to be covered.

When working with a professional for the first time, the architect or designer should list the purposes for which the photography is required ahead of time, even if they have been discussed. This prevents misunderstandings. The majority of architectural photographs taken today fall under the category of limited rights. This permits the client to make any direct use of the material, including portfolio use, display, office reference, slide presentations, local and national A.I.A. competitions, printed brochures, and certain other competitions, when the release of copyright is not required.

If the client is preparing a book, reproduction rights for this may also be included. However, the right to publication by parties other than the assigning client is frequently not part of the agreement. Practices on this matter differ.

Having to cover the potential value of an image for all publication purposes would mean charging a substantially higher initial fee to be fair to the photographer, who is the copyright holder. I feel it is unreasonable to expect the architect or designer to pay an inflated fee since such use may not occur. If and when it does, most publishers are able and willing to budget for reproduction rights. When the would-be publisher is a nonprofit organization—a university or other worthy organization—then exceptions can be made.

Most of the New York City photographers with whom I have spoken work with limited-rights arrangements. When unlimited rights are required, the fee may be fifty to one hundred percent higher. In the advertising field, rates tend to be much higher, so even an all-rights purchase is likely to exclude advertising rights. These normally have to be negotiated on an individual basis.

The Hedrich-Blessing Studio in Chicago has no less than eight architectural photography specialists. Their rights policy in this field is a bit different from most of their East Coast cousins. They normally include full reproduction rights as part of their normal fee. Any publication use of which the architect or designer approves is all right with them, including books, magazines, and brochures. The distribution of material is up to the client. Hedrich-Blessing does forbid resale of their photographs by architects or designers. Their rates are somewhat higher to cover the unlimited (except for advertising) rights, but probably are less than most East Coast professionals would charge for similar services. Their normal daily rate includes an assistant.

One of the reasons why architectural photographers limit the rights granted to their clients is that in proportion to other photographic fields, the fee structure for work that has to be of the highest quality is relatively low. Young clients may not agree, but a comparison of fees for architectural photography with a number of other specialties confirms this. Few interior or exterior photographers get wealthy from doing just that.

Some photographers will grant designers permission for unanticipated uses without additional fee, but the photographer should always be approached first. Unauthorized uses make everybody unhappy and can lead to surcharges nobody wants to pay. For example, when the photographer has not included reproduction rights in the fee and the work is used in a professional publication that refuses to pay, then the architect or designer will be responsible. (This assumes that such publication was not initiated by the photographer in the first place.) This sort of situation can be avoided if the design professional directs the photographer to supply material to the periodicals and deal with them directly regarding fees. Magazines tend to assume that when they receive photographs directly from an architectural or design firm they are free to use them without payment. This is particularly true when the submission is unsolicited.

I allude elsewhere to the A.I.A. competitions. These do not require the photographer to relinquish all rights, but some other competitions do. So beware, and read the rules carefully.

One stipulation that is universally enforced, regardless of the rights granted, is against resale. No architect or designer may sell the work of the photographer to a third party. This might be compared to a homeowner selling the plans of his architect-designed house to somebody else.

COPYRIGHT

Copyright laws are extremely complex, very confusing, and frequently ignored. On January 1, 1978, a major revision to the law was made, which resulted in the transfer to the photographer of many photographic rights that previously would have belonged to the assigning party. The present situation is that the photographer can relinquish ownership only by consciously signing an agreement to do so. This can be done either before or after an assignment is completed. When a photographer signs an agreement which uses the term "work for hire," then the copyright is transferred to the client or assigner.

From the architect's or designer's point of view, copyright ownership should not present any particular problems. This assumes that the client makes normal use of the photographs as previously discussed. Abnormal or unanticipated uses should be brought to the photographer's attention to avoid copyright infringement. The seriousness of infringement will depend on the circumstances—whether it was willful or inadvertent, for example. For more details, including how to copyright material, write to Register of Copyrights, Library of Congress, Washington, D.C. 20559.

THE WELL-PLANNED SHOOT

The more time a photographer can devote directly to shooting pictures, the more satisfactory the results will be. Unnecessary delays can be avoided by exercising common sense and caution. Special arrangement for transporting equipment to the job can be arranged prior to the shoot. Some establishments have time-consuming security procedures that can be short circuited by making a call in advance. If freight elevators must be used, are they available at the scheduled starting time? Removing equipment may require a signed building release. To prevent ruffled feathers, all the people involved should be notified as to whether the architect (or designer) or the photographer should handle the contacts with the appropriate building manager or house owner. It may be better if the architect handles communications, since presumably a degree of respect and familiarity already exists between designer and client.

When photography is being done for a competition, the photographer should be told what the relevant rules are and just what is needed. For example, showing views of all a building's elevations may be a stipulation, not just showing the front or main view. The photographer might have some suggestions on how to include, but not necessarily feature, a less important side. After the assignment is completed, enough time should be budgeted to meet the deadline for finished prints or whatever is required. Rush charges for last-minute changes can substantially increase the competition budget. The selection process is just one of a number of intermediate steps that should be allowed for prior to the assembly of the completed submission.

The photographer must have a clear idea of the design objectives to be portrayed. Once these objectives have been discussed and established, some photographers prefer or even insist on working alone or unsupervised. I personally have no problem shooting with and consulting the architect or designer as I go along, but I feel quite comfortable with either approach. I like to show my 4 x 5 Polaroid tests to the designer who comes along on a shoot, since viewing through a large-format camera is not comfortable for everyone. Sometimes seeing a 4 x 5 Polaroid test prompts the design professional to question a photographer's approach, and an alternative is tried. Often the designer decides the alternative is less successful than the initial view. Setting up alternative approaches takes time, so once some rapport is established, trusting the photographer's experience and judgment is beneficial. When the photographer feels strongly enough, shooting the subject both ways can be insurance against having to do double work should the client have a subsequent change of mind

Circumstances may not permit the client to be present during the shoot. How much direction should be given to the photographer in this case? This depends, at least in part, on the measure of confidence the architect or designer has in the photographer. But even when considerable trust exists, insufficient flexibility can result from overly detailed instructions. For instance, I once followed the architect's instruction too literally on an out-of-town shoot. Assuming that the objectives were well thought out, I recorded each area stipulated to the best of my ability but ended up with no overviews and no overall documentation that would provide a complete impression. Due to the nature of the subject, an overview would have been difficult to achieve. Since the assignment had to be accomplished in a single night, and there was no on-the-spot representative to correct what I felt was the designer's oversight, I didn't deviate from the explicit instructions. Unfortunately, the client was quite unhappy with the result.

Clear directions for getting to the job are frequently essential. When these instructions include approximate distances and typical travel time, they are even more helpful. And the photographer should always have an appropriate phone number in case emergencies arise. Publishers of house magazines normally have liability insurance, but not all photographers do. Accidents do happen, so it may be important to know if a photographer does have such a policy. The architect or designer may

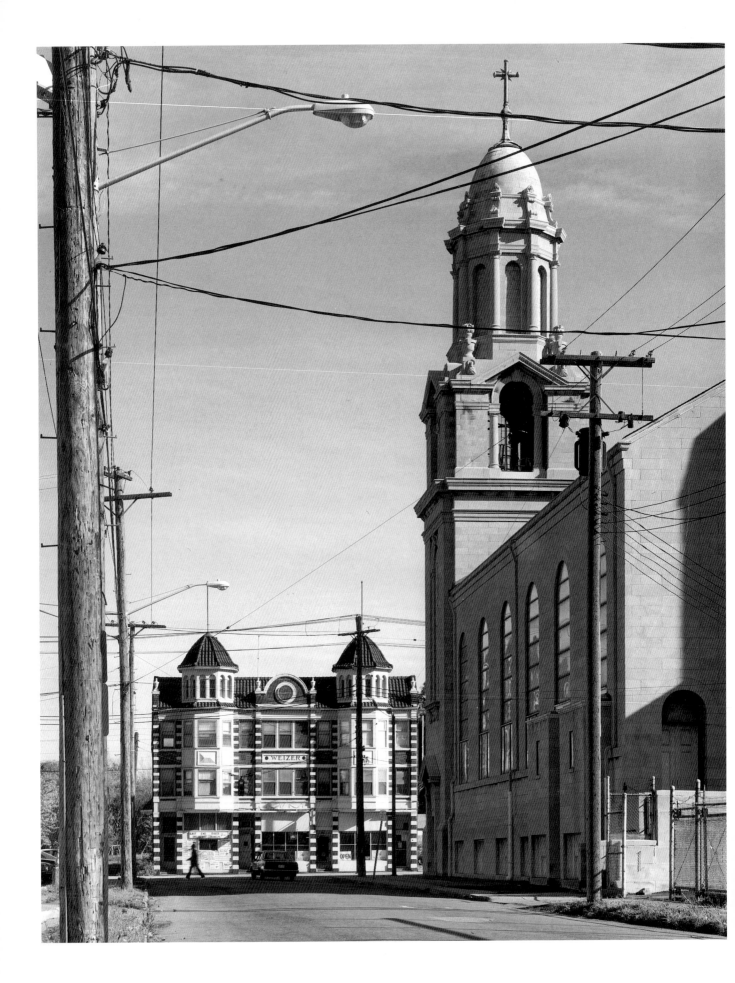

have adequate coverage to meet the requirement. Gaining access to particular vantage points may be conditional on the photographer having liability insurance or at least on the signing of a waiver of liability of the building owner or management.

When paying an advance visit to the site is practical, most photographers will give advice on props and accessories. I prefer that my client provide flowers, but I have on occasion had to work with very stiff, formal arrangements that were doubtful assets. Floral arrangements shouldn't be moved from one room to another, as the reuse will be evident in the photographs, but if there's no alternative at least use a different container.

A photographic documentation can only be successfully accomplished when the designer's philosophy is fully understood and appreciated by the photographer as well. To establish this understanding may require some detailed explanation by the designer. There may be aspects of the completed project that are only apparent after considerable familiarity with the design, and these should be brought to the photographer's attention. Design features that seem very obvious to the designer may elude the photographer.

Finally, the question of taste cannot be ignored. Any visually oriented person is bound to have certain preferences and dislikes when it comes to pictorial images. One architect may like dramatic views that sweep upward with exaggerated perspective, while another designer may hate this style. Occasionally, a client who associates wide-angle lenses with unwanted distortion might ask me not to use them. As a photographer experienced at interpreting three-dimensional subjects in a two-dimensional medium, I feel it is my job to correct

misconceptions about various photographer methods and precepts, while at the same time respecting my clients' taste and perceptions about the way they want their work documented.

Two contemporary masters of architectural photography who have very different approaches to composition are Cervin Robinson and Ezra Stoller. An example of Robinson's black-and-white documentation is seen here in this photograph of a street scene in Cleveland, Ohio. The bright sun of an October afternoon produced a bold image that is classical in feeling and recalls the great early tradition of architectural documentation.

Stoller's photograph of Le Corbusier's 1955 Chapel of Notre Dame du Haut, at Ronchamp, is both abstract and animate. Stoller writes that "It is architecture which is of primary interest to me, with photography being simply the medium for communicating its idea."

Weizer Block and St. Elizabeth of Hungary Church (left), from *Cervin Robinson: Cleveland, Ohio*, Cleveland Museum of Art in cooperation with Indiana University Press, 1989.

Chapel of Notre Dame du Haut, at Ronchamp, France (right), photographed by Ezra Stoller in 1955. Designed by Le Corbusier in 1955.

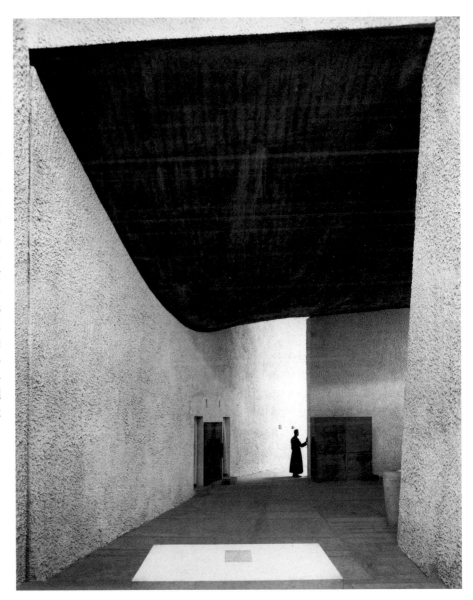

FITTING THE PHOTOGRAPH TO ITS PURPOSE

Architectural photographers have many publishing opportunities today. The market for architectural subject matter is bigger than ever before and extends well beyond the design press to such publications as *National Geographic*, *Travel*, *In Flight*, *Time*, and *Newsweek*, to name a few.

The ultimate purpose to which a photograph will be put has considerable bearing on its quality as well as how it is taken and by whom. Obviously, photographs taken for personal record or to test equipment, lighting, angles, and the like needn't have the high quality of those submitted for publication. Likewise, the standards of photographs taken strictly for documentation may not be adequate for publication purposes. But regardless of the ultimate objective, it is to the photographer's advantage to show a prospective client only high-quality work.

PUBLICATION

Not infrequently, clients ask me for recommendations about which magazines to approach with a particular project. When publication is the primary objective, I point out that while I can give advice and possibly put the designer in touch with the appropriate editor, there is no guarantee of success in getting a project accepted. It's extremely difficult to second-guess an editor.

Design professionals are likely to have preferences about where they want to be published—usually magazines they read regularly and respect—and, assuming the project is appropriate, these should be the first targets. Many times I have had a client with a high-quality office design say, "Wouldn't this look great in *Architectural Digest*?" and I have to point out that *Architectural Digest* seldom features commercial projects.

Submission and Acceptance Practices

There are no hard-and-fast rules for submitting material for possible publication. Popular and professional magazines and newspapers each have established submission procedures, and a phone call to the editorial department may be the simplest way to find out what the specifications are. For example, the architect or designer, not the photographer, should be the one to submit photographs to *Architectural Digest*.

Whoever handles the submissions must decide if preliminary scouting photographs are, in fact, adequate. Will an editor unfamiliar with the design be able to make a reasonable evaluation of it? Poor photographs may result in the premature rejection of a good project. Plans, renderings, and isometrics should be submitted in addition to photographs when available. Any material that helps convince a publication to feature a project is relevant to the submission.

Sometimes an editor will ask for more photographs before making any commitments This puts the architect/designer on the spot, since it may require costly additional photography. Occasionally, a visit by the editor to the project site can be organized to avoid this situation, permitting the editor to make a first-hand appraisal. If the quality of the scouting or preliminary photography is not up to the standard of the design or the publication, this latter approach is recommended where practical.

A photographic record of a building or house prior to its remodeling may also prove publishable. Some magazines like to publish "before" and "after" views to indicate the extent of the changes made and how preexisting conditions influenced the final design.

Magazines such as *Architectural Digest*, *HG*, *Metropolitan Home*, and *House Beautiful*, among others, are known as shelter publications. (*Architectural Record* and *Progressive Architecture* are examples of the professional design press and these magazines have their own preferred submission procedures.)

Architectural Digest and *HG* are in a class by themselves as shelter magazines. Both regularly run features with architectural content, if not emphasis. Both are presti-

gious publications in what might be termed the "up market." Projects included in their pages frequently lead to new work for the designers, and thus are considered plum spots in which to be published.

When *Architectural Digest* accepts a house or apartment for future publication, it rarely uses existing photographs, even when they are of high quality. The magazine prefers to assign or reassign the photographer it feels is most suited to record the particular design in question. The architect/designer can request a particular photographer, but unless he or she has worked for the magazine before, there is usually reluctance. All photography and related costs are, of course, the responsibility of the magazine. Once *Architectural Digest* has made a publication commitment, it rarely reneges on its decision—something that cannot be said of some other magazines.

Each magazine has its own practices for commissioning a photographer, and these arrangements tend to be very restrictive for both photographer and architect/designer, allowing only limited or no future access to the submitted materials. This presents everybody with a dilemma. Should an architect go to considerable trouble and expense taking preliminary scouting shots, or commission a photographer to do so in order to have a favorite project published, but subsequently have no access to the published material or even out-takes? Restrictions become more critical after the project is accepted for publication but prior to release. The architect/designer is often deeply involved in the photographic process and, in fact, frequently plays a vital role during this final phase of the photography. Before publication commitments are made, the architect/designer and the photographer should fully understand the magazine's practices on future use and the resulting ramifications.

Multiple submissions of a project—meaning sending the same proposal to several publications at the same time—is risky and should be undertaken with caution. It can lead to awkward situations if a project is accepted by more than one publication. Only occasionally, with very newsworthy designs, will publications agree to simultaneous release dates. Unexpected or unauthorized publication of a previously accepted project can cause a periodical to drop plans for a feature entirely, even after the expense of photography has been incurred. Likewise, once a commitment has been made, any approaches to other publications must first be cleared with the committed publication.

Another matter to consider is the fact that every publisher has its own list of competing publications. If a competitor on this list has already featured a design, it is unlikely that they will also. For example, The *New York Times Magazine* will normally accept only previously unpublished work. For a newspaper, this policy is not unreasonable. Most shelter magazines, however, do not regard professional design press publications (such as *Architectural Record*) as competitors.

Media: Prints, Slides, or Transparencies

With color prints available in a matter of hours at increasingly widespread outlets, "snapping off" a quick roll of 400-speed color negative with a fully automatic camera is a very convenient way to make a quick record. Rarely would the resulting photographs ever have any reproduction potential. For publication purposes, transparencies or slides are preferred to prints or negatives, except in the case of black-and-white prints. For the best reproduction of black-and-white images, high-quality prints on non-textured paper are preferred.

Most publications will use 35mm slides—though they may prefer not to—if nothing else is available. Some actually use slides by choice. Variety is the spice of life, and many editors claim that 35mm photographs look less stiff. The character of the periodical or book is what ultimately determines the type of image selected.

Many newspapers now use color photographs, particularly in their special supplements or Sunday magazines. Though staff photographers take a lot of these pictures, newspapers also use outside sources. The quality of newspaper images is frequently poor, partly as an inevitable consequence of the newsprint process. Black-and-white photographs tend to degrade more than color images. One of the reasons for this has to do with the inherent difficulty in handling a high-contrast print. The printers in a newspaper plant normally reduce a contrasty print by screening it, making the blacks dark-gray and the whites pale-gray, which reduces the impact of the original. Photographers who understand this can supply newspapers with images that can be better reproduced by this medium.

As a general rule nothing sent as a publication feeler should be irreplaceable, particularly photographs. Whenever possible, only send prints that can be remade, duplicate slides or duplicate transparencies, especially to overseas journals where submissions can easily go astray. Many periodicals only return materials when a stamped, self-addressed envelope is included. Damage frequently occurs in the mail.

I should make one particular point in connection with book publication. Most books take a long time to put together, sometimes years. The photographic research involved in doing books on architecture and design starts early in the editorial process. Preliminary photographs may be chosen long before the final selection is made. The photographer should be prepared not to see any

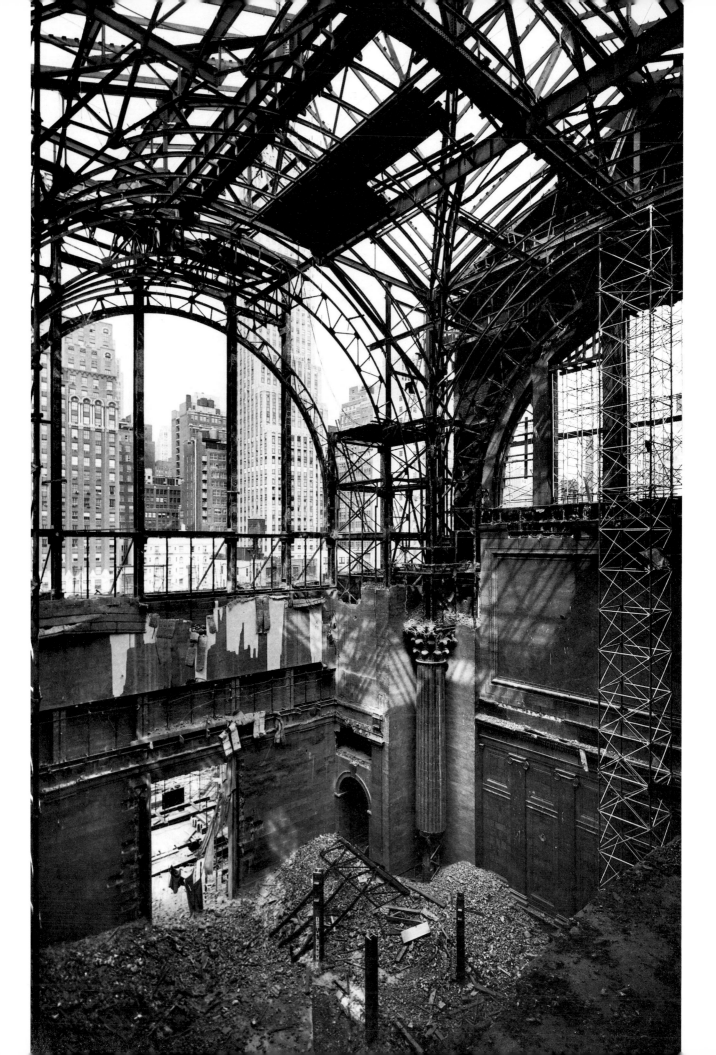

work selected in the first edit for a long time. For this reason it is advisable to submit duplicates or perhaps color prints initially and only release originals for the actual printing stage, if then. Reproduction-quality duplicates can be made and released as an alternative, but these are expensive.

DESIGN DOCUMENTATION

When it comes to company records, the standards for what different firms retain to document a design vary widely. Some design-firm files contain little, if any, photographic documentation. Instead, those companies rely solely on blueprints and renderings to record their completed projects, which has obvious disadvantages. There's many a slip 'twixt the plan and the finished product. Nothing can document the culmination of a good, successful design as well as a photograph can. This type of photograph may be taken by someone within the design firm, or a professional photographer may be hired, depending on the picture quality required and the degree of expertise available.

These file photographs can be an invaluable reference source for the company. During the design process, the ability to refer back to similar completed projects may be crucial. Image clarity may determine a photograph's usefulness from a reference standpoint, but a photograph kept strictly for file purposes needn't be sophisticated.

Work-in-progress photographs are frequently used in order to determine payment allocations to building contractors. These progress photos become part of a permanent record of a job's rate of completion. Their use is strictly informational, and they are usually taken once a month from the same vantage points. A 4 x 5 camera is commonly used since detail and clarity are paramount concerns. Aesthetic considerations are not a factor. Progress photos are not normally classified as architectural photography; however, the vantage points from which they are taken (especially if from an adjacent building in a confined situation) may prove useful when it comes time to shoot the finished project.

When proposed changes are being designed for a building in an historic district or a restricted area, photography is probably the clearest and most direct way of presenting just how the proposals would change the existing structure. This type of work can be quite involved, perhaps using combinations of art work (overlays), renderings, and photographs of design models.

Design firms can use 35mm slides for in-house presentations, for design studies, and—if their quality is good enough—for client promotion. Many design firms use slide presentations as their primary selling tool. Needless to say, the higher the standard of photography, the more effective this method becomes. Careful editing is essential. Closeups and long views should be intermixed to vary the pace and enliven the show. No apologies should be necessary for any shortcomings in photographic quality.

Photographs are increasingly popular for display purposes. Display photos range from large photomurals covering entire walls to small, framed photographs hung as art. There are few, if any rules for displaying photographs because the criteria involved vary enormously. If a high degree of enlargement is required for an architectural subject and maximum sharpness is desirable, that almost certainly dictates the use of a 4 x 5 or 8 x 10 camera, for the greatest resolution. Sometimes a soft or grainy look is preferable, making the use of a 35mm camera perfectly feasible. Producing large-scale photomurals is a highly specialized field, and only a handful of laboratories are capable of performing this task well.

As an architectural photographer, I always strive to make a maximum-quality photograph, regardless of its intended use. At the time of shooting, I may not even know what the ultimate use (or uses) will be, so I try to make a photograph that will be at least technically first-rate. There is nothing worse than having an editor or an art director reject an otherwise acceptable image because "it's not sharp," or "the color is off," or large-format quality is needed. Maintaining high standards across the board for all my work means that I can confidently submit to anyone a photograph that survives *my* editing.

Work-in-progress photograph, in this case the 1962 demolition of McKim, Mead and White's Pennsylvania Station in New York City.

SELECTING EQUIPMENT

Most readers of this book recognize the fact that attempting architectural or interior photography without suitable equipment is a difficult, if not impossible, task. To produce the best results, it is essential to select and work with the appropriate equipment and materials.

There is no substitute for a view camera as the basic photographic tool. With a view camera, lens movements are possible with all focal lengths. This feature permits careful, efficient control of the subject in a way that is only partially replicated by the best of the alternative camera systems. A well-equipped photographer will have a view camera, and perhaps a couple of smaller back-up cameras for specialized purposes.

35MM CAMERA SYSTEMS

Nothing smaller than the 35mm format should even be considered. For the beginning photographer, a single-lens reflex (SLR) camera is a good starting point. A quality rangefinder camera, such as the Leica, could do the job, but the rangefinder system has limitations, and there is a definite advantage in being able to see the image through the lens rather than through a separate viewfinder, however accurate. Only when shooting at very low levels of illumination might a rangefinder camera have an advantage over an SLR camera.

There is currently an astonishing array of sophisticated 35mm SLR cameras on the market. Architectural photographers can substantially reduce this list by eliminating brands with limited accessories and, most important, too few available wide-angle lenses. Also, automated-exposure cameras that fail to provide a manual-override capability can be ruled out; in many situations the photographer must have full control. Many cameras have sophisticated built-in exposure-metering systems. The best of these can handle most situations but there are still some conditions where a handheld exposure meter is preferable. One system can provide a useful check on the other.

Some photographers may already have a 35mm camera, so they must decide whether to add to their existing equipment or to start afresh. Those who doubt their camera's suitability may need advice from a good professional camera store or from a friend who is a professional photographer. The better manufacturers can also provide help, but naturally, they tend to favor their own products. It doesn't make sense to spend money on expanding questionable equipment unless doing so eliminates its shortcomings.

My advice is to start out with a high-quality camera system that incorporates a good range of wide-angle lenses. Some of the best systems include: Nikon, Canon, Pentax, Olympus, Minolta, Leica, Rollei, Contax, Yashica, Ricoh, and Konica. I will point out the features that I consider important, if not essential, when selecting a particular brand or model within that particular family. The top camera manufacturers offer a variety of models for different purposes, some models being more suitable than others for interior and architectural work. The reasons for my own preference for Nikon equipment will become more evident as you continue reading. But first, a word of warning about camera equipment bought in the so-called gray market. Rigid, sometimes unrealistic, pricing policies have led to the unofficial importation of certain camera equipment. Beware, however, of this less expensive, brand-name equipment not imported directly from the manufacturer. Gray-market equipment is not normally guaranteed, particularly in the United States. If something goes wrong, many establishments refuse to repair or service these items. Perhaps a photographer saves a little money initially, but my advice is to make sure all camera purchases have legitimate guarantees, wherever purchased.

Only the following manufacturers offer perspective-control (PC) lenses suitable for architectural use: Canon, Minolta, Nikon, Olympus, Pentax, Schneider, and Zeiss.

A PC lens, sometimes called a shift lens, enables the photographer to offset the lens from its normal optical axis in relation to the film plane, either horizontally or vertically, or by a combination of the two movements. This rise, fall, or lateral shift of the lens gives the 35mm photographer control similar to that possible with a view camera. This control permits the extension of the field of view in a chosen direction without tilting the camera, a movement that produces distortion. There is no substitute for this capability. Although they are expensive, PC lenses are indispensable tools for the serious interior/architectural photographer.

Canon, Minolta, Nikon, Olympus, and Zeiss produce 35mm PC lenses, (the latter for Contax). Canon, Nikon, Olympus, Pentax and Schneider offer shorter focal length PC lenses, either 24mm or 28mm. To date, no manufacturer offers all three focal lengths for one system.

A fully equipped photographer would want all three lenses for maximum flexibility. So far, my choice has been the Nikkor 35mm PC lens and the Nikkor 28mm PC lens. The new Schneider Super Angulon 28mm PC lens is excellent and comes in a variety of camera mounts, so it could plug the gap in an Olympus system that otherwise includes their 35mm lens and the remarkable 24mm shift lens. Canon has just produced the first automatic line of perspective control, tilt lenses. These are unique lenses, 24mm, 45mm, and 90mm respectively, designed for the EOS Canon camera system, which is all electronic. This rules out adapting them to the other cameras. The only other 24mm PC lens, the Zuiko for Olympus, can be adapted to other cameras, but conversion is expensive. The Canon 24mm F3.5 tilting, shifting automatic lens is terrific. The ability to tilt is used mainly to increase the depth of sharp focus without stopping down the lens diaphragm so it is not especially important in architectural photography, particularly with a 24mm lens which already has substantial depth of field even at wide apertures. All three Canon lenses have a similar appearance, but the 45mm and 90mm versions have less potential for the interior or architectural specialist because of their limited coverage.

Your basic camera must be rugged, reliable, and able to function efficiently in a wide variety of situations. My personal choice is the Nikon F-3 or FE-2, which is no longer available. The Nikon F-3 is tougher, heavier, and larger than the FE-2, but it is probably more reliable in the long run. The lightweight, compact design, and general ease of operation made the Nikon FE-2 my favorite, but it fell victim to the move to automation. Features of both models include: dial-set exposures of up to eight seconds, double-exposure capability, delayed exposure, standard cable release, automatic setting, sync connection sockets (not included on some recent autofocus models), a sync speed of a 1/250 sec. on the Nikon FE-2, depth-of-field preview, and removable focusing screens permitting the use of a square grid for architectural applications, particularly useful with PC lenses. The Nikon F-3 and FE-2 both operate with little noise, but not as quietly as the Olympus OM-4.

When using the Nikon F-3 and FE-2 interchangeably, remember that the viewfinder of the F-3 shows 100 percent of the picture area and, unlike the FE-2, makes no allowance for slide mounting. Double exposure capability is essential in situations when a portion of the lighting requires special filtration. I found it impossible to make accurately coincident double exposures with the Olympus OM-4. The same feature on the older Nikon F-2 was also unacceptable.

A photographer will inevitably face the necessity of using more than one film type, so a second camera body is essential. The backup camera need not be quite as elaborate as the first, but it should be compatible with your lens system. Only the Rollei 2000F offers interchangeable film magazines in the 35mm format.

A photographer should choose a camera with a viewfinder and focusing system that feels comfortable. One particular brand may feel better than another depending on the individual. For example, the size of the camera's eyepiece can be critical to a photographer who wears glasses. Most of the cameras thus far mentioned have diopter adjustment or interchangeability to accommodate these photographers. The "high eyepoint" Nikon F-3 viewfinder is very generous in size, enabling the photographer to see the complete viewfinder image from some distance back from the eyepiece. When selecting a specialized screen, such as the square-gridded screen, be sure that you can focus properly with it, even at low light levels.

Camera controls should be clear and easy to set. I prefer to have the settings visible from above the camera. On the Olympus OM-4, some controls are on the front around the lens barrel and are not visible from above, and I find this less convenient. The exposure settings should also be visible in the viewfinder when the camera is mounted high on a tripod. Auto rewind and auto-film-speed indexing are also convenient features.

The Canon EOS-1 is the most "user friendly" camera I have operated to date. Many of the features of this multi-mode camera may have little or no application to interior or architectural photography, but because of the convenience, simplicity, and all-around ease of handling, I suggest you test it before making your final selection. The Nikon F-4 is larger, heavier, and has a more complicated appearance than the Canon EOS-1, but in all fairness I

Olympus OM-4 with 24mm shift lens.

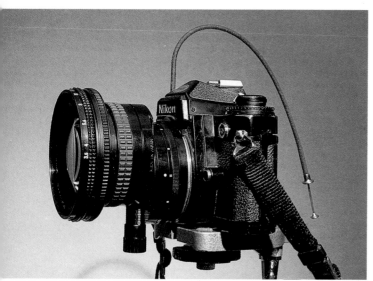

Nikon FE-2 with 28mm F3.5 PC lens.

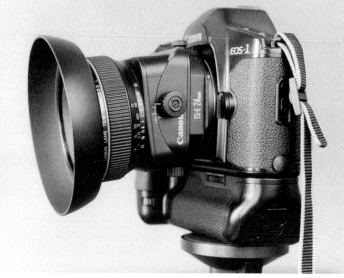

Canon EOS-1 with 24mm F3.5 shift/tilt automatic lens.

haven't tried one. The Nikon F-4 is also considerably more expensive, an important consideration.

To sum up, the proportion of time a photographer spends loading, determining correct exposure, setting shutter speed and aperture, focusing, and offsetting is still relatively short when compared to the other functions the photographer must perform in order to obtain top-notch results. Using the right camera simply makes the task easier, more efficient, and more pleasant, and thus encourages the unobstructed flow of creative juices.

Lenses for 35mm Cameras

When selecting lenses for architectural and interior use, unless you are a strong adherent to the "vignette school," you will need wide-angle optics. Even when it is possible to back up from your subject, more dramatic views are frequently obtained from a closer vantage point and for this, short focal length lenses are essential. The range of 35mm to 24mm will cover most needs. For certain critical conditions, lenses of 20mm or of an even shorter length may prove necessary, but their use will be somewhat limited for most photographers. For me, the 28mm lens is "normal." This focal length seems comfortable for both interiors and exteriors much of the time. This being so, I naturally chose the Nikon 28mm PC lens. I also have a 35mm PC lens. This gives me a lot of flexibility but I still lack 24mm shift capability, which is sometimes a handicap. My full complement of lenses, assembled over quite a long period, includes, in addition to the PC lenses mentioned, a borrowed 15mm lens (a linear lens); a 16mm full-frame, fisheye lens for special situations; an 18mm lens, and a 20mm lens, all Nikkor models. I then jump to a 24-50mm autofocus zoom lens. This is a particularly useful range, but there is some barrel distortion, most apparent at the widest setting. The quality of zoom lenses has improved substantially in recent years. I can use the autofocus feature of my zoom lens only with my Nikon N8008 camera, but its manual focusing differs little from my other non-AF lenses. The Canon 20-35mm F2.8 autofocus zoom lens for the EOS system is a truly marvelous wide-angle lens that exhibits no apparent sacrifices of image quality.

In the mid-range of lenses, I have the Micro-Nikkor 60mm AF lens. This lens is designed for close focusing and is a very highly corrected lens, giving extremely accurate color rendition. A Nikkor 70-210mm autofocus zoom lens fills out my basic outfit, although I do have longer lenses for nature subjects. The longer focal lengths are useful for details captured at distances.

With this array of lenses, I make few compromises and rarely face a situation I cannot handle. But I certainly could get by with fewer.

INTERMEDIATE SIZE ROLL-FILM CAMERAS

While cameras in this film group include such illustrious makes as the venerable Hasselblad, the 120 format has limitations and poses problems that only a view camera can solve. For this reason, I would not select a camera from this category as my basic tool. Having said that, however, I will add that for tasks where a format larger than 35mm is preferred, the Hasselblad or my Pentax 6 x 7 camera is the camera of choice for certain situations, such as aerial photography or when the photographer's mobility is crucial. The ability to shoot Polaroid test shots with the Hasselblad is another plus.

A photographer specializing in domestic interiors may not find the lack of lens movements a handicap. Many contemporary publications today prefer tight shots, or what I refer to as "vignettes." These photographs emphasize mood, rather than information. With the longer lenses normally used for this technique, it doesn't matter if the camera is perfectly level and the verticals are true, thus lens movements are not essential. Some camera systems do include PC lenses anyway, although usually not with particularly wide-angle optics.

VIEW CAMERAS

All the cameras previously discussed are, despite their adaptations, secondary in importance compared with the view camera, the architectural photographer's basic tool. Consisting essentially of a monorail supporting a front standard on which the lens is mounted and a back standard containing a groundglass for viewing, the view camera has a flexible bellows connecting the two standards, which permits extremely precise placement of the lens in relation to the film plane.

View camera focusing is achieved simply by moving the standards until the image of the subject appears sharp on the groundglass. The focusing principle couldn't be simpler, and, in fact, in its most basic form, the view camera is much less complex than a 35mm SLR camera. The view camera offers an unparalleled opportunity to control the lens-to-film-plane relationship and thereby the image, enabling the photographer to manipulate shape and limit distortion on the groundglass. This degree of flexibility in recording the subject, as well as the ability to expose and process via Polaroid individual sheets of film, make the view camera the architectural photographer's first choice.

A view camera must be mounted on a tripod; it cannot be used handheld. After an appropriate lens has been selected, the shutter must be opened and the maximum aperture set. The inverted image of the subject is then focused on the groundglass sitting precisely in the film plane. In order to view the image on the groundglass, it must be shielded from any strong light. The old-fashioned black cloth under which photographers regularly disappear serves this purpose. Though the black cloth is still used by some die-hards, monocular and binocular viewfinder systems that attach to the back of the camera are becoming the norm. The most sophisticated viewfinders render an upright though reversed image for viewing with both eyes (binocular) and also incorporate a magnifier for critical focusing. This is quite a contrast to struggling beneath a piece of black fabric in order to view the subject upside down, particularly on a hot day! It takes considerable practice to design and manipulate a composition when the image is inverted.

The view camera's front and back standards can be shifted up, down, and laterally, tilted forward and backward, and swiveled from side to side. These movements are respectively called the rise and fall, the shift, the tilt, and the swing, and they allow the photographer to adjust the size and shape of the objects in the image according to the assignment's objectives. When the photographer is satisfied with the image, the shutter is closed, and the aperture is set for the appropriate exposure. A film holder is inserted in front of the groundglass, and after removing the safety slide, an exposure is made. The length of the entire setup and exposure procedure depends on the complexity of the composition and other relevant factors, but it is never just a moment's work. So if speed or spontaneity is important to you, the view camera may not be the answer.

Occasionally it is advantageous to watch the subject through the camera's viewfinder until the exact moment of exposure. This is not possible with a view camera. In cramped quarters, the sheer bulk of a large camera will often make using it highly impractical. Also, the types of film available for the 4 x 5 format are more specialized and more limited than those obtainable for smaller formats. Nevertheless, in spite of all its disadvantages, the view camera remains the basic work horse of the architectural photographer.

The principal view camera manufacturers market a variety of models for a number of purposes, not all of which make them ideal for architectural and interior use. A still-life studio photographer will frequently make use of swings and tilts to control and extend depth of field, movements seldom used by photographers shooting interiors, and never with exteriors where depth of field is rarely a problem. For architectural and interior work, the ideal camera should be reasonably compact for transport, not overly complex (since normally only limited lens movements are required), sturdy and rigid, and reliable. It is essential that the camera have a sufficiently thin and flexible bellows so that wide-angle lenses can be easily

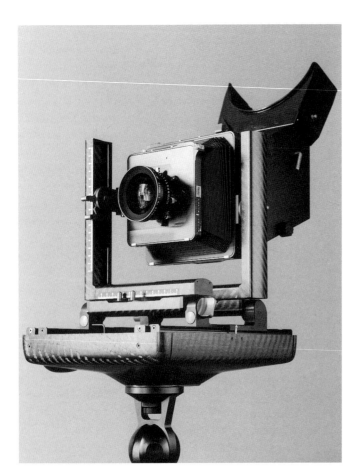

The Carbon Infinity "clam shell" 4 x 5 view camera, shown with Sinar binocular finder.

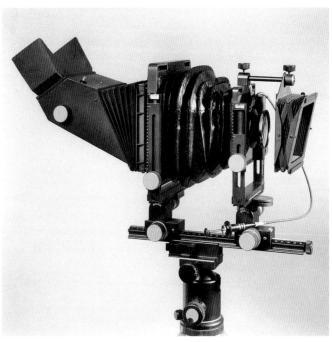

Comparison of 4 x 5 Arca Swiss F line camera and the 6 x 9cm version. The 6 x 9cm is shown with a 47mm Super Angulon lens, wide-angle bellows, and rollfilm holder, all mounted on an Arca Swiss ballhead. The tripods are by Gitzo.

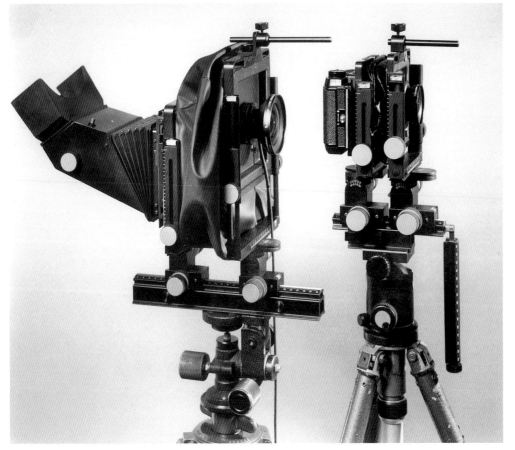

Here is the 6 x 9cm Arca Swiss camera shown with 4 x 5 conversion back, wide-angle bellows, binocular finder, and compendium lens shade/filter holder with a 150mm Symar S lens, mounted on the friction-adjustable Arca Swiss ballhead.

shifted and focused at infinity, preferably without the use of a recessed lensboard. Few standard bellows permit this. If the wide-angle bellows is well designed, it will also permit the photographer to use longer lenses without changing back to a standard bellows.

Some camera systems have more than one type of wide-angle bellows available. A soft bellows with folds may permit greater extension, but it probably won't compress into the compact size of a simple "bag type" bellows. One note of warning: Take care when working outdoors in windy conditions. I once had my camera blown over when the bellows caught the wind (the bellows can act like a small sail, even when placed on a heavy tripod). When shooting with the Arca-Swiss or the Sinar, I rarely use the standard bellows at all.

Reflex-viewfinder attachments for viewing non-inverted images are very useful. Some of these incorporate magnifiers for accurate focusing and mirror adjustments to see the extremities of wide-angle images (not easy in low-light level interiors). The controls for the various movements should be positive, secure, and easy to operate. They should be located so that the most frequently used adjustments can be made while the photographer is looking through the viewfinder. Single-function controls are best. Some cameras, including my earlier model Sinar F-2, had levers that locked the lateral shift as well as the swing. Sometimes an undesirable movement is locked in inadvertently; the locking mechanism should be very secure to prevent the image from shifting once it is set, particularly when film holders are inserted or subsequent adjustments are made to the lens, shutter, or filters.

There should also be provision for holding filters and a lens shade. The Arca-Swiss adjustable lens shade is a beauty. I prefer not to attach filters directly to the lens because this increases the likelihood of vignetting or camera movement if performed during exposure, a shortcoming

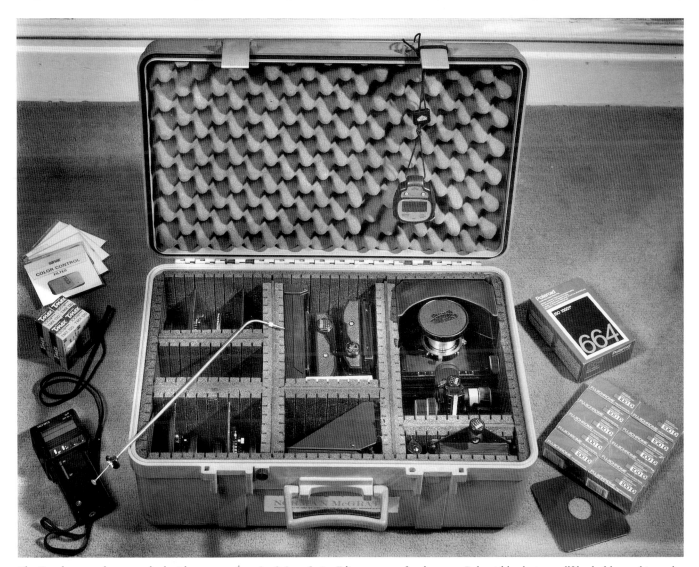

The Tundra case shown packed with my complete 6 x 9 Arca Swiss F line camera, five lenses, a Polaroid back, two rollfilm holders, a binocular finder and eyepiece, and a compendium lens shade. There is adequate room for film, an exposure meter, a stopwatch, and more.

of Sinar's current method. Accurate levels on both front and rear standards and on both sides, as on the Arca-Swiss model, make the camera much easier to level. A flaw in the design of the Sinar F-2 camera is that the front standard at times rotates around the tubular base rail. After coarse refocusing following a lens change, the front and rear standards may not accurately align themselves even though no offset has been made. Without a lateral front bubble level, this misalignment is tedious to correct. A squared grid incorporated on the groundglass facilitates subject alignment and Fresnel screens substantially brighten the image, particularly with wide-angle lenses.

Extendable monorails permit the use of longer lenses for detail work. The finish on the camera should be nonreflective, and black cameras are preferable. Although the 4 x 5 format is the preference of the majority of photographers, view cameras come in a number of sizes: 6 x 7cm, 6 x 9cm, 5 x 7", 8 x 10", and even larger. These days few people use a format larger than 4 x 5 on location, but the smaller 120 format, the 6 x 9cm, is coming into wider usage. The quality and size, as well as the economics, vary widely.

The demands, objectives, and working procedures in this field vary enormously. As an active professional, my assignments dictate a wide variety of approaches, so no single piece of equipment can meet all my needs. Every system, including the view camera, has limitations and it is important to be aware of them.

Small-Format View Cameras

The appeal of the 120-size view camera is that it combines all the functions of larger format units with the convenience of rollfilm. There is a wide variety of 120 film available today and it is substantially less expensive than 4 x 5 sheet film. The darkroom, changing bag, or tent are unnecessary because the film can be loaded in full daylight. The shape of the image, 6 x 9cm, is closer to 35mm in proportion. For an exact equivalent to 4 x 5, use an image size of 6 x 7cm, which will enlarge to 8 x 10 without cropping. Though not all 120-format view cameras are much smaller in size than their 4 x 5 cousins, two in particular stand out.

The 6 x 9 Arca-Swiss F camera is manufactured in the best tradition of Swiss precision craftsmanship. It is very compact and extremely sturdy. Of all-metal construction, the bases for both the front and rear standards are the same as those used for the larger formats with which they are interchangeable. I use one of these cameras and when traveling by airplane, my whole outfit fits neatly into a case that easily slides under my seat. It is a complete modular system with all controls serving a single function: levels front and rear and both sides, a binocular reflex viewfinder, bright Fresnel enhanced groundglass, adjustable lens shade/filter holder, Polaroid back, and 6 x 7cm or 6 x 9cm rollfilm backs. It has interchangeable bellows and positive detents for easy zeroing of movements, all calibrated for easy replication. With ample rise, fall, and lateral shift potential, as well as swings and tilts should you need them, this model is extremely rigid but not overly light. I have no fault with it, although it is expensive. In addition to the F field model, there is also an M model with even more features, but for location work the F is the way to go.

When 4 x 5 transparencies are mandatory, I have a 4 x 5 rear standard and a reducing wide-angle bellows to convert my 6 x 9cm to the larger size.

In selecting a 120-size view camera, keep in mind that it must be an extremely precise and well made piece of equipment to compete with larger formats. As Sinar points out, a view camera with full movement capability has no fewer than ten mechanical connections and tolerance must be minimal.

The Technikardan 23 is the smaller of two Linhof models designed for maximum compactness and full viewcamera versatility. The front and rear standards are sturdy L-shaped brackets attached to a multifunction, triple-telescoping monorail. This ingenious design permits the camera to be folded, via some slightly tricky maneuvers, into an 8 x 6-inch rectangle that is 3¾ inches high. A full 13 inches of extension is available for longer focal-length lenses. In addition, Linhof has installed a control module in certain lenses in order to permit all aperture settings to be made from the rear of the camera. Many accessories are available, including a reflex viewfinder. The only feature the Technikardan is missing is the ability to reverse the position of the film magazine when a horizontal composition is needed. In constricted locations where clearance to the right side of the camera is limited, this could present a problem.

If you already own a 4 x 5 camera system, then it may not be economical to switch to the smaller 6 x 9cm format. Consider a rollfilm back for your 4 x 5 camera. You may not have the compactness of the 6 x 9cm format, but your film cost will be reduced. You will have to adjust your lens selection for the smaller format. Not all 4 x 5 cameras are constructed to permit very short focal length lenses to be focused at infinity, even with wide-angle or bag bellows. In that eventuality, only recessed lensboards will permit the necessary focusing range.

4 x 5 Camera Systems

Since the first edition of this book, there has been a proliferation of view camera styles and models. Quite a number can now meet and even exceed the requirements of

the architectural photography field, but Sinar and Arca-Swiss stand out as favorites. Both are Swiss, of similar origins, and are fierce rivals. I have found the Sinar F model the most widely used view camera among architectural photographers. This camera comes in two forms: the Sinar F-1 and the Sinar F-2. Sinar, which stands for *Studio, Industrial, Nature, Architectural, Reproduction*, has recently modified the Sinar F-2, which is my preference, replacing the dual-purpose locking lever that controlled lateral shift and swing with two separate levers for these functions. The front standard of the Sinar F-2 is much sturdier and more rigid than those of the Sinar F-1.

Sinar currently insists on marketing the F-2 with a back that has a flange on it to receive a probe-type exposure meter rarely used on location. This flange prevents the back from being reversed, which would enable the photographer to load the film from the left as well as the right side, a very useful feature easily achieved with the standard, less expensive back that comes with the Sinar F-1. Another detraction of the F-2 is the length of the posts on both the front and rear standards. These are far longer than necessary or desirable, since they make the camera difficult to pack, they get in the way, and when used fully extended, the unit is not very rigid. Some earlier models of the Sinar F-2 lacked these compromising features.

Sinar's old type, swing-away gelatin-filter holder was a gem, but unfortunately is no longer made. If you find one, it is worth its weight in gold. Sinar's current filter holder is for their own plastic filters, which are expensive but of high quality. Two or three of these filters combined are quite thick. Gelatins are much thinner, and they are more fragile.

There are a number of methods for collapsing the camera for transport and the camera is not heavy. The binocular magnifier viewfinder, though large and not collapsible, is terrific. I can't imagine why anyone would use this camera without one. The Fresnel screen permits full-image analysis with wide optics. Levers to move the groundglass back from the camera make loading oversized film holders easy. Locks are positive and precise, the movements well calibrated. Lensboards, interchangeable with Horseman models, are flat, and even the shortest focal-length lenses can be focused without being recessed. Simple locking devices make changing lensboards and bellows a quick and easy procedure.

The modular system is expandable and upgradeable since many of the parts are interchangeable. Sinar has both mechanical and electronic behind-the-lens-shutter systems available; these permit the use of lenses without shutters, which are less expensive. However, when using these shutters, the lenses must be mounted on special boards, and this further expense offsets most of the sav-

The Arca-Swiss answer to Sinar's built-in depth-of-field finder. This neat gadget slips on the rear end of the monorail. The closest limit of sharp focus is selected and the indicator is placed in contact with the base of the rear standard. The furthest limit is then focused on, and you depress a button that releases the arm of a small gauge. A number will appear on the right side of the unit, 23 in the photograph here. One of four scales, depending on the format, then shows the aperture needed for the designated depth of field. Before you take the photograph, you must move the rear standard until half of the figure is indicated, in this case half of 23, 11½.

ings. There are also complications when using the widest optics. One nice feature of the behind-the-lens shutter is that the camera can be operated entirely from the rear. Another very useful Sinar device—until recently unique among 4 x 5 view cameras—is the scale for determining the aperture required for a particular depth of field.

Here's how it works: Focus on the farthest subject point to be rendered sharply and set the aperture scale to zero. Then using the fine-focusing drive, focus on the nearest subject point you wish to be sharp. Next, read off the appropriate aperture from the scale and set it on the lens. Turn the fine-focus drive back two lens-stop intervals and the exact focusing position is set. Using this system avoids guesswork and excessive stopping down. A similar device determines the tilt angle for the plane of maximum sharpness, a useful studio feature. The base clamp that attaches to your tripod head will permit the camera to be rotated around the base tube. This can be useful for extremely low viewpoints. The base clamp removes easily for compact storage.

For photographers who insist on geared rise and fall and self-locking movements, the Sinar C-2 camera is one solution. The Sinar C-2 is lighter than the top of the line Sinar F camera, which is a highly elaborate view camera used for studio work; it simply uses a P-2 rear standard with the rest being similar to the F-2. This is Cervin Robinson's camera of choice.

The first Arca-Swiss camera appeared in the early 1950s. The current models of the ARCA (All-Round CAmera) are the brainchildren of Philippe Vogt, the director and head of design at Arca-Swiss since the early 1980s. Arca has the M line and the F line, the former being a studio camera and the latter for location work. Of all-metal construction, they are beautifully built and extremely rugged, modular, and yaw-free.

The F line has a two-part monorail supported by a full-length extension bracket. One variation has a folding rail unit and a short supporting bracket, permitting the camera to be moved freely away or toward the subject. The former type is extendable without extra parts for most needs. Each control serves no more than a single function. Rise and fall is not geared but may be securely locked like all the controls. Clearly legible scales indicate exact amounts of shift and zero adjustments are easily set with detents.

The rather large lensboard is recessed, but at its outer edge, so it does not restrict access to the shutter. Lensboard adapters permit the use of smaller Horseman or Sinar lensboards or 6 x 9 Arca lensboards. When a lensboard is inserted in the camera, a small sensor locks it in place automatically. Depressing the rounded clip-holder controls lateral shift of the front or rear standards as well as their interchangeability with other formats, a very simple procedure. The function carrier is in fact common to all format sizes from 6 x 7cm to 8 x 10. Except for the F-line B (Basic), all models have Fresnel screens on the groundglass.

The binocular reflex viewer has a built-in magnifier and produces a very bright, upright mirror image. The soft rubber eyepiece is large enough to permit the use of eyeglasses. A flexible bellows on the finder allows adjustment of the view of the image. In the Sinar system, the mirror slides inside the finder to achieve a similar result. A nice alternative to the rigid reflex viewer is a soft leather viewing bellows, which can be used with or without the binocular magnifier but with the same rubber eyepiece. However, the image is inverted.

Finally, the Arca-Swiss compendium lens-hoods with scissor extenders are the best and most convenient I have used. Filter holders can be inserted either in the front or the rear of the hood without touching the lens. A small, removable extension bracket attaches to the front standard into which a rod is inserted to support the hood. With its all-metal construction, the Arca-Swiss is rigid and likely to remain so even with heavy use. It is now my camera of choice.

For the economy-minded, the least expensive view camera with removable bellows is the Toyo 45C, which at the time of writing costs about $650. This camera used to be the Omega, but the nameplate has since been dropped. The camera is now all black and comes with a Fresnel screen. The base rail is 18 inches long and non-extendable. Manual swing and shift movements have separate locks. A generous 12cm rise on both front and rear standards is geared, and this is a nice feature. Constructed of metal and plastic, the camera seems lighter than its 9-pound weight. It has an International revolving back. Either a lens hood or a combination filter holder/lens hood that accepts 4 x 4" or 3 x 3" filters with an adaptor is available. For 65mm lenses, a recessed board is necessary, otherwise the standard 6 x 6" flat lensboard is sufficient. The vinyl bag bellows, at $300, may seem overpriced, but it is essential. The reflex finder is also pricey at $600. This is a good basic camera, but once you buy the complete outfit, it is not significantly less expensive than the others mentioned above.

Perhaps the most exciting new view camera design to appear recently is the Carbon Infinity. Totally unlike anything you have seen before, this is the ultimate 4 x 5 location view camera. Like a clam shell, the base of this precision tool is the lower half of what becomes a rounded, carbon fiber box. This "box" is very strong, and gives no clue as to its contents. The camera weighs in at 7.5 pounds (3.3kg) and is roomy enough to include a lens inside the folded camera. With its measurements approximately 10 x 11 x 5", the entire unit is not much larger than a handbag.

The following is a list of currently available 4 x 5 view cameras that are suitable for architectural work because they have interchangeable bellows to permit lens movements with wide optics. The length of the base rail or monorail, plus the extension of the bellows will determine the longest lenses the camera can handle.

Cambo has five models, and the least expensive is the Cambo 45N, which has a 16-inch monorail and a 21-inch bellows; it weighs 8 pounds and costs less than $500. The Cambo Legend has a 16.5-inch monorail, a 21-inch bellows, weighs 13.5 pounds and costs about $1,000. The Legend PC and Master PC are heavier, more expensive, and less suited to location work. The Linhof E camera has a 20-inch monorail and a 21-inch bellows extension; it weighs 8.2 pounds and costs about $2,400.

Sinar has just announced its new entry-level camera, which joins the F1 and F2 cameras already discussed.

The Sinar A1 camera has a 19-inch monorail and 22-inch bellows extension and is priced at $850. This camera is not compatible with the other Sinar range of cameras so it cannot be upgraded, but is exchangeable for full credit as a tradeup anytime within a four-year period. Avoid the Toyo 45D camera, Toyo's least expensive model, because the bellows is non-interchangeable. The Toyo 45C (previously discussed) has an 18-inch monorail, with 18-inch bellows extension. The GB and G models both have two 10-inch monorails, 18-inch bellows, weigh 12-13 pounds, and cost between $2,000 and $2,600. All prices can vary substantially.

View Camera Lenses

Even more critical than the type of camera is the photographer's choice of lenses. If the camera selected represents a compromise, the lens should not. A photographer needs the best lenses affordable. With care, they will last indefinitely. If the photographer diligently searches for a particular lens, a used one can often be found at a lower cost. The shutters on used lenses are easily serviced if there is a problem. Older lenses are not usually multi-coated, making their color rendition less accurate. Color rendition may, in fact, vary substantially from one lens manufacturer to the next. For consistency, it is best to stick to one manufacturer's lenses, or at least to check them out first. In a project series of photographs, it is undesirable to have color variations due to different lens characteristics.

My most frequently used lens is the Schneider Super Angulon 90mm F5.6 lens. After my lens of choice, I prefer the Super Angulon 120mm and 75mm lenses. These focal lengths are approximately equivalent to 28mm, 35mm, and 24mm lenses for a 35mm camera, and cover most of the photographic situations I confront. The basic characteristics of these view-camera lenses make them particularly suited for architectural and interior work, and the reader should develop some understanding of their attributes.

The first sight of a wide-angle view camera lens comes as quite a surprise to anyone familiar with only 35mm camera lenses. Lenses for the different formats appear to have little in common. View-camera lenses are typically symmetrical in design, having two groups of four elements, the largest of which are at the extreme front and back of the lens. The shutter is located right in the middle where all the light rays converge. Thus, the view camera lens is shaped like an hourglass; it is not barrel-shaped like a 35mm lens. When a view-camera lens is focused at infinity, its rear element projects back into the space between the front and rear standards of the camera. When no lens movements are necessary, usually there are

no problems with the rear element unless a very short focal length lens cannot be focused at infinity since the front and rear standards cannot be moved closer to one another. The restricted movement may result from limitations in the camera's design or because a regular bellows in its fully collapsed position doesn't permit further adjustment.

The solution to this problem is to use a wide-angle, or bag, bellows. Large and flexible, this device is substituted for the regular bellows and enables the front and back standards to be moved to their closest possible position. When the distance between them is still too great for the lens to be focused at infinity, using a recessed lensboard becomes necessary. It positions the lens closer to the focusing plane or groundglass, but it also hinders access to the lens settings.

When listing specifications for particular lenses, manufacturers frequently use the term "angle of view." This term usually means the horizontal angle covered by that lens in a particular format. For example, a 28mm lens on a 35mm camera has a 65-degree angle of view measured on the horizontal. The closest equivalent lens in 2¼ x 3¼" format would be a 65mm lens with a 66-degree angle of view; on a 4 x 5 camera, a 90mm lens would create a 68-degree angle of view. Occasionally, a lens manufacturer quotes an angle of view that is measured on the diagonal of the scene, which would, of course, be considerably greater than the horizontal figure. The angle of view for a particular focal-length lens relative to a single format will always be the same, regardless of the lens design. A change in format, however, alters the angle of view for that lens. For example, a 135mm lens has a 15-degree angle of view for a 35mm format, but the same lens has a 48-degree angle of view with a 4 x 5 format. All the above figures are calculated with the lens focused at infinity, which is how manufacturers also calculate angle of view.

Image size is also determined by focal length. An object photographed from a fixed distance yields an image size on film determined by the focal length of the lens used; this image size won't change regardless of the format used or the optical design of the lens. Why, then, do manufacturers sometimes produce two and three lenses of the same focal length? The answer is that lenses used for different purposes require such variable characteristics that a single optical design is incapable of meeting the exacting needs of all photographers.

One of the major attributes for photographing buildings inside or out is the ability to use generous lens movements. In cameras that have a fixed lens-to-film-plane relationship, the image circle projected by the lens on the film plane needn't be much larger than the diagonal measurement of the frame size. In view cameras,

where the lens-to-film-plane relationship is adjustable, the image circle projected must be correspondingly greater to maintain the necessary sharpness no matter what part of the image circle is recorded on film. Hence, view-camera lenses must exhibit a wider "angle of coverage." These lenses must have larger image circles than similar optics for fixed lens cameras.

The highest-quality wide-angle lenses usually have the greatest angles of coverage. Optically, they are the greatest challenge to manufacture, so these lenses are likely to be the most expensive. The angle of coverage is also affected by the aperture of the diaphragm, and it is usually optimum at $f/22$. An examination of the specifications for the Super Angulon series of lenses indicates that they have a 105-degree angle of coverage for the 65mm, 75mm, and 90mm F5.6 focal lengths. Their corresponding image circles are 170mm, 198mm, and 235mm in diameter. As the focal length increases, the image circle does, too. That is why lens movement is most limited with the shortest focal-length lenses in any particular format.

The fastest wide-angle, view-camera lenses in the Caltar line (marketed by Calumet) and in the Schneider, Nikkor, Fujinon, and Rodenstock lines have remarkably similar specifications, and all are excellent. The second class of lenses made by these manufacturers are somewhat slower, having maximum apertures of F6.8 or F8. Their image circles and angles of coverage are usually smaller (Nikkor lenses are an exception), and their price is lower. You can buy two Super Angulon 90mm F8 lenses for the price of one 90mm F5.6 lens, but the image circle of the latter is 20mm greater, allowing for substantially more lens shift. All the lenses I've mentioned come with Copal shutters that are very reliable and have a range of shutter speeds from 1 sec. to 1/500 sec., plus B and T, but Compur shutters are also available.

Calumet's *The Photographer's Catalog* is a handy reference and comparison text, and Sinar also has comprehensive literature available on request. Sinar periodically runs seminars on view-camera technique, and Calumet publishes a videotape, "Large Format—the Professional's Choice," with an accompanying workbook. Both publications have much helpful information.

TRIPODS AND OTHER ACCESSORY EQUIPMENT

Once you have assembled a combination of camera and lenses, you must address the question of camera support. A sturdy tripod is a must. Obviously, a large, heavy tripod designed for large-format equipment is inconvenient for the 35mm format. But choosing a very lightweight tripod for convenience of transport is a mistake, because if there is a strong wind or you accidentally jar it, a lightweight tripod won't keep the camera stationary, which is the

objective. A lightweight tripod may oscillate after it has been adjusted, particularly if the centerpost is elevated. Whatever its size, the tripod should have positive, secure locking mechanisms and adjustments that can be achieved without having to apply too much force. Some tripods incorporate damping, so that if the centerpost is unlocked the camera does not "free-fall" and cause damage. In some cases the legs may also have damping or at least a certain amount of built-in friction. For a small-format 35mm camera or other non-view cameras, the tripod head should permit the positioning of the camera for vertical compositions and the platform should be modest in size, but not too small, so that no interference occurs when the lens barrel projects below the base of the camera (as it does on my Nikon). The platform surface is important because you don't want the camera to rotate when you wind the film between exposures. (Autowind also helps to prevent this.)

The tripod legs should have rubber feet or non-slip pads to prevent slippage and to protect delicate surfaces or floors. The Tiltall tripod also has retractable spikes for difficult situations. As for color, I prefer a matte black finish for its non-reflective property, but Gitzo's gray works well most of the time. For location photographers, a tripod that is compact when folded is easier to transport. A multiple-section tripod will be more expensive, take longer to set up, and have more joints to wear out.

Not infrequently, a special situation demands an unusual approach. A tripod with the ability to be adjusted both very high and very low is particularly useful. Both Gitzo and Bogen include devices on the leg lugs that permit the leg spread to be varied on some models. Most professional tripod makers have guides giving weight ranges for particular models, and these should be adhered to. This is particularly important when it comes to the centerpost mechanism. The locking of the centerpost must be adequate for the weight it must support, by a substantial margin. You will have a major investment perched on top of your tripod, so select carefully.

In some older models, the gearing of the centerpost is a weak link. If you are unsure, avoid geared posts. Some tripods feature removable centerposts that can be reversed with the camera attached below instead of above, but these are more difficult to level. When the camera to be supported is a view camera, I prefer a pan, double-tilt-type head, which makes leveling easier than a ball head, which some photographers prefer. Gitzo's pan, tilt, heads come in a variety of sizes and feature long handles (optional short handles are available) for ease of locking and leveling. For compact storage, you may have to remove the handles. Some models of the Bogen range feature a quick-release mounting plate, which is useful if

you have to shoot the same subject with different cameras from the same viewpoint. A note of caution here: If you live in a high-risk area you may need to use an anti-theft lock plate with a cable attachment. The design of the head should be such that your view camera can be pointed straight up, or down, and be held firmly in that position while adjustments are made and film inserted.

A sidearm is often an essential extension to your tripod. A sidearm enables you to position the camera in what would otherwise be an impossible location. Great care must be taken to ensure that everything is secure because the center of gravity of your setup may be potentially dangerous. Other accessories can include chain spreaders to limit the spread of the tripod legs; dollies, mostly for use in studios; and all-weather shoes for the photographer working in snow or sand. Beware of salt water: If you get sea water into the tripod legs, dismantle them immediately or the salt will quickly cause corrosion. I use plastic bags to protect my tripod when I have to set up on a beach. For the small-format user traveling light, a tabletop tripod or even a gaffer clamp with a standard mounting stud on it (like Bogen's Sky Hook) can become an effective camera mount; a monopod should also be considered.

A few tips on usage. Always spread the legs fully for maximum stability. For maximum elevation, set your view camera at its highest viewing position using the leg adjustments, and then raise up the centerpost for your Polaroid test. Make sure the camera is firmly attached to the head before starting. Keep the center of gravity of your camera as close as possible to the attachment point to the tripod. A few pieces of tape on the tripod frequently come in handy. When it's windy, hang a gadget bag or anything heavy on the tripod for added stability. Use the larger top sections when setting up, rather than the smaller, less sturdy, bottom sections. This also facilitates collapsing the tripod afterward.

Ballheads are convenient for smaller cameras but not quite as easy to level on two axes simultaneously (though some users become adept at this). Arca-Swiss has two excellent models, the smaller of which has a clever friction adjustment depending on the weight of the camera to be supported. It comes with either a standard plate for attachment or a clamp for the monorail of the Arca-Swiss view camera. The larger monoball is in fact a ball within a ball and when unlocked provides free movement on only one axis at a time. This makes accurate leveling of a view camera an easy two-step process. No annoying handles project from a monoball to poke you in the chest or otherwise restrict your movements.

One variation of the ballhead approach is a unique item known as the Prohead. Based on a patented mechanical joint, the Amrus Shpigel Joint, it permits a wide range of camera positions and yet has only one basic control handle apart from a simple locking knob at its base for panning. The control handle securely locks both tilt and swivel movements by rotation but has a separate section near its attachment point that enables the user to vary tension on the Prohead for different camera weights (similar to the Arca-Swiss ballheads). With only the tension setting adjusted, it is a simple procedure to level your camera by applying pressure first on one axis then on the other and then turning the main control handle clockwise until it is tight. The Prohead looks like a ball head and is just as compact. I recommend it.

I also like the more conventional pan-tilt head recently put out by Majestic. This model has nice fat control knobs, and is extremely sturdy and compact. You do have to reverse the camera to tilt the front upward, however.

Although Gitzo tripods are more expensive than most, they are particularly rugged and well designed (see page 26; the 4 x 5 Arca Swiss F line camera is mounted on a Gitzo tripod). In addition, the manufacturer guarantees the product and will frequently replace broken or failed parts free of charge unless gross negligence is evident. The internal bushings are very wear-resistant but are easily replaceable if necessary. Gitzo is my first choice. Small-format users caught without a tripod can resort to placing the camera on a flat surface (or a bean bag) and using either the delayed-action shutter feature or a long cable release. In either instance, use mirror lockup if it is available.

Very tight situations may necessitate positioning the camera where viewing is difficult, if not impossible. For Nikon users, all the F models have interchangeable viewfinders, including a right-angle finder. Otherwise a small mirror might do the trick. Cameras with Polaroid capability can rely on tests to indicate exact framing. A small dental mirror (available at drug stores) may enable the photographer to check exposure settings that are otherwise obscured from view.

About Electronics

Many of today's sophisticated smaller cameras rely entirely, or at least partially, on batteries to operate. As battery-related problems account for the largest single category of 35mm camera failure, my advice is always to carry spares. On some cameras, certain shutter speeds work without current, since they are mechanical rather than electronic. But if you are not completely familiar with your equipment, it is comforting to keep the instruction booklet at hand. Keep in mind that temperature will affect battery performance. Cameras that are likely to be subjected to extreme cold should be winterized by a

reputable repair/service establishment. Batteries lose efficiency as the temperature drops. Always carry spare batteries, especially those hard-to-find sizes. For long exposures, you will certainly need a good stopwatch. Get one that is easy to read and simple to operate. Large, clear numerals will be much easier to read in low-light-level situations. A pocket flashlamp with a clip is handy for after-dark shooting.

Always carry two or three cable releases. Even quality cable releases can be damaged accidentally, so you'll need backups. Electronic 35mm and other small-format cameras may not accept standard-type cable releases (like my Nikon 8008 or the Canon EOS-1). You may need a long one so that you don't cause a reflection. Some of my wide-angle view-camera lenses require a very short attachment fitting to the lens because of minimal clearance, so don't wait until you get to the job to discover that your new release doesn't work.

I always position my lenses on the camera so that the cable hangs downward with minimal strain. I much prefer the round, flat type of locking disk to the small, projecting screw type. In general, I like to use the T setting on my view camera lenses instead of the B, which must rely on the cable to hold the shutter open. However, not all shutters have T settings.

Exposure Meters

As I have already mentioned, many 35mm cameras come with sophisticated built-in systems for determining and setting correct exposure. Working only in small format, a photographer could possibly rely only on a built-in meter, but I feel that having a separate meter is more convenient and permits greater flexibility. Exposure determination can be quite tricky, particularly with interiors that frequently include light sources within the composition. I want a meter that reads a limited area; I find meter selectivity of about 20 degrees or so to be ideal. This allows me to choose an area of my composition that I know will give me an exposure reading I can use for the entire photograph. With the aid of a reflex viewfinder (another must) I can purposely avoid overly bright or unusually dark areas that would otherwise influence the exposure.

An exposure meter should be able to determine exposures that vary from snow scenes in bright sunlight to dimly lit interiors with dark surfaces, and night scenes. The latter sometimes require extremely long exposures, running to several minutes. This degree of sensitivity should be combined with a broad range of film speeds from ISO 10 to beyond ISO 1000 in order to accommodate the fastest films now available. The meter must be able to make reflected- and incident-light readings. A

number of new models can double as flash meters and have a digital readout; other models display analog readings. The final selection should be based on personal preference and accuracy.

The meter should be simple to use and not require tedious dial turning to obtain the readings. The more compact and easier to use, the better. The dial numbers should be easy to read even in low levels of light. Film-speed settings should be clear, and once set, they should resist accidental alteration. An exposure meter that retains the reading after use is helpful. If the meter has a mechanism that must be unlocked to obtain readings, this will probably protect it if it is accidentally jarred. Battery checking should be straightforward, and the photographer should always carry spares. Also the ability to check zero readings is, at times, a useful feature.

The top manufacturers of exposure meters are Minolta, Gossen, and Sekonic. They sell a wide range of meters for all purposes. Pentax produces good spot meters, too. One-degree spot meters are occasionally invaluable for determining the correct exposure of very distant objects or small important areas that are perhaps surrounded by subject matter of varying brightness. Spot meters require some skill to use, and a meter that averages exposures from a larger area is more useful for general purposes. My current meter, which is extremely accurate and fast reading, is the Sekonic L488. Not the most compact of their current line, it has a viewfinder and either an 18-degree setting that covers a large enough area to give me good average readings and enables me to exclude overly bright or dark areas that might otherwise create problems. A flash setting permits me to get combination ambient/strobe exposure values. For very specific situations the 1 degree can be useful, but I use mostly the wider setting. Some meters will now average several spot readings but I usually rely on my experience confirmed by Polaroid tests.

In addition to the above-mentioned exposure meters, there are a number of them specifically designed to take readings off the view camera's film plane. The exposure values obtained by this method automatically include adjustments for any filters and bellows extension affecting the normal exposure. This type of exposure meter is inserted into the back of the camera like a film holder, and readings are obtained after the lens has been stopped down to its appropriate *f*-stop. Horseman makes an exposure meter of this type for 4 x 5 cameras; it has three ranges and very good, low-level sensitivity for shutter settings as long as 30 minutes. Sinar makes two similar, though more expensive and elaborate, exposure meters: the Sinarsix-digital and the Profi-select TTL.

Special Aids for Prepping the Subject

I always carry a small tool kit along to a shooting session in order to make on-the-spot repairs or adjustments to equipment and for any other eventualities. Window cleaner, wood and floor polish, and other cleaning aids may be required. Some of these items should not really be the photographer's responsibility, but sometimes there isn't anybody else to provide them.

A variety of tape is invariably handy. So is a small supply of picture hangers, both the small pin type as well as the stick-on variety that doesn't leave a visible hole but needs adequate time to set before supporting any weight. Fine nylon wire has many uses and is often invisible to the camera. Also nylon wire is excellent for precise positioning of tree branches as well as large leaves on exotic plants. Double-stick or carpet tape is good for preventing or eliminating unevenness in rugs and carpets. A simple pair of scissors can cut paper or cardboard shapes to conceal or disguise some overly prominent item. An eraser is good for removing scuff marks from baseboards and other woodwork if other cleaning methods are unavailable. A small level to square up picture frames on a wall, and a tape measure can also prove helpful.

To prevent unwanted reflection in a composition, strategic placement of black paper or fabric may do the trick. In other situations, white paper may be required instead. When using supplemental lighting, the glare from shiny objects is sometimes a problem. A can of dulling spray or tape may be the solution. This simple spray-on liquid is inert and dries very fast, leaving a thin, non-reflective coating on the offending object. Before using dulling spray, the photographer should read directions for its use carefully and make sure that it won't damage any delicately finished surfaces. It can be tested on a small area first. Marketed by Krylon, the product is available through art supply stores.

SERVICE AND REPAIR

Virtually every piece of equipment, however good its quality, will need service or repair. To forestall trouble, check equipment thoroughly before important trips. Take backup equipment if possible. And never take untested or new equipment on an assignment when no alternative exists. It helps to build up a file of good repair services in all the localities where you work and to take along the telephone number of a local service when on location.

Marty Forscher, with Harvey Shaman, wrote a detailed article entitled "28 Ways to Prevent Camera Breakdowns and Cure Them When They Happen," which originally appeared in the now-defunct *Modern Photography*. Divided in three parts, the first discusses advance preparation, the second deals with common field problems, and the last with preventive maintenance. If you are interested in obtaining an offprint copy of this article, write to Professional Camera Repair Services, 37 West 47th Street, New York, NY 10036, or call (212) 382-0550. Also, if you need to have your camera or lens serviced, contact Professional Camera Repair Services.

FILM AND FILTRATION

One of the basic decisions any photographer must make before attempting any assignment is what film to use. Ten years ago most professional photographers working in 35mm format used Kodachrome. This film, originally developed in the 1930s, remains to this day the material that sets the standards for quality. Kodachrome 25 is the finest grain 35mm color film made and Kodachrome 64 isn't far behind. The latter is still the favorite of many professionals. The major drawback in this age of convenience is that Kodachrome requires very complex development (K-14). The expensive equipment required severely limits the choice and location of labs that can handle it. Kodak no longer directly handles processing as it once did and, as a result, other films now threaten its once invulnerable superiority.

The particular format a photographer works in will define the film choices available. A specific Ektachrome film may be available in 35mm or rollfilm, but not in 4 x 5 sheets. If a film is marketed for multiple formats, is there a good reason to use it instead of others that aren't as universal? You should consider the following criteria when selecting film.

Choosing Film

To some extent, film selection is a matter of taste. First, think about the type and range of subjects you expect to photograph, and then run a series of tests. If you intend to use a large-format camera and concentrate primarily on interiors, your choices are limited; in fact, they're frequently confined to film manufactured by either Fuji or Kodak. You might be able to find Agfa film in your region, but its availability varies widely. Of course, whichever film you decide to test should be readily obtainable.

What you'll discover is that some films produce very different results in certain circumstances, but virtually indistinguishable variations in others. Keep notes on your tests. That way you'll be able to analyze the film charac-teristics and match them to the subject matter. I am sure it is no accident that, in general, Fuji films give a somewhat warmer rendition than their nearest Kodak equivalents. The inroads that Fuji has made into the American professional film market are, I believe, at least in part due to this factor.

The job requirements will determine the basic type of film you use. If you want color prints, select a color-negative film since the most economical Type C print is made from this material. If publication is what you are aiming for, color-transparency (or color-reversal) film is the best choice because most magazines, books, and other publications make color separations from slides, not from negatives. Since wide variations are possible when making Type C color prints from negatives, I always shoot a transparency as well, if only as a guide for the printer. A printer with only a color negative has no indication what the correct color should be. Cibachrome and Type R prints are made directly from transparencies and don't require a negative. They tend to be more expensive than Type C prints, which can be made from negatives only. Cibachromes in particular are very stable and will probably last longer. If only a transparency exists, then it is necessary to make an internegative from it in order to produce a Type C print. Negatives and internegatives are virtually the same in terms of the quality of the finished print. When you need black-and-white prints, shoot black-and-white negative film if possible. Today, good quality black-and-white prints can be made from color negatives using special paper; however, avoid making copy negatives from color originals because the results are frequently inferior.

Another criterion that helps determine film choice is the type of lighting you encounter, or introduce; it will determine whether you use a daylight- or tungsten-balanced material. Most photographers shooting outside in the daytime use daylight-balanced film since no filtration is usually required. Some, however, prefer to use only

The master of infrared photography, West Coast photographer Julius Shulman uses black-and-white infrared photographs to emphasize and dramatize architecture, producing exciting images that are mysteriously abstract.

one basic type of film when shooting both artificially illuminated interiors or daylight situations, but corrective filtration will then be necessary. Using a tungsten-balanced Type B film in sunlight requires the use of an 85B filter for correct color balance. At dusk some exteriors may be rendered more dramatically with Type B film. As exposures lengthen due to falling light levels, reciprocity will begin to be a factor with daylight film. Experiment is the word here. When light levels are lower, as they are in most interior situations, I nearly always use Type B film, regardless of the type of light. Filtration may be necessary but this film is designed to be stable for long exposure times and will give more consistent results than daylight emulsions.

When selecting film, also keep in mind that, basically, the lower the sensitivity or speed of the film, the finer the grain structure or resolution and the better the image quality. The penalty for fine grain, however, is higher contrast. Faster emulsions tend to be more grainy and therefore will render detail and tonal subtleties less accurately. Less than ISO 50 film speed is considered slow, film speeds that range from ISO 50 to 160 are medium speed, and film speeds of ISO 200 and above are considered fast films. For large-format film sizes, this is less critical than it is with small format.

Working with 4 x 5 format, fast films may pose no problems, but this isn't true for 35mm transparencies. In my work I find that nine times out of ten, 35mm slides are used for projection purposes only and most of the reproduction is done from 4 x 5 originals. Choice of film speed for much architectural work boils down to convenience since the subjects are static and the camera is on a tripod. Length of exposure isn't usually critical.

Specific Types of Film
For most shooting situations ISO 100 daylight film is the norm; for tungsten emulsions, ISO 64. Both Fuji and Kodak market sheet film in the above speeds. Fuji 100D is available in both rollfilm and sheet-film sizes and is currently very popular. It is an excellent general-purpose film, easy to obtain, very consistent, fine-grained with very good resolution, reasonably wide latitude, holds shadow detail well, and exhibits relatively little reciprocity (color shift and loss of sensitivity at longer exposures). Fuji 100D renders blues and greens particularly well and has an overall pleasantly warmish cast. Unlike some other films, it successfully handles open-shade situations well and doesn't produce blue shadows. For large-format work, Fuji doesn't make anything faster than 100D, but this film can be pushed two stops, to ISO 400, with increased contrast but little sacrifice in grain. Push-processing increases the effective ISO rating of a film. Only

reversal films can be pushed; color-negative films can't tolerate variations in development time without loss of quality. The only exception to this rule is Kodak's Ektapress rollfilm line, which has the added advantage that it doesn't require refrigerated storage. For my everyday shooting, I like the extra speed the 100D film provides even though Fuji 50D is finer-grained and is perhaps the best choice for really critical work.

But the ultimate fine-grain film available for 4 x 5 work is Fuji Velvia, which is also rated ISO 50. Though very fine-grained, this film is contrasty and must be used with caution. It is extremely sensitive to minor color shifts and may exaggerate them in an unpleasant way. For example, late in the day it can produce very yellow results you may not like. When conditions are right, however, it has no equal. And although Fuji Velvia is rated at ISO 50 you may get better results at ISO 40 or even less. All these Fuji films use the same E-6 development process used by Kodak's Ektachrome line. This is what all the professional labs provide and E-6 is obtainable worldwide, frequently with very speedy turnaround.

Fuji 64T, a tungsten-balanced film, has long been my first choice, although Kodak's equivalent film, Ektachrome 64T, is now very comparable. So your choice comes down to whether you prefer Fuji's slightly warmer rendition or Kodak's cooler, perhaps more neutral, one. I avoid using Fuji 64T only when I'm shooting an interior with an unusually subtle pale blue palette. The added warmth of Fuji helps with tungsten-lit interiors where small amounts of daylight intrude, and it always renders pleasing natural wood tones. For extreme accuracy of color rendition when you photograph artwork, Ektachrome 64T may have the edge. When using either film with fluorescent light sources you'll need corrective filtration. I use the same for both types of film, although some photographers vary their filter packs according to film brand. When in doubt, make advance tests for best results. In truth, though, both films are excellent. Faster emulsions in tungsten-balanced films are unavailable in sheet film, so pushing is the only way to obtain more sensitivity.

Kodak has an extensive array of Ektachrome films available. I often use Ektachrome 100X daylight film; along with the Fuji equivalent, this is my standard daylight choice. Ektachrome 100X isn't as warm as the Fuji film; in fact, it produces a very true, neutral result. Although in many situations the results may be virtually indistinguishable, I prefer Fuji's rendition of green as it is more intense.

Kodak markets the fastest reversal and negative films available in sheet-film size. Both Ektachrome ISO 200 transparency film and Ektacolor or Vericolor ISO 400 color negative film are balanced for daylight use.

On Kodak's recommendation, I used the latter in tungsten light, unfiltered but rated at ISO 200 and got excellent results. All color-negative materials require the same C-41 processing, which is widely available. I haven't tried Ektachrome 200 recently but was not terribly impressed the last time I did. If you really need the speed, however, it may be the answer.

The last couple of years have seen the introduction of sheet-film packets that can be inserted into special holders: Kodak's Readyload holder and the Polaroid 545 equivalent. These holders eliminate the necessity for preloading your sheet film in a darkroom or changing bag into film magazines or standard sheet-film holders, which can take up a lot of space and can be pretty heavy. Polaroid markets Professional Chrome in this form, which is in fact Fuji 100D and 64T, one sheet per packet. Kodak's Readyload packets have two sheets in each envelope requiring reversing to expose each side. Fuji also now markets 100D, 64T, and Velvia in single-sheet packet form. Although promised, no black-and-white film has been released yet in readyload form. However, Kodak still markets 4 x 5 Tri-X film packs, sixteen sheets per pack, which must be inserted into a simple film-pack adaptor. I've used these for years with great success.

Fuji Reala color-negative film is a marvelous invention. Rated at ISO 100, this daylight film incorporates an extra fourth layer sensitive to the blue-green part of the spectrum. The result of this added sensitivity yields a material that "sees" color much as the human eye does, including fluorescent light, too. As a result, compositions that include what would be incompatible light sources with other films can be recorded in a single exposure without elaborate filtering. Today this film comes only in 35mm and 120 rollfilm form, but rumors persist that, if the demand is there, Fuji may release it in 4 x 5 sheet-film format also. In the meantime, beautiful prints can be obtained from formerly impossible mixed light situations. In fact, I've had 4 x 5 transparencies made from 120-size negatives using print film. (For a very detailed discussion of 35mm films available, refer to Susan McCartney's *Travel Photography*.)

Many films come only in rollfilm sizes. The films discussed so far are those available in sheet-film format or both. All these are considered "professional emulsions" and tend to be manufactured to more precise standards. As such, they are more predictable. Once you've settled on a particular film choice, buy enough of it so that you don't have to continually test newly released emulsions that might have slightly different characteristics. Your particular shooting style and the amount of work you do will dictate just how much film you should stock. You will have to take into account other factors as well, such

as the storage capacity of your refrigerator and economics. Refrigerated film will maintain its characteristics for an extended period; if stored in the freezer, this period is even longer. However, film must be given adequate time to reach ambient temperature levels prior to use. Both Fuji and now Kodak are currently producing films with little variation from one batch to the next, but this was not so in the past. Buy from good professional sources that you know handle and store their film properly.

Another important factor for the architectural photographer is the potential lifespan of the materials selected. The potential use of a coverage may extend over a considerable period of time. In the past, some films performed much better than others in this aspect. Much of my early work from the 1950s and 1960s deteriorated to the point of being unusable. This is particularly true of Ansco film and early Ektachrome processed the old E-3 way. Most of my black-and-white prints and negatives are fine. Kodachromes, even the earliest examples, retain their color and density to a remarkable degree. My files are in a largely non-air-conditioned apartment in New York City, so humidity and temperature vary substantially. All current files are of the archival hanging variety and modern films have a much longer life expectancy. In the future, important images may be converted to disc form and have indefinite lifespans. Color prints, either displayed or stored, vary tremendously in the time they will last. Cibachrome prints may last much longer than Type-C's. Best of all are the dye transfer prints but they are expensive. For the last word on this subject read Henry Wilhelm's *The Permanence and Care of Color Photographs* (Preservation Publishing Company, 1991).

Using Polaroids

Most architectural and interior photographers rely heavily on Polaroid for testing purposes. I frequently wonder how I ever operated without it. The ability to produce a 4 x 5 or some other size test print on the spot is invaluable. This permits not only a precise check of exposure but also of light balance, particularly strobe. Accurate focusing and precise depth of field can be confirmed. Polaroid tests enable you to evaluate the complete composition of a wide-angle view even when this is impossible due to optical limitations of the viewfinder system. The aperture for the test should match the final aperture selected to control depth of field. For this reason, the Polaroid and the film used should be close to the same speed.

Polaroid film for 4 x 5 use comes in a number of different forms, including slow and fast black and white. One type is designated "P/N" for "positive/negative," because it produces both a print and a negative that may be enlarged after a brief sodium sulphite bath to prevent staining by

residual developer. P/N is rated at ISO 50 and has a contrast level that closely matches the chrome materials I use. The print paper is not opaque, so that, when viewed with a strong light behind it, it closely approximates the shadow detail of a similarly exposed color transparency. Polaroid color materials, both daylight and now tungsten, are much improved but still have characteristics that vary substantially from transparencies. Color Polaroid tends to be sensitive to long exposures, which cause considerable color shifts. Be sure to make notes on your Polaroid tests for later reference.

Polaroid materials are also sensitive to temperature variations. Not only do the development times vary, but the effective film speeds vary as well. For this reason, you must take care to avoid excessive heat or extreme cold. A Polaroid film that produces optimum results at 70°F degrees or so will be will be unreliable at 85°F or 90°F, which it could easily reach if left in the sun unprotected. When working outside in very low temperatures you'll have to warm up the film before exposure and keep it protected during development.

My limited testing of Fuji instant film produced excellent results but the film has not yet been officially released on the American market.

FILTRATION

A large proportion of the photographs in this book required some degree of filtration. Every photographer should know something about filters, but in the realm of interiors and architecture this knowledge is essential. Basically, filtration is necessary to compensate for the fact that film doesn't see the way the human eye does. Even in those circumstances where filtration isn't essential, its use may well transform a straightforward subject into something much more dramatic. The range of filters available today is enormous. They fit into a number of different categories. Both black-and-white and color photography have their own specific filters.

Filters for Black-and-White Photography

Early black-and-white photographs invariably had blank white skies with little or no detail evident. This was because the first black-and-white negative material was orthochromatic, sensitive to the blue and green parts of the spectrum, but not to red. The orthochromatic material was unusually sensitive to blue light. The relatively lighter skies built up disproportionate density in relation to other areas in the composition. The introduction of panchromatic emulsions in the mid-1930s substantially improved this situation particularly after it was discovered that photographing through certain colored filters further improved the situation, as panchromatic films are sensitive to all the colors of the spectrum but not equally so. In landscape shots, the use of a yellow filter renders blue skies darker in tone, making clouds appear more dramatic because of the added contrast and the green tones of grass and foliage somewhat lighter. The overall effect of the resulting print is, therefore, enhanced. As standard procedure, I use a Kodak 8 yellow filter for all exterior daytime black-and-white photographs where either sky or greenery is included. When I shoot Tri-X professional film, this requires about a 1½-stop increase in exposure enabling me to use the same lens settings I use for ISO 100 color film (without filtration).

When an extremely dark rendering of a blue sky is the objective, use a red filter. A deep blue becomes almost black. The red filter also makes green foliage much darker, which might be less desirable in some compositions. The use of a 25 red filter requires about a three-stop change in exposure, which slows down the effective film speed substantially. The red filter is also used to produce those very dramatic infrared black-and-white photographs that Julius Shulman is so well known for (see page 37).

Filters for Color Photography

Filters for color film are another matter. Kodak and a number of other manufacturers produce color-correction (CC) filters. These come not only in the three basic colors—red, green, and blue, which when combined in varying proportions can produce virtually any color—but also yellow, cyan, and magenta. Yellow is a combination of red and green; cyan, of green and blue; and magenta, of red and blue. CC filters come in densities of as little as 05 all the way up to 50 or 60. With this array of filters available, a photographer is able to make extremely accurate color adjustments.

For light sources that don't match the light for which the film is balanced, color-correction filters will be necessary. Suppose, too, that a photographer wants to alter the color of the composition in a particular way. Subtle shifts in color can change the mood of a photograph. In addition to CC filters, there are filters sometimes referred to as light-balancing (LB) filters. An 85B light-balancing filter enables a photographer to use a Type B film in a daylight situation. Conversely, the addition of an 80A LB filter permits a photographer to obtain true color with daylight film under (Type B) 3200°K illumination. Refer to the table on page 53 for specific recommendations of filtration when fluorescent and high-intensity discharge (H.I.D.) lighting is encountered. This table gives filtration combinations and filter factors (the amount by which you must increase exposure) for a variety of lamp types. Today you might encounter fixtures that don't match these categories, in which case you may have to run

This lobby in a New York cooperative apartment block is entirely lit with warm, white fluorescent light. Much of the lighting is controlled by emergency circuits that cannot be switched off, making the space difficult to light. The solution was to use a Sinar A0.6ND graduated filter, with the dark portion covering the entire upper and brighter portion of the composition.

I used a 120mm Super Angulon lens with 40R + 10M filtration, with Fuji 64T film. Without the graduated filter, the exposure was 48 sec. at f/16. With the graduated filter, exposure increased to 2½ minutes. The exact filter position was confirmed by Polaroid testing. The lobby was remodeled by architect Alfredo De Vido.

The Baseball Hall of Fame in Cooperstown, New York, designed by William Kissiloff. The photographs were taken with unfiltered Fuji Reala film.

advance tests. Particular films react somewhat differently and you should establish your own filter packs for the film you use and the most commonly encountered types of lighting. Keep notes on unusual fixtures. Also keep in mind that with these recommended filtrations, no allowance has been made for reciprocity. In some cases, the filtration suggested requires a substantial increase in exposure. Since Type B films are generally more stable for long exposures, their use instead of daylight emulsions prevents you from having to use still more correction for reciprocity.

To better understand the nature of color and color filters, picture the typical color wheel. The three circles each represent additive colors: red, green, and blue. Where these circles overlap, they form yellow (the equivalent of red and green), cyan (the equivalent of green and blue), and magenta (the equivalent of red and blue). These are known as subtractive primary colors. Where all three additive primaries overlap, white light is produced. This relationship is useful when combinations of filters are specified for a particular situation.

A 20R (red) filter may be substituted for 20M (magenta) + 20Y (yellow), or vice versa. A 30B (blue) is equivalent to 30M + 30C (cyan), and so on. For example, if you don't have the particular filter combination noted when a table calls for 50M + 40Y when using Type B film with warm, white fluorescent lights, you may substitute 40R for 40M + 40Y and then add the remaining 10M to produce the same result. The fewer individual filters you use, the better, since each surface the light travels through will degrade the image slightly. Three filters should be a definite limit.

A primary color circle diagram is also useful since it indicates which colors are opposites. For example, the opposite color of green is magenta. If a composition has too much green, a magenta filter of appropriate density should be placed over the lens to correct this situation. The use of a color meter is one way to determine color correction. Cyan is the opposite of red and yellow is the opposite of blue. Color bias of a particular hue can be corrected with an opposite color filter.

To achieve accurate color balance, I suggest that you refer to the color-temperature balance dial in the *Kodak Professional Photoguide*. With the aid of this tool, it should be possible to handle situations from the warm light of a 75-watt incandescent bulb to the overly cool light of open shade under a clear, blue sky. The dial indicates the necessary light-balancing filtration for the film type selected in order to produce accurate color rendition. This, however, does not take into account the photographer's objective. If, for example, you want to photograph a sunset, corrective filtration would be counter-productive because it would eliminate the very features you are trying to capture, the marvelous warm glow permeating the sky as the sun is about to set. If you are trying to accurately record a painting illuminated by the setting sun, then filtration is essential and appropriate. I don't suggest this however; the light changes too quickly to do this properly.

For those of you who chose to work with a color meter, you'll require not only a set of CC filters but an additional set of LB filters as well. The latest Minolta Color Meter, the 3F, is quite an improvement over earlier models. Now it gives direct readings of filters required. You set the film type, daylight or tungsten, and the meter tells you which LB filter to use, if any, and which CC filter is necessary to produce accurate color rendition. I've found that there are very few situations where I can obtain more accurate results using color-meter readings than simply using tables and experience. Some photographers, however, swear by color meters. (The American Society of Cinematographers has a detailed handbook, *American Cinematographer's Manual*, that lists filtration for a large number of light brands. You'll find that some fluorescent light fixtures can carry a designation of degrees Kelvin. All this means is that lamps with higher Kelvin ratings are cooler than ones with lower figures. They aren't the equivalent of a tungsten fixture carrying the same Kelvin designation.)

Polarizing Filters

Polarizing filters can be quite useful. They can be used on both color or black-and-white film. Essentially, sunlight is unpolarized, with light waves that bounce around at various angles causing highlights and reflections. A polarizing filter permits light waves at only one angle to pass. By rotating the filter, you can control which waves pass through and which are eliminated. The result is a filter that can make a blue sky more intense, can block or alter a reflection, cut haze caused by moisture in the atmosphere, and can make certain areas of a composition brighter in color. However, reflections are sometimes just what make a picture. Very deep blue skies may not look natural, so you shouldn't overuse this filter. Exposure must be increased between 1½ and 2 stops.

Be careful when selecting your polarizing filter since some have an unpleasant greenish cast. For this reason, there are specifically warm-tone polarizers available that might be preferable. Although deepening the blue of the sky may seem to be an obvious way of making a building more dramatic, the use of offset, wide-angle lenses on a view camera has somewhat the same effect due to light falloff, which is the variation in light transmission between the center and perimeter of a lens, particularly a wide-angle lens. Falloff is exaggerated when a view-camera lens is offset or a shift lens is shifted from the neutral

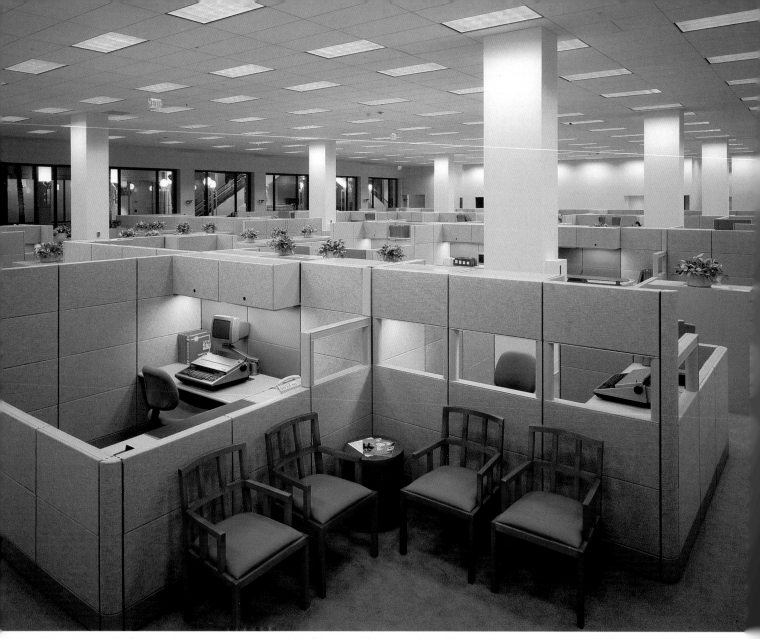

The photograph of this workspace serves as an example of the use of fluorescent light filtration in a two-part exposure with tungsten film.

position. You'll have to get a filter large enough to cover the front element of your biggest lens. Keep in mind that these filters can be expensive. For 35mm work you may require more than one to cover varying lens diameters. Some recent autofocus cameras, such as the Nikon 8008 series, require special circular polarizers or the metering system and focusing will be compromised. Ultra-violet (UV) or skylight filters have very little effect on contemporary films but since their use does not require any increase in exposure, they are popular with 35mm photographers as lens protectors. In poor weather conditions or dusty locations, they come in handy.

Special-Effects Filters

Cokin, Hoya, and Tiffen all have extensive lines of special-effect filters, diffusion to soften the sharpness, multi-image, starburst to create a twinkling effect around light sources, and vignettes of various shapes and densities, to name a few. Caution is the word here. The results can be very gimmicky. Far and away the most useful special filter is the graduated neutral-density (ND) filter. These filters are half clear and half neutral-density with a gradual transition from one to the other. ND filters are simply gray colorless filters that come in various strengths requiring additional exposure of one (0.3ND), two (0.6ND), or three (0.9ND) stops, respectively. Using these filters can salvage some very difficult situations containing ranges of brightness that exceed the capacity of the film to record. The quality of these filters has improved markedly in recent years. Their cost rises with size and unfortunately, when working with view cameras and wide-angle lenses, you need big ones. I have three of Sinar's plastic ones; these are excellent, remarkably scratch resistant, truly neutral with just the right transition from neutral to clear.

The physical size of the graduated filter and the graduation itself must relate to the size of the front element of the lens you're using, so my 4 x 5 Sinar filters are too large for use on my 65mm, 75mm, and 150mm lenses. I switch to the less expensive Cokin version, which is also less neutral (or colorless) for use with these lenses and 35mm work. Properly used, you may be able to avoid introducing lighting into an interior with one of these filters. They're great outside, too, where you have little or no control.

Graduated filters are also available in colors. Different manufacturers have a variety to choose from. The blue version is a lifesaver if you have a flat, light-colored sky. A hazy blue sky can be made more intense. I have a couple of the sunset filters, too, which can certainly enhance uncooperative conditions. You'll be surprised at the results you can achieve.

Glass Versus Gel Filters

Filters come in several forms. For small-format work where you may not need so many, glass filters may be fine, but glass filters for view-camera lenses are not only expensive, but large, heavy, thick and fragile. The thinnest and lightest filters are Kodak's gelatin ones. They now cost around $20 each for 4-inch square and have a very limited life. 3 x 3-inch filters are fine and less expensive if you don't have 90mm and 120mm Super Angulon lenses or the like. They scratch easily and don't work well in humid conditions. However, if you have to combine three filters, gelatin filters are the best way to go. I use gelatin filters for situations I don't encounter regularly and thin, plastic Sinar filters for more common situations.

Filter-Mounting Systems

Unfortunately, the Sinar plastics don't fit into the old Sinar swing-away filter holder, now discontinued but far and away the most convenient system for that camera. I don't recommend a filter-mounting system that attaches directly to the lens. When filter removal is necessary in mid-exposure as it is in two-part exposures, fiddling with something directly attached to the lens should be avoided.

In addition, a filter-holder system attached to the threaded lens rim, of whatever series, increases the likelihood of vignetting with wide-angle lenses when they are substantially offset. When making your Polaroids, have the filters in place to check that nothing protrudes into the picture area and that no unwanted flare occurs. Flare is caused by bright light coming from beyond the composition and bouncing around in the lens or reflecting off the interior of the camera onto the film causing local fogging. For this reason, bright sources of light beyond the composition should be shielded from the lens. In certain instances there may be advantages to mounting your filters behind, rather than in front of the lens. This means partially disassembling the camera to get at the rear element or at least removing the lensboard and this method does not permit removal of the filters in mid-exposure. Rear mounting sometimes does help to eliminate flare.

Alternative Filtration Methods

All the filters discussed thus far are for mounting on the camera. However, you can filter your light sources in some instances. Though the approach is different, the objective is the same; to match the light to the film. In this manner, by placing a sheet of gel filter over a fluorescent light fixture, it may be converted to either daylight or Type B illumination, whichever is appropriate. Obviously, if there are many fixtures included in the composition, this is tedious and time consuming. When you are unable to control a key component of the lighting, daylight for example, it may be the only approach short of waiting for sunset.

Rosco and Lee both make various filters in large-sheet form as well as long rolls. Large sheets of 85B filter can be placed over windows to convert daylight to Type B tungsten. This particular filter is available in combinations with neutral density to bring the outside light level into better balance with the interior. I find sheets of 30M useful when photographing kitchens with under-cabinet fluorescent lights, in basically daylight situations. This filter will take the green out even if you're using tungsten film. The light in the area of the fixture will be like weak daylight, which is a vast improvement over green. Actual tubes of filter are available for use over fluorescent light fixtures. These filters give a general correction but may not be sufficiently precise when they're used over the main light source.

One other approach is to filter your supplemental lighting to the existing ambient illumination. Strobe light manufacturers have filters specifically designed for use with their flash-heads. Follow their instructions and take care that improper use doesn't cause overheating. This problem is even more severe when you try to filter quartz (hot) lights. It is essential that proper ventilation of the unit be maintained. I recently had an expensive dichroic glass filter (which converts Type B to daylight) break into a thousand pieces when I used my light in a horizontal position. So make sure that not only do you use heat-resistant filters, but also that they're positioned as designed and aren't too close to the bulb.

INTERIOR PHOTOGRAPHY: MASTERING THE FUNDAMENTALS

In this book I divide the photographing of interiors into three basic categories. First, I discuss domestic spaces, which include all living situations. Next comes the commercial or office space, the contract interior. Another section considers public spaces—restaurants, stores and showrooms, auditoriums, churches, and museums. An in-depth study of each category of interiors is neither practical nor possible here, but a careful analysis of the common problems that arise at each stage of the photography process does reveal an approach that makes sense. The common denominator may be sheer size, scale, the mixture of light sources, or some other characteristic.

COLOR VERSUS BLACK-AND-WHITE PHOTOGRAPHY

There was a time when all architectural photography was black and white. Now the pendulum has swung the other way and most published material in the design field is in color. There is something very basic and I think quite satisfying about a good black-and-white print of an architectural subject. With filtration and good printing techniques, black-and-white images can be very dramatic. Enlarging from black-and-white negatives enables the photographer to control the degree of contrast as well as the overall tonality. Nevertheless, I am assuming that the majority of readers will find the discussion of color photography in the case studies that follow more pertinent to their needs. When I am doing an assignment, I frequently shoot both color and black and white. I recommend the use of Tri-X film for architectural work, either exterior or interior, and use it exclusively.

Once the basic angle has been established and the camera set up—and also, perhaps, the lighting—it is easy to shoot a black-and-white negative with nothing more than an adjustment in exposure to accommodate the higher-sensitivity film. This assumes shooting with a 4 x 5 camera. I usually shoot black and white only on the larger formats, because it is always easier to produce a quality print from a larger negative. This does not preclude the use of 35mm for black-and-white shooting, but it does require a highly skilled printer to come up with consistent, quality prints from smaller negatives.

If 35mm slides are required for projection, these will almost certainly be color. Very occasionally, I am asked to take black-and-white slides. Color slide film can be used to photograph a black-and-white print, producing a black-and-white slide. Black-and-white positive film, known as diapositive, is available and can be used to produce slides directly without having to go through the black-and-white print stage. Diapositive film is not widely available and may be hard to get.

If you have a color transparency, of whatever format, you can make a black-and-white print from it, but the quality is always inferior to that of a print made from an original black-and-white negative. The reason is that black-and-white copy negatives are always more contrasty than the original and therefore more difficult to print. A copy negative cannot match the tonal range of a properly exposed and developed original negative. Therefore, most good-quality prints are made from negatives. This is true of both color and black and white, but Cibachromes are a notable exception.

SIZING UP THE INTERIOR
BEFORE PHOTOGRAPHING

Unless tight schedules do not permit it, professional photographers should make a preliminary visit to a job site prior to an assignment. There are a number of reasons for this. Unpleasant surprises on the day of shooting can often be avoided. Elements of the space that may have a major impact on the photography but are not considered by the designer to be important must be worked out in advance. The photographer must also know if the space still conveys the designer's original concept. Perhaps some unwanted addition has been introduced without the designer's knowledge; a large plant, a strident piece of art, a rug at odds with the design scheme, an unplanned piece of furniture, unspecified window coverings, graphics that cannot easily be moved or changed, and so forth. So an advance visit should be mandatory for the designer too, to ensure that the space is in an appropriate condition to be recorded.

If the designer is also doing the photographing, then undesirable items may be eliminated during the photo session. If somebody else is doing the photography, it is up to the designer to make clear just what items are to be removed, moved, added, or otherwise modified. Alternatively, these decisions may be left to the discretion of the photographer, with photographic considerations outweighing other factors. These decisions should be made at the time of the preliminary visit, allowing any necessary arrangements to be completed in advance of the shoot. This will save time and money.

Another objective of the preliminary visit is to allow the photographer to get the feel of the space and select the most flattering angles for capturing the design. The sensitivity of the photographer to the design objectives is of the utmost importance. The degree to which the interior reflects the philosophy of the designer is also highly relevant. In situations where the design concept has been compromised in one way or another, the photographer is presented with the task of bridging the gap between reality and the unrealized objectives. The photographer can exercise "photographic license" to vary the moods of photographic images by using careful lighting, unusual camera angles, balanced composition, and a host of other methods and approaches. Only the more skilled interior photographer is likely to be able to achieve this.

A full check of the existing light sources and their control is paramount during the preliminary visit. The photographer can spot missing or inoperative light bulbs or perhaps mismatched fluorescent lamps. Also, window blinds and curtains should be checked. The controls for

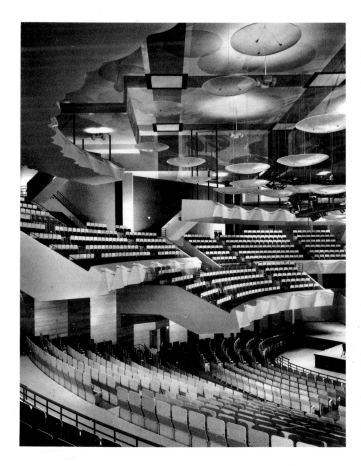
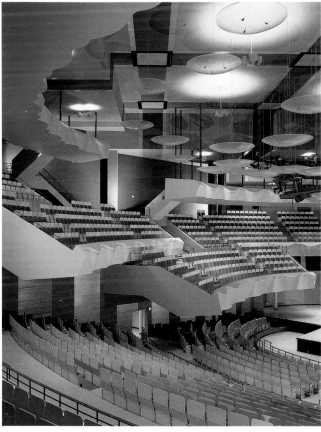

mechanically operated window shades or curtains may be cleverly concealed, sometimes in the locked credenza of an executive desk, so you should arrange to have access as needed. On this preliminary visit the photographer should also decide whether to have dining tables set or not, with tablecloths or without. Tablecloths must be clean and it may be necessary to iron or steam them to remove creases and wrinkles. Likewise, bedsheets and pillow cases, when shown, may require ironing. It is vital that these details be worked out in advance. Arrangements should be made for last-minute on-site prep work.

The condition of plants or trees should be noted. Are there blemishes on the walls or is the ceiling going to be a problem? Are there missing ceiling tiles? Spots on the carpet? Empty bookshelves? Look for anything that might detract from the impact of the final photograph.

Props

The preliminary visit will help you decide what additional props may be needed to enhance a photograph. These may vary from finding an alternative for a piece of sculpture to adding a large tree, perhaps rented for the shoot.

Reception areas and conference rooms frequently lack well-designed ashtrays, which can make a surprising difference. Suitable note pads and pencils may make good accessories to the large expanse of a conference table. Perhaps some beautifully leather-bound books can be arranged on a work surface that may otherwise look too bland. Suitable magazines with appropriate covers will usually enhance a reception-area table. Bring books if none are available on the job site, but select titles appropriate to the situation. An open book on a bed or chair may add a personal touch but may also be regarded as something of a cliché. A tray with glasses and a bottle of wine may provide just the right touch on a coffee table or sideboard. A filled wine glass beside a suds-filled Jacuzzi can add a titillating element. It is sometimes the unexpected that makes a good photograph really come alive.

When it comes to selecting props, the watchwords should be suitability and appropriateness. The wrong cutlery or flatware may be worse than none at all. Poorly designed vases, ashtrays, appliances, or lamps may seriously compromise an otherwise satisfactory picture.

Art is a delicate subject. The client's taste may vary considerably from the designer's. When this is the case, the photographer must be careful, lest feelings be hurt. When properly explained, sensitive clients will usually understand that the changes are being made strictly for the photography. I have been involved in jobs where the owners are perfectly willing to have items removed for documentation but are adamant about introducing others that are not of their choosing.

Flowers can make or compromise a photograph. A prim, traditional arrangement of mixed blossoms from the corner florist placed on a contemporary reception desk can be disastrous. Different varieties should be combined with great care. I find that a large mass of a single kind of flower is frequently much more effective. The arrangement should be the right scale for its location and the container is often as important as its contents. Make sure the water in a glass vase is perfectly clean and change it if in doubt. Cut glass is suitable for some dining tables but is wrong for a contemporary waiting area. A single, airy sprig of apple blossom may provide just the right softening effect when a more dense display would be too obstructive. Color selection is also important and must be coordinated carefully with the design scheme. The designer should make any preferences or dislikes known in advance. Some magazine editors dislike the use of certain flowers and plants in their photographs. However, since most magazine editors are usually involved in the shoots, these pitfalls can be easily avoided.

Out-of-focus foreground flowers have become something of a cliché in interior photography but nevertheless can be effective in the right circumstances. Apart from the added depth this technique suggests, plants and flowers can be used to conceal unwanted elements in a room. That might be the reflection of the camera or of the photographer (see photo, page 87).

The use of large trees as decorative elements in interiors has become virtually synonymous with the Modern Movement. Some interiors have literally become greenhouses, with plants widely used as an integral part of the design. Photographers should be careful not to include unhealthy or drooping plants. Also remember that trees or flower arrangements may have to be rotated to display their best sides to the camera or provide the required balance to the composition.

Tall vertical elements like trees can provide just the right exclamation point in a strongly horizontal scheme. Trailing vines can break and soften the hard edge of a balcony or other overhead element. The container in which the tree or plant is growing should be coordinated with the design theme. Small-leaf trees like the popular *Ficus benjamina* will have a much different effect than a cactus or a large-leaf philodendron. Exotic orchids can sometimes provide just the right touch. Some plant stores will rent trees or plants for photographic assignments.

PEOPLE IN PHOTOGRAPHS

Traditionally, most architectural photography has not included people. I think this was based on the assumption that documentation devoid of human figures was purer. The design could be studied and analyzed in pho-

tographic form with greater ease when uncluttered by distracting occupants. But taste has changed, or is changing. Since buildings are designed to be lived in, worked in, played in, slept in, prayed in, depending on their function, does it not make sense to depict them in use?

When working with interiors, scale may determine whether people should be included. In a small room in a house or apartment, for instance, it is almost impossible to include a person without having that person dominate the photograph. Since the documentation of the design is the primary objective, any elements that distract the viewer are counterproductive. If the photograph is taken to illustrate how a famous person lives or works, then including that person both becomes appropriate and adds authenticity to the result. As always, the purpose of the photo must be carefully considered.

With large spaces, people may be included without dominating the areas they occupy. Without figures the scale is sometimes ambiguous. The photographer must ultimately be the judge. A beautiful woman sitting behind a reception desk will certainly enhance most entrance lobbies and, may be appropriate, even if other photographs in that series do not include inhabitants. Polaroid tests during the photography session will help in making on-the-spot decisions about whether or not to include people.

The problem with including people in photographs is having them appear natural. Subjects frequently become very self-conscious and uneasy when they know they are being photographed. Try a dry run—going through the motions of taking the picture without actually doing so. People get tired of assuming unnatural poses and eventually begin to relax. Successful photographs of interiors with people may ultimately depend on the personality of the photographer and his or her ability to put the models at ease.

When long exposures of several seconds or more are involved, blurred movement may cause an even greater distraction. However, there are some circumstances when the inclusion of blurred moving elements, be they human or otherwise, will add an intriguing element to an otherwise dull subject or perhaps explain the function of what appears to be a static object.

One other factor should not be overlooked. Styles change and they tend to date photographs, limiting their usefulness. The miniskirt or the so-called "new look" immediately pinpoints the period of the photograph in which they are included. My general advice, therefore, if documentation is the primary objective and you really want to include people, is do so with care and to avoid closeups. Always shoot a couple of alternatives without people in case you change your mind.

A final word of caution. Permissions should always be obtained in advance. This is particularly true if the photographer is professional and if the photography is in a public place. Only when photographing members of a family or individuals at home, when arrangements have to be completed in advance and the planned use of the photographs is clearly understood, might it be redundant to obtain releases. In such a situation it is assumed, from a legal standpoint, that the photograph could not have been accomplished without the knowledge and cooperation of the subjects nor could they fail to be aware of the ultimate purpose of the session. However, even in such a situation, if the objective is material to be used for advertising, model releases are mandatory. Model releases can be obtained at any good business stationer. However, if model releases are not available, the standard A.S.M.P. release form provides typical wording for such a document. Even a copy, when signed, is legally binding.

AVAILABLE LIGHT

The most important single factor to be considered when documenting interiors is lighting. In the absence of light, there can be no photograph. Subtle changes in lighting establish mood and become an intrinsic element of the composition.

The term "available light" is used to describe all the light in a situation, from whatever source, both natural and manufactured, that is not introduced by the photographer. Daylight, tungsten light, and fluorescent light are the three light sources most commonly encountered by the photographer.

Daylight

The major source of available light that photographers encounter is daylight. While the photographer cannot make substantial changes in natural daylight, he or she may have more influence over this source than might be realized.

The most obvious way to control the effect of daylight in an interior is by carefully selecting the time of day during which to photograph. What may determine this will be the exterior view, seen from within. At different hours of the day this view will change as the sun moves. Sunlight also may penetrate into the room, which may or may not be desirable. The lack of sunlight can be a prime consideration and often makes rescheduling the photo session necessary.

Perhaps the single most important aspect of direct sunlight in an interior is contrast. When evaluating the illumination of any space, it is the evenness of the distribution of the lighting that will determine the photographer's basic approach. Direct sunlight will certainly produce a

Planet Hollywood in New York City, one of the last designs by the great Anton Furst.

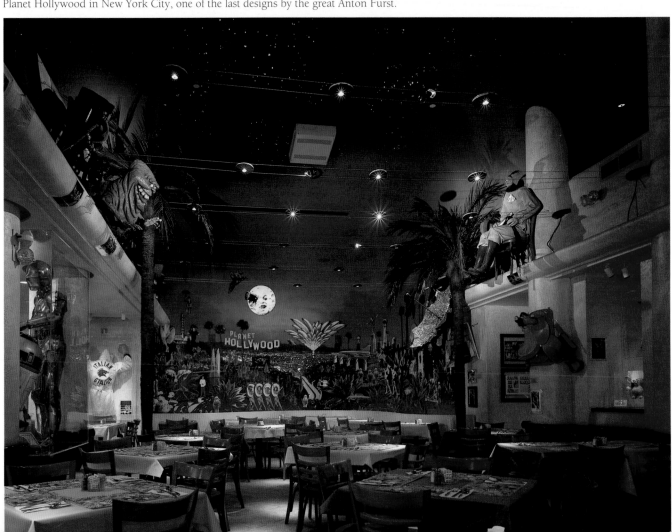

much greater range of brightness than will indirect natural light. It is also quite likely that a bright but overcast day will produce a softer, more evenly distributed light than a sunny day with blue sky, even in the absence of direct sunlight.

Natural light that bounces off light exterior surfaces, such as snow or sand, is another factor that can be a major influence. Also keep in mind that illumination, natural or otherwise, that bounces off a colored surface is going to alter the tones of other areas. Film seems to exaggerate this effect producing unexplained, undesirable color shifts.

Daylight has a complex personality. One aspect of this has to do with whether the light is warm, yellow/red or cool, blue/green. A scale has been developed that categorizes different light sources in degrees Kelvin. This is sometimes referred to as "color temperature." It arranges various frequently encountered light sources, in order, from warm to cool. For example, candlelight, which is very warm, has a very low 1930°K. Household bulbs are normally about 2900°K, depending on wattage. Most floodlights and quartz halogen bulbs used by photographers for supplemental illumination are 3200°K.

The range of daylight varies considerably. Noontime sunlight is about 5500°K. An overcast day is cooler and may be 7000°K. A bright but partially sunny day may yield a reading of 8000°K or more and a clear blue cloudless day might be as high as 10,000°K or 12,000°K. Sunset and sunrise would be much warmer, around 4000°K. (In their Kodak Professional Photoguide, Kodak prints an excellent color temperature dial that I highly recommend.) The variations in daylight quality emphasize the fact that under certain circumstances the atmospheric conditions may have a very direct influence on the photograph where daylight is its primary source of illumination. Once this is fully appreciated by the photographer, the necessary allowances can be made.

Film does have a nasty habit of emphasizing variations in color temperature when you least expect it. The human mind makes all sorts of adjustments to compensate for variations in the color temperature of light, so that after a few moments in any particular situation it quickly responds to the color observed, uninfluenced by the color of the light illuminating it. Film is unable to make these mental adjustments, so the photographer must compensate for this.

The season also influences the character of the daylight. In winter, when the sun is lower in the sky, the light tends to be somewhat more diffused, since it travels through more of the earth's atmosphere at lower angles than it does earlier or later in the day. Sunlight will penetrate much further into a space through window and other side openings in the wintertime. Conversely in summer, sunlight will reach further down into an atrium as it passes through skylights overhead.

The direction of the light relative to the direction of the view to be taken is another important consideration. The way in which the natural light enters the space will probably determine what angles of view are feasible with available light only. In most instances a room with a window to the right or left of the camera and another behind will have a combination of side and frontal light. This is an easier situation to handle photographically. Single-window illumination, unless it is large, is likely to be more difficult.

The shape of the room is as important as its general brightness. A long room with a window at one end will be difficult to control, since the area nearest the source of illumination will be much brighter than the opposite end. The way in which the light bounces around in the room will make a lot of difference too. For instance, white ceilings with light walls and floors will help disperse the light more evenly. A dark room with somber walls and deep-colored furniture and fabrics will be more of a challenge. But even here the most important factor will be the evenness of the distribution rather than the total quantity of light.

The photographer may be able to diffuse the lighting in a space by means of adjustable blinds or perhaps paper roller blinds. Direct sunlight can be intercepted, diffused, and redirected in this manner. This is true both for skylights as well as windows. The narrow-slatted Levolor blind is particularly useful in this respect and can be used like a neutral-density filter on a window. Simple white reflectors, even white towels or sheets, can sometimes be used effectively to bounce window light into the dark areas of a room. Surprising results can be obtained in this manner. Folding reflectasols are great for this.

Controlling the mood of the interior is more difficult when the photographer uses natural daylight exclusively. With some spaces it will not be possible at all, but by being sensitive to the variations attainable by diffusion and other methods, experimentation and experience should yield results.

Tungsten

Color film balanced for tungsten (or incandescent) light sources is readily available. Type B film is designed for use with 3200°K light sources, Type A for 3400°K. Slight variations in color temperature from one incandescent lamp to the next, particularly if they are warmer, are normally not critical. Daylight and tungsten are what I term "compatible," meaning that when photographing with these light sources, the film will record them in much the

same way as we perceive them. In a room with predominantly natural illumination, the area around an incandescent light source will appear yellow to the eye when photographed with daylight film. Conversely, within a space primarily lit by tungsten lighting, a small area of daylight will appear blue when photographed using a tungsten-balanced film. When color accuracy is paramount, as in art reproduction, for example, and the sources do not precisely match the color temperature of the film, some corrective filtration will be necessary.

A regular 100-watt incandescent bulb, approximately 2900°K, will give a warmer than normal color rendition using an unfiltered Type B film (balanced for 3200°K). This added warmth may or may not be acceptable to the photographer. Higher-wattage domestic bulbs have higher Kelvin ratings, particularly those in the tungsten-halogen or quartz family and are even closer to the rating of a Type B film.

There are two disadvantages with tungsten lighting. One is the generation of heat. Even low-wattage bulbs can get extremely hot and, if not properly ventilated, can ignite or scorch inflammable materials that are inadvertently placed too close. Quartz iodide bulbs, which are also in the tungsten category, get even hotter. For the quantity of light they put out, the quartz bulbs of either the long, double-contact variety, or the shorter, single-socket type are very small. However, the heat built up when they have been in operation for only short periods is considerable. Light fixtures designed for these bulbs can handle the heat, but the wattage used should never exceed the manufacturer's recommendations. This is equally true for photographer's quartz lights. The other disadvantage of tungsten lighting is that it is a fairly high energy user. Low-voltage lamps, such as the increasingly popular MR-16, are more efficient. A 12-volt 50-watt MR-16 puts out as much light as a 120-volt 75-watt bulb so there is an approximately one-third saving in energy used. Another advantage of the low-volt lamps is that they give a whiter light, a higher Kelvin degree, than the equivalent incandescent bulb, and this more closely matches the balance of the film.

Tungsten light sources left on in daylight situations or with electronic flash will be rendered yellow, or warmer, by daylight film. Their relative strength and distribution will determine if this is likely to be a problem. Some magazines object strenuously to running photographs of obviously daylight situations which include light fixtures turned on. One of the few photographic situations where a dimmer can be used without causing problems is a chandelier with small bulbs, included more for atmosphere than illumination which, when dimmed, will create a candelike appearance with any film.

There may be instances when neither daylight nor existing incandescent illumination predominate and the photographer will have to decide which approach to take. If the balance between the two different sources seems visually reasonable and flattering to the subject, then a double exposure may be the answer. A daylight-balanced film or Type B tungsten film with daylight conversion (85B) may be used for one part of the exposure with the lights switched off. The second part of the exposure will be with the incandescent sources switched on and unfiltered, if the film is balanced for that light or appropriately filtered if it is not. For the second part of the exposure the daylight should be eliminated, if possible. If it is not, a compromise approach would be a double exposure, one with corrective filtration and the other without and no adjustments to the lighting at all.

When the two types of lighting are well mixed, this approach will give surprisingly pleasing results. Variations of the ratio of daylight to tungsten may suggest different lengths of exposure for the filtered and unfiltered segments. If a Type B film is used and the photographer overestimates the amount of daylight present by giving a longer exposure with the 85B filter, then the resulting photograph will tend to be over-warm in tone. Conversely, underestimation in the same situation will yield overly cool results. So experiment a bit and try a couple of approaches.

Fluorescent
The other commonly encountered available light source is fluorescent. This is more difficult to deal with photographically since film is normally not balanced for this type of lighting and makes corrective filtration mandatory. Fluorescent light is not compatible with either daylight or tungsten; that is, a film balanced for either source will record fluorescent illumination in a manner completely different from the way the human eye perceives it. Both films will render fluorescent bilious green if unfiltered. Correct filtration is essential.

Here we begin to run into problems. There is a wide variety of fluorescent tubes in use. The light they produce is very linear and very diffused depending on the type of fixture used. When the tubes are visible they can produce quite a glare.

Known also as discharge lighting, the tubes contain mercury vapor in combination with a fluorescent coating on the inside of a glass tube. Depending on the nature of the coating, the quality of the light can vary substantially. The wavelength of fluorescent light is totally unlike that of either daylight or tungsten, which is the basic reason that film records it so differently. A rough classification of fluorescent tubes exists that categorizes the light they

emit in various degrees of warmth or coolness. Though roughly equivalent to the Kelvin scale in terms of appearance, it cannot be directly compared because of the basic difference of the source. Most tubes have the designation warm white or cool white. A table developed by Kodak for recommended filtration for daylight and Type B films is reproduced here. Because of variations in manufacturing, there may be some differences between warm white tubes or similar classifications produced by other companies. These filtrations should only be used as a general guide and whenever possible advance tests should be made.

When other lighting, tungsten or incandescent, for example, is mixed with fluorescent, a two-part exposure using appropriate filtration for each part may be the solution. To do this successfully, each different light source must be switched on independently of the other. If incandescent and fluorescent types are controlled by the same switches, that will make it necessary to unscrew and disconnect individual bulbs for the corresponding exposure. This can be extremely tedious and time-consuming. In situations where a substantial amount of daylight is combined with fluorescent, it may be impossible to control the daylight sufficiently to make double exposures feasible. This presents the photographer with a real dilemma. If a single exposure is made and no filtration is used for the fluorescent lighting, then the result will certainly have a greenish cast, depending on the proportion of that illumination to the daylight present. On the other hand, if the filtration required to correct the fluorescent lighting is used, then those areas where daylight predominates will be rendered with a reddish or magenta cast—certainly not natural or logical in appearance. Either the photographer must wait for nightfall, when the natural light will not be a factor, or the fluorescent light will have to be switched off and supplemental electronic flash used in its place. It is very difficult, if not impossible, to approximate the effect of built-in fluorescent lighting by other means without its being very obvious.

Another approach is the use of the large sheets of gelatin filter that are obtainable through movie supply houses. A filter which converts fluorescent to daylight

FILTERS FOR FLUORESCENT AND HIGH-INTENSITY DISCHARGE LAMPS				
Fluorescent Lamps	Daylight Films		Tungsten and Type L 3200° K Films	Type A 3400° K Films
	Group 1	Group 2		
Daylight	40M + 40Y + 1 stop	50M + 50Y + 1 1/3 stops	No. 85B* + 40M + 30Y + 1 2/3 stops	No. 85* + 40R + 1 1/3 stops
White	20C + 30M + 1 stop	40M + 2/3 stop	60M + 50Y + 1 2/3 stops	40M + 30Y + 1 stop
Warm White	40C + 40M + 1 1/3 stops	20C + 40M + 1 stop	50M + 40Y + 1 stop	30M + 20Y + 1 stop
Warm White Deluxe	80C + 30M + 2 stops	60C + 30M + 2 stops	10M + 10Y + 2/3 stop	No Filter, None
Cool White	30M + 2/3 stop	40M + 10Y + 1 stop	60R + 1 1/3 stops	50M + 50Y + 1 1/3 stops
Cool White Deluxe	20C + 10M + 2/3 stop	20C + 10M + 2/3 stop	20M + 40Y + 2/3 stop	10M + 30Y + 2/3 stop
Unknown Fluorescent†	10C + 20M + 2/3 stop	30M + 2/3 stop	50M + 50Y + 1 1/3 stops	40M + 40Y + 1 stop
High-Intensity Discharge Lamps				
LUCALOX	70B + 50C + 3 stops	80B + 20C + 2 1/3 stops	50M + 20C + 1 stop	55M + 50C + 2 stops
MULTI-VAPOR	30M + 10Y + 1 stop	40M + 20Y + 1 stop	60R + 20Y + 1 2/3 stops	50R + 10Y + 1 1/3 stops
Deluxe White Mercury	40M + 20Y + 1 stop	60M + 30Y + 1 1/3 stops	70R + 10Y + 1 2/3 stops	50R + 10Y + 1 1/3 stops
Clear Mercury	80R + 1 2/3 stops	70R‡ + 1 1/3 stops	90R + 40Y + 2 stops	90R + 40Y + 2 stops

Sodium vapor lamps are not recommended for critical use. Daylight film gives realistic yellow-amber appearance, tungsten film more neutral appearance.

*KODAK WRATTEN Gelatin Filters No. 85B and No. 85. Other filters are KODAK Color Compensating Filters (Gelatin), sold by photo dealers.

†For emergency use only, when you don't know the type of lamp. Color rendition will be less than optimum.

‡For KODAK EKTACHROME 400 Film and EKTACHROME P800/1600 Film, use CC25M + CC40Y filters and increase exposure 1 stop.

Group 1 Films: KODACOLOR and KODAK VERICOLOR Films, Type S, designed for exposure to daylight.

Group 2 Films: KODACHROME (Daylight) and KODAK EKTACHROME (Daylight) Films.

Film references include professional versions of films.

Note: Increase calculated exposure by the amount indicated in the table. If necessary, make corrections for film reciprocity characteristics, both in exposure and filtration. With transparency films, make a picture test series using filters that vary ± CC20 from the filters suggested in the table. Usually test filter series ranging from magenta to green and yellow to blue are most useful.

and another which makes daylight compatible photographically with tungsten are two of the many variations available. The filter must be cut in strips and wrapped around the tubes. If the number of tubes to convert is not excessive, this approach may be practical. It is certainly useful in locations where just a few tubes need conversion, such as an interior where the primary illumination is from other sources. Double exposure will then be unnecessary.

The large rolls of gelatin filter will enable a photographer to cover an entire window, converting the daylight to a tungsten equivalent. This permits the photographer to record a space with interior tungsten lighting, 85B filtered daylight, with the windows included in the photograph but without supplemental electronic flash. To reduce the contrast between inside and outside it may be necessary to use a neutral-density 85B combination filter. 85B filters are available in 30-foot rolls with either one- or three-stop neutral-density combinations.

A final approach to mixed fluorescent/daylight and/or tungsten combinations is to use Fuji Reala, a color negative film. To date, this film is available only in roll-film form, 35mm, and 120mm, but rumors persist that a sheet-film version may become available. Fuji Reala is the only film yet developed that renders fluorescent sources as the human eye perceives them, without filtration. For further information, refer to page 39.

Other Types of Lighting

Though only occasionally encountered in office interiors, another form of discharge lighting, mercury vapor, is frequently used in large spaces, such as shopping malls, atriums, sports facilities, factories, and other situations where a large amount of light is required. Like fluorescent lighting, this type of lighting requires special filtration and if ignored will yield unpleasant and unanticipated results. It is absolutely necessary to identify the exact type of lighting you are dealing with. This category includes metal halide, high-intensity discharge (HID), and also sodium vapor. This last type is most widely encountered in street lighting, is uncorrectable by filtration, and will yield a yellow result due to its almost entirely yellow wavelength. The other kinds are correctable, but many require heavy filtration and correspondingly long exposures.

Like fluorescent, mercury-vapor lighting is photographically incompatible with either daylight or tungsten. Because it is usually so much brighter than most alternatives, it is not frequently found in conjunction with other systems of illumination, and when it is, it usually overpowers them. Due to the types of interiors in which mercury lighting is used, I think it is true to say that accurate color rendition is likely to be less critical than with offices or homes.

I have encountered mercury lighting in offices mixed with other types that might suggest the double exposure technique. However, mercury vapor bulbs normally take a considerable time to reach operating temperature and maximum efficiency. For this reason, it is inadvisable to switch them on and off frequently, making double exposures difficult. Test whenever possible with this type of lighting. As a last resort, use fast color-negative film and have corrected prints or transparencies made afterward by the lab.

Controlling Existing Lighting

Sometimes the photographer can sufficiently control the available sources to avoid the use of supplementary lighting. Whether or not this is practical may depend on the location of light fixtures relative to the picture area. A ceiling with track lights, even quite bright ones, may easily be included within the frame of the photograph without causing any problems. Track lights often have housings which prevent glare by recessing the bulb or perhaps incorporating waffle grids for the same purposes. As long as there is no direct glare into the camera lens, the photographer need not be concerned. Strong light sources beyond the area depicted should be shielded from the camera lens or flare may result, thus diminishing image quality.

If there is an area lit by a track light that is too bright, either the fixture should be delamped using a lower-wattage bulb or redirected to a less critical spot. Even if the track is on a dimmer, its use should be avoided since it will change the color temperature of the light, making it appear overly warm in tone. An alternative to relamping is to turn off those fixtures which appear too bright for a portion of the exposure. Unless long exposures are involved, this will require a double exposure. Sometimes the use of aluminum foil wrapped around part of the bulb can reduce the output to the desired level. Remember to remove it afterward because overheating will probably reduce the life of the bulb if it is left in position.

Standing lamps with translucent lampshades included in a photograph will almost certainly have to be modified to avoid overexposure. These lamps may have two or three separate bulbs so it is easy to remove one or more or apply the double-exposure method, switching off for part of the exposure. When lampshades are positioned close to a wall, simply moving them further away may adequately reduce their brightness.

Can lights, when appropriate, are excellent sources of illumination. Frequently out of sight, they can brighten up an otherwise dark corner or highlight an indoor plant when placed beneath, projecting leafy shadows on the ceiling or accenting window openings. They may be used with either reflector floods or spots.

SUPPLEMENTAL LIGHTING

Supplemental lighting falls into two basic categories: electronic flash (strobe light) and tungsten lamps. These two types have distinctive characteristics and specific uses.

Electronic Flash

The ability to master the art of strobe lighting an interior is what frequently separates the professional photographer from the amateur. A built-in strobe light provides many flashes from a single battery at the flick of a switch. Although a large number of today's automatic cameras include built-in strobe units, the results they produce are rarely, if ever, up to professional standards. And direct, on-camera flash produces a flat, virtually shadowless light, with foreground objects too bright and the background too dark. The photographic results of such cameras are valuable only for the most basic recording purposes. Some more sophisticated SLR cameras are now available with built-in strobes. As useful as these may be, these cameras have severe limitations when used for interior photography. However, for many other subjects, a built-in strobe light is unmatched for convenience, and often for subtlety as well.

Learning how to use electronic flash correctly requires both time and practice. A strobe is difficult to use in interiors because the photographer cannot see the result of the flash as one normally would with a continuous light source. Many photographers have trouble determining whether or not to use strobe lighting in these situations. When photographing interiors, it is important to note that strobe light is compatible with daylight. In a space that has substantial natural light, but in which that light is too unevenly distributed for photographic purposes, the strobe is the correct choice. When correctly used, it is often impossible to distinguish between areas with natural light and supplemental illumination. This, of course, assumes that subtlety is the objective.

A strobe can sometimes be used to simulate sunshine coming into a room, although this is tricky to accomplish. To record a space that includes a view of the outside, use a strobe to boost the interior illumination to counterbalance the exterior. The unit must be powerful enough to enable the photographer to select a lens aperture to provide the necessary depth of field to sharply record both the interior and the exterior.

Unless there is substantial ambient daylight inside, the interior brightness will be unaffected by the shutter speed. The duration of the electronic flash is very short, 1/350 sec. or shorter, which is much faster than the shutter speed. Select an appropriate shutter speed/aperture combination to control the brightness of the exterior. The best way to determine optimum balance is by a Polaroid test. If this is not possible, substantial bracketing may be necessary to achieve the best results.

In a situation where no daylight is present, strobe lighting is not essential. I would only select a strobe as my preferred illumination in the absence of daylight in order to freeze motion or some other unusual circumstance not normally encountered when photographing interiors. Where no electrical supply is available, portable, battery-operated, electronic flashes may be the only option, daylight or other illumination notwithstanding.

Strobe units are divided essentially into two basic categories: battery-operated, portable units, primarily for hand-held or on-camera use or the larger, more powerful, A.C. models used by large-format photographers. In fact, the format used will most likely determine the selection of the strobe unit required. A photographer shooting in the 4 x 5 format needs enough light output to permit the use of apertures in the $f/16$ to $f/22$ range. For a large, dark space, this could dictate using a high-output unit. I recently photographed a church interior using my two Starflash Balcar units, each with 3,200 watt seconds of output. For my Polaroid tests at $f/11$, I needed two or three pops of the units with the Type 55 ISO 50 film to obtain enough brightness.

The small-format photographer doing interior work has two choices, either a compact, battery-operated, hand-held or camera-mounted unit or the more powerful A.C. units. Most interiors I photograph have A.C. power, so I use the latter for both large- and small-format work. For the small-format, roll-film photographer, smaller A.C. units than the ones I use would be more than adequate, but they are larger, heavier, and more expensive than the battery-operated units. If economics and portability are prime factors for you, stick with battery-operated strobes.

If you decide to work with battery-operated strobes, you will need good units. For my Nikon system, I use the SB-24 model. This is a sophisticated unit with moderate power and multiple features. I use it with three different cameras, the N8008, the F-3, and FE-2. Unfortunately, its operation varies substantially with each system. I am constantly referring to the guide book (which I find difficult to use). Nikon's SB-25 is a recent update.

The SB-24/N8008 combination is a particularly good one. This unit provides TTL (through-the-lens) metering with both the N8008 and FE-2, but not with the F-3. In the TTL-metering mode, which is the most accurate and complex, the camera's flash sensor measures all the light, both ambient and flash, that reaches the film plane, and then it shuts off the flash the moment the correct exposure has accumulated. The Nikon F-4, N8008, and N4004 to which the SB-24 is specifically dedicated also have Matrix balanced fill-flash that enables a photographer to

routinely produce well-balanced photographs with both background and foreground correctly exposed. Other features include automatic zoom adjustment to match the coverage of the lens in use (between 24mm and 85mm), repeating flash for multiple exposures, as well as variable tilt and rotation for bounce flash. Being able to bounce from virtually any camera position, or off-camera, is an extremely valuable ability for the interior photographer since this is the one situation where a single strobe unit may provide adequate supplemental illumination.

The output of portable, battery-operated strobe units is normally quoted by the manufacturers as a guide number. For a particular film speed, this number—when divided by the flash-to-subject distance—provides the aperture for correct exposure. For example, for ISO 100 film, a unit with a guide number of 110 placed ten feet from the subject would indicate an aperture of $f/11$.

Note, however, that some manufacturers may be a bit optimistic when quoting guide numbers for their units. Only direct comparison will be a true test of maximum output. There can be substantial variation in recycling times among the different manufacturers. Weak batteries also greatly extend recycling time, so be sure to use fresh batteries.

For most situations, more than a single unit will be required. For more details in the use of multiple, battery-operated, electronic flash units I will refer the reader to Susan McCartney's excellent book, *Travel Photography* (Allworth Press, 1992), which is must reading for every location photographer.

Economics may well be the governing factor when buying an A.C. strobe unit or system. Unfortunately, there is little standardization in this arena so the possibilities for mix-and-match are slim. Since all the shoots of an interior photographer are on location, compactness and portability are also very important features.

The design of strobe units continues to improve their efficiency and output while they get smaller and lighter. Today's models have much greater output for size and weight than their predecessors of even five years ago. The most widely used types consist of a basic box containing a capacitor that stores current over a period of seconds. The accumulated charge is then released in a zirconium gas-filled flash tube, mounted in a head, connected to the main unit. After discharge, the strobe recycles until maximum power is attained and it is ready for the next pop. The output of strobe units is measured in watt seconds (joules in Europe). The smallest systems have outputs in the 200 watt second range, more comparable in output to battery-operated portable units. The most powerful units have outputs of as much as 10,000 watt seconds or more but they are strictly for studio use. Recycling time varies with the output of the unit and from brand to brand. For interior use, the recycling time is not usually critical. In some systems recycling time is adjustable to reduce the wattage demand when limited current is available. Many photographers in this field use 1,000 watt second strobes but I don't recommend anything less.

As previously mentioned, I use two 3,200 watt-second Balcar units that are unusually light and compact for their output. These Starflash models are not dual voltage as some Balcar models are, and they have only a two flash-head capability with no adjustments in output between heads. They are, however, easy to use and not overly expensive. I may, on occasion, supplement my two main Balcars with a smaller unit in some remote location. Dynalites are also particularly suited to location work and come in many sizes, up to 2,000 watt-second output.

My advice is to select carefully, since your investment in strobe equipment may well equal or exceed the cost of your camera system. If possible, rent before you buy. Whether you purchase or rent, be sure to get proper instruction and to read the manuals carefully before attempting to use the equipment. A lot of energy is stored in a fully charged strobe, more than enough to electrocute an inexperienced user if mishandled.

Monobloc models are available from some manufacturers. In this model, the strobe head and capacitor are both contained in a single unit. This reduces power loss from long cables, thus permitting maximum output from a given charge. However, since the monobloc is completely self-contained, it is larger and heavier than a regular flash head requiring extra heavy light stands. Also, adjustments of the monobloc may be awkward and require lowering or repositioning the unit.

Top brand names to consider include Balcar, Broncolor, Comet, Dynalite, Elinchron, Norman, Profoto, and Speedotron. Service for any of the above should be easy enough to find in major cities in the United States, but in smaller centers it may be difficult to get your unit serviced. Careful packing is therefore essential when traveling. I particularly like the Lightware line of cases, since they are reasonably compact, lightweight, and, because they are fabric, shock-absorbing.

On a recent transcontinental flight, substantial damage was inflicted by American Airlines on my checked strobes even in a Lightware case. Two of my four flashheads, packed in a tough plastic case with what I thought was ample padding, suffered broken flash tubes and quartz modeling lamps, even though the case itself was unmarked. Moral: Remove flash tubes and bulbs when flying. Current airline policy on excess baggage is very limiting. You may find it more convenient and cheaper to rent lighting equipment at your destination than to bring

it with you. And make a phone call ahead of time to check availability and cost; reserving in advance is often recommended.

Just how you use your strobe or tungsten lighting system determines the look of your photograph. Of course, different subject matter dictates varied approaches. The photographer's objective should be appropriate to the particular interior. Low-level, mood lighting may be fine for a restaurant or perhaps a living room, but would be unsuitable for a hospital room or retail store. Match your lighting technique to the mood you wish to convey.

My normal procedure is to use my main light sources indirectly or bounced, off reflectors, umbrellas, or some neutral surface if convenient. I may use one or two accent lights directly, but these will be much less powerful than the main lighting and very limited in spread. With a strobe lighting system, I use different grid spots on the flashhead, which limit both the intensity and the area illuminated. These spots will introduce some highlights and shadows within the composition, depending on their relative strength to the main lighting source. I use "Inkys"—small theatrical spots of limited wattage—for a similar effect with incandescent lighting.

All the contemporary strobe units mentioned have built-in sensors or eyes, which, when switched on, will trigger the unit when another unit is fired. In this way, multiple strobes can be popped simultaneously without being physically connected to one another; only a single unit needs to be attached to the camera to set them all off. If a radio control unit is used, no physical connection need be used at all. This is particularly useful where the lighting is very remote from the camera and concealment of a connecting sync cord would be difficult or impossible. Again, the receiver for the control need only be attached to a single strobe since it will trigger the others.

To aid in setting up the lighting, the strobe head is equipped with a modeling lamp, usually quartz these days. If the subject is not too bright, and the modeling lights are reasonably strong, the photographer will be able to spot unwanted reflections or highlights and perhaps roughly gauge the final effect. If, however, there is strong ambient illumination, it may be impossible to do this. The incandescent modeling lights are much less bright than the strobe flash. For all except really long exposures, it does not matter if the modeling lights are left on for the final exposure since they will normally be completely overpowered.

There are now many different accessories available for strobes, enabling the photographer to produce a wide variety of effects. Experiment until you find the particular style that suits your objectives. One basic accessory you will need is a strobe meter. These used to be special

meters just to read the strobe output and they had to be attached to the unit. The user stood at the subject and pointed the meter at the camera. Contemporary meters take reflected-light readings that combine both ambient and supplemental strobe illumination. The meter will give you both an aperture and shutter setting. When the ambient daylight level is low, the shutter setting may not be of great significance. Changing the shutter speed setting on the meter may have little or no effect on the aperture reading. Use multiple consecutive flashes if your strobe output is inadequate at maximum output.

The best way to confirm your exposure reading and the balance between ambient and strobe light is by Polaroid test. This is the most efficient way to work, and though Polaroid film is not inexpensive, the savings from poorly exposed film and over-bracketing more than offset the cost. Polaroid-test capability is a basic part of my routine. For more information on Polaroid tests, refer to pages 39-40 in the Film and Filtration section.

Tungsten

Most professional tungsten lighting is 3200°K. Simple photo floods, if unmarked, are probably 3400°K. The latter are for home movies and Type A film. To my knowledge, Kodachrome 40 Type A is one of the only films balanced specially for this color temperature that is still widely marketed. All the rest of the tungsten-balanced films are Type B, 3200°K. Far and away the most popular tungsten lights today are quartz. Available in a wide variety of shapes and sizes, though they get very hot, they are extremely efficient. Treated with care they have a surprisingly long life. The color temperature does not change during the life of the bulb as regular incandescent bulbs tend to. Also known as tungsten-halogen, quartz lights are now the first choice of most photographers.

My tungsten lighting system consists of three Lowel Omni lights, each with about 650 watts of power and two 1,000 watt Lowel DPs. These comparatively inexpensive lights have a limited focusing ability and a wide range of accessories including barn doors, filters and filter holders, brackets for gobos, umbrellas and so on. As already mentioned, I usually use my main light sources indirectly, or bounced to produce a more diffuse light, much less harsh than when used directly, which I try to avoid. I use various sizes of reflector umbrellas for different effects. Avoid the use of plastic umbrellas as they cannot withstand the heat from quartz lights. The right umbrellas may be used for both tungsten and strobe systems, avoiding expensive duplication. In addition to my Lowel lights I have three or four small focusing spotlights in the 100 to 200 watt range, also with quartz bulbs. Known as "Inkys," these spotlights are invaluable

when highlighting some particular item in your composition, such as flowers, a piece of sculpture, a painting, a fireplace, and so on. Because their light is so concentrated, Inkys are effective even in conjunction with 1,000 watt bounced illumination. The concentration of light from these fixtures may be varied by changing the position of the bulb inside.

If you find yourself on location somewhere without enough lighting you may be able to get by with 250 to 500 watt reflector floods which come 3200°K. These bulbs fit into standard electrical sockets.

Whatever a photographer's choice of lighting may be, use common sense and be careful. Whenever possible, check the capacity of electrical circuits and distribute your lighting to avoid overload, especially in older installations where wiring may not be to modern standards. If you do trip a circuit breaker, turn off your lights and any other heavy load before switching back on. Eliminate all load on the circuit you do not need. Older installations may have fuses rather than breakers. Make sure there are spare fuses. The distribution of outlets may make the location or extent of some circuits difficult to determine. Get access to the circuit breaker locations in advance. Beware of union problems if there are resident electricians. They don't take kindly to infringement of their territory, even bulb changing. Avoid frayed wiring and have an ample supply of extensions, grounded and ungrounded. Carry adaptors so grounded plugs may be used in ungrounded outlets.

LENS SELECTION

There are a number of factors that the photographer should keep in mind when selecting a lens. Having decided on the boundaries of the photograph, there may be more than one lens capable of providing the necessary coverage. For example, the same lateral coverage that can be obtained with a wide-angle lens from one viewpoint can be achieved with a less wide-angle lens by pulling the camera back further from the subject. However, the resulting photographs will be very different. With a wide-angle lens, objects near the edge of the composition may be quite distorted and unnatural looking. The further off axis and the closer these items may be, the more aggravated this condition becomes.

Off axis, round objects photographed with a wide-angle lens are depicted as extreme ovals sliding out of the composition. (Tables should be tilted to offset this problem.) It is this sort of distortion that illustrates the undesirable characteristics of the wide-angle lens and brings it into ill repute. To solve this problem, select the longest focal-length lens capable of including all that is to be recorded. The particular conditions at hand will deter-

mine the optimum choice. I suggest that the photographer try as many variations as the number of lenses available permits. In this way only will the characteristics of a particular focal-length lens become familiar.

Another important consideration is the distortion of apparent size. Wide-angle lenses expand the volume of a space. The shorter the focal length of the lens, the more pronounced the expansion. This is the great photographic dilemma: select the lens to show as much as possible of the interior without enlarging it unacceptably. Basically, all interior photography is a compromise. The photographer sacrifices some coverage to prevent the scale of the subject from becoming overly enlarged. There will be instances when the expansion of a tight space is desirable. Not only will the apparent dimensions of the space be influenced by the focal length of the lens selected, but the relative size of the contents and the distances between objects will be affected as well.

A wide-angle lens exaggerates the size of objects close to the camera and diminishes those that are furthest from it. There are techniques for minimizing this form of distortion. One approach is to show only portions of foreground furnishings that, if shown in their entirety, would be too dominant. The moving of background objects closer to the camera can partially compensate for their otherwise diminished importance. If a long, narrow space is to be photographed, the use of a very wide-angle lens will lengthen the corridor and make it appear almost infinitely long due to perspective exaggeration. Using a longer focal length lens will visually reduce the length of the corridor.

Whatever adjustments the photographer makes must ultimately be determined by what is seen through the viewfinder of the camera or on the groundglass. The photographer must train himself or herself to see what is in the camera and not be overly preoccupied by the reality. When viewing a room, the photographer may know that a grouping of furniture is symmetrically arranged in relation to the fireplace. From the selected camera position, this symmetry may be much less apparent or not at all apparent. And yet, because the photographer knows that the furniture arrangement is axial about the fireplace, he or she may fail to notice that it does not appear to be so in the viewfinder.

This is another reason why Polaroid tests during shooting are so valuable. Even in black and white, these tests permit close examination of the total composition in photographic form before it is actually recorded.

Some would-be photographers become so preoccupied with what they are looking at through the viewfinder that they are unaware of the frame and may inadvertently crop out part of their picture, or fail to notice that the

Here is a full-frame fisheye view of the skylit atrium of a Michael Graves house. I used my 35mm Takumar lens on my Pentax 6 x 7cm camera, with Ektachrome 64 film and bounced strobe supplemental lighting. Note how the light fixtures and other linear elements radiate from the composition and thus exhibit no curvature. Also, because the basic shape of the space is round, little distortion is evident. (Photograph reproduced courtesy of *Architectural Digest*.)

camera is not level. Make sure the camera is directed exactly to frame the image that is planned. Normally I compose my photographs to fill the frame of the format I have selected. Occasionally I will produce an image that needs specific cropping. However, cropping 35mm slides is tedious and requires special mounts. If the photographer intends a photograph to be less than full-frame, then the cropping should be clearly indicated. If necessary, the transparency should be taped.

Narrow-angle telephoto lenses will foreshorten spaces, compressing elements so that they appear to be much closer to one another. This can be an interesting way of emphasizing repetitive features like columns or alcoves, pilasters, and so forth. The photographer can draw attention to particular relationships by reducing the distance between them. If only portions of architectural elements are shown, the results may be quite abstract. So the use of the long focal-length lens to focus on details can complement the wider, all-encompassing views used to establish the basic context. The very different look of these two types of photographs will add interest and liveliness to the overall photographic documentation.

The essence of a design may at times only be captured with extreme measures that I would not normally consider. I am referring to the use of the fisheye lens, or more correctly, the full-frame fisheye lens. The difference between the two is that the former creates a complete cir-

cular image while the latter incorporates only the central portion of such an image and the edge of the circle lies beyond the frame of the photograph. The angular coverage these lenses provide is very wide, well over 100 degrees, and wider than anything possible using regular lenses with no linear distortion.

With the full-frame fisheye lens there will be distortion and the photographer must use the lens with extreme care or the results can be disastrous. The distortion will be most extreme at the edges of the frame and least noticeable at the vertical and horizontal optical axes. The image will render straight lines parallel to the picture frame in progressively curved fashion the further away from the optical axis they occur. If the subject has no straight lines near the perimeter of the picture area, the distortion may not be objectionable. Objects close to the middle of the photograph and not too close to the lens may even appear normal with little visible distortion at all. Round subjects may not appear to be distorted at all and straight lines radiating from the optical axis will remain unbent.

COMPOSITION

The subject of composition in photography is highly complex and also very personal. All the subjects dealt with in this chapter have an influence on composition. In addition, there are more involved philosophical aspects

Here are six versions of the living room in the McGrath house, which was designed by architect Myron Goldfinger. I used an Arca-Swiss F camera for each of these photographs. Shots A, B, C, and D were taken with Fuji 100 daylight film, E was on Fuji Velvia, and F was on Kodak 64T. I moved the camera between shots to include a portion of the wall to the left and the right, framing the composition. The camera position remained the same for views D, E, and F.

65mm Nikkor lens, with no supplemental light.

75mm Nikkor lens, with bounced strobe fill, and grid spot on fireplace.

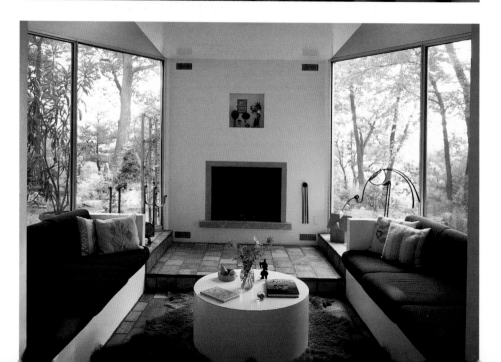

90mm Super Angulon lens, with no supplemental light.

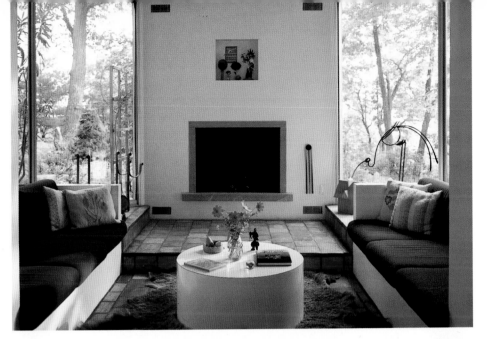

120mm Super Angulon lens, with no supplemental light.

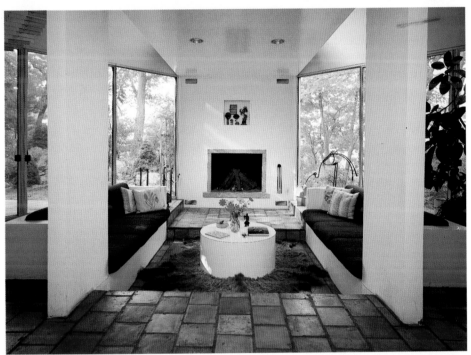

75mm Nikkor lens, with bounced strobe fill and grid spot on fireplace.

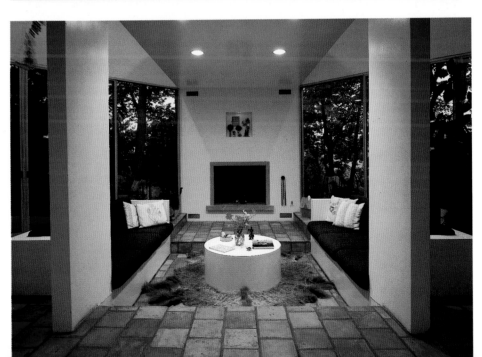

75mm Nikkor lens, with no supplemental light.

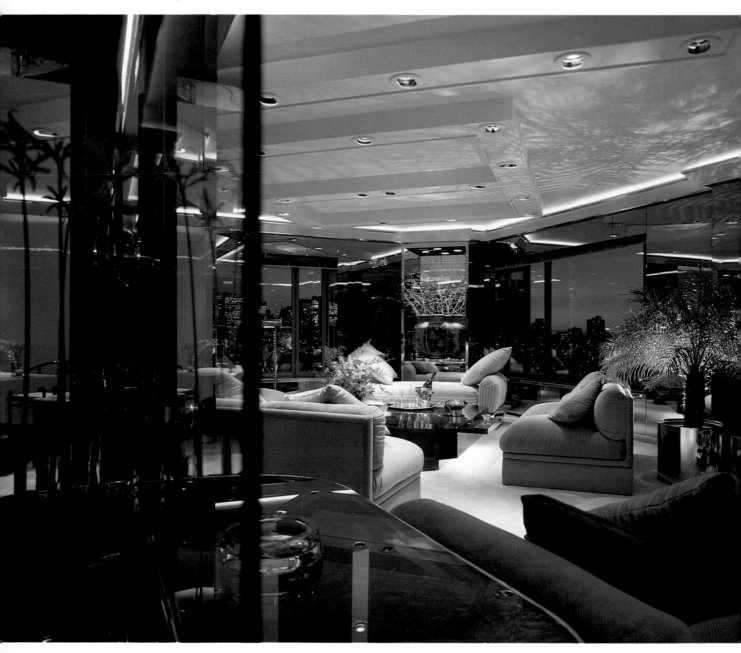

This low key, low angle, dusk
photograph typifies the evocative
mood of Jaime Ardiles-Arce's work.

St. Anne's Hill, Chertsey (outside London).
One of the first examples of the decorative
use of plants in a contemporary interior.
Architect: Raymond McGrath, 1937,
photography by Herbert Felton.

that the reader should be aware of. When considering a set of photographs, it would be quite unusual to obtain a consensus of opinion on the subject of composition from any sort of diverse group. Taste varies widely and few persons will have exactly the same priorities. The celebrated interior photographer Jaime Ardiles-Arce is known for the drama of his compositions. Foreground objects are often very prominent in his photographs and darkness and light are manipulated in complex ways. (See photo, opposite page.)

Much has been written about whether or not composition can be taught. For many people, it does not seem to be a natural instinct. If it cannot be taught, it can certainly be developed. The careful analysis of particularly admired photographs may reveal just what elements contribute most.

My own sense of composition began to be developed in the highly conservative field of the salons of amateur photography promoted by the Photographic Society of America in the late 1950s. The "rules" for success in this field were astonishingly rigid and the formulas predictable. It has always surprised me that in the field of serious amateur photography, unpressured by economics, then, there was a great reluctance to experiment and that the pictorial material produced, even by technically very competent nonprofessionals, was usually very conservative. The photographer should be prepared to ignore the rules should the circumstances dictate.

In his book *Photography and Architecture* (The Architectural Press, London, 1961), Eric de Mare lists the following five qualities relating to composition: contrast, repetition, balance, climax, and cohesion. Contrast, he elaborates, is between light and dark, solid and void, vertical and horizontal, rough and smooth, plain and decorated, or large and small. Repetition helps to bring unity. In architecture, it may be the repetition of windows or of a cohesive "grammar" of detailing. Balance means equilibrium, placing of the focal climax in the right spot, arranging the elements in the right relationship to one another.

The essential question is: Does the composition feel right? Climax is the dominant, binding point of a composition to which all the other parts are related. The climax will be the center of attraction and will often be subtly concealed. Finally, cohesion depends on the above factors but on something more as well—the story the creator wishes to express, the simple, binding idea the photographer has experienced and wishes to communicate. These qualities are equally appropriate to both interior and exterior photography and also to both black-and-white and color photographs.

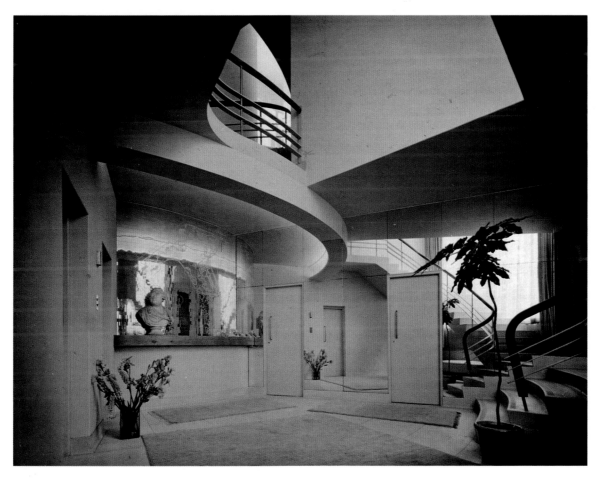

PHOTOGRAPHIC STYLE

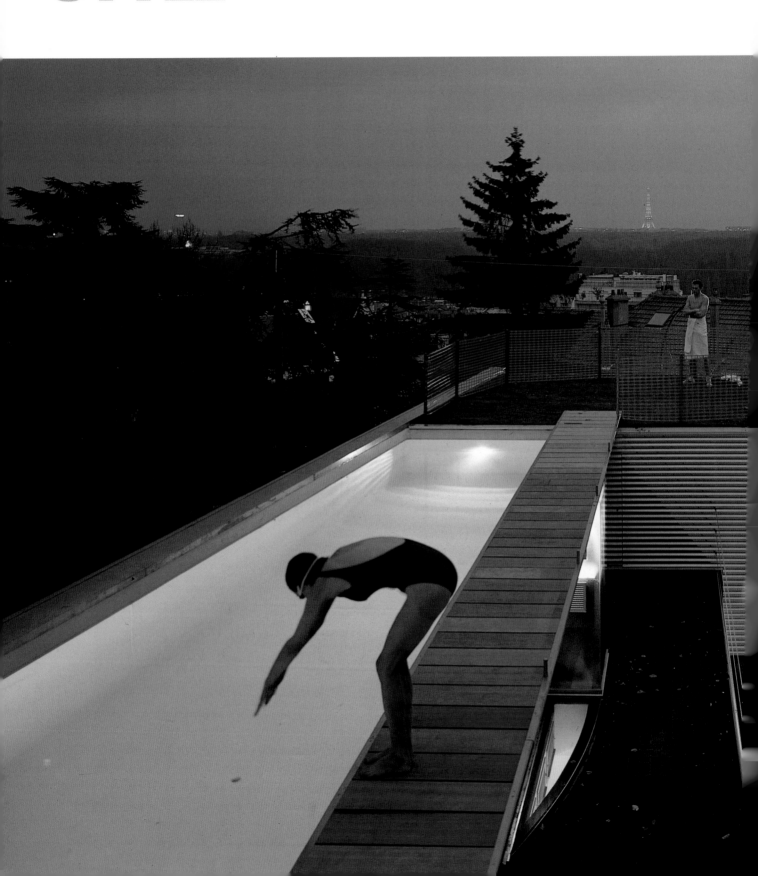

High-quality architecture today, be it interior or exterior, exists on two levels: in reality, in situ, for some to see and experience depending on location or circumstance; and in print, for all to see. Today, virtually all major works of architecture are documented photographically and end up in print. Ideally, the photographic image freezes the work in time and circumstance for evaluation and reference in the future.

Only the most devout students of architecture are likely to analyze their subjects the way an architectural photographer does routinely. Even the serious viewer rarely adjusts his or her viewpoint to see the subject from the best possible vantage that displays all the intricacies and subtleties of the design. And why should they, you may well ask? Viewers can record the subject in their memory and need not be restricted by the encumbrance of a camera's limitations. Nevertheless, photographs often present such powerful images that it is those images that are committed to memory, rather than the reality.

As a photographer, I have found that on an extensive project it is not unusual for me to forget which views I have actually photographed. I normally go through the motions of planning my shoot in advance, selecting the particular views and thus imprinting them in my brain. As an experienced photographer, I weigh the pros and cons of a particular angle and decide what compromises may be necessary or are unavoidable to produce the most informative and presumably most flattering result. I keep in mind not only the important features of the architecture but also the particular circumstances that will highlight them best. I also consider how the totality of the space will translate to the two-dimensional form of the photograph. There may be several influencing factors: the purpose of the photograph; how it will ultimately be used; my client's particular taste; the desired mood (if that is important); the basic quality of the subject; appropriate

Peter Aaron's preoccupation with light is well illustrated here. His photographs frequently also include an element seldom found in architectural photography—whimsy, such as the plunging diver seen here or a leaping cat. These humorous touches are a welcome relief in an overly serious arena. The diver was Peter's assistant and the photo was taken mid-winter.

"Is is possible to capture the very essence of a subject in a single photograph? ... She searches for an unforgettable moment, like it or not, and she reveals sparsities and densities—the basic substance of architecture." *Judith Turner Photographs Five Architects* (John Hejduk. London: Academy Editions, 1980.)

treatment of the work; the time available to complete the task; and so on.

I have explained the processes of how I work, but different photographers have other techniques and varying philosophies. Does this affect the results? Of course: It is in the realm of interior photography that individual style is most apparent. The reasons for this are obvious. When working with interiors, a photographer has much more control of his subject than is possible when photographing building exteriors. Photographers recording exteriors must work with available, natural light unless the projects are very small in scale. And working with the time of day and seasonal changes, certainly the photographer has a limited range of choices. Few have the luxury of being able to wait for that special moment, that unique meteorological condition that enabled Ansel Adams to produce *Moonrise over Hernandez*, to say nothing of the hours of darkroom manipulation that went into that magnificent image. An experienced photographer can recognize and anticipate natural phenomena that are likely to produce striking or unusual images.

In *Architecture Transformed* (MIT Press, 1990), Cervin Robinson points out that in the early days of photography it was "what" rather than "how" one photographed that was the measure of accomplishment. Photographers sought unique subject matter, at which to aim their cameras. A photographer who knowingly recorded what another had done before was guilty of blatant plagiarism or was at the very least unworthy, due to lack of originality.

In time, tastes and attitudes changed. Technological evolution made life for the growing number of photographers much less taxing. New materials and equipment opened up previously unexplored avenues of creativity. Meanwhile, new architectural movements advanced and spread with considerable speed as a result of the rapid distribution of the latest creations via the printed photograph.

For today's architectural photographer, "how" one photographs is primary: approach and interpretation, the ability to enhance, create a mood, bend reality, glamorize, and embellish are all attributes one may be called on to exhibit. Any serious reader of periodicals devoted to architecture, interior design, and related fields will recognize, over a period of time, the approach and look of different magazines. For example, shelter publications, like *HG*, *Metropolitan Home*, and *House Beautiful*, feature interiors somewhat similarly, though one is inclined to find on their pages some examples that are within reach of a less affluent readership. *HG* is less predictable, and like in *Architectural Digest*, many features are meant to typify what the reader's dream house might be like. Even if one cannot personally aspire to such opulence, it is interesting to see how the rich and famous live.

The degree to which each magazine's "look" reflects photographic style is less obvious because we do not know the role that editorial direction played in the production of the images. Having worked for all these publications, I know something of what is involved in a photographic assignment. Of these four, *Architectural Digest*, *HG*, *Metropolitan Home*, and *House Beautiful*, the one that gives me the most freedom is *Architectural Digest*. This magazine does not routinely send their editors on photo shoots as the others do, but leaves all the details of how something is to be shot entirely to the photographer, who may work in conjunction with the architect or interior designer involved. When neither of these two professionals is on location, the photographer is left entirely to his or her own devices. There may have been an editorial hint in some cases, based on advance scouting material submitted before publication, to "avoid unfortunate furnishings or artwork" and "concentrate on architectural details." In the past, at least, the other three publications were not above refurnishing and accessorizing to produce photographs that truly reflected their editorial viewpoints.

The degree of editorializing certainly contributes to the "look" of the magazine. So, too, does the style of the photographer. Whether the photographer changes style to suit the journal or is in fact selected to do the assignment in the first place because his or her style compliments that of the publication is a moot point.

Photographer Jaime Ardiles-Arce has a style that has become synonymous with the *Architectural Digest* look (see page 62). It is evident that, at the beginning of their long association, art directors encouraged Ardiles-Arce to pursue his very theatrical approach to interiors. More than any photographer I know, Ardiles-Arce has a crystal-clear vision of how he wants his photographs to look. He accepts no compromises. Offensive elements are eliminated, be they plants, artwork, or pieces of furniture.

Trained as an architect, Ardiles-Arce truly designs for the photographic image. His work is highly distinctive, marvelous to look at, immediately recognizable, and—judging by the number of would-be emulators—difficult to copy. Perhaps Ardiles-Arce is closer in philosophy to the moviemaker who creates a product based on an idea or concept rather than a relationship to the subject. The extent to which the photographer's philosophy alters the final image of the subject is interesting. For example, there are photographers who decide that the introduction of artificial lighting violates some unwritten code and unacceptably changes an interior. This view fails to recognize one of the basic realities of the photographic medium: Film does not record what the human eye perceives.

Encouraged by the shelter magazines in particular, one approach that gained popularity and wide acceptance in the 1980s is what I refer to as the "vignette style." Photographs taken in this manner substitute longer focal-length lenses for wide-angle optics and instead of expanding spaces, compress them. Elements within the composition seem to be much closer to one another and rarely appear in their entirety. Part of a chair with a slice of pillow adjoins a small table, only a corner of which is included, superimposed against part of a window frame seen through a layer of diaphanous curtain. These photographs, when produced by a photographer of the caliber of Lizzie Himmel, for example, are quite beautiful and evocative, if not informative. The viewer is left exercising much imagination to evaluate what the whole scene is about. The vignette style is concerned more with the atmosphere, texture, and contents of the space; it does not address the spatial or volumetric qualities of an interior. Experiencing the room is thus more difficult.

When evaluating interpretations made by different photographers, it is hard to make comparisons unless we are familiar with the subject matter or they have all photographed the same subject. Unfortunately, the design press seldom features the same projects unless they are of unusual importance. As I write this, following the recent reopening of the restored and enlarged Guggenheim Museum, an unusual opportunity arises. This is such a unique piece of architecture that only a truly unimaginative photographer can fail to make interesting images.

I think most of us do recognize that photographic interpretation or style does play a role, even in architectural photography. It is odd, however, that this recognition tends to be suspended by most readers of serious architectural journals. The approach and appearance of these periodicals tend to be so serious and focused that the suggestion that the images they present are anything but totally true-to-life is unthinkable. Readers rely on the assumed moral integrity of the publication, convinced that they would not be knowingly misled. Yet, we know how easy that is, and there is always the possibility that if this occurs, it may be unintentional.

Finally, let me quote from the excellent book *Architecture Transformed*, in which Cervin Robinson writes: "The task of an ambitious architectural photographer at the beginning of the 1930s was much what it had always been and continues to be to our day: to produce a print of sufficient physical quality that one's work is taken seriously, to get ahead of the pack of one's fellow photographers by some aesthetic act, to remain in the public eye thereafter with a recognizable, individual style."

This interestingly grainy 35mm shot by Lizzie Himmel is a good example of the vignette style for which she is well known.

DOMESTIC SPACES

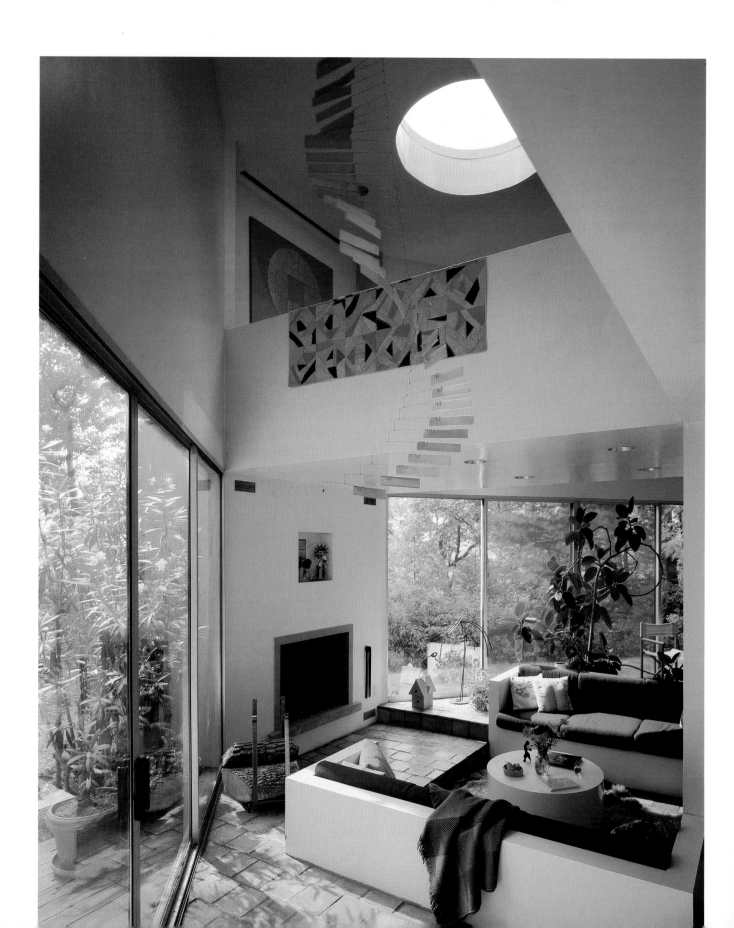

Average-Size Living Room in Available Winter Light

The room pictured below and the one on the next page are the work of interior designer Elizabeth "Toppy" Wade. Traditional with a contemporary flavor, both settings are in New Hampshire houses.

For the red room pictured below, I used Kodachrome 64 film in my Nikon FE-2 camera, with no supplemental lighting. There are windows to my left and behind me. On the following page, in addition to the small window on the right, there is a large bay window to the left. For those photographs, I shot two different films in my Nikon F-3 camera. The lenses I used ranged from 35mm PC to 20mm focal length.

This diagonal view shot from the corner between two windows was taken with a 24mm lens. The camera height was adjusted to include the complete cube table. I carefully adjusted the profile of the chair on the left to minimize distortion, showing the two front legs and maintaining a logical position in the room. I moved the cube table to the left to make it appear to be on axis with the sofa in the rear. White birch logs were added to brighten up what would otherwise have been a very dark fireplace. I opened the door to relieve the flatness of the wall on the left.

The view (below, right) is on the axis of the fireplace with the film plane parallel to the back wall. Using a 20mm lens, I was able to include the corner of the room on the right. However, the armchair appears stretched, the sofa seems endlessly long, and the foreground table is distorted in shape. Though the shot includes much information, a less wide-angle composition would have been preferable.

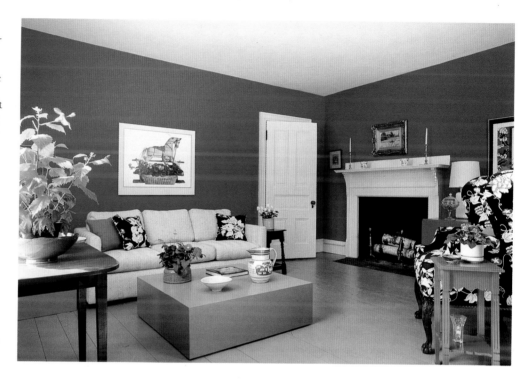

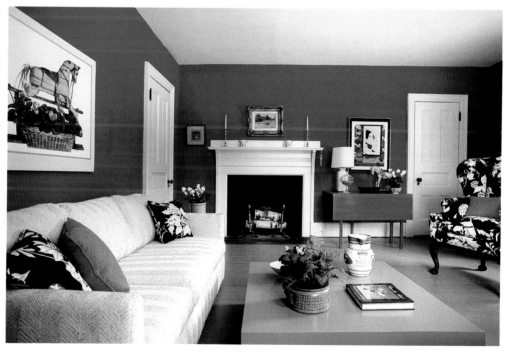

McGrath living room (left), Patterson, New York. The architect was Myron Goldfinger; the mobile is by Tim Prentice. 75mm lens on Arca Swiss camera, 1/4 sec. at ƒ/16 with available light, Kodak 100X film.

This first shot was taken from as far back as I could get. I elevated the camera to show as much as possible of the furnishings and their relationship to one another. I used my 35mm PC lens offset 5mm downward rather than tilting the camera. The effect was to minimize the ceiling and show more of the layout of the room. Foreground chairs were pulled toward the camera so that only their backs are seen and the table beyond is visible. The exposure time was 1 sec. at ƒ/8, Kodachrome 64.

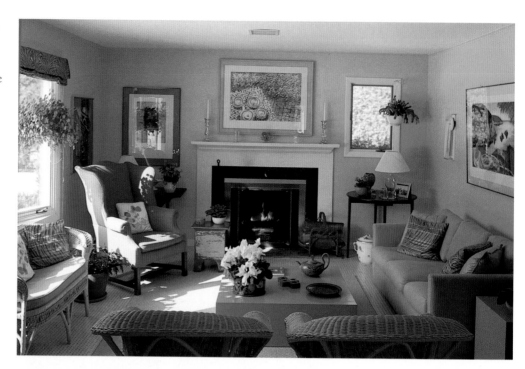

Here is an axial view taken without direct sunlight. After this was taken, I made some minor adjustments in the furniture position. I used a blue bulb in the lamp behind the wing chair on the left. The light from this source, although warmer than daylight, is much more acceptable than that of a regular tungsten bulb. The camera position is perhaps three feet closer into the room and lower down. Also, the chairs in the foreground were placed closer to the table. I used Fuji 100D film, exposed for 1 sec. at ƒ/5.6 to 8.

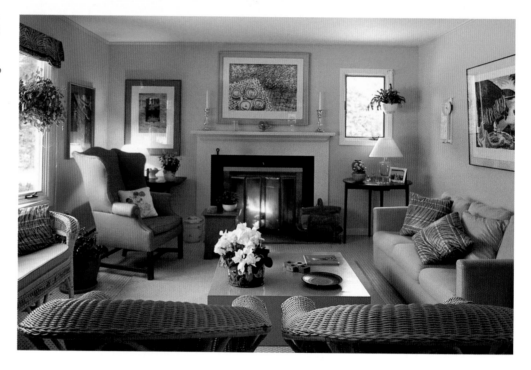

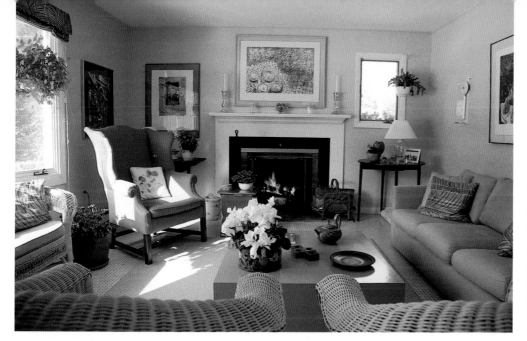

This third version at top left was taken with a 24-50mm zoom lens set at 24mm. The camera is now positioned even further into the room and tilted downward slightly so that less of the ceiling is shown. The position of the chairs was carefully adjusted so as not to overwhelm the composition. Now the vertical planes are no longer vertical and the furniture appears to splay outward from the center of the composition. More than with the prevous two shots, this viewpoint does encourage you to feel as if you are inside the room, but there is both exaggeration and distortion of some elements. The exposure time was 1/4 sec. at f/8, with Kodachrome 64 film.

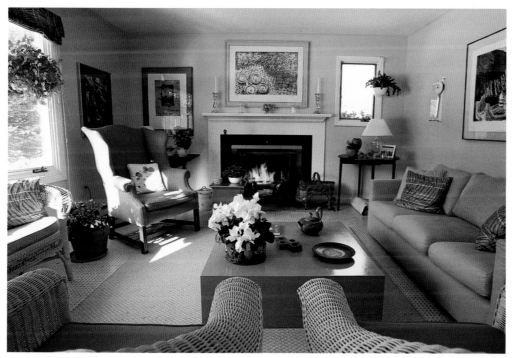

This is an ultra-wide view photographed with a 20mm lens. The camera is positioned even closer than before and it is more tilted as well. The furniture on both sides of the composition appears to be falling out of the frame. Also, note that in this photograph, the seats of the chairs are now visible. An 18mm lens version was even more extreme. The sofa seems incredibly long and the room feels larger. With Fuji 100D film, the exposure was 1 sec. at f/8.

For this final image, I include this low-angled photograph of the room taken with the 28mm PC lens. I shifted the lens slightly downward and to the left. Careful positioning of the camera enabled me to minimize contrast by eliminating from the shot the snow on the ground outside and the sun on the rug inside. This final view was taken with Fuji 100D film, exposed for 1 sec. at f/5.6 to 8.

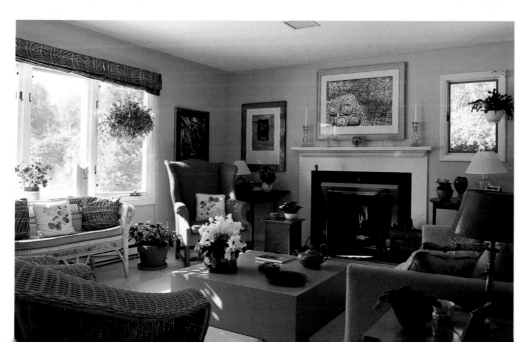

A Mies House With All Glass Walls

Now in print for only the second time in this country, this is one of only three houses in the United States designed by the master Mies Van der Rohe. The original owner was a brother of one of Mies's Chicago clients and the window frames are the same as those used on one of the well-known apartment towers in that city.

In the 1980s, architect Peter Gluck was approached to do an addition to the house. After first refusing to take on the project because of the house's famous lineage, Gluck ultimately created a discreet wing, complementary to the original design. With a combination of restoration and remodeling, he produced a house with none of the compromises Mies had to make in the original plan.

In photographing the house, I have deliberately employed a rigid one-point perspective style in keeping with its design philosophy.

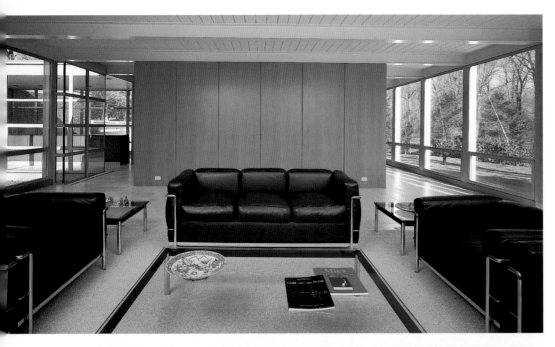

My goal was to capture the airy quality of the house. Occasionally I will take a photograph in a proportion other than 4 x 5. Here I used my widest-angle lens to include as much glazing as possible. The result was too much ceiling and floor, both of which have been cropped. The photograph's extreme horizontal viewpoint accurately portrays the feeling you experience when in the room. To balance the interior light level with the outside, I bounced strobe light off the wall behind the camera and the white ceiling, producing a soft, even illumination with little shadow. The 65mm Nikkor lens on my 4 x 5 camera distorts the width of the Mies chairs and the apparent size of the window bays on the right, but that was not too high a penalty to pay for its use. I used Fuji 100D film for this image.

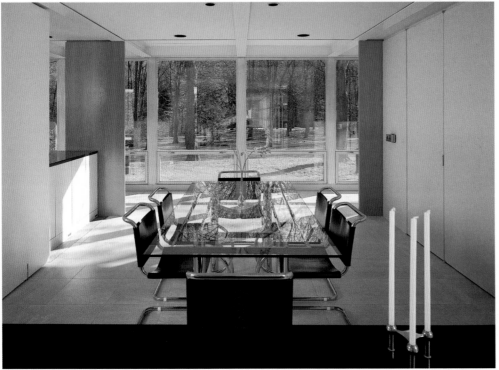

Originally part of the now more spacious living room, the dining room now occupies what was once the master bedroom. I had to plan this view to record the penetration of sunlight into the room and achieve the correct balance between interior and exterior illumination. I concealed a strobe in the kitchen, which is off on the left, and also to my left and right behind the camera, taking care not to create unwanted reflections. The candelabra relieves the rather severe, dark marble surface of the foreground sideboard and adds depth to the composition. I used a 120mm Super Angulon lens on my 4 x 5 camera with Fuji 100D film.

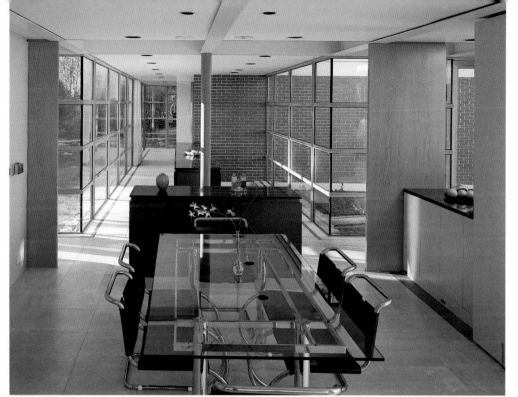

The dining room looks toward the new wing, which contains a master bedroom and bathroom, a small adjoining study, and a family room down below. This camera position dictates a substantial lateral lens shift to the right and downward to maintain the one-point perspective. I placed fill strobe light behind the camera to the right and in the kitchen, also on the right. The camera used was a 90mm Super Angulon lens, with Fuji 100D film.

The late afternoon sunshine streams diagonally into the house. No supplemental lighting was used here. This southern view shows the junction of the new west wing with the original design. Again, I used Fuji 100D film; the 120mm Super Angulon lens is shifted downward and to the left.

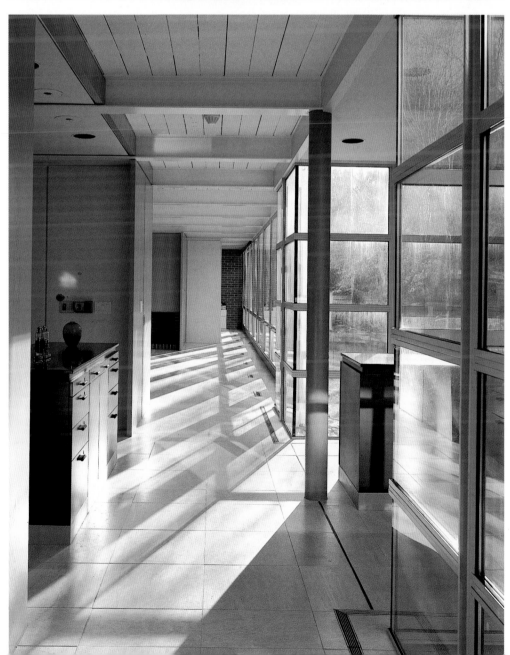

Big Beds in Small Spaces

Photographing large rooms where it is possible to pull back some distance from the subject does not present any particular problem. To compose balanced compositions of king-sized beds in tight quarters certainly does, however. This is particularly true in situations where the most flattering angle is looking directly toward the bed. In my experience, keeping the camera low helps to minimize the mass of a large bed and, whenever possible, I try to show only a portion of it. Showing only the foot of the bed can be more than adequate to convey the function of the room. In the each of the examples I have selected, mirrors play a vital role.

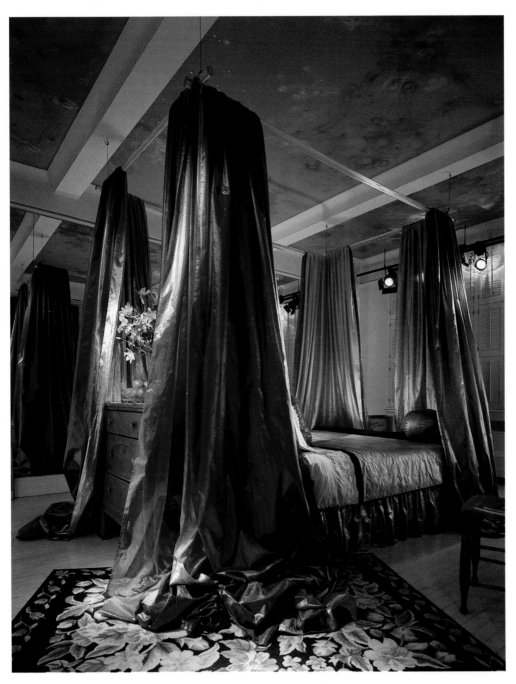

The bed as stage set. Everything about this remarkable room (at left) is theatrical: the bed itself, the elaborately lined drapes at each corner, the color, and the gelled spotlights hung from the ceiling. The mirrored back wall enlarges the modest dimensions of the space.

Although the whole bed ensemble is visible, much of the detail of the furnishings is concealed and there is some sense of mystery here. The reflective nature of the fabric, as well as the mirror, made supplemental lighting tricky. I had very little space to maneuver suitable reflective surfaces to produce the soft, natural-appearing lighting I was after.

I bounced a low-watt tungsten light off a reflector on the floor behind the bed to lighten up the ceiling and another off to the left in a small bathroom. To emphasize the four-poster effect, I used a vertical format. The 75mm Nikkor lens on an Arca-Swiss camera was elevated to include more of the hand-painted ceiling. The foreground drapery was arranged to minimize distortion resulting from its close proximity to so wide a lens. I used Ektachrome 64T film.

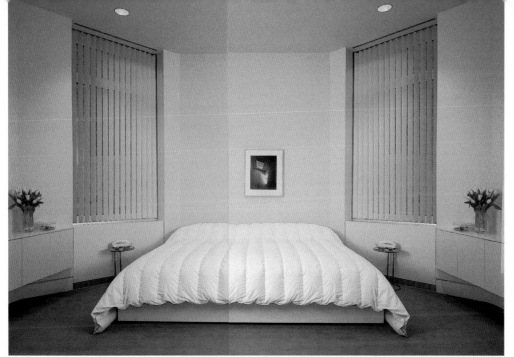

Almost half of this composition is mirror reflection in an open closet door. The (slightly asymmetrical) abstract above the bed is the only exception to the apparent symmetry of the composition. The actual room is almost shown here, but it lacks the intrigue of the photograph. A diffused tungsten light is concealed to the left. I waited to shoot until dusk, when the ambient daylight diminished. The remodeled townhouse is the work of architect John Fondrisi. I used a 75mm Nikkor lens on a Sinar F view camera with Ektachrome 50 tungsten film.

This second view of the bedroom explains the room a bit more fully. All the details are the same, but I switched to a less wide 90mm Super Angulon lens.

Below is the guest bedroom in designer Harry Stein's Los Angeles House. The open door conceals the reflection of the Nikon F-3 camera with 28mm perspective-control lens. I used Fuji 100D film with available light only.

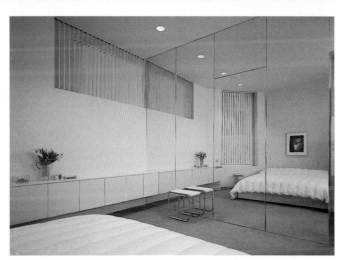

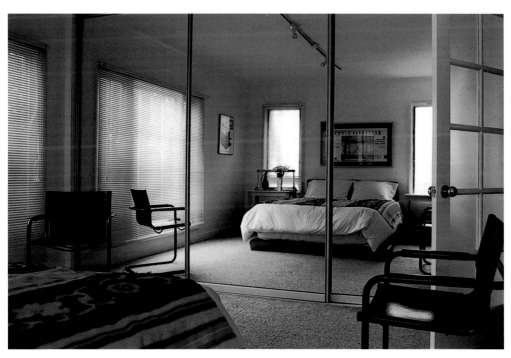

Custom-Designed Kitchens

No other room in today's home assumes so important a mantle. The role of the kitchen with respect to the rest of the house has evolved, just as family roles have been altered. The kitchen has become the gathering place for shared activities and experiences and the social meeting area for the family. In addition to more traditional functions, many modern kitchens incorporate entertainment centers into the eating area. Ever more sophisticated appliances provide a wide variety of services for the enthusiastic gourmand and the reluctant cook alike. Even computers have a role to play. Small wonder then that photographs of kitchens provoke such wide interest and curiosity.

The market for photographs of kitchens is substantial. In addition to the editorial field, many books on the subject are published regularly. Because of the complexities of contemporary kitchens, a large number of companies and manufacturers are either directly or indirectly involved in further expanding the market for pictorial material.

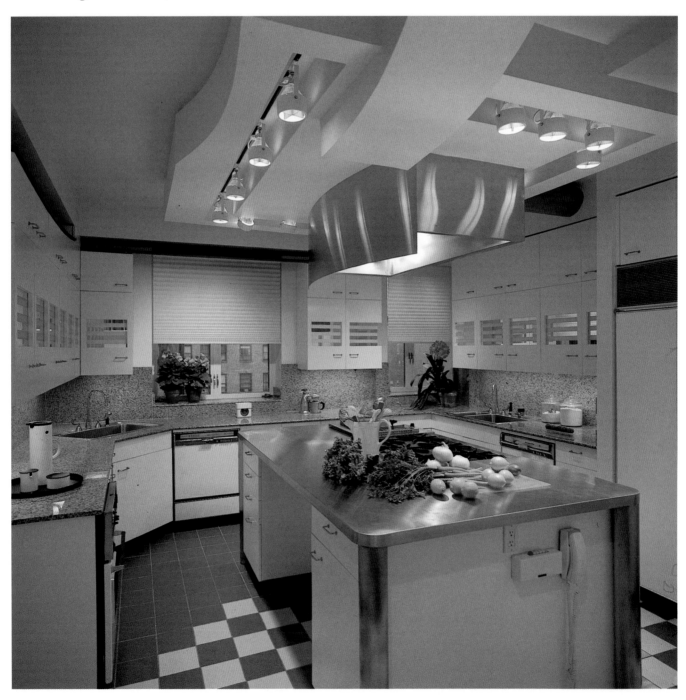

The architect for this inviting example (opposite page) was Alan Buchsbaum for the Design Coalition. Photographed for *House Beautiful*, I used a Hasselblad CM with a 40mm Biogon lens. Because tungsten lighting is an important component of the design, I decided to cover the windows with sheets of 85B gelatin filter from Rosco. Care must be taken to ensure that the filter material remains flat, or unwanted reflections will result. The window light from an overcast sky is still cooler than the interior light, but the balance looks believable. I supplemented the ambient lighting with bounced quartz units to both the left and right. The camera was carefully leveled to avoid unwanted distortion. I used Ektachrome 50 Type B (EPY) film exposed for 1/4 sec. at f/8 to 11.

The remodeled New York co-op at right was designed by architect William Cohen. Clean detailing, handsomely styled German cabinetry, and an unusual stainless-steel tile floor lend appeal to this kitchen. Supplemental quartz light was bounced off the ceiling and the counter lights are all incandescent. I set the camera as low as possible, without revealing the undercabinet fixtures. Minimal daylight provides a pleasing blue accent. The 90mm Super Angulon lens on my Sinar F camera was lowered to include more of the floor in the image.

This closet-sized Manhattan efficiency is the work of artist and designer Betti Franceschi. The mirrored backsplash complicated both lighting and photography. I managed to conceal my camera and tripod reflection by almost closing the swinging doors that enclose this tiny kitchen and by turning off all lights behind the camera. I taped a circular Reflectasol to the ceiling above the hanging pots and pans. Then I placed a small 200-watt spotlight on the floor and focused its beam toward the reflector. I had to make a two-part exposure because the counter lighting was fluorescent.

I used a 65mm Nikkor lens on my Sinar F-2 view camera. The first part of the exposure was made with only my spotlight switched on. For the second portion, only the fluorescent lights were on and I used a 40R/10M filter combination to correct the warm white bulbs to Type B balance. Polaroid testing confirmed the correct exposures. The film used for this shoot was Fuji 64T.

Custom-designed, high-quality cabinetry helps to make use of every inch of space in this compact design of a complex kitchen on New York City's West Side (pictured at left and below). Polished surfaces and tight quarters made the lighting setup difficult. Every bowl and jar has its place. The precise and orderly mind of the artist-owner is accurately reflected by this meticulous room. The clear, lacquered birds-eye maple is accented with ebony shelves and trim. A no-nonsense restaurant stove confirms that this is a facility for serious endeavors. The kitchen was designed by Shape + Structure, Inc. For both views, I used a 90mm Super Angulon lens on the Sinar F camera with Ektachrome 50 Type B film. I opened the book in the left foreground to a dark illustration to diminish the brightness of the laminate countertop. The low level of daylight seen through the window contrasts comfortably with the warmer light inside.

The combination of wood, white tile, and stainless steel gives this Nantucket kitchen (opposite page) an inviting "come work here" look. I have always admired restaurant refrigerators with glass doors. The pulley and decorative fish are appropriate for the island setting. Two round speakers are set into the gable wall on the right. The architect of this kitchen was Edward Knowles.

I bounced a strobe off the sloping white ceiling above the camera to the right and a second, similarly, to the left. A 90mm Super Angulon lens was used on a Sinar F-2 view camera with Fuji 100D film. (Photo reproduced courtesy of *Architectural Digest*.)

This unusual open-plan kitchen is strategically located at the core of a "log" townhouse, in Ketchum, Idaho. Win Lauder was his own contractor and had substantial design input, and worked along with Stan Acker and interior designer Frank Pennino. However, it is Joan Lauder's culinary prowess that is allowed to revel here.

Circulation in and around the kitchen is pleasantly unrestricted. The log canopy conceals indirect lighting above, in addition to recessed lighting fixtures. Beyond the windows to the right is an enclosed courtyard and a long dining table is conveniently located to the left out of view. Beyond is the living room and behind the camera is comfortable

seating with a television and books, a sort of family area for informal living. Sitting on the polished granite counter top is an Idaho-shaped cutting block. The basket of wood spoons intercepts unwanted highlights from one of my three bounced strobe lights. I used a 90mm Super Angulon lens on a Sinar F-2 view camera with Fuji 100D film.

This spacious kitchen in a weekend house north of New York City (bottom, left) is a floating island right in the center of the house, with the living and dining rooms on either side. The working counters, sink, and stovetop are concealed by a high backsplash, which is transformed into handsome wood cabinetry. This clever use of space then incorporates on one end a curved shelf and display niches for *objets d'art*. The grid of square openings continues on the sides of the island kitchen, housing speakers, books, and more favorite items. On the back wall is a refrigerator flanked by concealed storage. The refrigerator door has a trompe l'oeil painting of a screen door capturing a view from the back porch. The architect for this unusual design was William Cohen, who also designed the house.

I elevated the camera and used bounced strobe-lighting low down to throw light into the niches. Tungsten counter lights produce a warm tone inside the enclosure. I used a 120mm Super Angulon lens, offset downward on my 4 x 5 camera with Fuji 100D film.

Architect Jefferson Riley of Centerbrook recently remodeled the very simple kitchen he and his wife had built in their Connecticut home. What began as basic quarters has been transformed over the years into a large, quite elaborate house. This view of the new kitchen (opposite) captures the somewhat inside/outside quality, with the bedroom above looking out into the high area of the space. The many windows restricted the possible locations for my strobes bounced into umbrellas. I located one strobe in the above bedroom, one high to the right of the camera, and two more to the left. The recessed tungsten lighting warmed the wood tones in the background. The red bowl on the counter above the dishwasher blocks reflection of one of my lights in the polished granite backsplash. I used a 90mm Super Angulon lens on an Arca Swiss F view camera with Fuji 100D film.

Complex Spatial Relationships in Halls, Corridors, and Stairways

The entrance hall of a well-designed interior is where the design is first communicated and therefore its documentation on film is of considerable importance. The photographer should have a clear grasp of the subject and the design objectives before shooting.

The photographs I have chosen are of Herb and Edna Newman's New Haven, Connecticut, home: a multilayered, complex, highly individual design. It gave me a large number of alternatives and variations, and was, without a doubt, a highly photogenic space.

This classic-style entrance hall, done in a modern idiom, is the heart and the core of a radiating design. The design is a culmination of many ideas and inspirations of the designer's over a considerable period of time. To get

from one room to the next, most paths lead through this space at one level or another. Basically square in plan, it is three stories high with a "flying" stair leading from the second to the third level.

The hallway is virtually flooded with light most of the day. Above the second floor there is a sloping line of glass all the way around, permitting light to enter from the open corners and from the large round openings in the upper part of each wall. A four-foot-wide circulation space runs around at the second floor between the inner and outer surfaces of the tower.

I took these photographs on a bright, early fall day. Available natural light was supplemented in certain views by a 5000-watt second Balcar strobe unit with two heads.

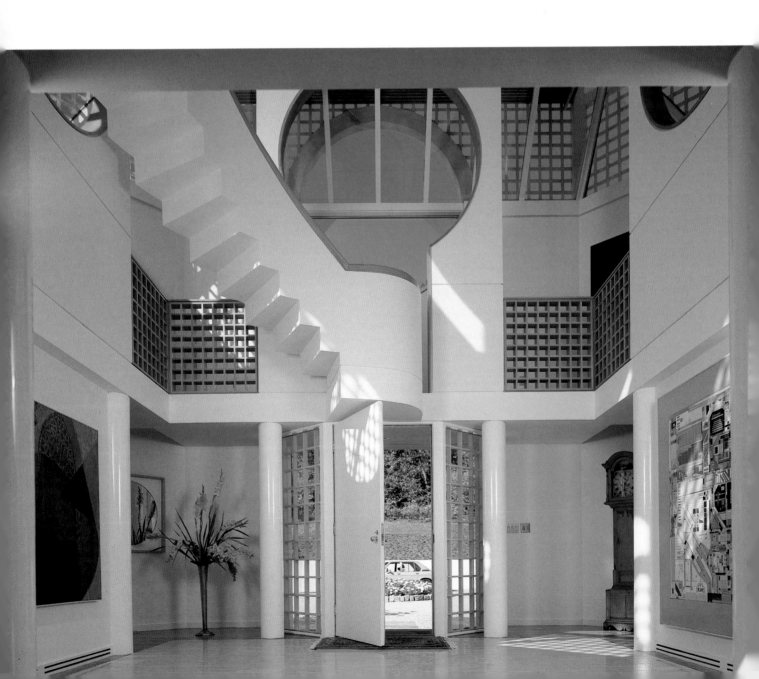

This first photograph, opposite page, is of the hallway looking toward the front door, due north. I wanted to frame the photograph between two round columns on either side of the entrance to the living room. Moving down some steps into the living room, I was able to include both columns and part of the floor above without using a very wide angle lens. The camera was approximately three feet above the hall floor, so I had to use a substantial amount of lens rise to show so much of the upper space and so little floor.

Being back this far gave me grater flexibility in locating my strobe heads with umbrellas. With bright sunlight falling in the room the contrast range was too great for an available-light-only photograph.

Here, above, is the camera position and lighting setup I used in the first shot. Note that this shows the 35mm Nikon rather than the Sinar F 4 x 5 view camera used for the photographs reproduced here. (This shot was taken with the Pentax 6 x 7 and a full-frame fisheye lens to show the whole step.) I left the front door ajar to see more of the outside. I moved my car into the background to conceal an overly bright section of sunlit white wall.

I used the 90mm F5.6 Schneider Super Angulon on the Sinar F 4 x 5 camera with Ektachrome 64 Daylight film. Exposure was approximately 1/15 sec. at between f/16 and 22. The blue of the sky is somewhat exaggerated by the amount of lens offset.

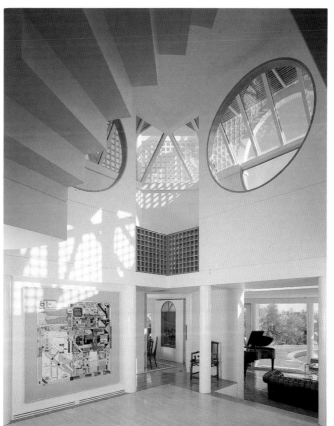

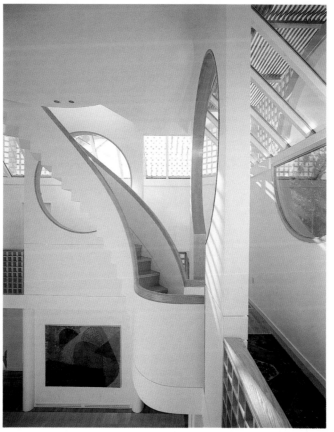

I took this photograph, top left, looking diagonally into the dining room. I selected a high camera position because I wanted the underside of the stair to be a major element in the photograph and because the higher elevation rendered the drop in level into the living room more clearly and exposed more pool and grass. The photograph is symmetrical about the diagonal axis. I substantially elevated the lens to include as much of the stair as possible but still retain a comfortable amount of floor. I again used two bounced strobe lights, one on either side of the camera. The left light was lowered slightly to better clear the stair. In addition, another strobe unit was positioned in the dining room and it was triggered remotely with an electric-eye. Without it, very little detail would have been visible there.

I used a 75mm F4.5 Nikkor lens on the Sinar F 4 x 5 with Ektachrome 64 Daylight film. The exposure was approximately 1/15 sec. at f/16 to 22.

The photographic possibilities were even greater at the second-floor level. This view explains much about the design function of the stair, the circulation system at the second floor, the sloping window detail, and the relationship of the outer round windows to the inner circular openings. By including both the floor below and ceiling above, the viewer is provided with plenty of information to recreate and understand the spatial significance of the design. To lighten up the lower part of the hall I positioned one strobe with umbrella downstairs, slightly to the left of the camera. A second bounced head was situated at the second-floor level. This compensated for the rather strong back lighting in this photograph.

I used my 90mm F5.6 Schneider Super Angulon lens on the Sinar F 4 x 5 view camera. Ektachrome 64 Daylight film was exposed for 1/15 sec. at f/16 to 22.

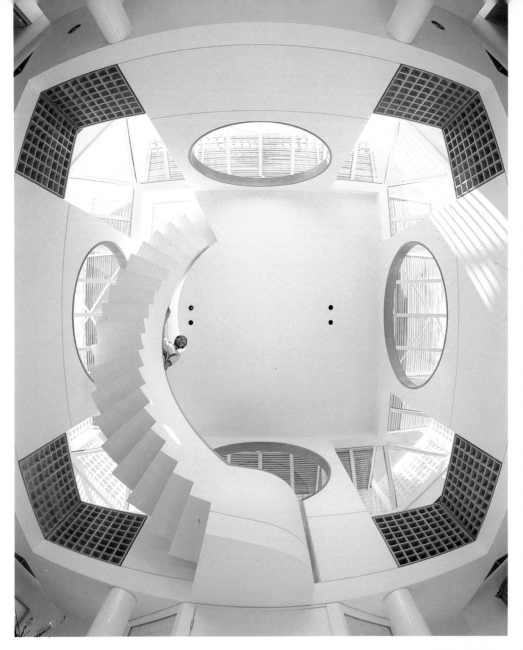

Here, left, is the 120 format, fisheye-lens version of the ceiling scape. This lens has an astonishing coverage. It offers much more than the 58mm optic, which is the widest available non-fisheye lens for the 4 x 5 format that does not vignette. Being of the full-frame variety, this lens does not have a circular image, but has a rectangular format which is only the central portion of the round image this lens would produce on larger film. Many people are offended by the curvature this type of lens introduces, so it should be used only in moderation, and, when possible, as an alternative to a normal wide-angle lens version. Note, however, that the distortion is minimized near the center of the image and increased toward the perimeter. I included my assistant for scale.

Ektachrome 64 Professional 120 Daylight film was used in the Pentax 6 x 7 single-lens reflex camera in conjunction with the 35mm F4.5 Takumar fisheye lens. The exposure was approximately 1/60 sec. at f/8 to 11 and no supplemental lighting was used.

The photograph below left shows the setup for the final upshot. The camera shown here is the Sinar F, not the Pentax 6 x 7 actually used. This shot was taken with the Pentax using the full-frame Takumar fisheye lens. My camera was as close to the floor as I could get it and still attach the reflex viewfinder. Note that I used my gadget bag as a counter weight for the 4 x 5 camera to stabilize it. The exposure was not recorded.

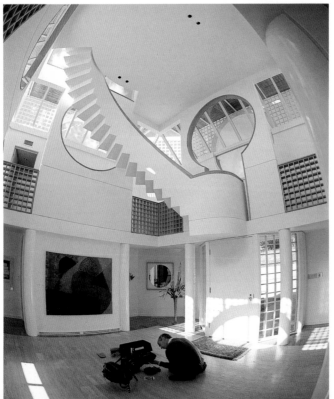

Mirrors in a Tiny Bathroom

The tiny bathroom shown here is in a remodeled New York City townhouse, designed by architect John Fondrisi. Two angled mirrors are set above a cantilevered lavatory basin. One of the mirrors is a medicine cabinet door, and opening it to conceal my reflection would have destroyed the symmetry that is such a basic part of this design. The tulip-filled vase was large enough to conceal my view camera used for one version of this photo. To get back far enough, I had to retreat into the diminutive shower stall and shoot through the closed glass door, causing the slight green cast. Fortunately, no supplementary lighting was necessary. Because of the multiple reflection, the tulip arrangement was much enlarged. The inset view shows where my reflection would have been. Below, you can see how cramped the situation was. I used a 65mm Nikkor lens on a Sinar F, with Ektachrome 50 Type B film.

The Ultimate Loft

Husband-and-wife architects, Malcolm Holzman and Andrea Landsman, are an unusual couple. They had a very handsome loft, but their lease was running out. Their collection of large paintings was growing, as was their commemorative plate collection. They were also thinking about an addition to the family. In short, their requirements were demanding. Their new living space had to be within walking distance from the Hardy, Holzman, Pfeiffer office, and it had to be uniquely special. It is a tribute to their perseverance that they were able to fulfill their dreams, and more besides. These four photographs only hint at what they have achieved.

From the west wall of the new loft two landmark towers are visible, the Metropolitan Life Tower and the New York Life Tower a block or so to the north. Malcolm inserted a special viewing window to see the former. The towers both have night lighting and are especially striking after dark, as can be seen in these photographs, which were taken on consecutive evenings.

The window of opportunity for both these shots was not more than 10-15 minutes, as the tower illumination is most dramatic when it is brighter than the sky behind it. The value of the sky should be such that the buildings are clearly silhouetted, but the sky should not be lighter than the more brightly lighted areas inside. Take care not to over-illuminate the interior or it will dominate the photograph.

It is essential to plan ahead. Select your angle and lens carefully. The shot should capture the experience of looking outside from within, not be simply a photograph of the view.

Start photographing as soon as you think the value of the sky is correct. You should use Type

B film without filtration. Be aware that your first shots will probably be taken too soon because the daylight rendition on tungsten film tends to be exaggerated. The towers shown in these views have different types of floodlighting, so the color rendition may not be accurate. Since some building illumination is purposely tinted, the color recorded is not usually critical. To try and correct the building lighting is rarely feasible, particularly in view of the limited time available. Also, the color of the sky may be unacceptably changed and will not look realistic.

If you wait until the outside gets darker, you can sometimes salvage your shot by switching off all the interior lighting and opening up the lens to expose the outside only. To do so, you will need a small flashlight to see the camera and your stopwatch. As the light level outside drops, you may start to see reflections of the interior in the window. These may or may not be objectionable. If these reflections are from sources not included in the composition, they will be easy to eliminate.

If there is time, you should use Polaroid tests to check the light balance as you go along. Because the exterior light levels are dropping rapidly, no two shots are likely to be exactly the same. Have plenty of film loaded so you don't run out at the critical time. Since I was adjusting the inside light level as I was going along, my exposure was changing. The longest, toward the end, were close to one minute at about f/16 to 22 with a 90mm Super Angulon lens and Fuji 64T film.

One of the major paintings in the Holzman loft is the allegorical work by Sidney Goodman. Its location (above) suggests that the figures in the painting are illuminated by the skylight above. The wall behind the painting is covered with old-fashioned-style galvanized steel. The longitudinal beams all seem to be new, but those at right angles to them have been preserved in their original dilapidated condition. The corrugated translucent wall is part of a

"floating" enclosure for storage. There is a garage-type door at the far end of this storage space. When the lights inside are switched on, as they are in this shot, the space glows. In fact, I had to substitute quartz lighting for the fluorescent lights that normally provide light there.

On the floor is a length of blue carpeting designed by Hardy, Holzman, Pfeiffer Associates for Best Company Headquarters. I supplemented the ambient daylight with bounced strobe behind and to the right of the camera. I used a 150mm Symmar S lens on my 4 x 5 camera with Fuji 100D film.

Here we see part of the kitchen, embellished by a Blatz Beer sign Malcolm retrieved from an almost demolished bar. You can see part of their plate collection receding into the background. Bounced strobe provided most of the lighting. For this photograph I used a 120mm Super Angulon lens with Fuji 100D film.

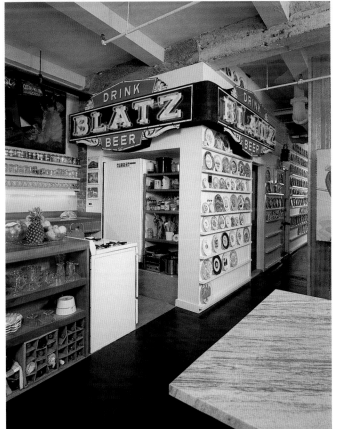

WORK PLACES

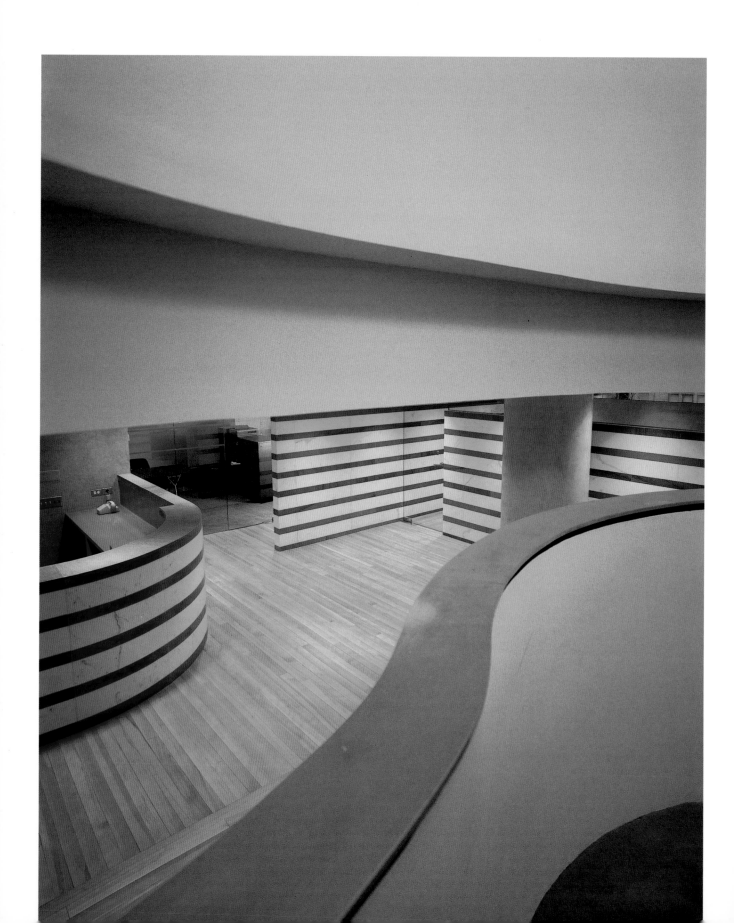

White Serenity at the Italian Trade Commission

The photographs on these pages show parts of the facility of the Italian Trade Commission in New York City, which was designed by architect Piero Sartogo. Though pictured here void of any people, the long, high space is utilized periodically for exhibits and receptions. In addition to the lobby, there is a wine-tasting area downstairs and a large exhibition space with movable walls. Upstairs are various offices and a lecture theater.

Between the two office floors is a connecting stair enclosed by a curving partition. The lighting within the stairwell is partly fluorescent. I decided to use incandescent illumination to visually separate the well from the floor below. The warm tones of the bare wood floors combined with the strong black-and-white banding of the office partitions makes for a very abstract but strong composition. I used a 75mm Nikkor lens on a Sinar F-2 camera with Fuji 64T film. The camera is tilted downward.

The encaustic white walls compliment the white marble floor, column, and stair enclosure. Thin brass inserts in the floor run the full depth of the space. Starting from the rear of the lobby is a series of rectangular marble blocks; each block diminishes in size as the series progresses toward the entrance. The black marble reception desk contrasts sharply with its white surround. Brass handrails frame the stair leading down to the wine tasting center below, which is pictured on page 93.

I elevated my Sinar F-2 view camera to show more of the stair and accent the curving wall of the stairwell. The axis of this view is the right-hand brass floor insert. The 120mm Super Angulon lens was offset to the left. I supplemented the recessed tungsten lighting with quartz lights behind the glass block wall at the rear to even the illumination in that area. I used Fuji 64T film. The blue cast comes from daylight filtering through tinted window glass from the street.

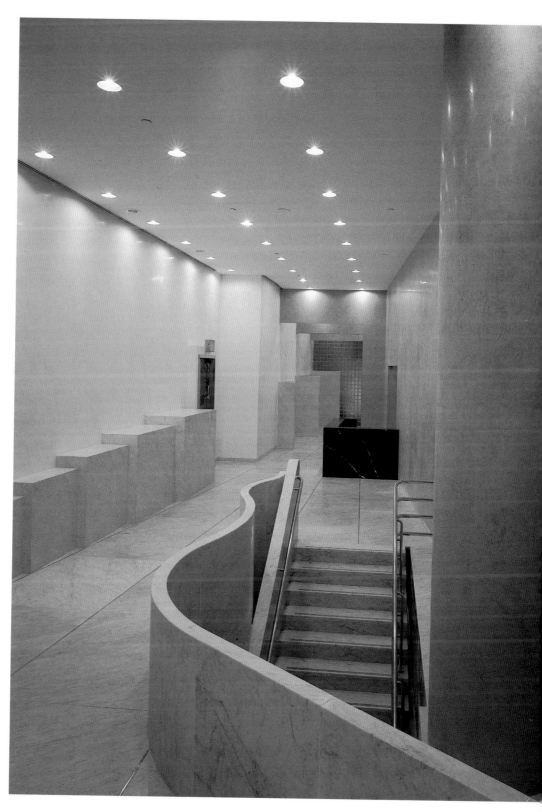

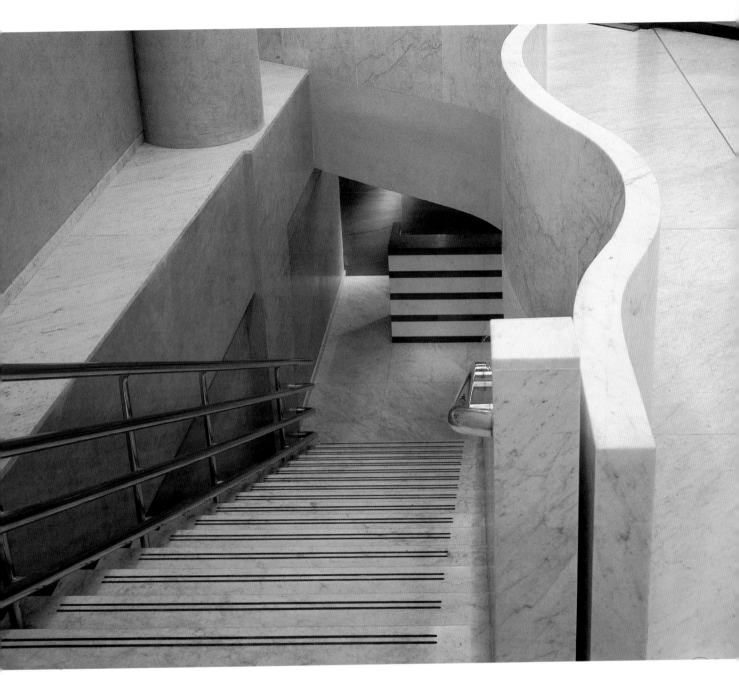

Here is the stair leading down to the exhibit and wine-tasting center from the street-level lobby, which is pictured on the previous page. I used a 120mm Super Angulon lens on my downward-tilted Sinar F-2 camera. To preserve the geometry of the composition, I maintained the film plane parallel to the horizontal axis. The stair treads and other elements do not converge laterally. So, although the vertical axis of the camera is close to the right-hand stair enclosure, the central axis of the photograph is considerably left of this. In addition to the lateral lens shift, I raised the rear standard to make some vertical correction of the camera tilt. Using Fuji 64T film, I introduced supplemental lighting downstairs to balance with the brightness above.

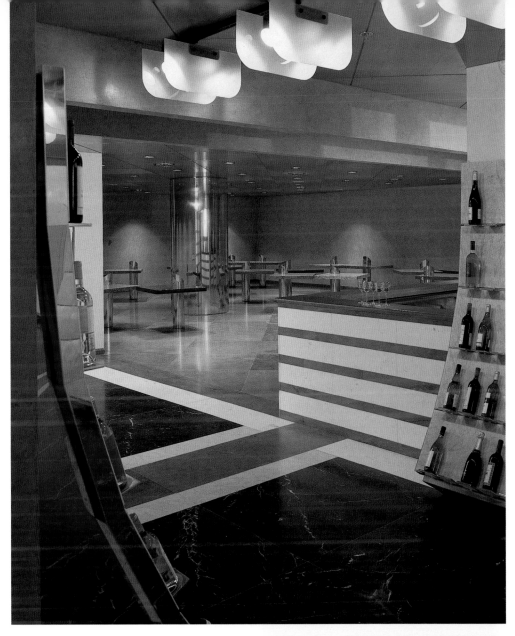

The two photographs on this page illustrate the wine-tasting center. Many varieties of Italian wine are displayed on the curved walls of a long, marble-floored corridor. The view at left shows the tasting room with small cantilevered, glass-topped tables at different heights. The center post of each table incorporates a discreet drain for emptying the wineglass following evaluation. Both these views were taken with a 120mm Super Angulon lens. In the case of the photograph below, I swung the rear standard counterclockwise. This permitted me to obtain sharp focus on the foreground bottles without excessively stopping the lens down. All lighting is incandescent Fuji 64T film for the bottom photograph and Ektachrome for the tasting area with its pale green encaustic plaster walls.

Mood-Setting Reception Areas

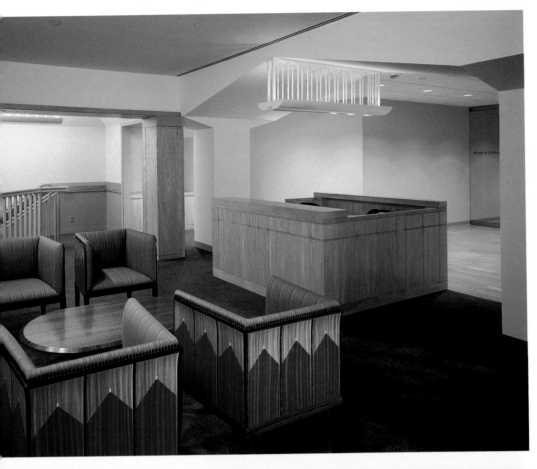

This is one of several reception areas at the headquarters of a New York insurance consultant. After selecting my vantage point, the main problem to overcome was balancing the darker foreground with the much lighter background. The dark carpet and furniture needed much more light to balance with the light walls, the ceiling, and the wood floor seen on the far right. To accomplish this, I used direct light rather than bounced illumination, which is more difficult to control. In this way, I introduced some texture to the carpeting, and the wood grain of the table and chairs is enhanced. The carpet clearly separates the reception area from its surround, but by selecting this particular viewpoint I was able to provide the viewer with more information about the overall space. A small portion of a glass wall on the right leads to the elevator lobby beyond.

Some of the corridor area contained fluorescent illumination, which required a two-part exposure with appropriate filtration. I used a 90mm Super Angulon lens and Fuji 64T film. The architects for this project were Kliment & Halsband.

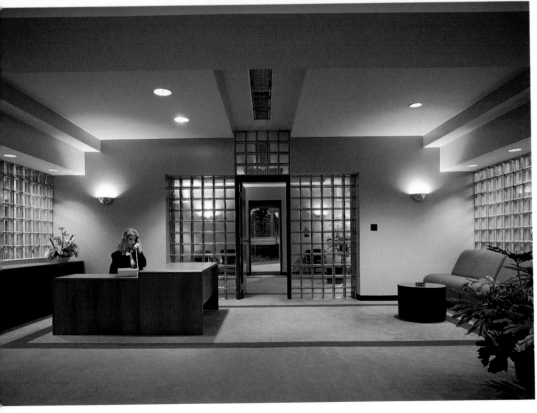

Designed by the firm Einhorn, Yaffe, Prescott, Krouner, of Albany, New York, this is the reception area of a local manufacturing company. This situation required making an extreme horizontal subject fit the 4 x 5 format I was using. Indeed, this photograph could be cropped top and bottom without losing much impact. However, I was able to use the changes in carpet texture and the beam above, the side and soffit of which frame the stepped ceiling area. The symmetry of the space is emphasized by the one-point perspective. I boosted the illumination behind the glass-block window walls to increase the impression of airiness. A glimpse of the outer lobby and the exterior at dusk are seen beyond. I moved the plant to the foreground at right to add texture and depth. The receptionist adds both scale and life to the composition without dominating the whole.

I chose to turn off the rather overpowering, centrally located fluorescent fixtures both in the foreground and beyond. The lighting shown provided a lower level of illumination but a more pleasant atmosphere in the photograph, if not in reality. I used a 75mm Nikkor lens with Ektachrome 50 Type B film.

The subject of the two photographs on this page is the same, but the pictures were taken on two separate occasions. The top left photograph shows the area, with maroon chairs substituted for the original chairs meant for the design.

To make the reception area appear more spacious, it was necessary to photograph from the elevator lobby through glazing separating the two areas. Careful camera positioning avoided concealing major design elements with the logo, further deemphasized by the soft focusing. To permit the visual flow into the conference area in the background, the doors into the area are left ajar and the vertical blinds are adjusted to control daylight. The plant in the center of the background conceals the reflection of my camera in the mirror behind.

The second view was also taken from the lobby but now the lens is positioned very close to the glass. The foreground chair legs were cropped off to avoid the elongation that occurs when objects are placed close to a wide-angle lens near the edge of the composition.

Peter Gisolfi Associates of Hastings-on-Hudson, New York, was the architect. A 90mm Super Angulon lens was used with Ektachrome Type B film, without supplemental lighting. The film was exposed for about 12 sec. at between ƒ/16 and 22.

Complex Spaces of an Open Reception Area

This reception area of an architect's office is located on the fifth floor of 65 Bleecker Street in Manhattan, Louis Sullivan's only highrise in that city, completed in 1898 and recently restored by Edgar Tafel.

The space is not self-contained but flows into various other specialized work areas, including a glass-enclosed conference room, receptionist/switchboard station, a filing and secretarial area with message center beyond, and, on the opposite side, a double-station desk for secretaries of the partners whose offices are located behind glass frontal partitions to the rear.

Large round columns punctuate the space. Above a line of these columns is a pair of parallel, waving, shallow fascias projecting below the ceiling, following the line of the curve-fronted desk below and enclosing a line of green-tinted reflector floods. Carpeting in two colors covers the entire reception area and defines the central core containing the conference room. Bright colors designate the differing functions of areas behind.

Except for some task lighting at workstations, most of the illumination is provided by individual tungsten track lights. The only daylight in the space is what filters through the partners' offices on the perimeter, and that can be controlled by the Levolor blinds.

This is a complicated design with many facets presenting the photographer with many alternatives. No one view could tell the whole story, so I took four.

Film for all these shots was Ektachrome Type B, unfiltered and shutter speeds were in the region of 12 to 15 seconds at f/16. I used a 90mm F5.6 Super Angulon lens on a 4 x 5 Sinar F view camera for the four views on these two pages.

This is the office of Sydney Gilbert and Associates, who also designed it.

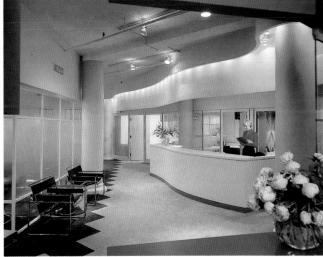

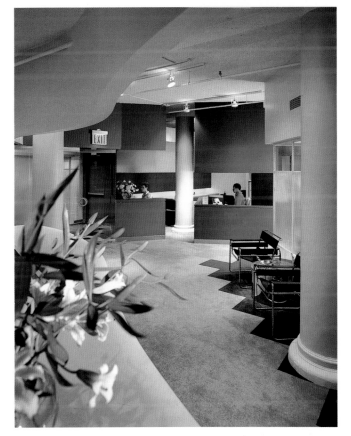

The first shot, opposite page, shows the initial view of the space as seen by the arriving visitor from the small, partially glass-enclosed, elevator lobby. I selected a 75mm wide-angle lens in order to show the complete glass wall and entrance door enclosing the elevator lobby and, in addition, the receptionist's red enclosure wall including the vertical element that links it to the fascia above. The top surface of the reception "desk" is a strong diagonal leading the eye along the corridor into the background. The curving fascia with its strong green lighting also leads the viewer in the same direction. The only illumination in the lobby comes from a fluorescent cove light on one side. Such a small area of the photograph is affected by this light that I decided not to filter for it separately and, in addition, supplemental tungsten lighting was introduced in the lobby to light the flowers and red wall on the left. Some lighting was also added behind the green fascia and in the background offices.

The second shot, top left, moves further into the reception area and uses the glass door to frame the photograph on the left side. The reflection in the door adds interest to the composition. This view looks down the other aisle with the conference room now on the right. I deliberately positioned the dark triangular element in the center of the photograph. Supplemental tungsten lighting bounced off umbrellas was added to the right of the camera, in the conference room and behind the central elements to make them float more. The selected viewpoint was dictated by the counter height of the reception desk creating a straight horizontal line for the vase of flowers to balance on. Beyond in the background is the drafting area of the office.

The third view, top right, is taken from behind the reception desk looking toward the private offices with the curved secretarial island and fascia above framed by two columns above. The dark green carpet squares flow out of the conference room at left, making a strong zigzag floor pattern, which recedes into the background. The photograph is framed by the red fascia and counter of the reception enclosure as well as a small portion of the dark blue partition at the extreme left. The figure standing at the reception desk was added for human interest, but far enough away to not be overly dominant. Some supplemental tungsten light was added: in the far office behind the flowers, in the conference room, to the right of the figure, in the foreground to brighten the flowers. A small amount of daylight is visible filtering through the Levolor blinds in the private offices.

The last photograph, left, is a vertical format looking back at the entrance lobby, showing the reception desk and the blue partition behind it to the right. I wanted to accentuate the curve of the secretarial station in the left foreground and the fascia above. These two elements become strong features of the composition. A nice rim of green light falls on the edge of the desk at left, further separating it from the darker carpeting. The out-of-focus foreground flowers add color and depth to the photograph, but conceal unwanted details at the extreme left and also break up what might otherwise have been too large an expanse of desk surface in the foreground. The two figures seated in the background add interest.The vertical height of the space is emphasized by the vertical format and the way the view is framed by columns left and right.

Curves and Angles of an Open Office

This project is the corporate headquarters of Best Products in Richmond, Virginia. The space, designed by Hardy, Holzman, Pfeiffer Associates, contains multifunction facilities, private offices, and semi-private and open plan areas with low, modular partitions separating workstations. The offices occupy two floors of a very long, curved building with one exterior wall of glass block that lets daylight into the adjacent areas. This glass block is very green in color but has set into it a pattern of contrasting reflective blocks. A major feature is the tiled "roadway" following the curve of the front facade, down the spine of the building, bisecting the office areas. A highly patterned carpet covers the floor. A structural grid of columns, beams, and ceiling coffers contrasts with the curvature of the building and is strongly expressed in the interior layout.

There are a number of fully enclosed, private, executive offices but for the most part there are no rooms; areas flow from one to another. Workstations with low fabric-covered partitions are lined up along a higher storage ele-ment, the lower portion of which is also fabric-covered and the upper part of green painted wood with alternating book shelves and enclosed storage. These spines of storage follow the structural grid and are approximately 9 feet high with an elaborate cornice detail running along the upper edge. The basic ceiling height is a good 12 feet and suspended below it are continuous baffled fluorescent light fixtures bouncing light off the pale-colored, exposed structure of the ceiling (or floor), giving a direct downward component. Dispersed throughout each floor is a series of contrasting wood-finished boxes that house restrooms, service facilities, and small conference rooms. The structural columns are round. Items from an art collection are distributed throughout the building and add greatly to the overall impact.

The photographer must exercise restraint when documenting an interior as complex as this. There are literally hundreds of possibilities. The photographer should therefore analyze the objectives very carefully before attack.

This first shot, right, is an aerial view overlooking a series of workstations, terminating in a wood-finished "box." The camera height approximates the view of a standing person, just enough to show the partition layout clearly without losing the height of the storage spine element to the left.

I used a 90mm F5.6 Super Angulon lens on the Sinar F 4 x 5 view camera. The rear standard was slightly elevated to show a little more of the foreground desk and chair and somewhat less ceiling. The available warm white fluorescent lamps provided plenty of even lighting. Type B Ektachrome Professional film was used with filtration of 40R and 10M CC Kodak gelatin filters, which required a one-stop additional exposure increase. Exposure time was about 24 sec. at f/16 to 11 and was determined by meter and confirmed by a Polaroid test.

For the second photograph, the camera was moved forward about five feet and slightly to the right. The main result of this shift was to de-emphasize the foreground desk and show the tops of the file cabinets to the right. Aligning the camera with the center of the middle file cabinet makes for strong

converging partitions and ceiling geometry. The two shots are surprisingly different, considering the comparatively slight change in camera position relative to the space.

I concentrated on a single workstation in this next photograph, (opposite page, top). This is one of the larger cubicles and includes a small, round conference table. This area also has a nice complement of books to help accessorize the space. The photograph was taken in late afternoon in the wintertime, so the level of daylight was quite low. The natural light is still rendered with a reddish cast as a result of the filtration used for the predominantly fluorescent light. Had the level of light outside been higher, the whole area near the windows would have been distorted in color. The pinkish glow in the corner of the workstation behind the telephone is the result of the incandescent desk lamp in the next cubicle having been left on. A similar color shift is also evident in the top photograph on this page, in the fourth cubicle down. Some lateral lens shift to the right was used in this shot to reduce distortion, that is, reduce the convergence of the diagonals.

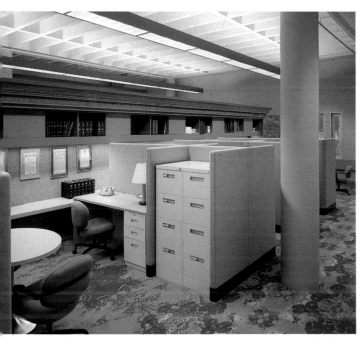

My brief for the first assignment was to document as fully as time permitted the basic office system. This meant carefully selecting views that illustrated the various design features. Some of the areas were less tidy than others and these were avoided whenever possible. When photography had to be tackled in daylight hours I avoided the locations close to the main glass block facade where daylight would have been a major complication. For the same reason, I avoided areas on the upper floor where a line of small skylights also introduced daylight, as did windows along the back wall of the building. Some of the artwork had tungsten spotlights accenting them. In certain cases these were switched off so that the photography could be completed with one source of illumination only. The basic fluorescent lighting system provided more than enough light for photographic purposes without additional supplemental sources. Individual desk lights (tungsten) were provided more for appearance than necessity and were switched off.

A 90mm F5.6 Super Angulon lens was used on the Sinar F. Film and filtration were the same as before.

The view at right is more of a detail shot, but adds to understanding of the space. As a complement to either of the first two photographs taken longitudinally, this photograph shows the lateral circulation system at right angles to the initial view. It was taken right on the axis of the opening and of the column.

Careful selection of lens and camera position were essential here. To separate the fabric-covered partitions, the camera was positioned above the top of the rounded edges but still low enough to prevent the cornice line of the more distant unit from blending in with the ceiling of the opening. This photograph assumes considerable significance in illustrating how the space works.

A Super Angulon 120mm F8 lens was used with Ektachrome Type B film and filtration for the available fluorescent light was 40R plus 10M.

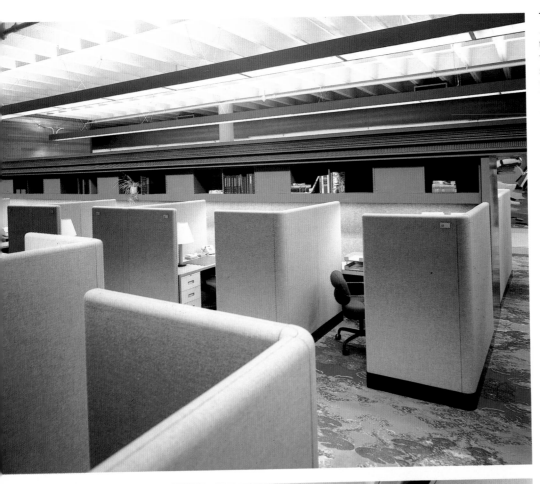

Moving through the opening in the previous picture and turning to the left we get the view, top left. This shows the smaller workstations and illustrates their degree of privacy. Incandescent desk lamps were switched off.

A 120mm F8 Super Angulon lens was used with the same film and filtration as before. The exposure was approximately 20 seconds at ƒ/16. I did not feel that the foreground partition being somewhat out of focus was significant.

Here, bottom left, is another longitudinal shot along the structural axis of the columns, lighting, and workstations. The object of this photograph was to show how the details of the design relate to the tiled walkway that curves through the space following the basic shape of the building. Also illustrated is the relationship of the wood boxes to the workstations and how they are used as background for the artwork. The geometric patterns of the small tiles are in sharp contrast to the carpeting. The camera viewpoint here was selected to show the line of columns receding into the background, the wood box on the right, and the disappearing walkway.

I was also concerned with the artwork both to the left and in the foreground. Keeping the optical axis aligned with my subject, I shifted the lens laterally to eliminate much of the exit sign at the extreme left, while still showing the full painting and also including more of the abstract work to the right. The incandescent picture lights were switched off to avoid two-part exposures which would have been difficult, if not impossible, under the circumstances. In the far distant background there is a bright spot of daylight coming in, but it was too far away to be of any significance. Fortunately, the position of the main fluorescent lights provides ample lighting for the art in this photograph. A 90mm F5.6 Super Angulon lens with the same film and filtration as before was used.

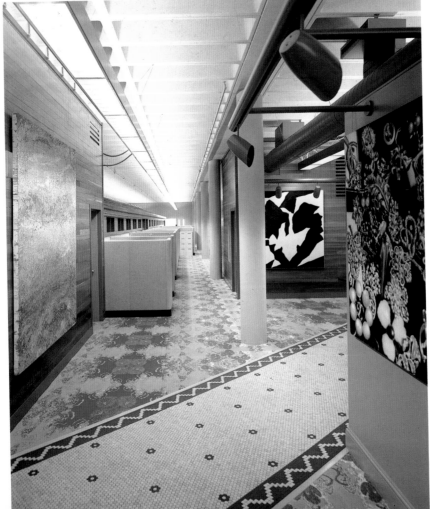

Filling a Foreground Void

This marvelously airy room on Fifth Avenue, in New York City, is part of the offices of architects Paul Segal & Associates, which was responsible for the remodeling. Used for various functions, the space contains a conference area at the far end. Through an interior window at top left we catch a glimpse of skylight and part of a library one level above. Photographing from the conference area seemed to overemphasize the furniture and upstage the room. However, with little else besides the trees and plants, I felt a foreground element would be helpful and what could be more appropriate than an architectural model. To boost the light level inside, I bounced two strobe heads into umbrellas behind and to the right of the camera. The open window eliminated the reflection of one of these. I positioned a third strobe head with a grid spot high on the left, lighting the urn and tree in addition to the column and opening behind it. To get this shot, I used a 120mm Super Angulon lens on an Arca Swiss F camera with Fuji 100D film. The incandescent fixtures add some overall warmth to the photograph.

Private Offices with Important Views

The view beyond the windows plays an important role in these two New York City examples of offices in the corporate world. The first photograph, below, shows the private conference room of the president of a Manhattan bank with a view of the forecourt of the New York City Public Library seen through the window. The photograph on the opposite page shows a sunny view of the midtown skyline from an office in the same area.

Although documentation of the interior design was my primary objective, as soon as I saw this space, I knew I had to take a photograph that captured this special picture window. The narrowness of the space in combination with the large expanse of window reduced my options. The location of both of the doors leading into the room did not give me the best view outside. Only a secretarial area adjacent to the conference room provided the ideal vantage point, and that was behind a glass panel above some filing cabinets.

Bright morning sunshine that falls on the library outside makes for extremely high contrast and would have presented an impossible lighting task inside, even with the heavily filtered sunscreen on the window. With some difficulty, I was able to position the camera close to the interior glass partition. By waiting until late in the day, when the light level outside dropped substantially, I was able to capture both the interior and exterior without the complication of supplemental lighting. I was aided by the sunscreen, which not only cut down the amount of daylight entering the room but made it warmer in tone. The out-of-focus foreground plant reduces some, but not all, of the reflections. Even some lights in the upper part of the main banking floor to the rear are reflected weakly in the window.

For this shot, I used Fuji 64T film, which is somewhat warmer than its Kodak equivalent, to further correct the daylight component. I offset my 90mm Super Angulon lens to the left to correct some of the horizontal convergence. The architect for this project was Eli Attia.

This is the private office of a textile-company corporate executive. The office overlooks Bryant Park and the New York Public Library, a prestigious location. A weekend was selected to shoot the job to permit the necessary cleanup and cause a minimal amount of disruption of the normal work schedule. Also, I wanted to photograph on a bright and sunny day. I had ideal conditions, clear, crisp light with white clouds dotting the blue sky.

The general tones in this office are quite dark. The carpet, chairs, and sofa are dark gray. The desk, table, and enclosures below the windows are all a rich, natural, wood finish. A few carefully selected items are shown on the desktop with a dark writing pad in the foreground to break up what might have otherwise been too large an expanse of wood. An arrangement of blossoms was carefully placed on the window ledge at right, making sure no important feature of the view was concealed. A striding bronze horse adorns the adjacent window. The curtains were stacked as neatly as possible on either side of the corner column. My two strobe heads were positioned so that the reflections of their umbrellas fell just beyond the frame of the photograph. The room lights were kept switched off but would have been overpowered by my electronic flash anyway.

The unexpected dividend in this photograph is the abstract quality that results from the clarity of the urban mural, which truly looks almost too perfect to be real. Ordinarily I might have overexposed the exterior to produce a more normal realistic effect, that is, with the outside much brighter than the interior. But by balancing the two elements of the composition, I was able to achieve something more interesting. I was helped in my task by the fact that the colors of the buildings complement the interior furnishings. The right-hand chair was partially cropped to reduce its otherwise exaggerated proportions due to its proximity to the 75mm F4.5 Nikkor wide-angle lens on a Sinar F view camera.

This office was designed by Paul Segal and Associates.

This is a multi-purpose conference room of a New York City corporation. The table is in fact made up of three separate square units which, when pulled apart, can be set up as a small dining area. There are concealed black-out blinds, which can entirely darken the room for audio-visual presentations. Recessed fluorescent fixtures between the windows and curtains give the room a more lively appearance when the latter are drawn after dark. Frosted glazing on the interior window and doors permits natural light to filter into the corridor beyond.

The recessed incandescent fixtures in the ceiling were not switched on for the photograph. I did however want to show the lighting on, above the alcove, on the right, and in the floating troughs on the opposite side. The warmth of these incandescent sources is largely offset by a combination of ambient daylight and supplemental strobe. Fortunately, I had adequate time to observe this room at different times of the day, so I was able to schedule my shoot to take advantage of the late afternoon sun streaming into the room. I bounced one strobe head into a large umbrella behind my axially positioned camera. A second unit in the hallway confirms the fact that these are indeed glazed windows, not opaque panels.

It is in a situation such as this that Polaroid is such an invaluable tool. It is the power of the combination of strobe and natural light that determines the aperture used, but the ambient light alone dictates the shutter speed at that *f*-stop. If the shutter speed is too short the exterior view will appear too dark and the sunlit surfaces diminished in value. If the shutter speed is too long the view gets blown out and the areas where sunlight falls are harsh and overexposed. Without Polaroid, I would have had to do a lot of bracketing.

I used a 90mm Super Angulon lens on a Sinar F-2 camera in combination with Ektachrome 64 daylight film. The architects for this space were Kliment and Halsband.

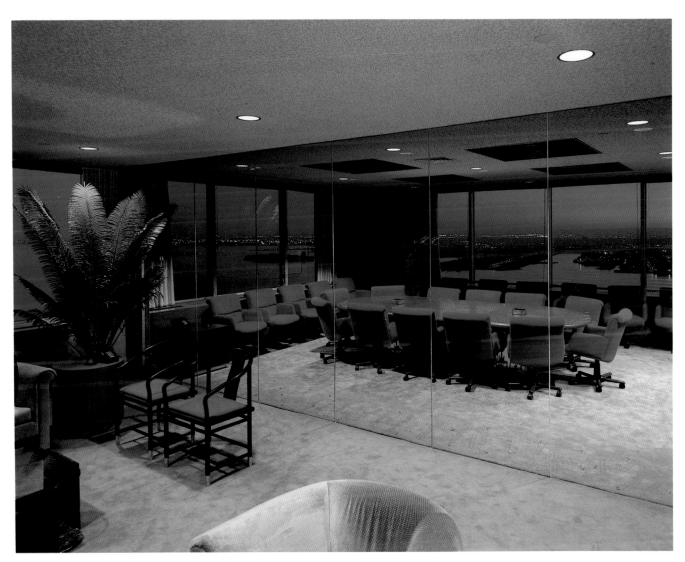

The challenge in making this photograph was to capture the magic of the dusk skyline and balance it with the interior illumination. This was complicated by the fact that the conference room is separated from the lounge area by a heavily filtered glass wall. It was through this glass wall that the conference room and the view had to be recorded. The amount of glass tinting is apparent from the change in color of the carpet inside and outside the confer-

ence room. Although the carpet appears to be gray in the reflection, it is actually the same color as within the room.

The fluorescent fixtures over the table in the conference room were much too bright for the situation so I switched them off. Exposure readings and Polaroid tests indicated a substantial variation in brightness between the foreground and the area beyond the wall. Bounced supplemental tungsten light was added inside the conference room, but not

enough to make it obvious. A long exposure was then made with all the foreground in darkness. A second, shorter exposure was made on the same film with the nearer lounge area illuminated. Starting with substantially more light outside, several exposures were completed as the light level dropped. A couple of exposures were made with no interior lights on at all, exposing for the view only. These were three-part exposures, again exposing separately for the conference area.

Ektachrome 50 Type B film was used for all the exposures, unfiltered. The outside has that very rich blue look that results from using Type B Film unfiltered in a predominantly daylight situation. The hint of sunset also helps the composition. A 90mm F5.6 Super Angulon lens was used with the Sinar F camera. Exact exposures were not recorded.

This Bankers Trust office is in New York City and is the work of I.F.A.

PUBLIC SPACES

House of Worship for
the Baha'i faith, New Delhi,
India (right). Ceiling detail
(left). The architect was
Fariburz Sahba, with
structural design by Flint
and Neill of London.

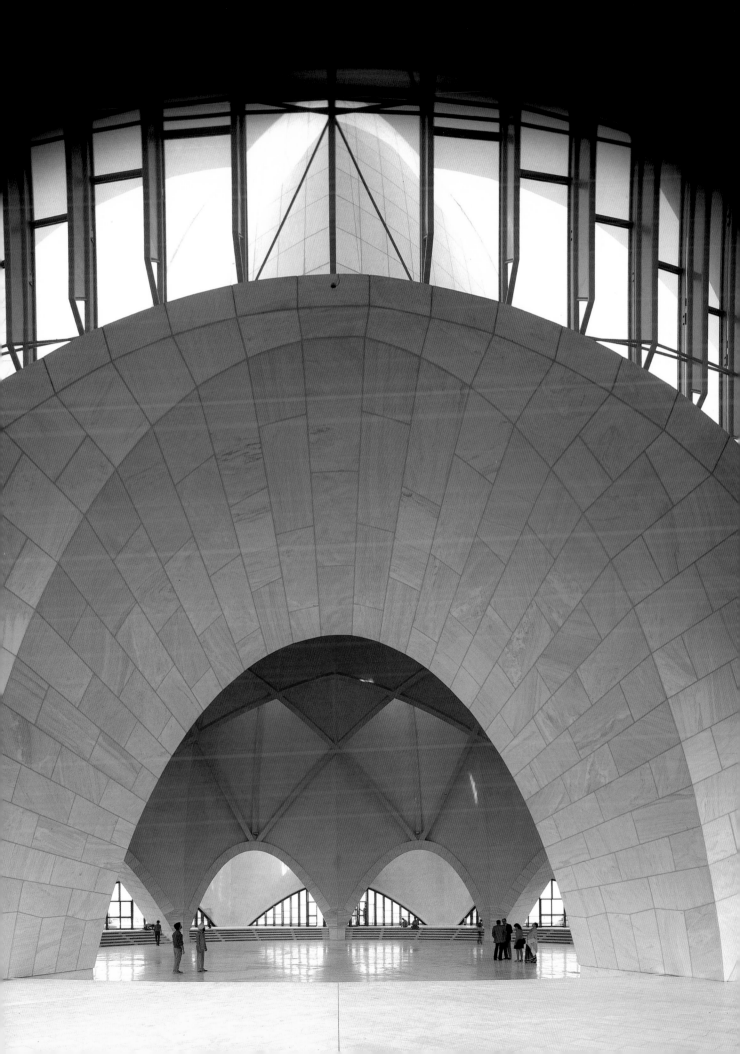

RESTAURANTS

Restaurant interiors can be particularly challenging for the photographer for a number of reasons. To achieve the desired ambience, the design of a restaurant frequently relies on low levels of lighting in combination with dark colors for the interior finishes. Some of the illumination may be provided by candlelight or low wattage bulbs which produce yellow-toned light. Velvet and similar fabrics in dark tones tend to look almost black when photographed and the contrast with light-colored tablecloths and napkins can be extreme. Even when bright lighting is installed, it is usually used only in the daytime and is frequently dimmed to low levels to produce the right atmosphere, which is rarely suitable for photographic purposes. One of the problems with dimmable light sources is that the color temperature changes as the light level is lowered, resulting in even warmer or yellower transparencies. During daylight hours it may not be possible to control the natural light and this presents further complications.

Quite apart from the lighting problems, there are logistic difficulties to contend with. The restaurant may be open six days a week for lunch and dinner, with photography practical only on the seventh day. Worse still, the establishment may function continuously, making photography possible only in the middle of the night or in the early morning after closing time. This is a strain on everybody involved.

There are good reasons why photography should not be attempted when food is being served to paying customers. Taking photographs of a functioning restaurant immediately produces situations that are beyond the control of the photographer and limits the options. If the scale of the design is modest, the presence of people makes the task of capturing the major design objectives a lot more difficult, if not impossible. From a practical standpoint, the only chance of success is a combination of small format with very fast film.

Whenever the shoot is scheduled, it is essential to have the management's cooperation to ensure that the place is basically clean. Nothing is more annoying than having to waste time cleaning up, particularly when it could have been done much more efficiently by the regular staff. An advance check should be made to be sure that all light fixtures are functioning correctly and that the switches are accessible. If the bar area is to be included, ask that the bottles not be removed. Have clean tablecloths and napkins available and, if necessary, have an iron on hand. Watch for tables on which cloths are unevenly placed; these give an off-balance appearance. Whenever possible involve the restaurant staff to check the place settings and table decor. It's easy to miss an item that may be obvious only in the completed photographs. If the designer is not going to be present at the time of the shooting, a floor plan can be helpful to crosscheck the table layout since the restaurant owner may have modified the original plan for practical or other reasons and the designer's positioning may be aesthetically preferable for the photography.

Photographs of a restaurant interior can sometimes be enhanced by the inclusion of a food display. Advance arrangements are necessary for this, and the chef will almost certainly want to be involved. Purists may not feel that this is within the realm of design documentation, but there may be times when the inclusion of an elegant display is appropriate and desirable. Floral arrangements should not be neglected. A fresh flower or bouquet on each table, for instance, can add warmth and touches of needed color.

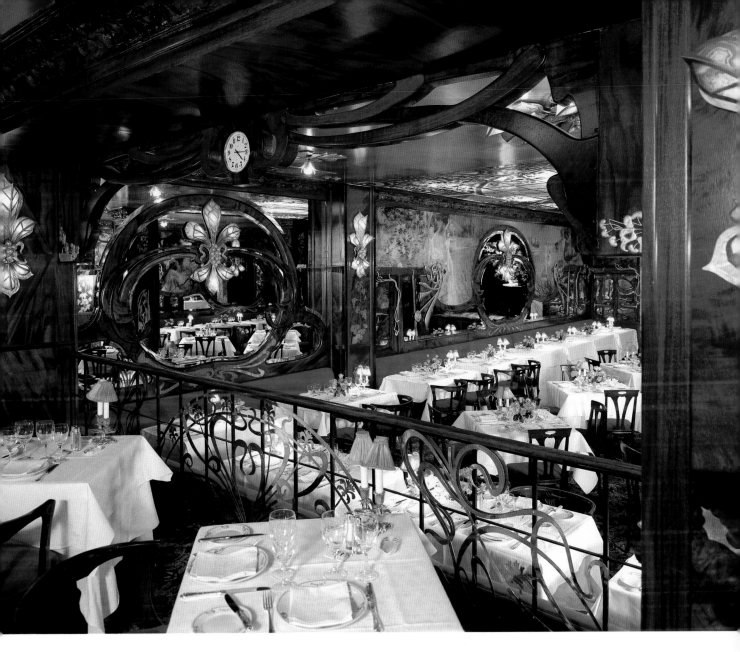

Clarity in an Atmospheric Image

The clock indicates 4:15 and that's A.M., not P.M. The photograph shows the New York version of Maxime's. Based on the original Paris night spot, the decor, ornamental light fixtures, murals, and inlaid brass metalwork were all recreated for this larger-than-life Manhattan rendezvous.

This view from the elevated section of the main dining area purposely excludes the small dance floor and stage beyond to the right because the stage looks very empty without musicians and because the contrast range is too great with only the basic lighting.

A small portion of the luminous ceiling over the dance area is seen above to the right. The light is provided by fluorescent tubes which can be switched on and off in sections, giving some control of the brightness. The ceiling is multicolored but leans toward magenta, one of the major components of the corrective filtration required with a tungsten-balanced film. For this reason, I did not make a multiple exposure (switching the different light sources on and off and changing filters) to obtain the correct color. The small table lights are low-wattage units, some of them battery operated,

which produce even less light than the regular 110 volt. a.c. fixtures. Positioning of the supplementary quartz lights, bounced into umbrellas, was complicated by the mirrors and shininess of some of the surfaces. Portions of the space that are seen only in reflection must also be illuminated. I kept my lights fairly low to reduce the amount of additional brightness on the tabletops and directed as much light as possible on the dark walls.

In retrospect, I could have turned the table in the foreground to make the back edge parallel to the bottom of the picture and thus eliminate the

apparent slope of the tabletop. A smaller aperture in combination with longer exposure would have increased foreground sharpness, but I was more concerned with the balustrade and the area beyond.

I used Fuji 100 Tungsten Balanced film to produce a warm-toned image, a 4 x 5 Sinar F view camera and a 120mm F8 Schneider Super Angulon lens. Exposure was approximately 24 sec. at between ƒ/16 and 22.

The designer of the interior is Janco Rasic, AIA, of New York City. The photographs were done for portfolio use and prospective publication.

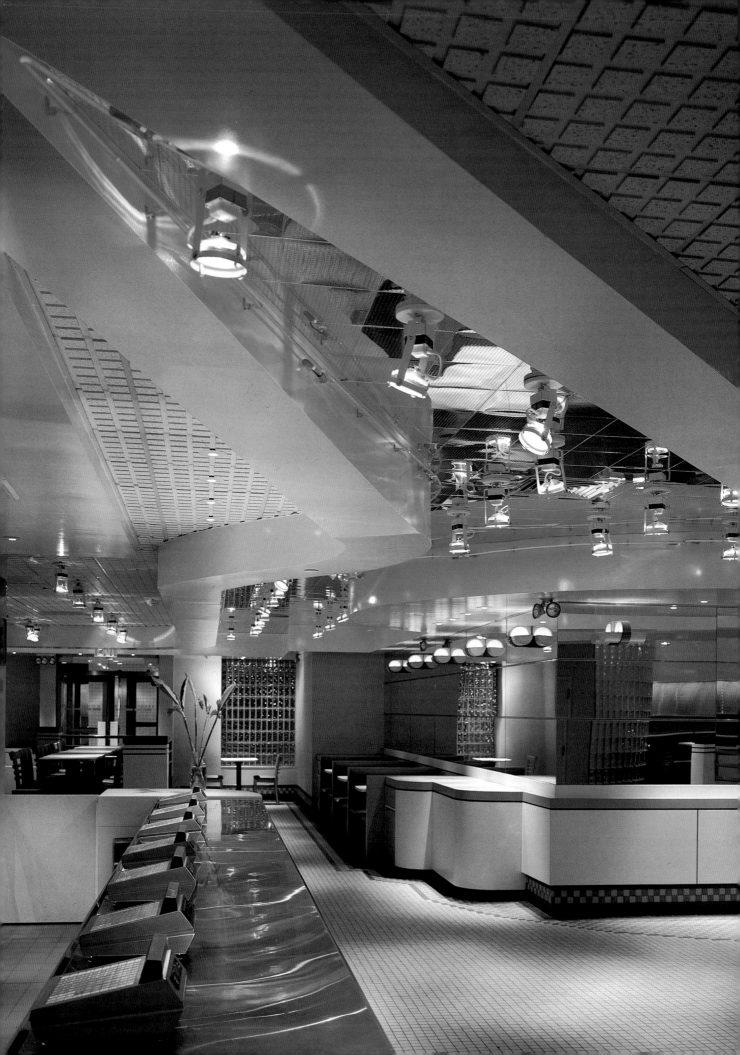

Multi-Purpose Objectives

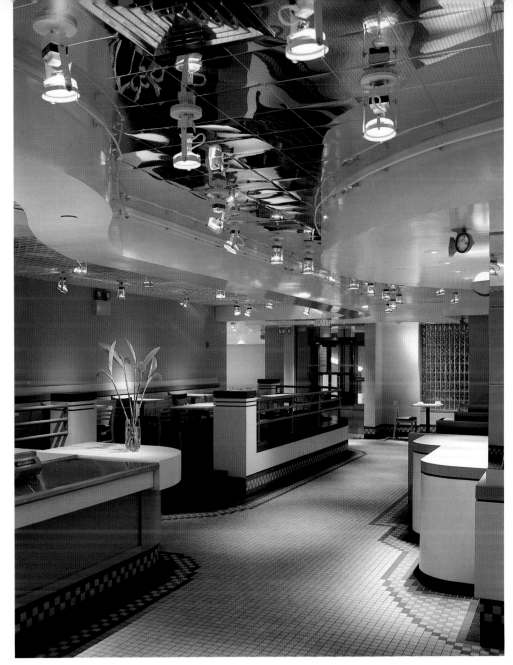

McDonald's is changing its image. One of the recent versions is underground at Rockefeller Center in Manhattan and is a far cry from the typical fast-food establishment. In this interior, several features immediately catch the eye. Perhaps the most dominant is the ceiling design with its combinations of Simplex reflective panels and blue neon tubes snaking their way through the space. Another interesting design element is the patterned tile work on the floor and adjacent surfaces. There are also rounded forms of blue and white plastic laminate, a stainless steel service counter, glass blocks, and blue handrails. In addition to the blue neon, there is a variety of tungsten lighting; only the kitchen and rear service area are lit with fluorescent tubes.

The first view, opposite page, features the check-out counter in the foreground with its particularly noteworthy cash registers. I selected this angle to dramatize the ceiling design, which comes to a point just above the counter. I used a compact tripod to position my camera low on the countertop.

The key to this photograph, however, lies in obtaining the right color and brightness balance. The blue neon tubes are very bright and tungsten film is particularly sensitive to color in this region of the spectrum. From experience, I know that any colored neon lighting system must be used sparingly to avoid overpowering all other colors. The visible dissemination of color through the composition can be misleading. Overexposure of the tubes themselves will dilute their color. My advice is to underexpose when dealing with such sources. In this example, I exposed the neon for approximately one-tenth of the total exposure. When dealing with intense color, it is usually unnecessary to use correction filters. (When the neon is white, I have found that filtration for warm white fluorescent tubes yields reasonable results.)

All the other lighting within the space, except for the illuminated menus that are not shown, is incandescent. The round wall fixtures with semicircular glass tops seen on the mirror to the right are extremely bright compared to the others. These were exposed for only two seconds of the ten-second exposure. I was able to confirm the correctness of this balance with the aid of black-and-white Polaroid test. No supplemental lighting was introduced.

I set the camera up with the optical axis of the lens directly along the counter and with the film plane parallel to the entrance wall of the restaurant. I then shifted the lens to the right to eliminate the back counter area and to include most of the converging ceiling detail at the upper left. To show this I also had to use considerable lens rise. The result is a dramatic composition which is more than half ceiling. The small bit of blue-green light beyond the doors is part of Rockefeller Center. The red floor tile behind the counter is a nice counterbalance for the blue neon.

I used a 90mm F5.6 Schneider Super Angulon lens on a 4 x 5 Sinar F view camera and Ektachrome 50 Type B Tungsten film at ƒ/16 with no filtration for ten seconds.

A second view of McDonald's shows the same area from a different angle and with a different emphasis. The tile floor is more important now. The lighting is exactly the same as in the other shot, but there is a considerable difference in color because I used Fuji film instead of Ektachrome. Because of the inherent warmth of Fuji film, I wanted to compare them in this situation. I feel that the Fuji film's color rendition is probably more accurate. Camera and lens were the same as before but the aperture was reduced by half a stop to between ƒ/16 and ƒ/22 because of the increased sensitivity of the Fuji 64 Tungsten film. The shutter openings are the same as in the other view. There is a hint of fluorescent light on the counter at the left from the menu board.

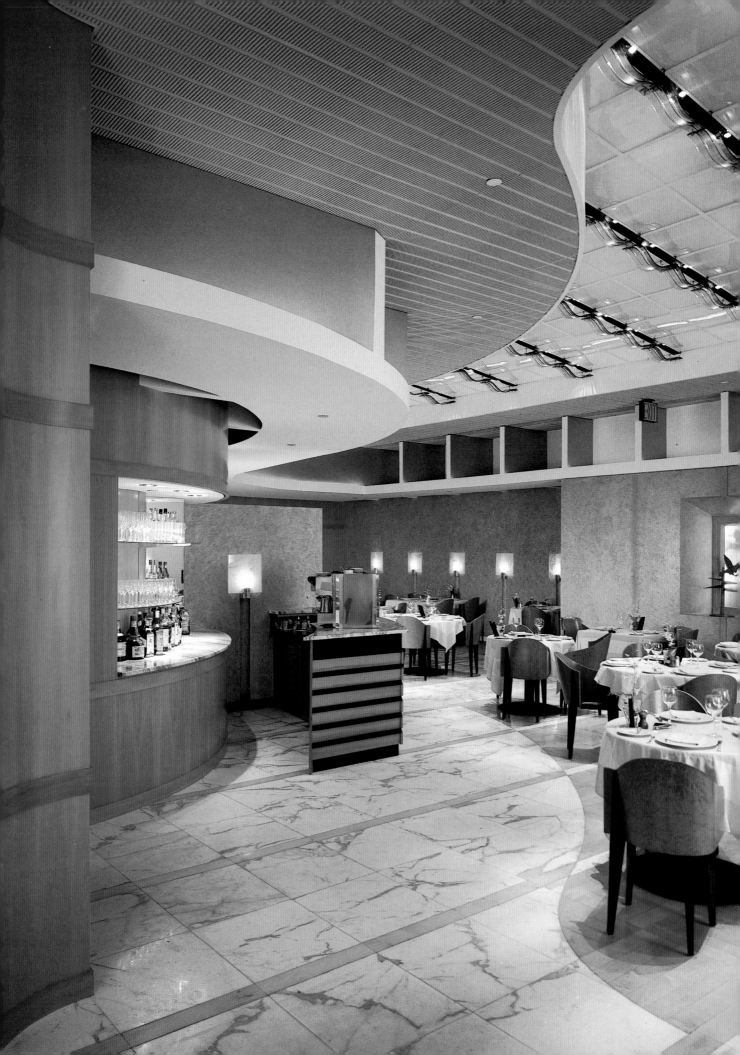

Integrating Complex Lighting Conditions

Many strong design elements make the Toscana Ristorante in Manhattan particularly interesting to photograph. These elements are combined to produce this special restaurant space: curved forms, subtle combinations of wood and marble, custom light fixtures, and the chairs, designed for this project by the architect, Piero Sartogo. Floor treatments delineate varying functions within the space and the ceiling design picks up and reflects these changes.

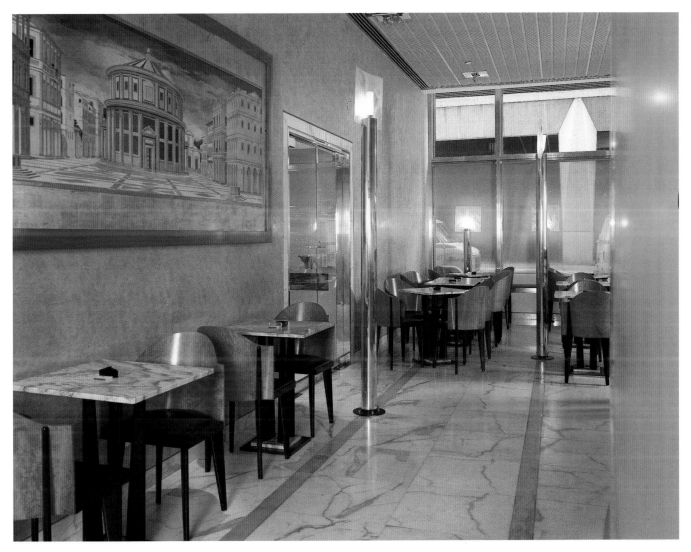

This vertical, diagonal view accentuates the curved ceiling forms and translucent lighting panels with their looping fixtures of blue-green glass. The floor is a combination of wood and marble, with a pattern of wide marble and thin wood stripes dominating one area and in an adjacent location, the reverse. The floor pattern reflects the level changes in the ceiling above. The chairs have one side open for easy seating while the other side wraps around to form a comfortable armrest; there are both left and right versions of this design. The wood-surfaced core wall undulates, alternately concave and convex.

A wide variety of lighting effects is possible with multiple dimmers. I repositioned some of the chairs and tables so that an uninterrupted view of the floor design was visible. I introduced some bounced quartz lighting off to the right, behind the camera, as well as in the back to the left. Bulbs in the exit sign were removed. The right of this image is slightly out of focus due to the inadvertent introduction of swing movement of the rear standard while inserting the film holder. The important moral is to ensure that all the camera movements are firmly locked into their correct adjustment prior to shooting. I used a 120mm Super Angulon lens with Ektachrome 50 Type B film.

This photograph shows the entrance and bar area opening onto a view of the street beyond. For scheduling reasons, this shot was taken early in the morning rather than at night, when the restaurant is open for business, hence the daylight outside. The level of light outside was still low, however, making it possible to shoot this angle and still preserve a reasonably low level of illumination inside.

The warm wood tones of the wall, chairs, and picture frame, as well as the brass lamp standards and trim, contrast nicely with the gray encaustic walls and white marble floor. The blue area around the window only seems to make the interior more cozy. I added bounced quartz light through the entrance on the left, in the rear on the right, and behind the camera to the left. Various highlights seem like they could come from natural sources. I used a 120mm Super Angulon lens with Fuji 64T film.

Camera Tilt and Lens Swing

The Ancora, now Las Delicias de Rosa Mexicano, on Broadway on the Upper West Side of Manhattan, was unusual in that the building was designed as a restaurant and not just an interior. One of the main features of Ancora's design was an open-hearth pizza oven with a large, round flue which thrust upward through a second-floor opening beneath a skylight.

The photograph, taken from the second-floor level, shows part of the upper dining area, the top of the oven with flue, and, in the immediate foreground, an elaborate display of fish, fruits, vegetable, and cheeses. To emphasize the opening between the second and main floors, I chose a high viewpoint at the head of the stairs with the camera angled downward on the main axis of the space. This camera position enabled me to include the top of the oven, to see the dining tables adjacent to the railings, and to get a better view of the food. The camera was very close to the underside of the ceiling beams.

Looking at this photograph, it is obvious that the camera was tilted downward. The verticals are not, in fact, vertical but converge toward the bottom of the composition. This was done on purpose. I could have reduced some of this distortion by dropping the lens down more than I did. Had I moved it any further, a different sort of misrepresentation would have begun to appear. This happens when a wide-angle lens is shifted off its normal axis. The greater the shift and the shorter the focal length of the lens, the more pronounced will be a stretching of the image, with the portion of the subject furthest from the optical axis displaying the most elongation.

Here, the foreground display does exhibit some of this characteristic. For example, the yellow pepper on the extreme left is not actually as oval as this photograph suggests. The way this particular display was set up did not help to minimize distortion.

But had all the foreground been made up of truly round objects, the changes in shape would have been much more obvious.

Overall sharpness is important in this kind of photograph. Both background and foreground should be in sharp focus. To ensure this, I did use lens swing. This is one of the few instances where this movement can be used to advantage in interior photography. Lens tilt, or swing, is used to control focus. Tilting the upper part of the lensboard towards the foreground display brings it into sharper focus without overly affecting the background and without resorting to stopping the lens down to a very small aperture, which is the other method of obtaining greater depth of field. (Alternatively the rear standard may be tilted back. However, unlike the former procedure, there will be a change in shape and perspective of objects recorded.) This can only be done with a view camera.

To highlight the food, I used a 250-watt, focusable quartz spotlight on the left. This lamp has the same color temperature as my other supplemental lighting. To balance the light from the spot, I used a quartz light bounced into an umbrella on the right, taking care that it did not reflect in the background window. This source reduces the harsh shadows that would result from the use of the spot alone. In addition, it provided general illumination to the upper level. Two additional bounced lights were used downstairs. Fortunately, there are no disturbing street or store lights visible from outside, only enough to suggest the Broadway scene beyond.

A 90mm F5.6 Schneider Super Angulon lens was used on a Sinar F view camera. Ektachrome 50 Type B Tungsten Balanced film, unfiltered, was exposed for approximately 20 sec. at between f/16 and 22.

The photography was done for portfolio use and prospective publication. The designer is architect Charles Boxenbaum.

STORES AND SHOWROOMS

Store and showroom interiors are somewhat different from the other spaces in this chapter. The design objectives for most stores is twofold: to provide an inviting atmosphere for the would-be purchaser and to display the merchandise in an appropriate fashion. To a large extent, the success or failure of the store or showroom may depend on the degree to which these objectives are met. Likewise, the documentation of the sales establishment will fail or succeed not only on the quality of the photograph, but by the balance between the environment and its contents. Neither element should overpower the other.

The task of the photographer is considerable in situations where the merchandise is displayed in such a dominating manner that only the strongest design elements can compete. (Store management that is insensitive to the architecture of the space, or at odds with it, will pose problems.) However, assuming that the subject is of good quality, the documentation of it can be more straightforward than some other categories.

The use of incandescent light systems is widely favored, particularly in smaller establishments. The illumination it produces is pleasing and is likely to be more flattering to the items for sale and the shopper than most of the alternatives. An added advantage is the ease of control. Incandescent sources are easy to dim and come in a multitude of types from wide-dispersion to mini-spot. This is all good news for the photographer, since this category of lighting needs little or no filtration when a tungsten film is used. The addition of fluorescent tubes may somewhat complicate the procedure.

In almost all situations, incandescent and fluorescent lighting are on separate circuits and can be switched independently. Sometimes a tedious experimental process is necessary to locate unlabeled controlling circuit breakers. Rather than rely on elaborate switching in combination with two-part exposures and filtration, it may be possible and, in fact, less complicated to wrap the fluorescent tubes with the appropriate filter to convert all sources to a single balance. Exit signs, by design, are prominent and should either be minimized in some way—by a suitable colored card, for example—or removed. Switching them off is usually not possible; removal of the bulbs will reduce their prominence. Showcases frequently have low-wattage, very small fluorescent tubes. The light-spread is usually minimal, and unless the location is a particularly dominant one, the photographer may be lucky and not have to double-expose or use corrective filtration in an otherwise tungsten film situation.

When a particular area is too bright, try switching off the lights in that one spot for part of the exposure. Otherwise, supplemental illumination will be required to boost the darker parts of the composition. The former method may be simpler and just as effective. The difference in light level between a highlighted display and its surroundings can be surprising. The ratio can be as high as ten to one, which translates into giving the "background" ten times more exposure than the brightest area. A more typical ratio is in the range of two or three to one.

In large department stores lighting may vary substantially, but, in general, will probably be of one basic system. This may be a combination of different types mixed together and in such situations only advance testing is likely to produce acceptable results.

The paraphernalia of selling is likely to include cash registers, credit card machines, electronic monitors and telephones. If moving these items is necessary, be very careful. Never unplug a computer or electronic machine without first checking that no serious consequence will result.

Mirror, glass, chrome or other reflective surfaces can also produce problems. For real emergencies, take along a can of dulling spray to kill undesirable highlights. Make sure first that the spray will not harm the surface to which it is applied by testing a small area in an out-of-the-way spot.

Most store windows are better photographed at night or at dusk. The drama of the lighting will be more apparent and, most important, reflection of the outside world will be minimized. Adjacent establishments with bright lighting may pose problems. Try to have them switched off during photography. The other solution is to make a large black backdrop to intercept all unwanted interference. If much of this type of photography is to be attempted, a backdrop is a worthwhile acquisition, since it can be reused indefinitely. "Polecats" (aluminum tubes) can be used to support the backdrops. They are light and break down into shorter sections for transport, and can be rented from professional supply houses.

Clarity in Composition

Although the display cases on the left and right are not the same, the space is otherwise symmetrical. I selected an axial viewpoint and moved the free-standing items just enough to permit each element to be visually separated from its background. The positioning of various silver objects was also adjusted for similar reasons. The two primary sources of light are incandescent downlights in the ceiling and thin, vertical, tubular lighting concealed by the wood sections of the perimeter cabinets. Though the latter are fluorescent tubes, they happen to be deluxe warm white, one of the few types of tubes that is incandescent- compatible and thus does not require special filtration with Type B film. To produce somewhat more even illumination, I did use a single 1000-watt quartz light, bounced into an umbrella behind the camera.

The subject is Buccellati's silver store in Manhattan, designed by Gabriel Sedlis. The photograph was taken for the architect's use and for publication in an interiors periodical.

I used a 4 x 5 Sinar F camera and a 90mm F5.6 Schneider Super Angulon lens with Ektachrome 50 Type B tungsten-balanced film exposed for 5 seconds at f/16 to 22.

A Challenging Lighting Situation

When the Italian-owned Bulgari company decided to open a New York salon, one of the most prestigious locations in the city was chosen the site, the corner of Fifth Avenue and 57th Street. The Crown Building dates to the earlier part of this century and is classical in style. Bulgari retained architect Piero Sartogo to create a thoroughly modern store for their very particular needs, and he fulfilled their requirements.

Sartogo designed a fascinating facade that weaves in and out of the bays of the older building, turning the corner from Fifth Avenue around onto 57th Street. To display some of the choice gems and silver for which Bulgari has become renowned worldwide, there are a series of intimate-sized vitrines. These are used for window display outside, and in the inside as well.

To photograph the entrance facade (above), I chose an overcast day when the light level was low. As a result, the vitrines stand out prominently and some interior detail is visible. Because of the location, there is a lot of vehicular and pedestrian traffic; I had to exercise much patience to get the necessary views. The figures in this photograph are essential to provide scale. I took this shot from a location across the street on Fifth Avenue.

A display corridor runs from the entrance back to the rear where it curves out of sight (opposite page, top). The elements that enclose this space, arcade-like on the right, have a wide radius junction with the ceiling. The floor is marble with bands of a contrasting color at each opening. Located off the arcade is a series of private salons, where clients view appropriate merchandise.

All the surfaces are warm in tone and most of the lighting is indirect. Much of the arcade, particularly to the rear, relies on the brightly lit vitrines to provide general illumination. This factor made photography particularly difficult. The vitrine illumination had to be lowered in intensity in order to see anything within. This was a time-consuming task: redirecting and switching off several of the numerous fixtures within each case and repositioning the displays so that the contents were visible from the camera position for each view. Then I also had to very subtly introduce lighting to provide the general illumination level I needed. I used 10B filtration to compensate for the overly warm ambient lighting.

For this view I used a 90mm Super Angulon lens with Ektachrome Type B film.

The arcade curves around and terminates at a window on 57th Street (opposite page, bottom left). Again, I selected a time of day when the light level was sufficient to suggest daylight but did not overpower the soft, incandescent lighting within. Only in the closest vitrine is the display visible and that required repositioning. The shiny wood paneling further complicated the illuminating problem. Here, I used a 75mm Nikkor lens with unfiltered Fuji 64T film.

On the opposite page, bottom right, is a view of the main entrance on Fifth Avenue as seen from inside. Yet again I had to wait for the adequate level of daylight outside to balance with the interior incandescent lighting. I selected a viewpoint with my 120mm Super Angulon lens that enabled me to include parts of two vitrines and the complete curve overhead. I raised the lens to include more of the intricate ceiling detail. I used Fuji 64T film with a 10B filter.

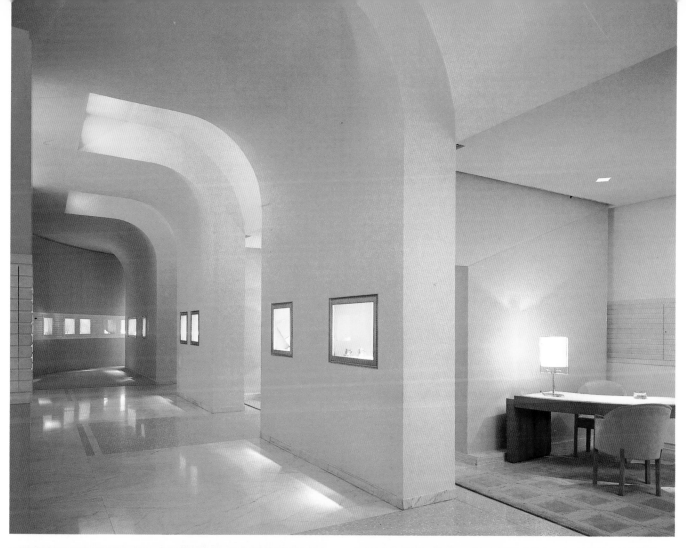

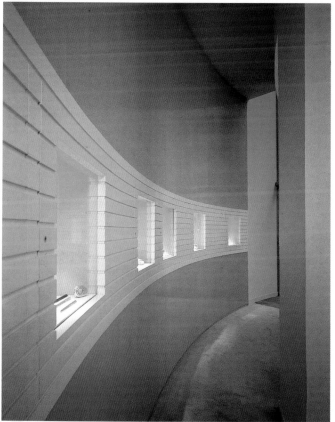

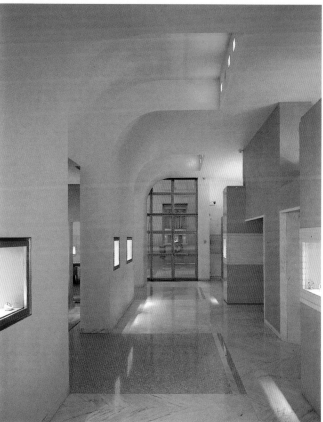

Diverse Light

This top photograph shows the Robert Homma store, located just below street level in a New York City brownstone building. The single, street-level window serves as a frame through which shoppers can see the enticing environment beyond. In spite of its narrow dimension, the strategy is successful and provided the basis for my photographic approach.

In addition to beautiful flowers and plants, the owner of the store selected particularly handsome pots and art objects for inclusion. All the lighting is by individual, adjustable, incandescent fixtures attached to two tracks running the full length of the shop. There are both wide and narrow beam spots. Many were adjusted to avoid hot spots on the white areas or to highlight a particular arrangement. To reduce contrast and to lighten up some shadow areas I used two bounced quartz lights off to the left of the space.

My client was Formica, manufacturer of the plastic laminate used for the tabletop, shelving, and counters. The designer for this flower boutique is Michael Haskins. I used a Nikon FE-2 with a 28mm F4 PC lens. The lens was offset downward to show the top of the window close to the edge of the frame from a high viewpoint. Ekta–chrome 50 EPY Tungsten film was exposed for 1 sec. at ƒ/11.

The San Francisco branch of the Hermès boutique chain of Paris closely follows the design theme established by French architect Rena Dumas. Local implementation and design is by Whisler-Patri Architects of San Francisco.

Merchandise must be carefully organized for a shot like this. Some items have to be oriented for the camera, rather than the shopper. The relief sculpture at the rear required additional illumination. The ceiling fixtures are bright, so I switched them off for part of the exposure. There are a number of different types of display cases and cabinets. Glass-topped units in the foreground incorporate fluorescent lights to illuminate merchandise inside. Further back are wood-framed,

open shelf cabinets with luminous glass shelving, also fluorescent. There are also luminous panels above garment hanging areas with similar lighting.

For this photograph it was necessary to isolate all the included fluorescent lighting, which was warm white, and filter it separately with 40R and 10M filtration (one stop factor) for the Fuji 64T film. All the switches controlled one single type of lighting; where this is not the case, the task of isolating incandescent and fluorescent is very difficult or even impossible.

There are three levels downstairs as well as an upstairs level. I set my Sinar F-2 camera high up on the lowest level to dramatize the curved handrail and the brass Hermès logo inset in the wood and marble bordered flooring. I used a 120mm Super Angulon lens for this two-part exposure. As mentioned before, I switched off part of the incandescent lighting for a portion of my exposure for a more even balance. I offset the lens downward to eliminate ceiling and show more steps at the bottom.

The facade view of Rizzoli's bookstore in New York City suggests the elegant style of the interior. This particular version of the photograph was taken at a time when neither the interior nor exterior light dominated. I used a tungsten-balanced film with 85B daylight filtration for better color rendition for the five-second exposure. Reciprocity failure of daylight film would have required corrective filtration also but would have been less predictable. The yellowish cast of the incandescent interior lighting is somewhat exaggerated but is acceptably accurate.

I selected an axial viewpoint using a 120mm F8 Schneider Super Angulon lens on a Sinar F 4 x 5 view camera. The lens was substantially raised to crop the sidewalk and include more of the building. My tripod was set right at curbside.

Ektachrome 50 Type B film was exposed for 5 sec. at ƒ/16 with the 85B filter. This bookstore was remodeled by the architects Hardy Holzman Pfeiffer Associates.

High-Contrast Lighting

This display space was designed to introduce a line of new fabrics to designers. More akin to a surrealist stage set, the trick here was to preserve the dramatic atmosphere created by the high-contrast lighting. The writing on the wall is, in fact, projected. The brightness of the candle is an indication of the generally low level of illumination. I introduced a minimal amount of bounced quartz light from two locations, the main one being to the left of the camera. The supplemental lighting is most apparent in the foreground. I adjusted some of the ceiling spots to reduce contrast, redirecting beams from light to darker fabrics and ensuring that none shone directly toward my lens. The exhibit was designed by Lee Stout for the Knoll Design Center in New York City.

For this photograph, a Sinar F 4 x 5 view camera was used with a 120mm F8 Super Angulon lens. Ektachrome 50 Type B Tungsten film without filtration was exposed for approximately 30 seconds at ƒ/22.

Dramatizing a Strong Design Feature

This is the lobby of the American Express Building in New York's World Financial Center, another example of the work of Lee Stout, who designed the exhibit, not the lobby. Taking advantage of the strong graphic quality of the floor, Stout produced this striking display in harmony with its surround.

The double-height lobby has a balcony overlooking part of it. This design feature enabled me to dramatize the exhibit by tilting my camera downward, thus splaying the columns and walls outward. I was careful to select an axis of the floor grid that recedes sharply to the rear (top) while maintaining my horizontal axis parallel left to right.

I used a 90mm Super Angulon lens offset downward to correct some distortion which, particularly in the foreground, adds to the impact of the photograph. I used bounced quartz lights to supplement the existing incandescent illumination. The film used was Fuji 64T.

Two Looks

Here is another view of the Hermès store in San Francisco, also seen on page 120. Anyone familiar with this city will immediately recognize the square outside in the background, with its neatly trimmed hedges and palm trees. During the day this shot would have been impossible. By waiting until dusk, when the light balance was much more even, I was able to capture both the store interior and the view. Although carefully planned, this shot was not on the clients' list. It was one of their favorites nonetheless. I used no supplemental lighting. The cool early evening light offset some of the warmth of the incandescent interior producing surprisingly natural color without filtration. Blurred flags and passing buses outside spoiled some of my transparencies. The Hermès scarf on the glass-topped display cabinet in the foreground blocks an overly bright reflection of the sky. I used a 120mm Super Angulon lens with Fuji 50D film. The architects were Whisler-Patri of San Francisco and Rena Dumas of France.

The major design theme of the wholesale garment show-room shown here is the partly plaster wall with its wire lathe and metal support structure. The existing incandescent lighting had to be supplemented to reduce the contrast. I bounced a quartz light into an umbrella high up to the left of the camera to minimize reflection from the screen of the monitor. I chose a low viewpoint and used a wide-angle lens to exaggerate the perspective, with the sharply converging horizontals of wire lathe disappearing into the giant crack. Snippets of color at the left suggest activity beyond.

James D'Auria, architect, designed this showroom for Gene Ewing in New York's garment district.

I used Ektachrome Professional 50 Type B film (EPY) in a Nikon FE-2 with a 24mm F28 lens. Exposure approximately 1 sec. at f/8 to 5.6.

Altered
Viewpoint

Shown at right is part of a wholesale shoe salon. The showroom has a series of windows around the perimeter of the space which the designer wanted to show. For this reason I positioned my camera to catch the view from the lefthand window and adjusted the blind to the half-way position. Normally I would have had to use an electronic flash to illuminate the interior and include the scene outside. However, the interior lighting is an intrinsic part of the design, and overpowering it with flash would have destroyed this aspect of it.

My solution was to convert the window light to a tungsten equivalent by exactly placing a sheet of 85B filter over each pane of glass. Since the blinds are translucent, the window areas behind them were also filtered.

This procedure yields a reasonable balance between the daylight and the incandescent light inside. The formality of the room was somewhat offset by the random positioning of the black chairs. To reduce contrast, I introduced two quartz lights bounced into umbrella reflectors, on either side of the camera.

I used a 90mm F5.6 Super Angulon lens on a Sinar F 4 x 5 camera. Ektachrome 50 Type B film was exposed for 10 sec. at ƒ/16 to 22. The Craddock-Terry Shoe Corporation showroom in New York City was designed by architect Stewart Skolnick.

Another angle of the same space is shown below to illustrate how different two photographs of the same interior can be.

I chose an axial viewpoint for this version, pulling back as far as I could from the subject and using a lens of double the focal length to compress the composition. The stepped platform and the ceiling recess above are foreshortened and appear more modest in dimension. The entire room seems to be smaller.

Each photograph has its own validity. This picture is more graphic but less informative than the one above, providing the viewer with less of the impression that actually being in the space would provide.

Lighting and camera details are the same as before but for this photograph I used a 180mm F5.6 Symar S lens. Exposure was approximately 15 seconds at ƒ/22 for added depth of focus.

SPORTS FACILITIES AND AUDITORIUMS

Few inexperienced photographers will have to tackle the problems that are inherent in documenting very large spaces. The major problem involves recording the design and capturing the space with available light sources only and with limited control.

The majority of auditorium-type spaces are too large to light artificially. Even when it is possible to introduce supplemental illumination, it is almost always obvious in the photograph that the added lighting is not part of the basic design.

The easiest conditions occur when a single type of lighting has to be dealt with: daylight alone, for example, or only tungsten. Since films come balanced for both these sources, no filtration may be required. In the case of daylight film some filtration may be necessary for reciprocity; the light level is likely to dictate longer exposures than those typically used for exteriors. Unless extreme accuracy is required, an interior with only incandescent lighting will probably yield acceptable results using unfiltered tungsten film. The existing lighting will probably be of lower degrees Kelvin than the film is balanced for (3200°K), and the resulting photograph will be warm in tone.

If the space has daylight and incandescent light in a fairly even combination, a photograph that has approximately the same ratio may look all right. This will depend on how evenly the two kinds of lighting are mixed. The use of tungsten film, half of the exposure unfiltered and the other with an 85B for daylight conversion, may produce a satisfactory result. Keep in mind that the filter has a factor which will lengthen that part of the exposure correspondingly.

The exact ratio between the two different types of light is not as critical as one might think but will be translated into pictures that may be somewhat warmer or cooler than the interior appears to the eye. Experiment with different ratios and see which results you prefer. Try switching off the interior lighting to evaluate the contribution of the daylight portion. Obviously, if the space seems to be sufficiently evenly lit without the variable source, then shoot it that way.

In a situation that has unusual lighting requiring heavy filtration, tests may be necessary. There are now on the market large numbers of light categories for which filter recommendations are hard to come by. These include certain kinds of mercury vapor and neon lighting, which is sometimes similar to fluorescent but sometimes not, high intensity discharge (HID), and metal halide.

Light sources may be used indirectly bounced, off wall or ceiling surfaces. When these surfaces are not white, the result is a shift in color temperature which, if extreme enough, may require additional correction. Only advance testing will guarantee acceptable results. In certain circumstances, a color temperature meter may be helpful.

When faced with difficult circumstances, the photographer may have to compromise. Filter for the predominant light source and hope that those areas with other types of illumination will be rendered reasonably well, if not accurately. Eliminating offending variables and allowing certain portions to go dark is a possible alternative. If all else fails, shoot a 120 or 35mm Fuji Reala color negative and have a print film transparency or print made from it. High-speed color negative material, available only in roll format, is much more forgiving when used in awkward light situations.

A note of caution when selecting the lens to use in recording a large space. Unless you wish to exaggerate the apparent size of the subject, don't use a wider-angle lens then necessary. The scale of the design may be important. The architect may wish the space were even larger than it is, so a photograph which suggests this may be preferred. Usually, however, a large enclosure will not need that sort of amplification. Careful selection of viewpoint may enable the photographer to include repeating elements that suggest the true dimensions of the space without showing everything.

Evaluate the architectural features of the space and play up these attributes by careful composition and selection of camera position. If the design has more than one basic axis, a strong diagonal perhaps, consider photographing along it for added impact. The inclusion of foreground elements—railings, columns, or screens—will add depth. Keep the contrast range within manageable bounds by avoiding photographing directly toward very bright areas, or conversely, overly dark ones. Sometimes a minor change in position can radically alter the parameters of brightness within the frame of the picture.

Don't be overly concerned by moving people or objects in the photograph. Unless they are very close to the camera, they probably won't be a distraction. If it seems that they might be, select a smaller aperture and use a time exposure. When you do include human figures, try not to have them look posed. You can try going through the motions of taking pictures a couple of times and then catch the people unaware.

Perspective Control

The large indoor swimming pool shown here is part of an athletic complex at Wellesley College in Massachusetts. I had photographed this interior in late afternoon the previous autumn. However, with direct sunlight entering from the left, the results were extremely contrasty.

During my return trip in June, I was able to select a time of day that the sun entered the room from the southeast, to the right and behind the camera. I selected an axial viewpoint and a location that would feature the decorative floor tile work, the pool itself, and the bleacher seating up on the left.

The axis of the main building and that of the pool are parallel but not the same. This is reflected by the structure of the back wall. Notice the half-lowered blinds in the far windows. I needed the natural light at the end but wanted some contrast control. The interior lights were switched on but had little effect because the natural light level was so high.

I used a 35mm camera for this shot in conjunction with a very wide angle, perspective-control lens. The lens was shifted to the right and slightly upward. The camera was fitted with a gridded screen viewfinder and was carefully leveled on a tripod. Even a small amount of tilt would have been immediately evident with a lens of such short focal length.

Exposure was approximately 1/30 sec. at $f/5.6$ using Kodachrome 64 Professional film. The camera was an Olympus OM4 with 24mm F3.5 Zuiko shift lens. Architects for this projects were Hardy Holzman Pfeiffer Associates.

Two Views, Two Lights

The fronton, or playing area, of this Jai-Alai facility in Milford, Connecticut, is extremely bright. This area is illuminated by mercury lamps, while the rest of the lighting is primarily incandescent and at a much lower brightness level. The objective of the photograph above was to relate the playing area to the seating area. The exposure and the filtration were determined by the playing area alone.

Because the fronton enclosure is very much the focal point and focus of the composition, the color and exposure of it had to be the controlling factor. This meant substantial underexposure of the seating. However, there was just enough detail to manage it, and the very reddish color resulting from the combination of tungsten film and filtration for mercury lighting does not jar the eye. The figures of the Jai-Alai players are ghostly though visible, because of the length of the exposure.

The camera was a Sinar F 4 x 5 and the lens a 150mm F5.6 Schneider Symar. Exposure was approximately 10 sec. at f/11 with a 70R and 10Y filter combination. The facility was designed by Herbert Newman and Associates of New Haven, Connecticut.

The photograph, left, shows the seating area of the Jai-Alai facility. Between each match, the house lights are raised to permit the audience to examine their programs and decide how to place their bets. The house lights are incandescent and quite bright when turned up fully, but the fronton illumination is even stronger and remains on both during and between matches. The right-hand area of the photograph, closest to the fronton, had a cool cast since I used Ektachrome Type B film unfiltered.

The Sinar F was used with a 90mm F5.6 Schneider Super Angulon lens. Ektachrome 50 Type B Tungsten Balanced film was exposed for about 8 sec. at f/11 without filtration.

Inclusiveness

The key to the photograph above was the control of the screen image. I was able to select and freeze the image of the projected race, permitting a time exposure. Although the screen occupies quite a small portion of the composition, it is very much the focal point and the brightest part of the picture. The lighting in the main body of the "theatre" was purposely kept rather low, so many areas are quite dark. The curves of the balcony fronts, the main seating, and the ceiling all combine to give a good impression of the space. Most of the more brightly lit service areas to the rear are hidden from view. The four bright rectangles in the background are closed-circuit screens that I was unable to control.

Teletrack, in New Haven, Connecticut, was designed by Herbert Newman and Associates. I used my Sinar F 4 x 5 view camera with a 75mm F5.6 Schneider Super Angulon lens. Ektachrome 50 Type B film was exposed for 12 sec. at f/11 to 16.

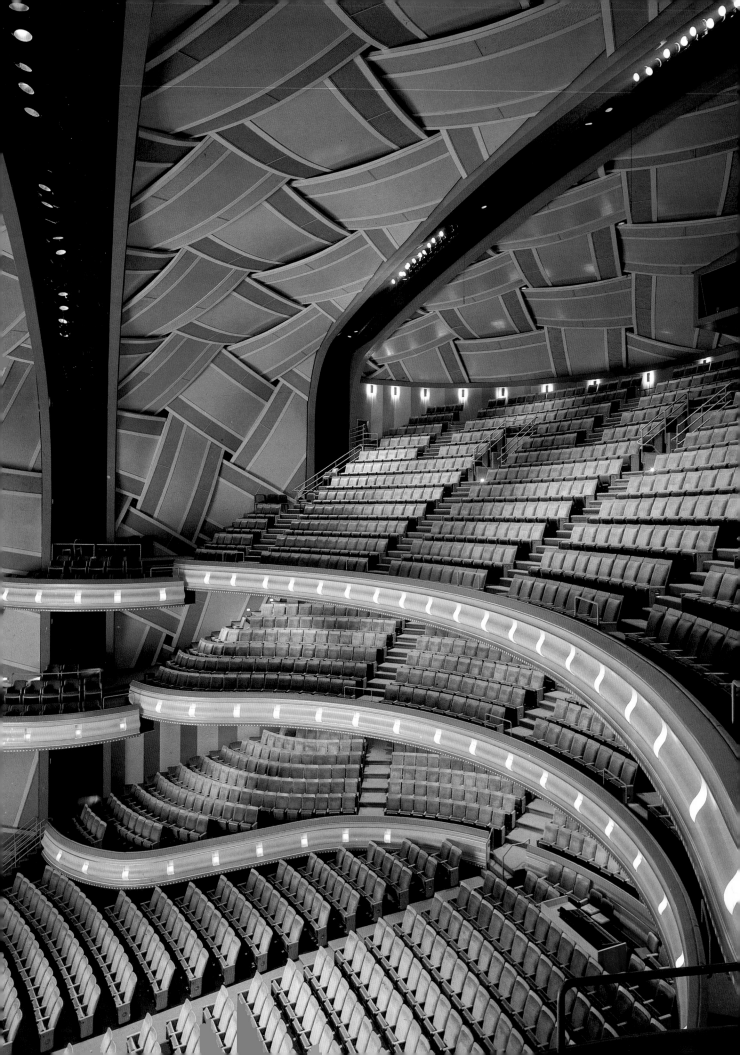

Vast Space, Many Possibilities

The auditorium of the Hult Center for the Performing Arts in Eugene, Oregon, uses various types of incandescent lighting, both switchable and dimmable. The basic house lights give a somewhat contrasty result, particularly when the balcony fascia lights are adjusted to maximum intensity. The wall sconces at the rear of the upper balcony are also quite bright. I had both these systems adjusted to rather low levels and was able to organize the raising of the main curtain. The surfaces in the stage area behind were white or neutral in color and with the aid of some of the stage lights, I was able to substantially boost the general level of illumination in the auditorium.

The main features of this multi-purpose hall are the unusual green and gold, basket-weave patterned ceiling and the sinewy, curving balconies over the mezzanine. After some exploration I found a location where all the balconies and the lower seating were simultaneously visible. The ceiling is divided into three segments by two banks of recessed stage lights. These recesses spring out of the upper corners of the composition to give added impact.

The camera used was a Sinar F 4 x 5 view camera with a 75mm F4.5 Nikon lens. The film used was Ektachrome 50 Type B. Exposure was approximately 20 sec. at ƒ/16 to 22. No filters were used. The architects were Hardy Holzman Pfeiffer Associates.

The picture at right is a candid photograph of the same auditorium taken during a performance. This time I could exercise no control; the shot is strictly the result of existing available light. The general level of illumination was only a fraction of the amount for the other view. I used a fast tungsten-balanced roll film, Ektachrome 160 EPT in my Hasselblad. With this 120 rollfilm format, I was able to use faster film than would have been available for the 4 x 5 view camera, and in addition the wider aperture and shorter focal-length lens permitted the selection of a shorter exposure time. Also, the film was pushed in development approximately one and one-half stops, so it was effectively rated ISO 400. One-second exposure was dictated by the lower level of light in spite of the wide aperture of the lens, ƒ/4.

In situations such as this, it is tricky to focus and operate the camera. Be careful when changing settings, since it may be quite difficult to see them in the dark. Reading the meter either through the lens or handheld, may be equally hard. For instance, it may be wise to have the processing lab run a frame test on a couple of frames to determine if the exposures are in the right range. (This assumes that the entire roll of film is of the same or similar subject and was shot at more or less the same ISO rating.) A frame or two may be sacrificed for testing, but if adjustments need to be made, it will have been worth it.

By avoiding the stage area in my photograph, I was able to keep the contrast range within reasonable bounds. Had I tried to include it, I would have been forced to substantially reduce the exposure and little, if any, detail of the audience would have been evident.

Keep in mind that a noisy camera can make you extremely unpopular during a concert. Wrapping something around the camera may help to absorb some of the sound of the shutter. If you are using a Hasselblad CM, as I was, you should trip the mirror before the actual exposure and then wait for a loud passage of music to disguise the sound. The mirror and safety cover make more noise than the shutter.

The Hasselblad 500CM was fitted with a 40mm F4 Biogon lens on a tripod.

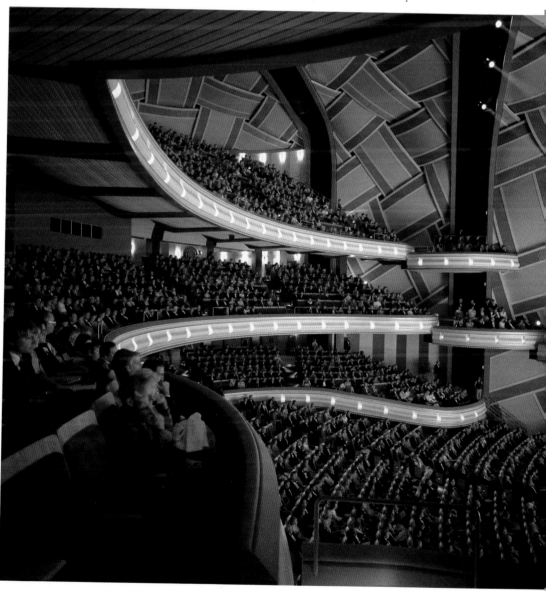

CHURCHES

Churches are frequently symmetrical in plan. Axial photographs will emphasize this. If you plan to do several views, resist the temptation to do too many symmetrical compositions. In other words, plan the coverage to give a variety of pace which will make it more interesting to the viewer. Mix verticals and horizontals and, when in doubt, do both of the same view. This may be quite easy to accomplish since the lighting is not likely to change much, if at all, between the two versions.

The majority of church interiors have some natural light; some others may be comparatively bright. When daylight provides the primary illumination, the weather conditions will have considerable influence. Where openings are well distributed and little direct light enters, the lighting may be quite even. If, however, most of the daylight penetrates from a single source, there will probably be quite uneven illumination. These factors may well dictate the photographic approach. It is not always possible for the photographer to take what might otherwise be the ideal view due to excessive contrast or some other uncontrollable factor. A compromise may be necessary when the option of waiting for more favorable conditions is not practical.

Tungsten fixtures are generally the most widely used type of lighting in churches, particularly in the older ones. In a contemporary church, you may find mercury vapor fixtures. These should be avoided whenever possible since they are not compatible with any other light sources or film without substantial corrective filtration.

When supplemental lighting is necessary, tungsten lamps are easier to transport and locate than strobes. Additional tungsten light is not difficult to judge, which strobe light is, thus making Polaroid testing less essential. Only if small format is acceptable in combination with fast film is it practical to light with flash. My advice in such situations is to bracket the exposures widely, trying a variety of settings. Remember, though, that direct flash can yield very harsh results.

My experience is that most supplemental lighting has to be used directly, not bounced, to have much effect, particularly with a large-scale interior. With careful positioning of the lights, it is usually possible to avoid distracting shadows. Also, if the daylight coming through any windows is not too strong, it may be possible to overpower its effects, thus permitting the use of a more stable tungsten-balanced film. The daylight areas will be rendered more blue with this film, but the colors of the interior surfaces may not be adversely affected.

How do you determine whether or not supplementary lighting is required? Keep in mind that it is not the overall level of illumination that will determine whether additional lighting will be beneficial or even desirable, but the evenness of the light distribution. Beautiful photographs can be produced in dimly lit interiors. Only in high-contrast situations must the photographer take action. In such cases, allowing dark areas of an interior to be recorded with little or no detail may be acceptable.

Don't expect those beautiful stained glass windows to be recorded the way you see them. Only in the most unusual circumstances will their detail and beauty be within the range of the film, if it is also to record the interior. When photographing stained glass, take direct exposure readings of the windows. Since this readout will dictate the camera settings, additional lighting must be introduced to capture interior detail surrounding the window which is included within the composition. The amount of supplementary lighting required will vary as the light transmitted through the glass changes.

A church with an interior lit entirely through stained glass windows, as some of the great cathedrals are, may exhibit some color shift when photographed. If blue glass predominates, then the results will be cool in tone; if yellows are in the majority, the photograph may assume a more "sunny" or yellow hue. Often no single color predominates, and the photographer need not be unduly concerned with attempting corrective filtration. If very accurate color is essential, some advance testing may be necessary or, if one is available, the use of a color temperature meter to determine the filtration will be required.

Whenever possible, check out the position of electrical outlets in advance if you expect to introduce lighting. You may find that power sources are few and far between and require long extensions. Also, avoid plugging in more than one lamp in each circuit whenever possible and find out where the circuit breakers or fuse boxes are. Their capacity will determine how many lights can safely be connected to a single circuit. I have used as many as five or six 1000-watt quartz lights directly to illuminate a large church interior.

When selecting the lens to use, keep in mind the fact that the space may already be quite large and the use of an extremely wide-angle lens will further exaggerate this. Try, therefore, not to use a shorter focal-length lens than necessary. Shooting a high space from floor level may only be practical when using a perspective-control lens or a view camera.

Stained Glass Windows

This stained glass window is located in one of the side aisles of the recently restored West End Collegiate Church in New York City. Late afternoon light was best for the window, which is attributed to Louis Comfort Tiffany. I wanted to include the inner arch to show the context of the window. I positioned one strobe head and umbrella close to the camera and slightly to the left. The second head, also bounced, was located in the aisle behind the column to the right. The head nearest the camera was set at half the output of the other to reduce the impact of the arch and the foreground seating. Leaving the tungsten light switched on makes the upper area of the aisle a little more interesting, and it has minimal effect on the color.

The photograph was taken for the architects of the restoration, William A. Hall Partnership, for portfolio use and potential publication. I used a Sinar F 4 x 5 view camera with a 120mm F8 Schneider Super Angulon lens and Ektachrome 64 Daylight film. Exposure was approximately one sec. at f/16. A 5000-watt Balcar unit provided the necessary strobe light.

St. Augustine's Church in upstate New York was designed by architects Moger Woodson. In order to maintain one-point perspective, my viewing axis is parallel to that of the subject. However, I was substantially to the right, so I used lateral shift in addition to considerable lens rise and was close to the acceptable limit of movement, as can be seen from the top left vignette. The symmetry of the design is still apparent.

Some incandescent lights were left switched on despite the bright sunlight. I used supplemental bounced strobe off to the left. I used a 90mm Schneider Super Angulon lens and Fuji 100D film.

Angles and Views

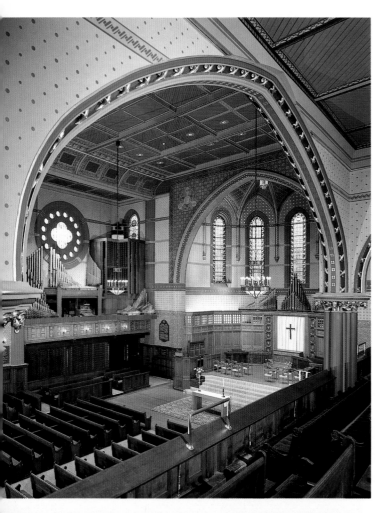

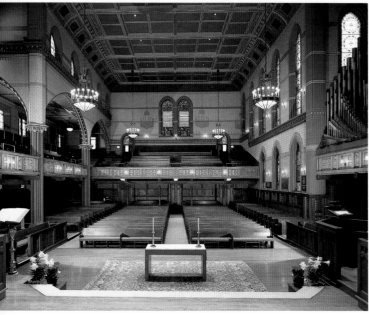

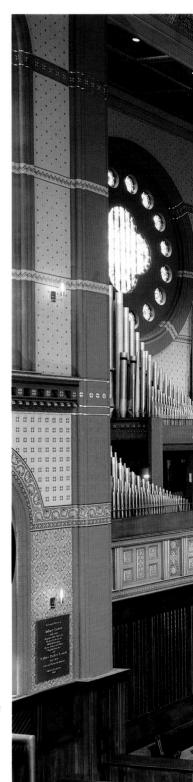

This renovated chapel in New Haven was photographed by choice on a mainly overcast day. A modern lighting system using incandescent fixtures was installed when the remodeling was done, producing a brightly lit interior even without daylight. I figured that I could overpower the daylight with supplementary quartz lights if I used them directly rather than bounced. Only the chains supporting the chandeliers cast shadows, but by carefully locating my lights they become almost invisible. The sanctuary has more illumination than the rest of the chapel. I selected this viewpoint to show the large organ and the round window above. Most of the lighting is dimmable but only the wall sconces and chandeliers were lowered in intensity for contrast control and to preserve color accuracy.

I used a 250-watt spotlight to boost the brightness of the choir stalls below the organ and the pulpit. The dark wood in this area made it necessary to add this illumination.

A particularly obtrusive aluminum handrail which appeared to the left of the pulpit after the new work had been completed was covered with black tape to make it less noticeable. A similar one on the right was removed, but with some difficulty.

The project is the Battell Chapel at Yale University and the remodeling and restoration work was done by the firm of Herbert Newman and Associates of New Haven. The photography was for publication and portfolio use.

I used Fuji 64 Tungsten film, since it is faster and produces a somewhat warmer, or yellower, rendition than Ektachrome would have. A 120mm F8 Schneider Super Angulon lens was used with a Sinar F 4 x 5 view camera. Exposure approximately 5 sec. at ƒ/16.

The view shown above left is quite different. Using a vertical format, I framed both the organ loft and the sanctuary on the right between one of the large, arched balcony openings of the side aisle. The shape of the arch is rather distorted by the wide-angle lens, the penalty I had to pay for including as much in this single view as I did.

The lighting is much the same as for the above picture except for the foreground. In this instance, since the camera was much closer to the arch and columns, the lights could also be

moved in without being included within the frame. I used two bounced quartz lights with umbrellas which enabled me to control the output more precisely and balance the background with the foreground.

Film and camera were as in the previous view, but here I used a 75mm F4.5 Nikkor lens.

The axial view of the chapel below looks down the nave to the rear. The light level outside had dropped, so the two central windows were then much better balanced with the interior light level.

I used all the lights I had, two to the left and two on the right, with a fifth on the balcony of the side aisle. I could have used one more light in a space below to the left. All the lights were used direct and were either 1000-watt or 650-watt quartz flats that produced a very wide spread of even illumination.

My lighting produced shadows of the chandeliers on the back wall, but these were unavoidable. The light level of the sconces was raised somewhat to make them appear brighter.

For this photograph, I used a 90mm F5.6 Schneider Super Angulon lens on the Sinar F camera. Exposure was approximately 10 seconds between $f/11$ and 16 with Fuji 64 Tungsten film.

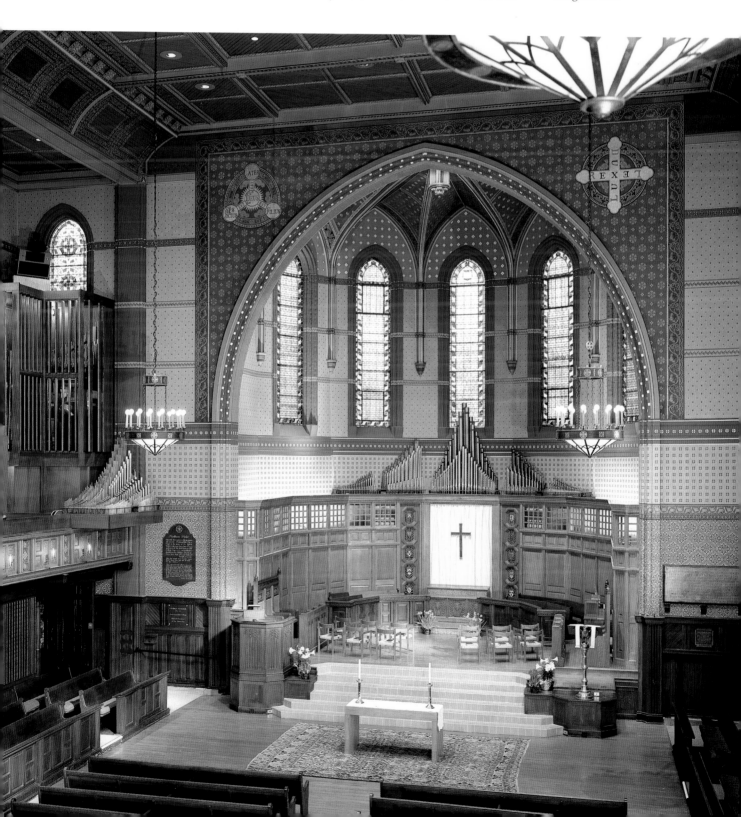

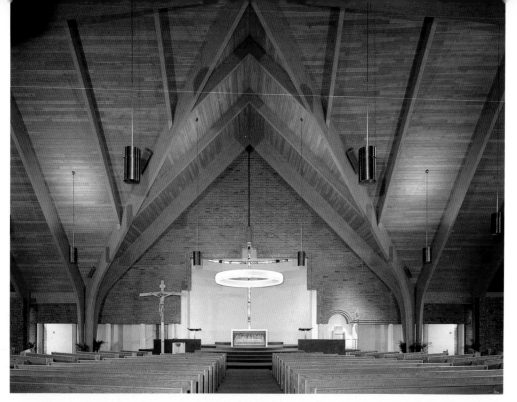

Horizontals and Verticals

All three photos shown here are of Our Lady of Lourdes Catholic Church on Long Island. Limited interior daylight was overpowered by quartz lights, as in the Battell Chapel examples on the previous pages. Unfortunately, some of the interior lighting was mercury vapor and could not be used. Quite a lot of heavy-looking furniture was removed from the sanctuary and adjacent areas for the photography.

Careful positioning of the lights kept objectionable shadows to a minimum. A quite low camera position was selected to help explain the suspended circle above the altar, but was high enough to get some separation between the rows of pews. The daylight produces an overly cool back wall with the tungsten film, but it is a welcome contrast to the otherwise almost monochromatic tones of the wood and brick. I used a 90mm F5.6 Super Angulon lens, raised substantially to include as much of the ceiling structure as possible and, in particular, to capture the meeting point of the main trusses. I used Ektachrome 50 Type B film in the Sinar F camera. Exposure was approximately 2 sec. between ƒ/11 and 16. Bentel and Bentel are the architects for the church.

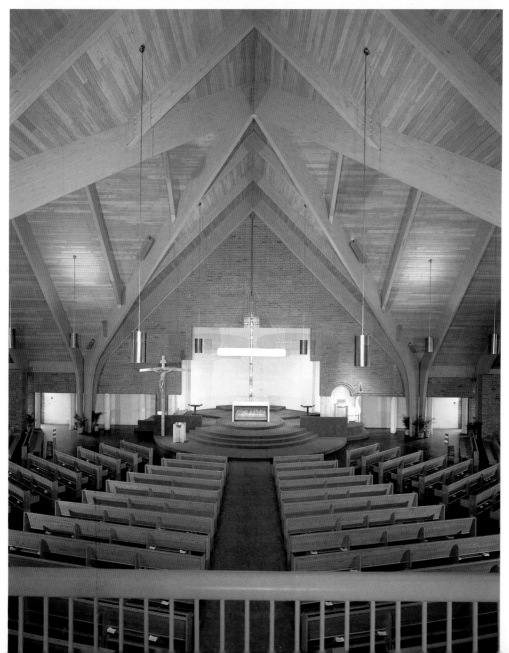

All the lighting remains the same for this vertical version, left, done from the rear balcony. Not only the switch in format but the elevation of the camera produced a totally different composition. Some daylight coming from behind the camera produces a cool cast on the foreground railing.

The full-page view, opposite, is a closeup detail of the sanctuary and altar. The major difference here is that the lights have now been moved closer in, so I was able to bounce them into umbrellas to produce a softer light without sharp shadows. The curvature of the rear wall is now much more apparent, as well as its relationship to the brick wall.

The lens and film were the same for all these photographs.

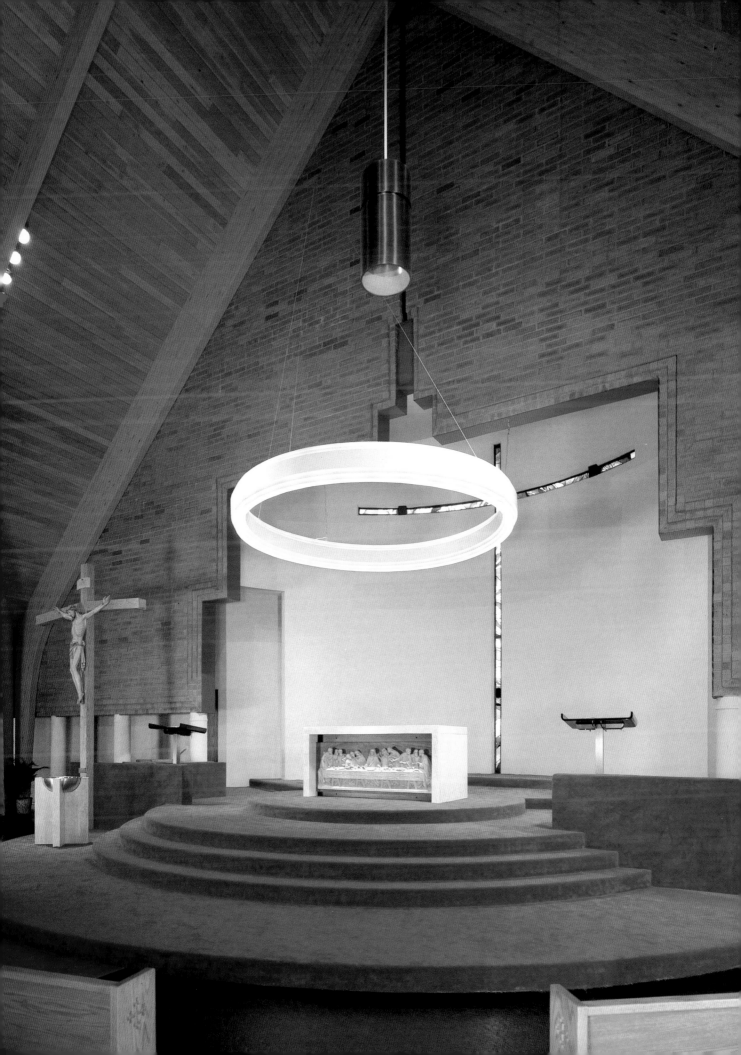

MUSEUMS

Museums have virtually no common denominators. Some are public, some private, others corporate; some are very large, others very small, and their styles are equally diverse.

Many museums are closed one day a week. When this is the case, the institution to be photographed may prefer, or, in fact, may insist, that any photography requiring a tripod be done on that day. Find out what the rules and regulations are before attempting the assignment. Also determine if the museum restricts the use of the completed material. Make sure that the necessary authorizations are obtained in advance. Museum personnel can be difficult when they feel they have been left out, or worse, circumvented, in the permissions or planning stages of a project in which they are involved.

Having made all the necessary arrangements, the photographer may find that other conditions, like the weather, may be unfavorable. If good weather is essential to the assignment, notify the museum in advance that you are counting on favorable conditions to complete the documentation. They won't have people hanging around waiting for you if the weather is uncooperative. These suggestions are mostly obvious but are frequently overlooked.

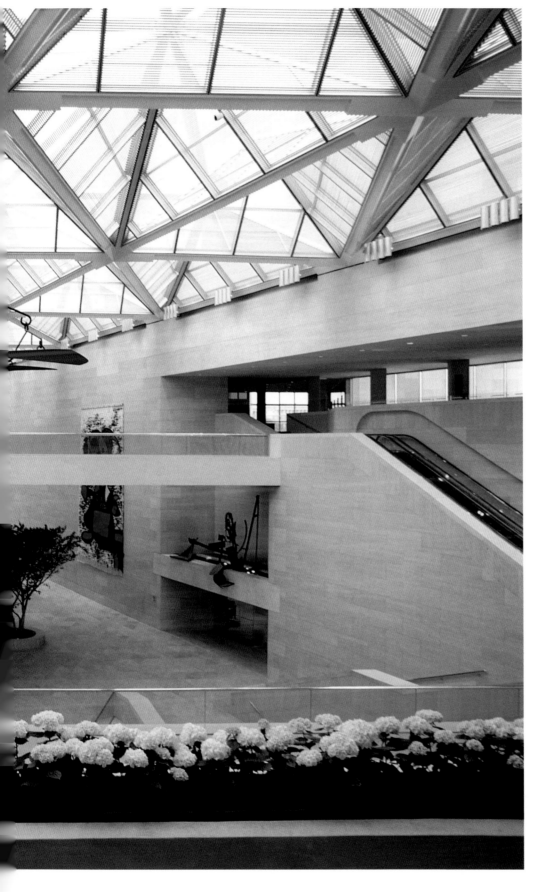

The Importance of Viewpoint

In 1978, the eagerly awaited addition to the National Gallery of Art in Washington, D.C., opened. I was asked by *Vogue* magazine to photograph I. M. Pei's latest masterpiece for a spread or two in their publication. My photographs were taken during a brief period prior to the gallery's opening.

From the technical standpoint, this was an easy assignment. The entire ceiling is one vast skylight, so the interior is as bright as day. A series of interlocking trusses span the basically triangular column-free space and support the glazing. The triangular-shaped enclosure comes to quite a sharp point at the eastern end of the building. My favorite views of the design are those that look in the direction of its easternmost terminus. There are many different levels so the photographer has a wide choice of vantage points.

The vantage point for this overall view is a stair leading to one of the upper galleries off the main space. The main axis of the complex roof-support system divides the triangle virtually in half in an east-west direction. The symmetry and the convergence of the design is emphasized by shooting along this axis. In addition, there are several design elements on or at right angles to this axis. By selecting this common one, I emphasized several contrasting axes of the interior: parallels that intersect the strong converging diagonals. This lends an order to the composition and simplifies the structural geometry.

I watched the slowly rotating Calder mobile to determine its most flattering orientation, both for the work itself and the background. Skies were overcast when I took the shot and some of the interior perimeter lighting was on, adding a warmish tint to some areas of the otherwise daylit interior.

Part of the alcove in which the stair is situated is seen at the left. I moved down the stair far enough to minimize this wall but still maintain the desired optical axis. The 24mm Nikkor wide-angle lens does not have perspective-control capability, so I had to shift my camera position to achieve the necessary balance, being careful to keep the Nikon FE-2 absolutely level. I used Kodachrome 64 film exposed at about 1/8 sec. at ƒ/8.

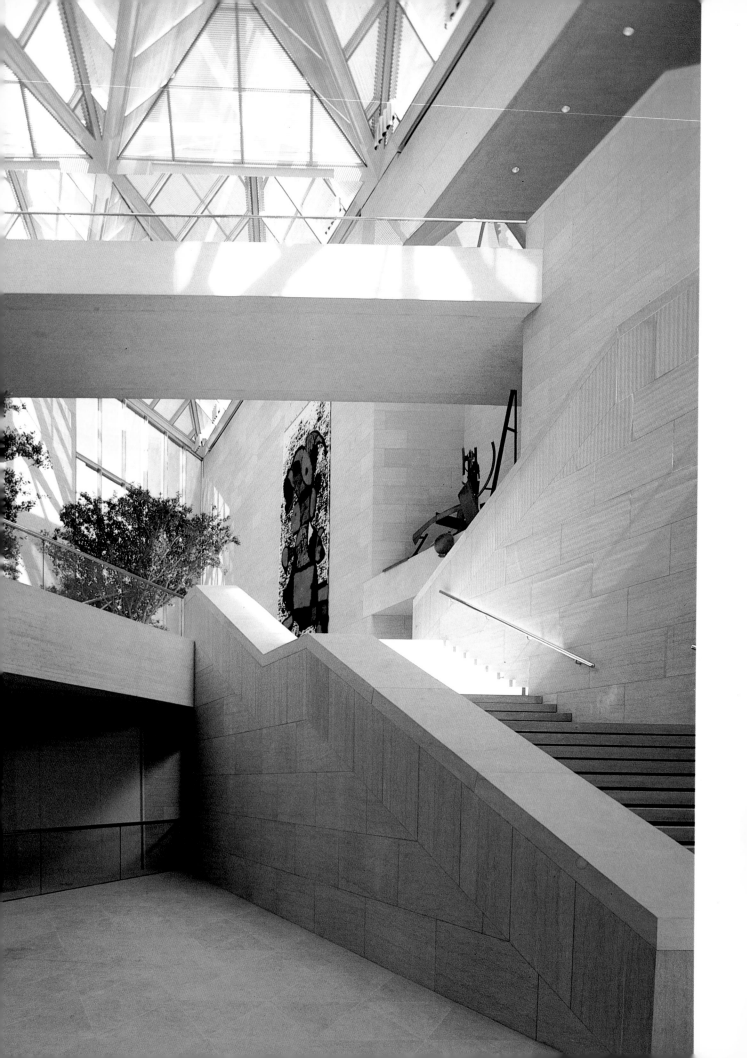

Dramatic Approaches

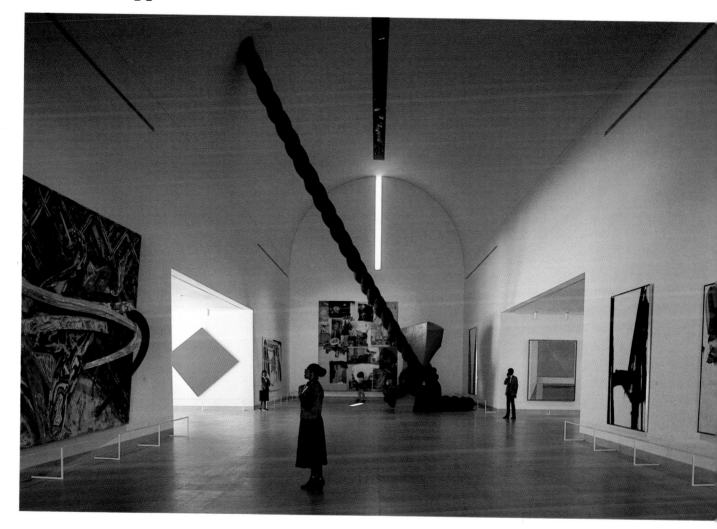

T he new wing of the National Gallery may be entered from street level or by coming underground from the connecting link to the main building. Entering from below heightens the drama even more, as the photograph on the facing page illustrates. Here strong forms and shapes collide with one another. The sun broke through the clouds briefly, washing the wall at right with light and enhancing its texture. The key to this photograph is the use of the 28mm F4 PC Nikkor lens. I used the maximum lens rise,

capturing the structure above and eliminating foreground floor area. By avoiding camera tilt, no objectionable distortion is apparent. Only with a 28mm, or 24mm, perspective-control or shift lens is it possible to accomplish such a shot with a 35mm camera. The exposure was about 1/30 sec. at f/8.

T his museum interior, above, illustrates a high-contrast situation. Although there may appear to be some fill light from behind the camera, it comes

from natural sources. The main illumination comes from the opening to the left; it bounces around the mostly white space, producing surprising brightness. The light behind me and from the narrow vertical slot also helps. In addition, there are incandescent spotlights on the artwork.

The symmetry of the design is well captured by the axial viewpoint. The strong diagonal thrust of the Lichtenstein sculpture is what makes the picture successful. The scale of the art, howev-

er, could not have been captured without the inclusion of human figures. The figures were not posed; I had to patiently wait for the right moment.

This is the Amon Carter Museum in Dallas, Texas, designed by Edward Larrabee Barnes.

I took the photograph for my personal files using a Nikon FE-2 with a 28mm F4 PC Nikkor lens with quite a substantial offset to include the top of the sculpture. Exposure was an 1/8 sec. at f/5.6 to 8.

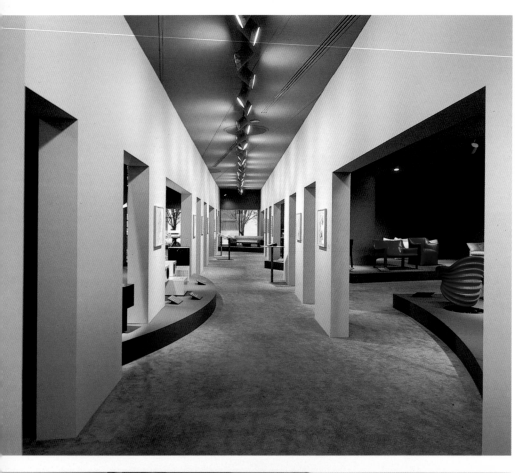

Spotlighting

When the Museum of Modern Art in New York City featured the work of Italian designer Mario Bellini, they persuaded him to design the exhibit. The setting became as important as the items displayed. Bellini created an internal street bounded by two walls with different sized and shaped openings punctuating them. Individual pieces of furniture and various products were positioned on raised platforms in more intimate spaces off the street. Spotlights focused on each item.

In order to record the exhibit, I introduced a modest amount of tungsten fill light to reduce the rather high contrast. Part of the exhibit terminates in a window overlooking 53rd Street. Fortunately, a heavy filter reduces the natural light entering from this source. For the top view, I used Ektachrome Type B film with a 120mm Schneider Super Angulon lens on my view camera. The same lens is used, downshifted, for the bottom view. The "street" was brighter than the adjacent spaces, so I boosted the light level to bring them to an acceptable level while still preserving this difference.

Over the last twenty years or so, the Metropolitan Museum of Art has grown considerably, with new wings, remodelings, and, in the case of the Petrie Court shown at right, the enclosure of what used to be exterior space. The red brick and stone facade was the 1888 carriage entrance to the museum. Now it forms one wall of a skylit sculpture court.

Individual pieces of sculpture are highlighted by powerful incandescent spotlights, which produce the warm glow somewhat exaggerated by the daylight film I used. I purposely avoided direct sunlight for this available-light shot.

The blue sky seen through the skylight is brought into better balance with the lower part of the composition by use of a number 6 Sinar graduated ND filter. The precise positioning of this filter was confirmed by Polaroid testing.

The figure on the left was used to partially block the very bright light entering from the end wall behind. I used a 90mm Super Angulon lens on an Arca Swiss F camera with Fuji 100D film. The exposure was approximately 1 sec. at f/16 to 22. The architect for this project was Kevin Roche of Roche, Dinkeloo.

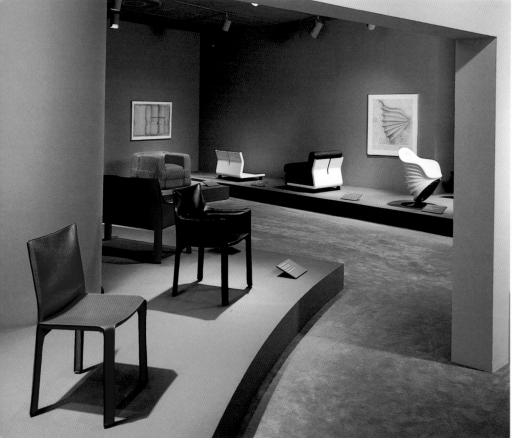

One Shot

This picture shows part of the ongoing modernization of The Metropolitan Museum of Art by Kevin Roche of Roche, Dinkeloo architects. On the occasion of the opening of the new home of the Temple of Dendur, *Vogue* asked me to produce a single definitive image for their readers. It was an unusual challenge to create, not a series, but a single photograph.

Focusing too closely on the temple itself, without showing much of its new setting, might have pleased some archivists but would not have satisfied the assignment objectives.

The temple consists of two elements: a free-standing entrance portal surmounted by a carved pediment and a lower rectangular structure with two columns set into the front facade, which stands some distance behind. Only when viewed obliquely does this relationship become clear.

I decided to position my camera close to the interior corner of the reflecting pool, thus silhouetting part of the temple against the sloping glass wall on the north side. On a Monday, when the Met is closed, I was able to set up without interfering with museum visitors. Some window cleaners appeared to add needed human scale. I used an especially high tripod to elevate my camera to a point where the base of the temple is visible behind the low wall at the near edge of the platform, about nine to ten feet above the floor. The floating wall opposite the windows is quite high and featureless, so I only included enough of it to balance the composition. To show the complete platform and its reflection, as well as the near edge of the pool, I used a 75mm F5.6 Schneider Super Angulon lens.

I used Ektachrome 64 Daylight film in the Sinar F 4 x 5 view camera. Exposure was approximately 1/2 sec. at ƒ/11 to 16.

PHOTOGRAPHING BUILDINGS OUTSIDE

Architectural photography falls into two distinctive categories, interior and exterior. Though both can be termed "architectural," the approach to each is totally different.

In general, nonprofessional photographers have more success with recording architectural exteriors than they do with interiors. The manipulation of light, in combination with the restraints of limited space, make the documentation of interior areas especially demanding. But with exteriors, even a comparatively inexperienced photographer can recognize favorable conditions for recording a building. The photography may even be accomplished with relatively unsophisticated equipment. A good working knowledge of the capabilities of the different focal-length lenses makes the task that much easier.

The key factor in all photography is light. With interiors, photographers have a degree of, or even complete, control. But when it comes to the documentation of the outside of a building, they are at the mercy of Mother Nature. The sun cannot be made to stop shining, nor can it be switched on when it is reluctant. When it rains or is foggy or unclear, nothing can be done. Photographers must either wait it out or deal with the prevailing conditions. Keen observation skills and an ample supply of patience are prerequisites for optimum results.

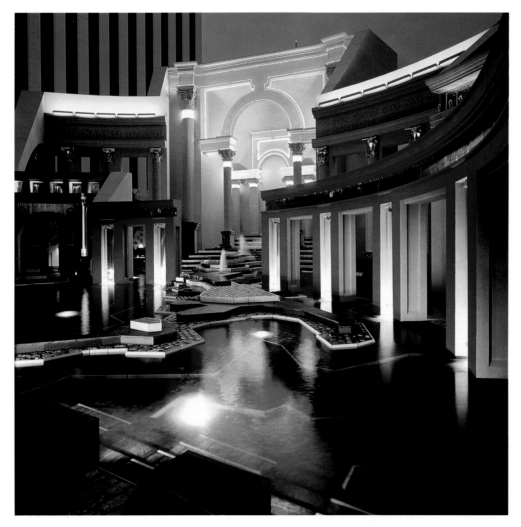

Piazza d'Italia Fountain, New Orleans, Louisiana. Designed by Charles Moore. I don't know if Charles Moore realized at the time he designed the Piazza d'Italia that it would become the summation for and the very essence of the post-modern movement. But it is and it has. I can think of no other single design with such symbolism. Certainly judging by the regularity of requests for publication and exhibition, it is a design that set the pace and continues to endure.

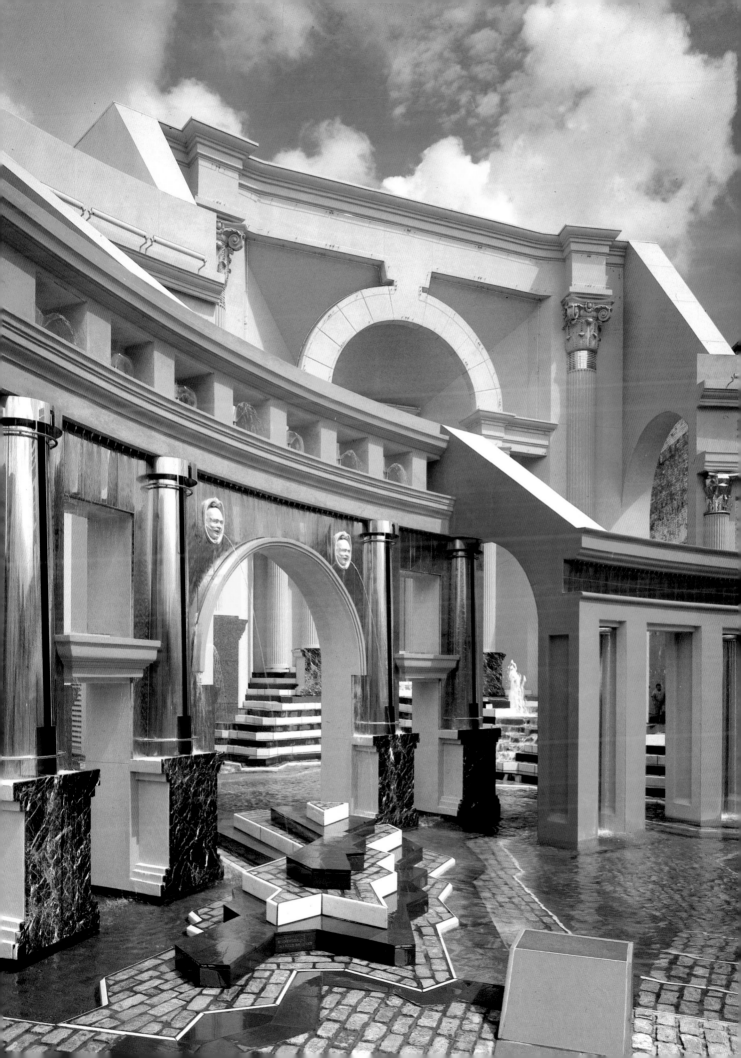

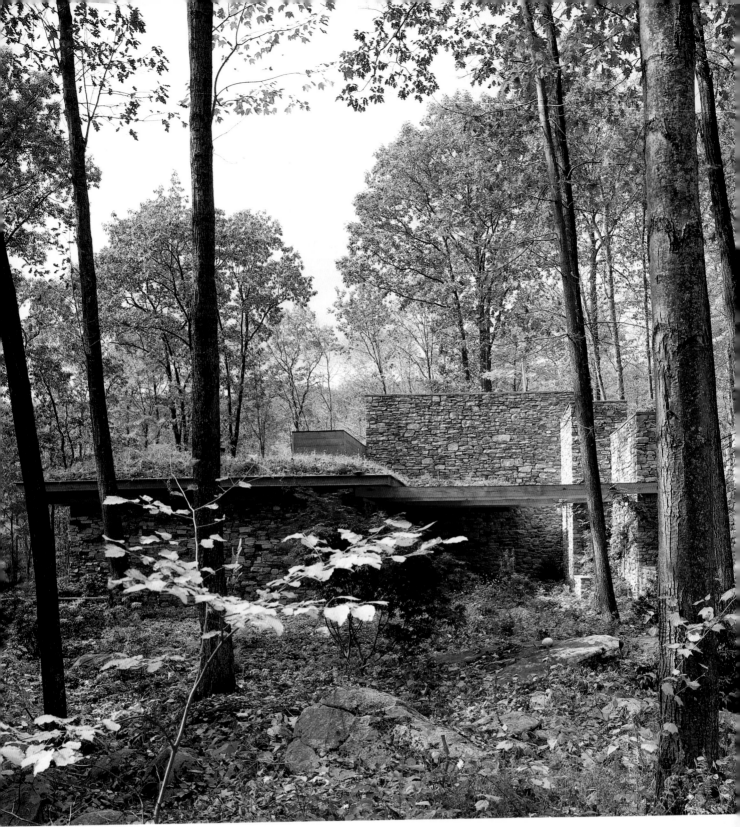

The owners of this New England house, designed by architect Alfredo DeVido, are both graphic designers. The wife is from Japan, which accounts for the Oriental touches that are evident. The couple bought the land and camped on the site for nearly ten years before they decided on just the house they wanted. They were able to harvest enough trees from their property to provide all the wood that was necessary for construction. Having already created the lake, they knew just where the house should go. They were determined not to intrude on the landscape any more than was absolutely essential, and this dic-tated a low house hugging the ground, and in fact partially underground. Skylights provide light to the underground spaces of the house.

The design is so subtle that it is a real challenge to illustrate, particularly in the summer when the foliage is most dense. I had to select just the right time of day to let the filtered sunlight highlight the architecture. At the east end of the house is a partial-ly underground two-car garage. The house was positioned so that a minimum number of trees had to be cut down.

The view above shows how wooded and how natural in . appearance the site is. Directly

A Difficult Site

Having stated that interior and exterior photography fall into two distinct categories, I should now modify that statement in the case of houses, particularly modern ones with large expanses of glass. When documenting a contemporary house, especially for an architect's purposes, the interior and exterior are often of equal importance and for this reason the photographer should take advantage of circumstances that permit these two aspects to tie into one another. Part of a house seen from within can be linked with an exterior view, giving the reader more useful information. Therefore, wherever possible, try to provide some visual overlap. Certainly from an editorial viewpoint, the more clues the photographer can give the reader, the more successful the coverage is likely to be.

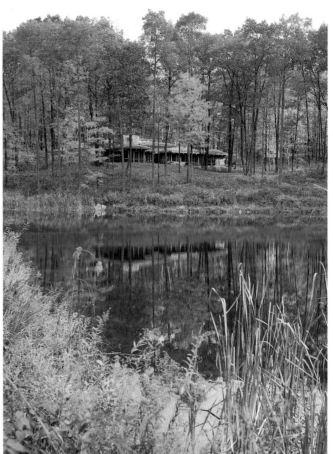

ahead in the center is the entrance court and part of the garage is on the right behind the tree trunks. Note the grass sod roofs. I used a 75mm Nikkor lens so that I could get close to the house with little interruption from foliage. The roof overhangs the walls, creating rather deep shadows in some spots. I had to raise my lens and shift it to the right; this movement is the reason for the slight vignette in the top right corner.

I used Fuji 100D film for all the photographs of this house. I had to use a number 03 Sinar graduated filter to hold detail in the upper part of the composition because of the hazy light.

Above, this tranquil, long view of the house was taken from across the lake with a 180mm Symmar S lens. To add depth to the photograph, I utilized the reeds in the foreground and eliminated most of the somewhat bland sky. This photograph was taken during a late-afternoon shoot.

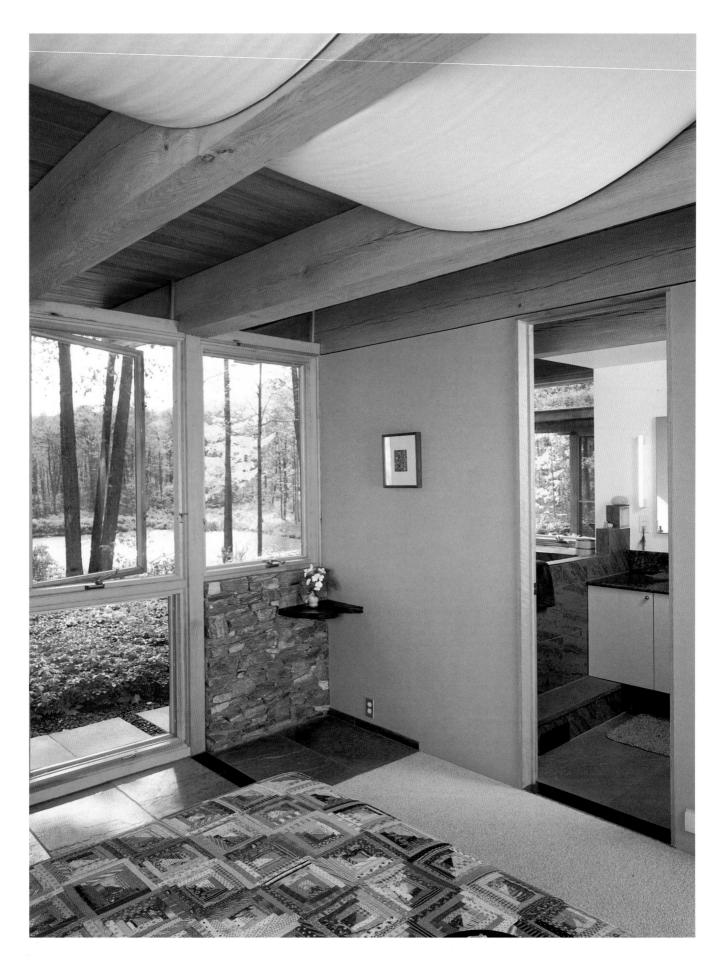

The beautiful view of the lake in the distance, left, is the highlight of this bedroom. The bathroom on the right is fitted with a large, Japanese-style marble bath. The stone floor pattern in the bedroom is mirrored by the flagstones outside, set with bands of black pebbles in between the stones.

I used a bounced strobe in the bathroom with an additional two heads in the bedroom. The open window avoids the reflection of one of my lights. Draped fabric between the ceiling beams creates an interesting effect. I used a 120mm Super Angulon lens for this view.

This photograph, right, shows the skylit passage that runs along the center of the house. The stone wall mirrors the exterior walls and contrasts with the wood and plaster opposite. The sandstone floor, inset alternately with wide and narrow bands of dark granite, leads to a modest-sized dining area at the end of the passage. The pumpkin adds color, in addition to confirming the autumn season. I took this shot with a 150mm Symmar S lens using available light.

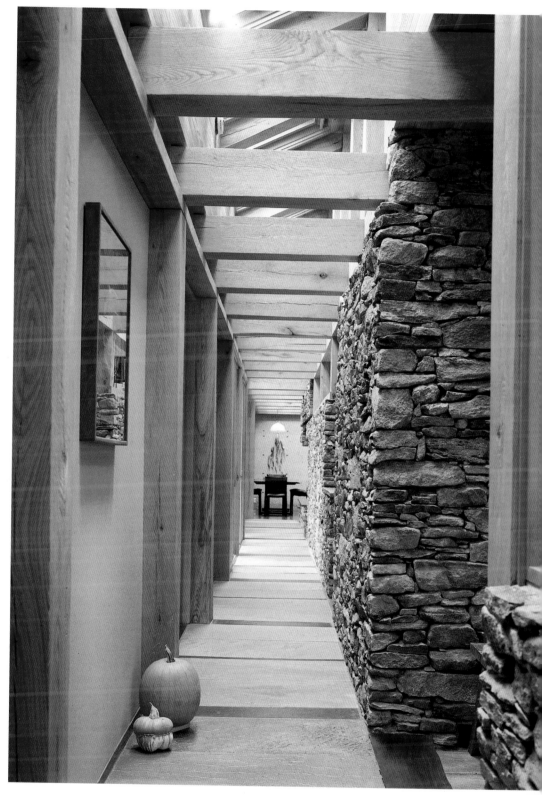

Traditional-Style Houses

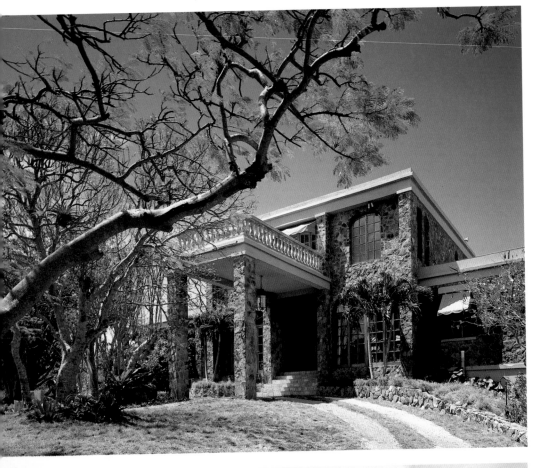

This is a traditional-style, but not old, masonry house on the island of St. Thomas in the Virgin Islands. On the site of an earlier structure, the house has been cleverly designed by architect John Garfield to look like a colonial dwelling of an era long past. Finishing touches to the ground cover were being made at the time of the shoot, so I had to be careful to avoid bare patches. The diagonal tree limb fills the upper part of the composition and complements the roofline, while the curved apron leads the eye naturally into the composition. I used a very low camera position, which enabled me to include more foliage without concealing parts of the house. The low stone wall and the driveway were hosed down to reduce their brightness in the strong Caribbean sunlight.

I used a Sinar F 4 x 5 camera and a 90mm F5.6 Super Angulon lens. Exposure was approximately 1/60 sec. at f/16 with ISO 100 Polaroid Professional Chrome Daylight film. No filtration was needed.

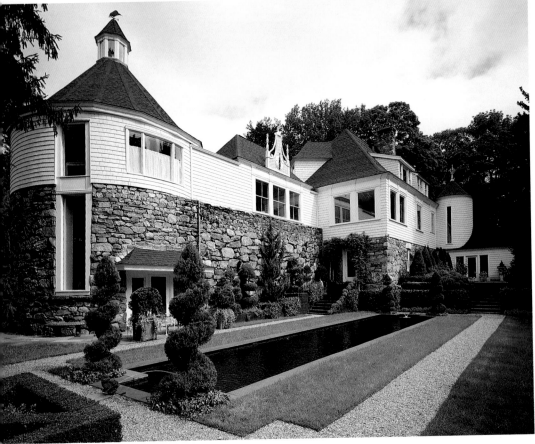

Architect Stanford White designed the ice-house tower on the left and the school-house building on the right. The owner joined the two structures together to produce the striking "Castle House" in northern Westchester County, New York.

The buildings were originally commissioned by the retired president General Ulysses S. Grant as a gift to his son and daughter-in-law in appreciation for their hospitality following his leaving office. The remodeling and restoration work, as well as the pool and landscaping, were completed in the 1980s by Edythe Schubert. The pond is actually a lap pool for serious swimming. Great care was taken to make the link match the original masonry and siding.

The sun provided soft, even illumination so that detail can be detected, even in shaded areas. I used a 90mm Super Angulon lens and Fuji 100D film.

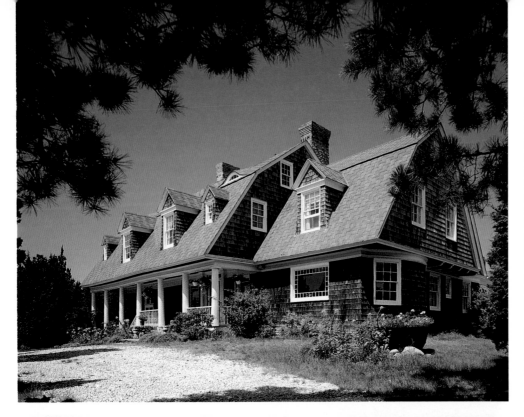

This 1892 house was designed by the architect Stanford White of McKim, Mead and White for his friend the painter William Merritt Chase. Located in Southampton, Long Island, the house's front porch once had a clear view of the Atlantic Ocean. The most flattering and descriptive view shows the south-facing front of the house in combination with the east gable end. This view clearly illustrates the relationship of the dining room wing to the main part of the house where the gambrel roof projects over the full-length porch.

By using a very low camera position, I was able to pull back beneath the overhanging pines without obscuring important features of the house.

The camera-to-subject distance was still comparatively close, requiring the use of a 90mm lens on the Sinar F 4 x 5 camera to include a comfortable margin around the house. The use of such a wide-angle lens at this distance exaggerated the near end of the house. This was partially offset by laterally shifting the lens to the left by between one and two centimeters. The lens was also raised to include more sky and foliage and less driveway.

A 10R filter was used with Ektachrome 64 film to counter the very blue sky. Exposure was approximately 1/30 sec. at f/16.

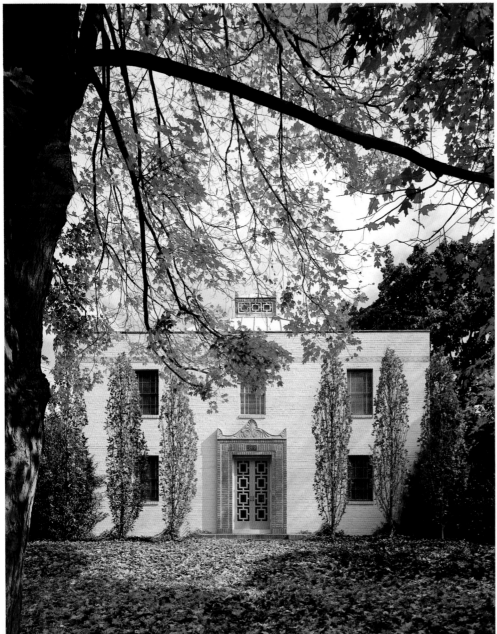

This handsome house designed by the architect Waldron Faulkner is in the Cathedral Heights section of Washington, D.C. On the fall day when this photograph was made, I waited for the sun to brush the front elevation with light to give texture to the brickwork and highlight the detail of the entryway with its combination of stone, brick, and tile. By positioning the camera as far away from the house as I could but staying on axis, I was able to include part of the copper roof and the lantern surmounting it adding emphasis to the symmetry of Faulkner's design. The leaves adds nice texture to the foreground. I used a 120mm F8 Super Angulon lens on the Sinar F 4 x 5 camera. Exposure was 1/15 sec. at f/22, with Ektachrome 64 and a 1A filter.

Contemporary Houses

Houses in the modern idiom tend to rely more heavily on form and geometry for their impact than do most traditional-style houses. Many contemporary designs require a distinctive approach that is guided by the architectural concept and a photographic style that complements it. For architectural photographers, this means avoiding documentation in a predetermined or formulaic fashion. The most successful photographs of contemporary houses are a harmonious blend of design philosophy and interpretive sensibility mixed with a dash of good luck.

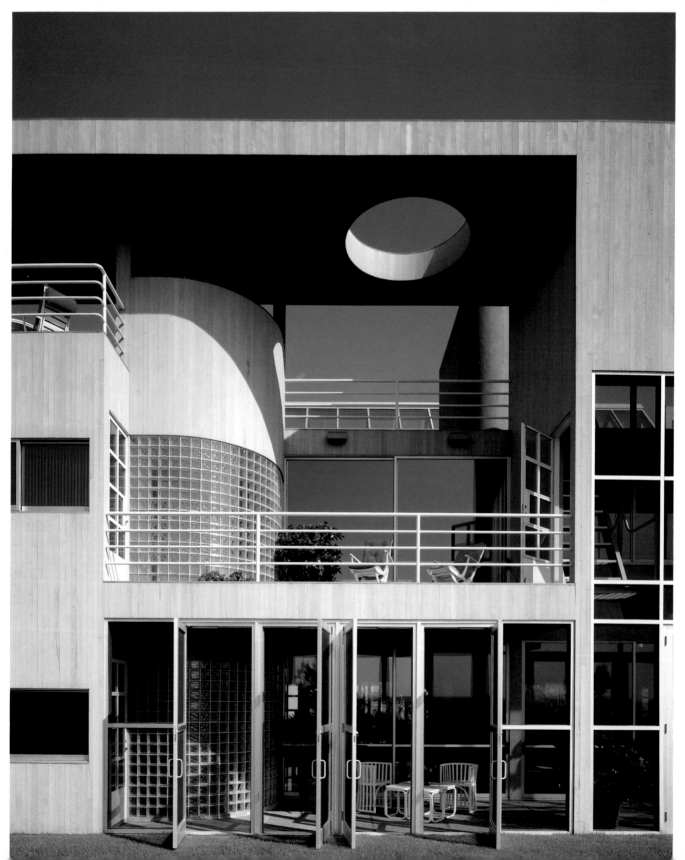

Readers may be familiar with the photograph on the left-hand page. It is on the cover of the book, *Charles Gwathmey and Robert Siegel, Buildings and Projects 1964-1984* (edited by Peter Arnell and Ted Bickford, Harper & Row, 1984). Certainly one of the most complex projects ever to come out of this talented office, the de Menil house in East Hampton, Long Island, is regarded by Charles Gwathmey as "not only the summation of all previous work, but also the opening up of new avenues for future investigation."

The complexity of the design makes the house both a photographer's dream and a challenge to photograph. With so large-scale and multi-faceted a subject, it is difficult to avoid overpowering the viewer with too much visual information in any one photograph. The de Menil house is typical of situations in which the photographer must exercise restraint and self-control.

It is no accident that the most successful images of this mansion are probably those that focus on a particular element. The most dramatic overall documentation is of the less complex entrance facade. On the ocean side, the house presents less opportunity for overall viewing, unless one ventures onto the dunes.

This single photograph illustrates many features of the design: layers, transparency, attention to detail, geometry, and some complex interior-exterior relationships. The axial one-point perspective presents the information in straightforward style. Positioning of plants and furniture at all three levels suggests uses for these areas, and the open doors invite the viewer inside.

I used a 120mm F8 Super Angulon lens on the Sinar F 4 x 5 view camera. The approximate exposure with a 1A filter on Ektachrome 64 was 1/30 seconds at *f*/22. Today's Fuji 100D or Ektachrome 100X film would not require any filtration.

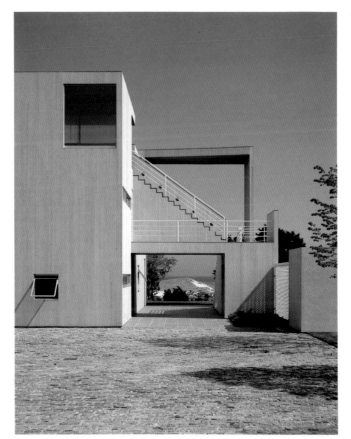

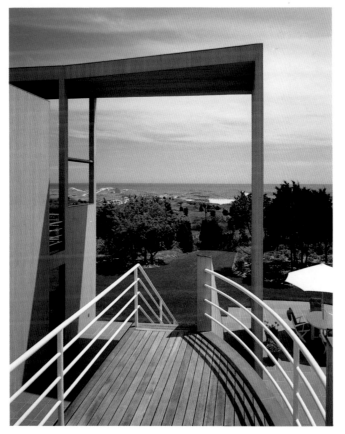

The top photograph on this page shows the west end of the house, which is a portal and frames the visitor's first view of the Atlantic Ocean. On the axis of the long, cobbled driveway, this element is also the link to the swimming pool enclosure to the right. By selecting a longer focal-length lens, I was able to preserve the relationship of the house to the dunes and the ocean. The architecture is reduced to a series of interrelated planes. Strong sidelighting articulates the texture of the vertical cedar siding. The diagonal shadow of the latticed panel counterbalances the lines of the stair and balustrade. The two lower windows were purposely opened, and the upper blinds were adjusted to permit sky to show through.

I used a 180mm F5.6 Symmar S lens on my Sinar F view camera. Ektachrome 64 was exposed at 1/60 sec. at *f*/11 to 16 with a 1A filter.

Another angle on the portal, also framing the ocean view, gives the viewer a sense of the commanding vista obtainable at the second-floor level. I positioned the camera as far back and as high as possible in order to include as much of the foreground deck and railing as I could. The curve is very important to the otherwise rigid geometry. The disappearing stair leads the eye down to the lawn and through the trees to the shore and beyond. The high viewpoint positions the horizon line above the midsection of the portal and is also visible through the wall opening to the left.

A 120mm F8 Super Angulon lens was used on the Sinar F. Approximate exposure was 1/30 sec. at *f*/16 to 22 with a 1A filter and Ektachrome 64 film. The lens was lowered to obtain more foreground and less sky and was offset to the left to limit horizontal distortion that would have resulted if I had pointed the camera further in that direction. The normal optical axis would have been slightly to the left of the supporting wall at the right.

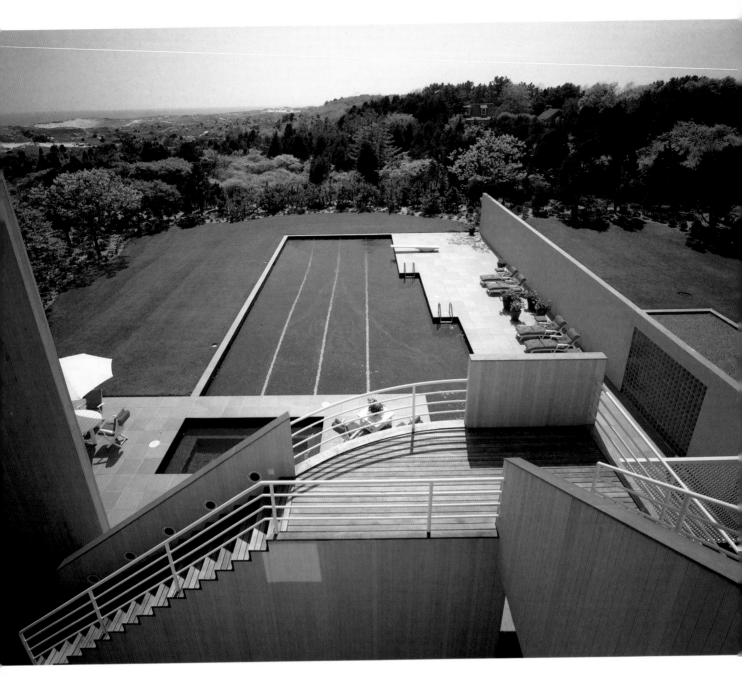

Sometimes distortion can be used in a creative way and may be justified on the basis of the extra information included. For this photograph, I purposely directed the camera at the central axis of the pool terrace and carefully aligned the composition to maintain parallel horizontals. From my position on the roof deck, I tilted the camera downward to include the base of the stair in the foreground, using my widest 65mm F4 Nikkor lens. I also retained a comfortable amount of sky. Note the careful balance of wall shapes, all of them in shadow.

I used the Sinar F camera for this photograph. Ektachrome 64 film was exposed 1/30 sec. at ƒ/16 with a 1A filter.

A delightful feature of this house is an enclosed English-style garden. This elaborate trellis and walkway is parallel to the house on the far side of the garden. The curved wooden arches will eventually support climbing vines and the like, but in the meantime they make a very handsome backdrop for the fine garden. This photograph was taken on Fuji 100D film with a 120mm Super Angulon lens on a Sinar F-2 view camera.

This Nantucket vacation house appears, in the view below, to float on the water. One half of the house is actually bordered by an artificial pond. In addition to the large deck off the living room, pictured here, another smaller deck projects off the master bedroom at the far end. The dark, clouded sky contrasts with the brightly lit facade of the house.

To avoid a reflection that is too mirror-like, create some ripples on the water surface before taking the photograph. If the conditions are windy, there will be little or no reflection and you may have to wait for a lull. I used a 120mm Super Angulon lens with Fuji 100D film; the exposure was 1/60 sec. at *f*/16 to 22.

The architect for this house was Edward Knowles. This house appeared in *Architectural Digest* (August 1990); these photographs are reproduced courtesy of *Architectural Digest*.

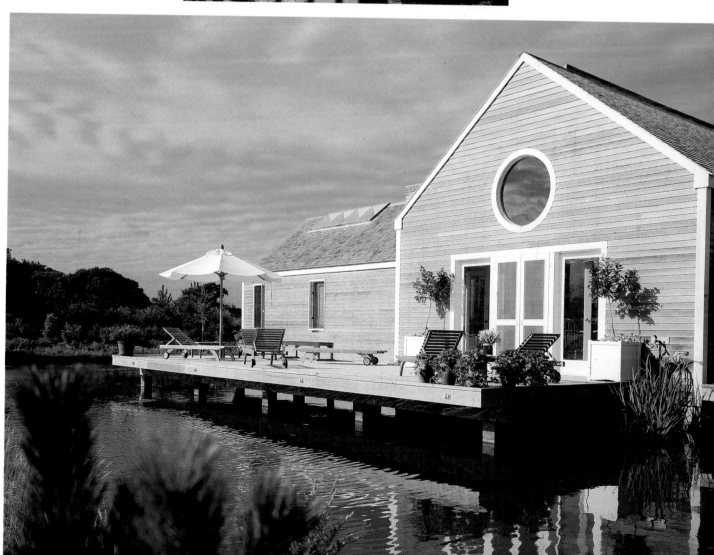

Idaho Revisited

Many architects are impatient to document their houses upon completion. And there is great pressure on an architect to photograph the project as soon as it is completed. Magazines vie with one another for the right to publish images first; some publications even demand exclusivity. The architect must weigh the alternatives carefully. If the landscaping is incomplete, the house will not look its best. Even if all finishing touches to the surround have been accomplished, new trees and shrubs will not have had time to fill out and look the way the designer originally intended.

I first photographed the house on these pages ten years ago for *Architectural Digest*. The owners really liked my coverage of their home, so after many additions to their collection of art and sculpture, plus a new wing, they invited me back to record what it looks like today. Sun Valley is a spectacular place, so here was a golden opportunity for a revisit and re-evaluation. Now the trees are the size that had originally been intended and the landscaping has been shaped and formed, preserving the natural look and highlighting the original design. Interesting large boulders have been set on the hillside as natural sculptures. There are changes inside as well, including the living room furniture. Contemporary Korean sculptures peer into the lower part of the central atrium from a small exterior court.

The architect of this concrete house and its addition was Neil Wright of Ketchum, Idaho. The owners are responsible for most of the changes and refinements to the surrounding landscape.

The drama of the photograph at left is that it is taken directly toward the sun, which you can detect from the direction of the shadows. The backlit trees silhouette against the paved front court and distant mountains. To provide foreground interest, I repositioned the table and chairs. After positioning the camera under the overhanging eave of the front entry and framing the view with it, I took this shot. I used a 75mm Nikkor lens and Fuji 100D film. (The Fuji Velvia film would have provided too high contrast.)

For much of the summer the skies are cloudless, but I was fortunate to have wonderful conditions for photography. A landscape photograph such as the one above would have been far less dramatic without the fluffy, white clouds. I wanted to show a wide panorama, including the monolith on the right and the pair near the horizon on the left. The good strong side-lighting helped the situation. I used a 90mm Super Angulon lens on the Arca Swiss F 4 x 5 view camera and Fuji Velvia film for its particularly good rendition of green and blue.

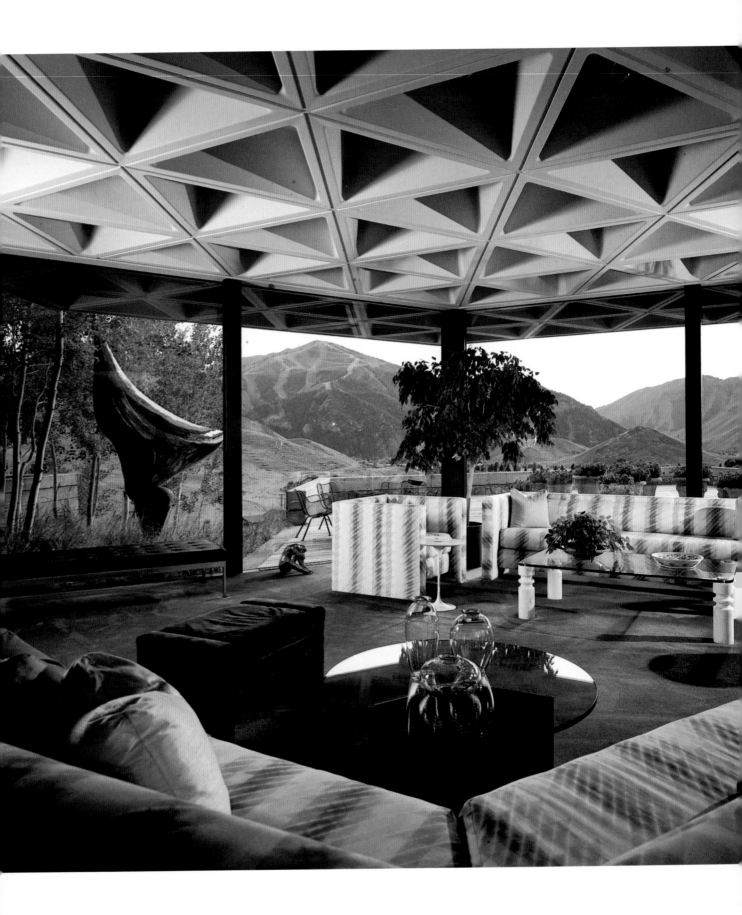

The stunning living room view at left clearly indicates the setting of the house within its surround. Locating my strobe heads was difficult because of possible reflections from the huge expanse of glass. After some experimenting, I found I could camouflage most of the strobe reflection with the Ficus tree in the center. The glazing is heavily filtered, as can be seen by the portion of the roof that cantilevers out beyond the glass. I used the strobe head direct on the right to mimic the sun, which also comes from that general direction. I was able to shield some of the strobe light from the ceiling. I used a 90mm Super Angulon lens and Fuji 100D film for this view.

It took me some time to find an angle to show these Korean sculptures (top, right) relative to the house. They are affectionately referred to as "Baby's Bottoms." Even though there is no direct sun on the house, the sculptures are well lit. I used a 150mm Symmar S lens with Fuji 100D film for this photograph.

The small enclosed courtyard, at right, is situated below the entry to the house. I had to watch the light carefully to determine what time of day was best to record this Oriental style court. At times it was quite dark and at other times, overly contrasty. The condition for the shot I took seemed a reasonable compromise. The light striking the figures is sunlight reflected off a window above. Eventually the concrete wall on the right will be covered with green vines, but in the meantime the supporting wires make a nice diagonal pattern.

I selected a 120mm Super Angulon lens and Fuji 100D film. I tried a wider lens but it made the courtyard feel too small and overemphasized the house above.

Landscaping

Landscaping can range from the careful siting of a structure to take advantage of natural elements in the surroundings to a formal, entirely man-made setting. More often, it involves a combination of the two approaches. Landscaping can entirely transform an otherwise mediocre design; conversely, a poor surround will prevent what might otherwise have been a masterpiece from obtaining deserved recognition.

I can offer few rules for photographic documentation except to suggest careful analysis of the most photogenic aspects of the subject. Unusual or elevated vantage points may be required for best results. Certain types of gardens may be more successfully photographed with moody or overcast lighting. Relating different elements within the design is particularly valid when the viewer must rely solely on photographs for an impression of the design.

In this Massachusetts residence, opposite page, the main house, the guest house, and the setting for them are the work of the Japanese architect, the late Teruo Hara. All the carefully planned terracing, the steps, the waterfall, and the marvelous granite bridge to nowhere are the product of his fertile imagination. Painstakingly shaped and pruned, even the native trees of Martha's Vineyard assume an Oriental form. Every rock and stone has meaning and purpose. The astonishingly authentic traditional-style Oriental villa, nevertheless, fits comfortably in an American setting. The house and garden were handcrafted by Hara and a small group of Korean workers.

This view is from the equally authentic teahouse. The late afternoon light produced a soft and peaceful atmosphere. I used a 180mm F5.6 Super Angulon lens on my Symar S camera. Ektachrome 64 film was exposed at 1/15 sec. at ƒ/22.

The view of the entrance to the Tashkovich house was taken from the roof. Even though only small parts of the house are shown, the viewer has a suggestion of its generous dimensions and clean, modern lines. There is also more than a hint of formality in the slate paving, punctuated by the masonry retaining wall and manicured lawn beyond. The position of the flowering cherry tree draws attention away from a dull gravel forecourt.

The composition of the photograph is enhanced by the diagonal thrust of the walkway, which leads the eye upward to the disappearing driveway. I used a 120mm F8 Super Angulon lens on my Sinar F camera. Ektachrome 100 film was exposed at 1/15 sec. at ƒ/16 to 22. Photography was for Vuko Tashkovich, the designer of both the house and landscaping, and was done for his personal use and for potential publication.

I have always thought that this setting for a building devoted to atmospheric research is particularly appropriate. Ezra Stoller's photograph of I. M. Pei's design for The National Center for Atmospheric Research in Denver, Colorado, perfectly captures the way the complex fits into the natural landscape. The fact that the subject occupies such a small area of the composition only heightens the drama. Stoller took this photograph in 1967.

Eero Saarinen left a legacy of spectacular buildings when he died in 1961. One of them is the IBM Building in Yorktown Heights, New York. This sleek, long, low, curving building sits on a hilltop in Westchester County. The sweep of grassy expanse rising up to the dark glass facade is breathtaking. Only an occasional tree interrupts the panorama of the unspoiled surrounding countryside. I don't know if the site was originally as open as my photograph suggests, but the minimalist treatment was, and is, appropriate. I took this 35mm shot in the fall of 1962, early in my photographic career, but it still appeals.

I used Kodachrome II, as it was then called, in my Nikon F camera. The Kodachrome of 1962 was higher in contrast than today's product, a factor that did not help this photograph. Exposure was probably 1/50 sec. at f/8 with a 24mm F2.8 lens. The photography was done for one of IBM's public relations departments.

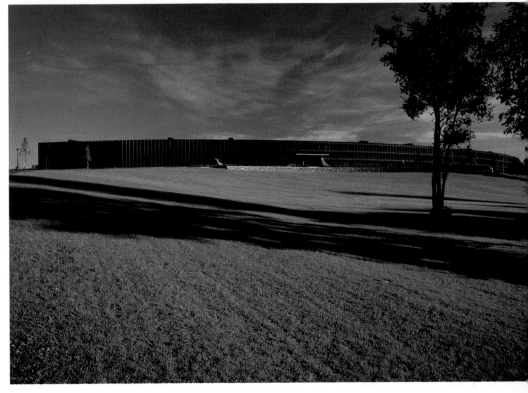

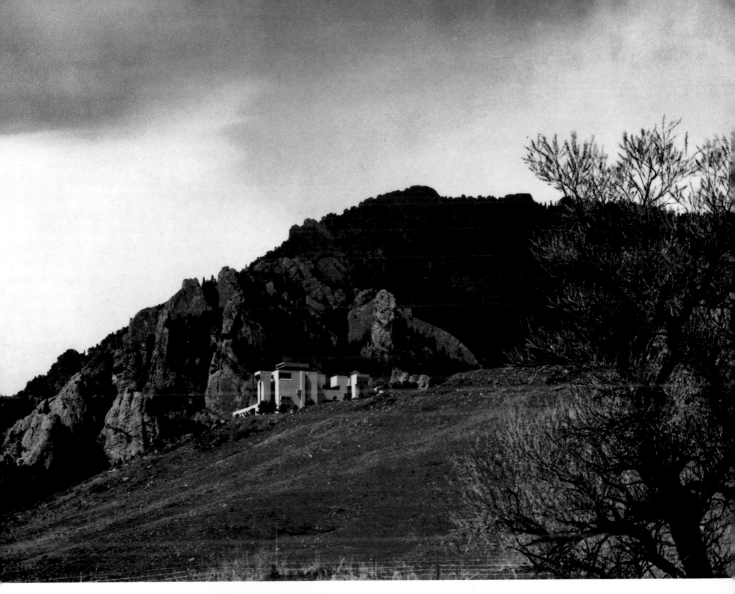

At the back, or concave, elevation of the building is a moat with walkways bridging it. These provide access to the parking areas at the rear. The moat contains not water, but a sea of white gravel with grass islands floating in it. Flowering trees add to the Oriental quality and provide a particularly pleasing prospect from the offices on this side of the complex. The red crab apple trees add a colorful touch. The highly textured masonry walls contrast with the sleekness of the windows.

Even after twenty-five years, the Kodachrome exhibits no evidence of fading. I used a 24mm F2.8 Nikkor lens on a Nikon F. Kodachrome II was exposed at approximately 1/60 sec. at f/8. The landscaping for the Saarinen-designed IBM facility was by Sasaki Associates.

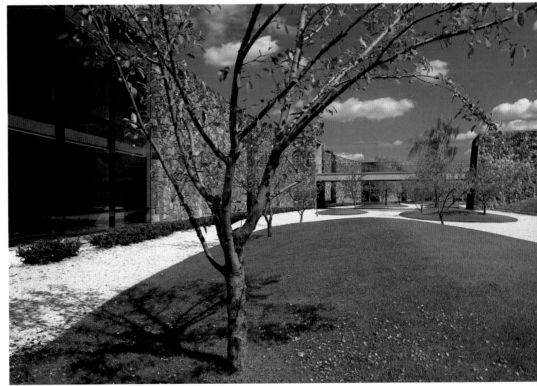

Large Urban Buildings

Photographing large urban structures in city surroundings is, typically, a problem of limited access. Often it is impractical to utilize the best vantage points. The photographer constantly has to compromise.

Specific equipment may be required in order to successfully complete the project, and this can only be determined by advance scouting. When preliminary or construction photographs are available they can sometimes provide useful information. A walk around the job by both the architect and the photographer—together—can be invaluable. The designer may express some desires and preferences *in situ* that the photographer might otherwise be unaware of, and the photographer may point out obstacles or conditions that could significantly affect the success of the picture-taking.

Advance preparation will frequently help. For example, flags that might not otherwise be hoisted can be arranged for; window-washing rigs can be moved, if not removed; parking can be restricted; fountains can be turned on or off; unsightly garbage receptacles or vendor stands can be concealed; offending signs can be relocated. With enough advance warning, power lines or other temporary services sometimes can be eliminated. Make sure that all the appropriate people have been alerted to the photography. Nothing is more annoying than being unable to accomplish the objective because of an unanticipated condition.

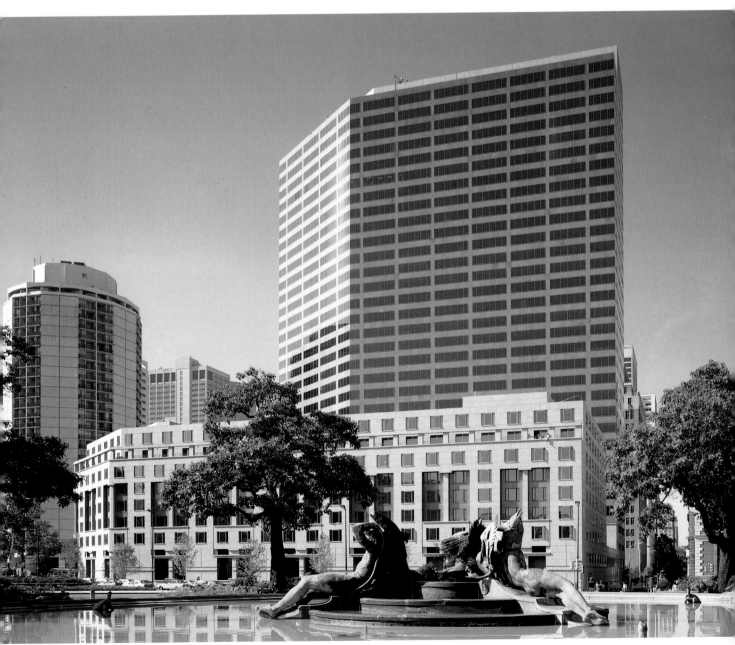

In many situations it is only possible to capture part of a building in a downtown location, such as the one at right, in San Francisco. There was no way to get back far enough in order to show any more of the tower than I have included here without tilting the camera upward, which would have produced an entirely different result, as you can see by looking at my photographs of Citicorp in New York City (pages 180-81). I was stretching things to the limit optically, as you can see by the vignetting at the top left corner.

I was photographing from an elevated plaza underneath part of the building across the street. The angle of the sun was very high off to the left, so only the terraced plaza and background buildings on the right catch direct sunlight. The photograph could be cropped somewhat from the top to eliminate the vignette and would probably be just as strong. 101 California was designed by Johnson/Burgee Architects. I used a 75mm Nikkor lens with Fuji 50D film.

I particularly liked the way the sunlit plaza bounced light back into the lower part of the main tower. I used the interesting granite steps and potted flowers to shield the lens from the very bright paving beyond. I decided to crop this shot to a square format, which I feel is stronger than the vertical I had taken originally. Again, I used a 75mm Nikkor lens on a Sinar F-2 camera, with Fuji 50D film.

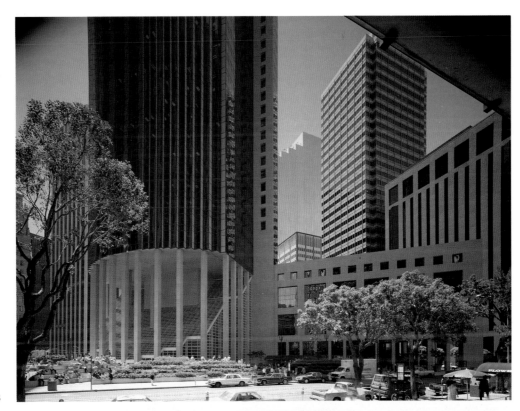

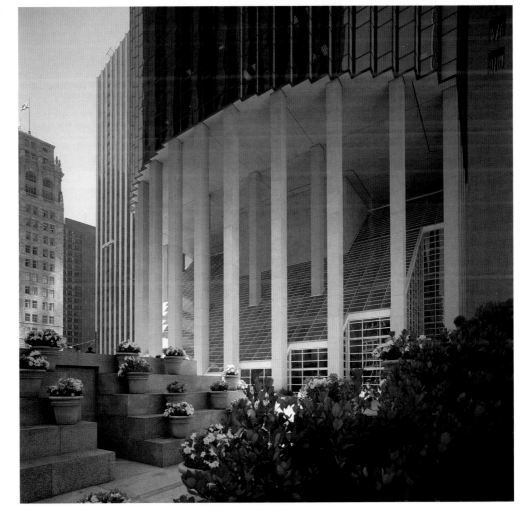

In the early 1980s, Hercules, a diverse multinational company, built a new headquarters in downtown Wilmington, Delaware. Designed by Kohn, Pedersen Fox's Arthur May, this prominent site overlooks a small public park running along the bank of the Delaware River. The surround is a mix of contemporary office structures of varying quality and some old, small houses.

The subtle geometry of the building's architecture changes the viewer's perception of the structure's overall shape, according to one's distance from it as a comparison of these four photographs shows. The building is set behind a red brick forecourt. The base is of granite with modest-size windows to better relate to its environment. A mirrored glass block rises from the base. The contrasting treatment effectively reduces the very substantial mass of the complex.

The ample plaza considerably simplified the photography. An adjacent parking garage provided me with a very convenient and flexible vantage point from which I made the photograph seen at the right. I used a 90mm F5.6 Super Angulon lens on my Sinar F camera. Exposure for Ektachrome 64 film was 1/30 sec. at ƒ/16 to 22, with 1A filter. I shifted the lens to the right to correct some of the horizontal convergence and raised it to reduce the foreground. The detailing is enhanced by the clear afternoon sidelighting.

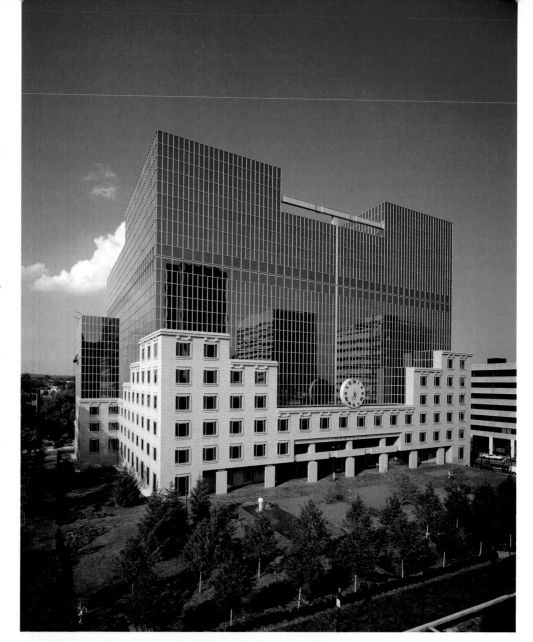

The lower photo shows a pedestrian's view of the plaza and main entrance from across the adjacent street. The true size of the large, precariously balanced clock can now be fully appreciated. The difference in the apparent scale of the building compared to that seen in the previous photograph is arresting. The inclusion of people helps.

For this more compressed view, I used the 180mm F5.6 Symmar S on the Sinar F camera. Ektachrome 64 film with a 1A filter was exposed for approximately 1/30 sec. at ƒ/16 to 22. Substantial lens rise was used to include the upper, near corner of the granite base as well as a portion of the tower without losing the base of the steps.

Once the park had been completed, I was able to take this ground-level shot, which also gives the viewer some idea of the setting. The proportions are less distorted than in some of the other photographs. Unfortunately, with the cloudless July sky, there is little to suggest the reflective nature of the mirror glass.

Because of its orientation, this facade receives direct sunlight only until about 9:30 or 10:00 A.M. The left side was already in shadow when I took this picture, but the angled planes contrast nicely, particularly the slight corner bevels, I had a window-washing rig removed from the right, but even after removal, part of it was visible on the lower roof. (It had not been in an earlier view from a different

camera position.) I used a 120mm F8 Super Angulon lens on my Sinar F. Ektachrome 64 film was exposed for 1/30 sec. at f/16 to 22 with a 1A filter.

Backing up as far as possible in a park, I took a precisely axial elevation. Although most of the clouds were low in the sky, they do reflect in the two main panels of glazing. This view emphasizes the angle of the side elements. The strong, clear light enabled me to capture the subtle details of both stone and glass surfaces. The height of the atrium can be appreciated because its skylight is seen through the topmost openings. To prevent the grass slopes from concealing the base, I elevated the camera tripod to its fullest extension.

Why does the shape of the building look so different in this view when compared to the photograph above? My proximity to the subject has changed the perspective. The axial camera position and careful leveling ensured that all the planes of the building that are normal to the film plane exhibit no linear distortion; the verticals remain so and the horizontals are all parallel because I used no lateral lens shift. However, the angled surfaces become increasingly exaggerated as they recede from the horizontal axis or ground plane. If the building were higher, the effect would have been even more pronounced.

The darkness of the upper sky is due to light falloff resulting from the considerable offset with such a wide-angle lens. A center-weighted, neutral-density filter will eliminate this but requires at least a two-stop exposure increase and is expensive. The filter must be matched to one particular focal length only.

I used a 75mm F4.5 Nikkor lens on my Sinar F. Ektachrome 64 film with a 1A filter was exposed at 1/30 sec. at f/16.

Long, Low Buildings

The most widely used standard in the field of professional photography is the 8 x 10-inch print. (The equivalent business standard is 8½ x 11-inch size, which is only fractionally different in proportion.) The proportions of a 35mm slide are substantially longer, or less square, than the 8 x 10 format. Many photographic subjects don't easily fit into either of these shapes.

It may prove to be quite a challenge to produce a satisfactory composition from an extremely horizontal building, unless the photograph can be cropped to suit the subject. Long, low structures, particularly when photographed from some distance, sometimes appear to lack impact. One solution is to wait for interesting or unusual skies to relieve what will otherwise be a featureless area of the composition. Take advantage of trees and other greenery to frame the subject whenever possible.

Another solution is to select a rather extreme viewpoint, perhaps very low and quite close, to introduce some drama. Try shooting along the facade, with part of the structure close to the camera, to fill the frame more fully.

I have cropped the entire upper half of this photograph to make a long panel, which suits the subject. For this project, I did want to have at least one image showing the complete design, but the sky was cloudless, and there was nothing in the surroundings to improve the composition. The east and south surfaces have sufficient contrast, thanks to the sun's more southern position.

Apart from the young trees, there is little to suggest the building's true scale. It is forty-five feet high from the top of the berm. I was unable to have the yellow mower moved.

The windowless structure is a giant automated warehouse. The architects were Richard Dattner and Associates in collaboration with Davis Brody.

I used a 90mm F5.6 Super Angulon lens on my Sinar F. Exposure was approximately 1/30 sec. at f/22 with a 10R filter.

To create a somewhat less bland image, I made this variation. Moving much closer,

perhaps half the distance to the near corner, I needed a much wider lens. The combination of these two changes results in a greatly increased contrast between the relative size of the near and far corners. Again, I cropped off the upper part of the 4 x 5 transparency to produce a more balanced composition.

I used a 75mm F4.5 Nikkor lens on my Sinar F. Ektachrome 64 film was exposed at 1/30 sec. at *f*/22 with a 1A filter.

This detail view picks up two corners at the rear of the building. I was able to concentrate on the juxtaposition of the two round vertical elements and the large tube to the left, which provides an enclosed pedestrian link between the warehouse and the rest of the facility. The vertical format contrasts nicely with the extreme horizontals. With the inclusion of a figure on the stair landing and the red door, the true size of the complex now becomes apparent. I waited for just the right light; the shape of the shadow is very important to the composition.

I used a 180mm F5.6 Symmar S lens on my Sinar F. Exposure was 1/30 sec. at between *f*/16 and 22 with a 10R filter.

The industrial complex shown here is an extremely horizontal subject. Even at a distance I needed an ultra-wide lens to encompass it. This presents a problem with 35mm equipment, since the widest lenses lack shift capability. This usually means too much foreground and sky. In scouting around, I found this meadow of wildflowers on a little hill overlooking the site. With the aid of an eight-foot stepladder, I took this shot very early in the morning. I needed the extra height to get an unobstructed view of the facility and to make the most of the floral foreground. The fluffy white clouds enhance the photograph greatly. The facility houses oilfield-related servicing equipment for Schlumberger in Aberdeen, Scotland. The architect was Jean Pierre Bonneau of Paris.

This preparatory day school has two long wings at right angles to one another. The classrooms are contained in a series of two-story, triangular-shaped projections clad in white-painted industrial siding. Above the linear glazing, a continuous awning projects, adding further horizontal emphasis. The ventilation system is expressed by large ducts which punctuate the roof.

Careful observation enabled me to select a time at which the sunlight produced a wide variety of contrasting tones. Photography was scheduled during term time because human figures were very necessary to this composition. The clouds also add greatly. The photography was done for the architects Hardy Holzman Pfeiffer Associates and Progressive Architecture. The Pingry School in New Jersey appeared in the August 1984 issue. Their award-winning coverage used this photo, cropped horizontally across two pages.

I used a 65mm F4 Nikkor lens on my Sinar F. Ektachrome 64 film was exposed at 1/50 sec. at f/16 with a 1A filter.

To contrast and complement the other shot, below, I did a long-focal-length lens view which compresses the elements I wished to record. These distinctive profiles of the corners, superimposed as they recede, create a strong vertical composition and also show some of the wooded surround. By careful camera positioning and lens selection, I was able to control the location and size of each of the three corners. (The longer the lens, the closer in image size the three sections become; the apparent distance between them diminishes. The camera, of course, has to be moved further from the subject.)

I used a 240mm F9 Schneider Claron lens on the Sinar F. Exposure was 1/30 sec. at f/22 with Ektachrome 64 and 1A filter.

It may be argued that the bicycles in the top photograph distract from the architecture. (I made plenty of views without them, of course.) But since this assignment was for an annual report rather than for the design press, I took greater liberties than usual. Approaching rain clouds add greatly to the drama. British architect Michael Hopkins designed the Schlumberger Cambridge Research building in the United Kingdom.

Kodachrome 64 film was exposed 1/125 sec. at ƒ/11. I used the Nikon FE-2 with a 28mm F3.5 Nikkor PC lens, with some lens rise to include additional sky.

Even with the little cloud, the network of cables adds the necessary interest for this vertical composition. The delicate dimensions of the supporting structural system are an integral and major part of the design. The facility is a research center for oil drilling, testing, and pumping services.

I used the 28mm F3.5 Nikkor PC lens on my Nikon FE-2. Exposure for Kodachrome 64 film was 1/125 sec. at ƒ/11. For more views of this installation, see the information on aerial photography in the section entitled Handling Special Situations.

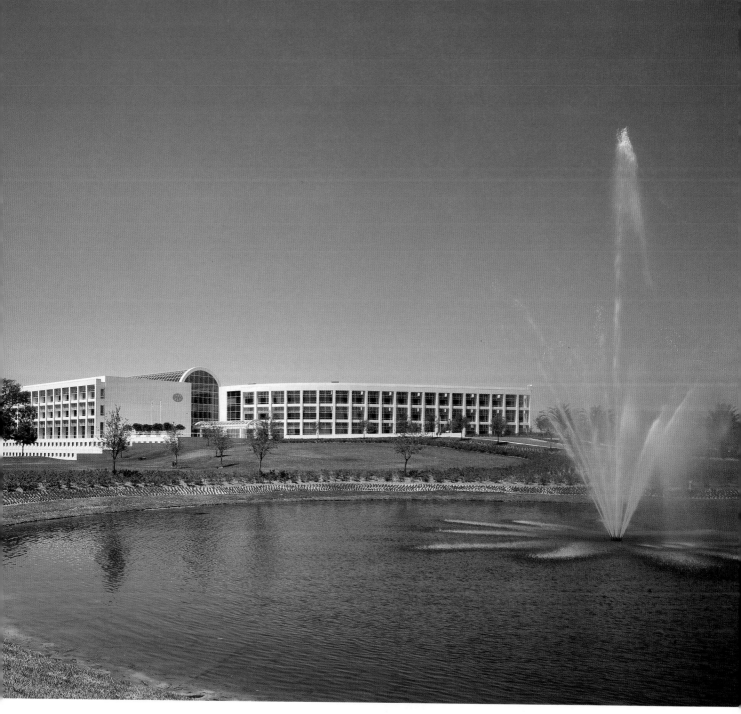

One of the many newcomers to the corporate scene in Orlando is the American Automobile Association (AAA), whose headquarters is pictured here. The building is very large, with wings extending from either side of a multistory, dome-roofed atrium. The company owns a large property, which includes the lake and fountain shown here, as well as another lake on the left closer to the building. Apart from the trees, there are few vertical elements that I could use to interrupt the strong horizontal emphasis of the composition. By careful positioning I was able to show the curve of the lake edge and the fountain on the right. I really could have used an interesting sky to make the composition more compelling, but none was forthcoming. I did take another version, with the fountain on the left, but I preferred this one. Like Texas, Florida has a lot of sky, so picturing this much expanse seems natural.

The architect for this project was Spillis, Candela and Partners. I used a 150mm Symmar S lens with Fuji 100D film exposed 1/60 sec. at f/22. (See page 193 for an interior view.)

Florida: The New Look

When photographing groupings of buildings, the relationships between them are paramount. Yet there must be emphasis on the individual designs.

When a complex is a series of buildings, designed by one architect and all carefully related to one another, the photography should be relatively straightforward. What is usually more difficult is capturing the subtlety of neighboring structures that are not clearly cognate. And along with all the other concerns, a good photograph needs to be composed with artistic merit. In photographing groupings of large buildings, this takes some luck and occasionally great perseverance.

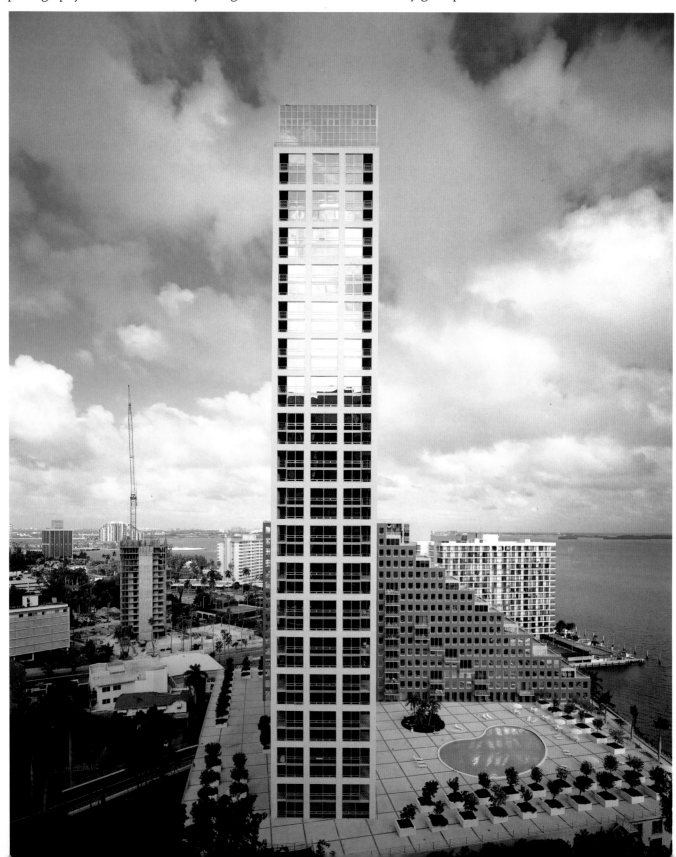

The Palace is seen in the foreground of the photograph at left. A second project by the firm is seen nearing completion, in the distance. Although completely different, these two share a complementary, fresh vocabulary of style. Between the two towers is a third building, not by the same designers, which I purposely blocked by the palm trees. A crane on the second structure is almost concealed. I wanted particularly to show the way the Palace steps down to the waterfront with low condominium units closest to the shore.

I used a 90mm F5.6 Super Angulon lens on the Sinar F. Exposure for Ektachrome 64 was 1/30 sec. at ƒ/16 to 22 with a 1A filter. Photography was for *HG*.

Further down the promenade is a third building by Arquetectonica, the Atlantis. A striking feature of this residential block is the sky court. After trying several different vantage points from an adjacent block, I found this one that had a contrasting background of greenery and was close to the axis of the opening. In addition to the red spiral stair, the court boasts a large palm tree and a raised hot tub, overlooked by a tiny balcony that cantilevers from an undulating yellow wall. Down to the lower left is the start of four yellow balconies that contrast with the otherwise all-glass facade.

I used Kodachrome 64 film and a 35mm PC lens on a Nikon FE-2 camera. The Atlantis was featured in *Progressive Architecture*. See page 6 for a view of the sky court, from the opposite side of the building.

The resort community of Coral Gables, Florida, has seen enormous growth and development in recent years. Some of the most exciting work is that of Arquetectonica, which includes the Palace, shown here.

At first glance, the photo on the facing page may appear to be two separate buildings. It is not. Relating in scale to its neighbors to the east, the red, stepped-block unit butts at right angles to the slim tower and penetrates it, reappearing on the opposite face. Its crisp detailing contrasts with that of the nearby structures.

I found an unfinished balcony on an adjacent construction site that provided the axial viewpoint I was looking for. Cloud cover enabled me to shoot without unmanageable contrast. I was quite close to my subject and had to use my widest lens. This is most noticeable in the amount of light falloff at the bottom of the picture and in the plaza paving. It would have been better to have had people around the pool, but this was shot in November.

I used a 65mm F4 Nikkor lens on the Sinar F. Ektachrome 64 film was exposed at 1/30 sec. at ƒ/11 to 16 with a 1A filter.

Tall Buildings

The documentation of multistory structures in confined spaces is probably the most difficult task the architectural photographer faces. Nowhere does this seem more true than in Manhattan, my hometown, where the density of the midtown and downtown is more acute and the ratio of street width to building height more extreme than anywhere I know.

From a practical standpoint, it means that straight-on elevations are rarely possible and overall views showing an entire tower are challenging even when practical. The consequence is that the photography of skyscrapers is frequently reduced to a selection of the least damaging compromises.

When the only vantage point is not only too close to the subject but also at an awkward angle to it, the situation is tailor-made for distortion. Ground level is often the worst of all vantage points. A wide-angle lens/camera combination, pointed sharply upward, will yield tremendous convergence of vertical planes as well as of horizontal elements and is usually very unflattering. I usually try to avoid this. When photographing a small tower from the ground, I try to obtain an axial view which enables me to keep the horizontal components parallel. Even though the camera may be far off vertical, some lens rise (when equipment permits) reduces the degree of convergence on the verticals. I rarely attempt to include the ground level of the structure in such shots. Occasionally, one can use distortion creatively to produce an interesting composition, but only rarely is this likely to flatter the design.

If the photographer is fortunate enough to find an above-ground location that is at a good angle to the subject, then the problem may be reduced to simply having a sufficiently wide-angle lens to encompass it. Advance scouting helps here, perhaps with a small-format camera. Don't rule out renting or borrowing special optics for the final shoot; the quality of the lenses may be critical. When substantial lens offset is used, both light falloff and vignetting can occur. Expensive center-weighted, neutral-density filters may eliminate the former, but only switching to an even shorter focal length can cure the latter. The drawback is that the shorter the focal length, the less the lens movement capability will be.

The projects shown here are the Republic National Bank, midtown Manhattan, and the World Financial Center, with the Twin Towers of the World Trade Center in the background, downtown Manhattan.

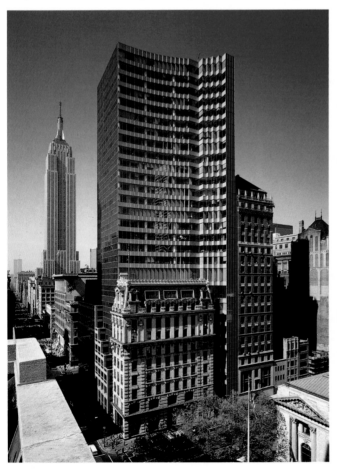
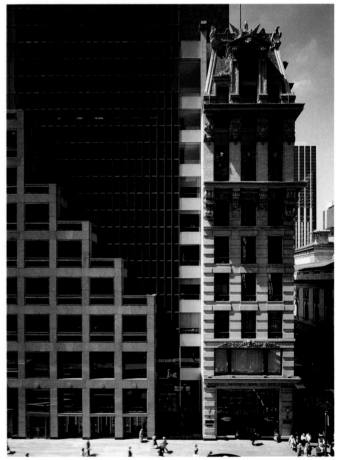

The fortunes of this bank have grown substantially since its founding in New York, as has its headquarters. I originally photographed only the older corner building, when the bank first moved in. They then acquired the adjacent property south, along Fifth Avenue. At that point, architect Eli Attia was retained. His mission was to design a tower backdrop for the original classical building, to provide a large public banking facility south of the old block, and to provide retail rental space at street level for the remainder of the Fifth Avenue facade. All the interior spaces were integrated together with the upper levels of the corner building providing much of the bank's new executive offices. Attia developed a complex scheme with the north face of the main tower stepping in ever-increasing increments to the northwest corner.

I could only obtain good light early in the day, in summertime. At other times of the year, buildings to the east cast unwanted shadows. It was only after several futile attempts that I was able to gain access to this vantage point. Others viewpoints were too close, requiring extreme wide optics that distorted the shape of the building. Further back the trees and the Public Library begin to intrude and the Fifth Avenue facade is even more acute.

I was particularly pleased to be able to relate my subject to the Empire State Building in the background. I was able to capture the entire project easily with a not-too-wide 90mm Super Angulon lens on my Sinar F camera with Fuji 100D film. I was lucky also to find yet another above-street-level viewpoint for a detail of the northeast corner, where the three elements converge. This indicates the very interesting way in which these very different facades link hands. I had to use a 65mm Nikkor lens to fully fit in the corner building. By keeping the focus plane normal to the facade I minimized distortion (and the horizons remain parallel). I used Fuji 50D for this shot.

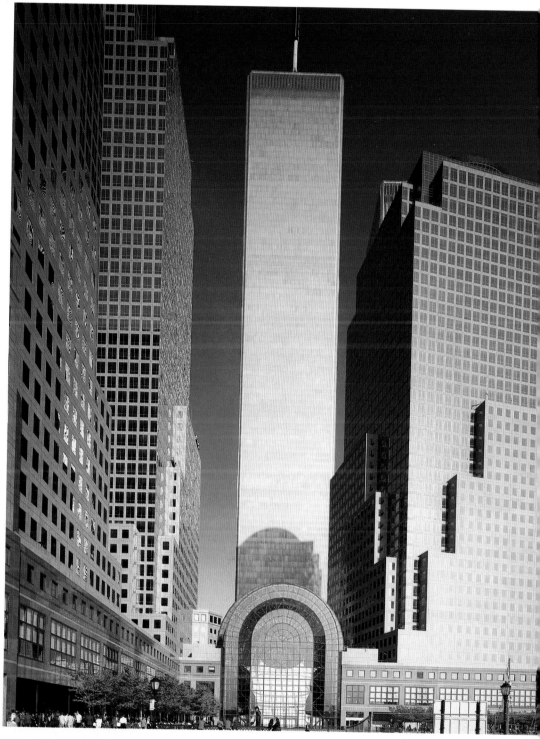

This photograph was part of a lens test I made with Schneider's latest 90mm Super Angulon XL lens. I was amazed when I saw the Polaroid test as it was very difficult to view the extremities of this shot. I figured that the angle of elevation from my camera to the top of the central Twin Tower was over 60 degrees. The lens rise was 5 centimeters. This shot would not have been possible with any other lens currently available.

There is some light falloff but as you view upward, both the buildings and the sky look darker. Note the upper corner of the second tower behind the building on the right. I used an Arca Swiss camera with Fuji 100D film. Exposure was 1/30 seconds at $f/22$.

Yamasaki designed the Twin Towers. Caesar Pelli was the architect of the World Financial Center.

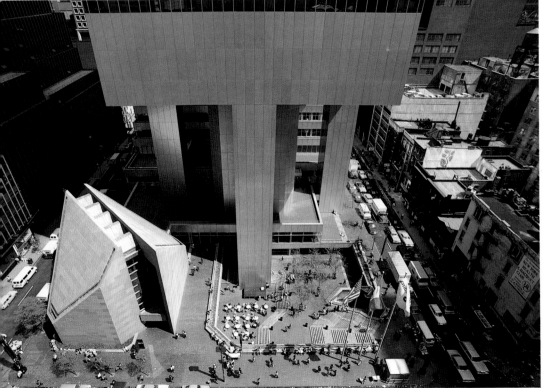

The photograph above left became the cover of the June 1978 issue of *Architectural Record*. Format for covers of this magazine are almost square or slightly vertical.

I had taken most of the upward-looking views from ground level from the opposite side of the street, but in walking around closer to the base of the tower, I discovered this angle. The dramatic way in which the building rises above its giant free-standing columns is a major

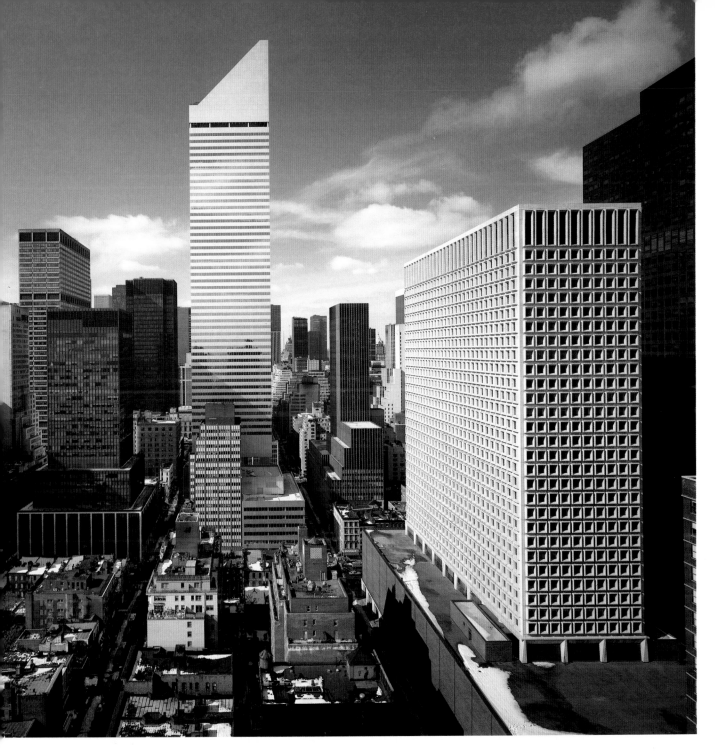

feature of the design. In February, the north facade receives little or no direct sun, only bounced light and fill light from the sky. The aluminum panels have a sheen which picks up highlights. Sunlight on the walkway above is reflected by the underside of the tower.

In this situation, I used a 90mm F5.6 Super Angulon lens on my Sinar P camera. Exposure with Ektachrome 64 was approximately 1/15 sec. at ƒ/16 with a 1A filter.

On the facing page, lower left, is a rare example of a successful downward-looking view. By late April, the higher altitude of the sun reached down into the plaza underneath the tower, where access to the various arcades, lobby, a chapel, and subway entrance is provided. By advance scouting, I found the ideal camera location on one of the setbacks of Citibank's building to the west. Just as I was about to shoot the photograph, the fountains were switched off.

A telephone call to the right person brought them back into action. The only unplanned addition was the temporary platform at the base of the central column.

I used a 24mm F2.8 Nikkor lens on a Nikon FE-2. Exposure was 1/125 sec. at ƒ/8 with Kodachrome 64 film.

Although nearly two long blocks away, the vantage point for the above photo was ideal, since I was able to make an elevation view of the entire tower. No other high buildings compromised the photograph. Not only is this view of the project a flattering one, but the cityscape complements it. By using my widest lens, the foreground streets and buildings all converge and focus on the subject.

I used a 65mm F5.6 Super Angulon lens on a Sinar P. Exposure for Ektachrome 64 with a 1A filter was approximately 1/30 sec. at ƒ/16.

HANDLING SPECIAL SITUATIONS

No guide to the documentation of architecture, inside or out, could possibly cover all the varied situations that can arise to test the mettle of photographers. Most of the examples in this chapter, therefore, are in the nature of tips on how I solve certain problems that are particular to the experience of architectural photography.

These vary from how to get high enough, low enough, or sufficiently far back from a subject to how to handle tricky filtration problems. Sometimes only the camera can be in the optimum position, not the photographer. I have suggested compromises for situations where particular equipment was either unavailable or where its use would have helped but, for one reason or another, was not at hand.

Remember, there may be several ways to achieve your objective. Some solutions may be obvious, but others are less so. Many procedures followed by professional photographers are utilized for speed, convenience, or consistency of results. Comparable results are sometimes obtainable using less elaborate equipment but more time.

In the photograph below, I had to elevate my camera as high as possible. Here, I was shooting the 35mm hand-held version of the view so I could get even higher on the ladder than was possible with my 4 x 5, tripod-mounted camera. Be warned, it's easy to become giddy in a situation such as this one. The architect of the project looks on apprehensively.

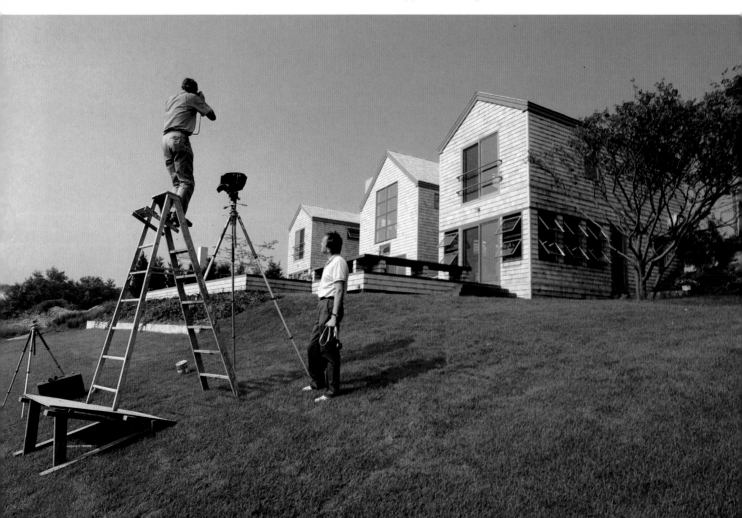

Dusk Photography

Half-day, half-night photographs require preparation and precise timing. When done properly, they are probably the most dramatic photographs of all. Here are some suggestions for creating eye-catching pictures.

Try to select a camera position that silhouettes the subject against the sky, or at least separates the subject from the background. Keep in mind that trees and foliage will be rendered very dark unless they are illuminated artificially. You should select the most transparent elevation so that as much as possible of the interior may be seen. If advance scouting permits, evaluate different levels of lighting in the visible interior areas. (Some may require boosting or lowering.)

The western sky stays light much longer than the eastern, but being backlit will tend to silhouette the subject rather than illuminate it. Light-toned exterior surfaces will also retain detail better as daylight wanes. Depending on the scale of the building, don't rule out introducing external lighting. Try daylight film early on, and then switch to tungsten film as it gets darker. Type B film with a portion of the exposure filtered for daylight frequently produces the best results, I find.

Located in New Delhi, this spectacular building is the new House of Worship for the Baha'i faith. Inspired by the lotus blossom, the delicate petals are actually thin concrete shells with a veneer of white Greek marble cut in Italy. Designed using the latest computer technology, the structure was, nevertheless, handcrafted in a way possible only in that part of the world. The workmanship of the reinforced concrete is the best I have ever seen. Dedicated in December 1986, three weeks after this photograph was taken, the building took nearly seven years to construct, following more than two years of design work.

It was difficult to resist axial views of this edifice. I didn't, although I decided not to risk taking dusk shots from the thirty-foot-high scaffold that had been erected for me. I didn't think I could obtain sharp pictures from it and there was not time for reshoots. The sun sets almost directly behind the main entrance. Interior lighting is quartz, and the exterior is floodlit with mercury lamps. (The latter are responsible for the greenish cast which contrasts with the warm tones of the sky and the inside illumination.)

I used a 180mm F5.6 Symar S on my Sinar F. Exposure for Ektachrome Type B film was 30 sec. at f/16 to 22 with an 85B filter for 15 seconds.

The architect was Fariburz Sahba, with structural design by Flint and Neill of London.

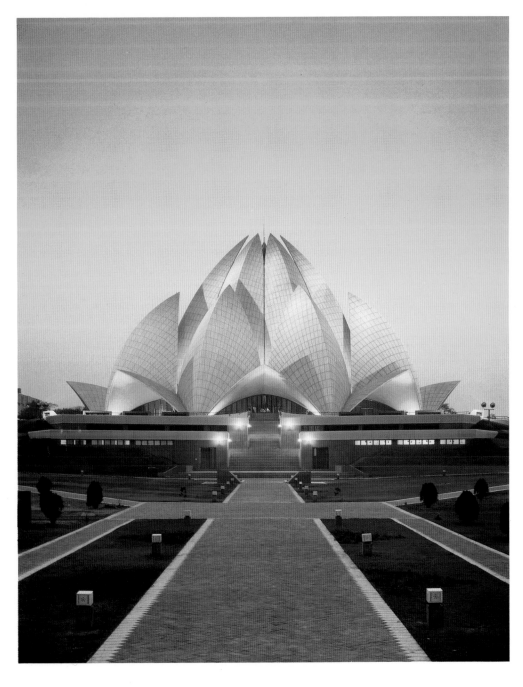

Triangular in plan and elevation, this unusual Long Island house is particularly appealing at dusk. I had to add supplemental incandescent lighting to several of the interior spaces and in particular to the open terrace at the top left.

Even before darkness approached, I could see that the existing exterior lighting was very contrasty. The sun set at the left, so there was not much fill light from the sky. I decided to use a couple of 650-watt quartz lights, direct, to illuminate the exterior—one on either side of the camera. Their location was critical because of reflections and shadows. I used a 75mm F4.5 Nikkor lens on my Sinar F. Ektachrome Type B film was exposed for 24 sec. at ƒ/16 with an 85B daylight conversion filter for 8 seconds. The architect was Richard Dattner and Associates.

A photograph like this may not precisely document the architecture of the house, but in terms of establishing a mood and setting the location, it is hard to beat. Only a unique site such as this one can provide the right ingredients—set on the slopes of Beverly Hills overlooking Los Angeles with a west-facing window to reflect the setting sun.

To set the scene, I moved the glass-topped table to the foreground and positioned the champagne bottle and glasses upon it, then I moved the telescope from the living room to the terrace and waited. I switched on the dining-room lights so that the image is a combination of reflection and interior. The surprise is how much brighter the western sky reflection is than the city skyline to the southeast. The range of colors is also surprisingly narrow, but just seems to add to the mood. The streak of light in the sky is flare from an overhead spot, which in this instance I don't mind. It takes experience to anticipate a photograph like this unless you are able to do a lot of advance scouting, which in this case was not possible.

I used a 120mm Super Angulon lens on a Sinar F-2 camera, with Fuji Velvia film without filtration. This is the work of Harry Stein, Untitled, of Los Angeles.

This is the dining room of the house pictured on the facing page. By the time I was ready to work on this shot I had lost the dusk sky. However, the interior reflection more than made up for this. I did give an extra long exposure for the city view with the room lights off, about one minute. The colored neon lighting above was switched on for only a portion of the exposure to avoid washing out the vivid color. The flowers and reflection made place settings superfluous. I used a 120mm Super Angulon lens on a Sinar F-2 camera, with Fuji 64T film.

Buildings At Dusk

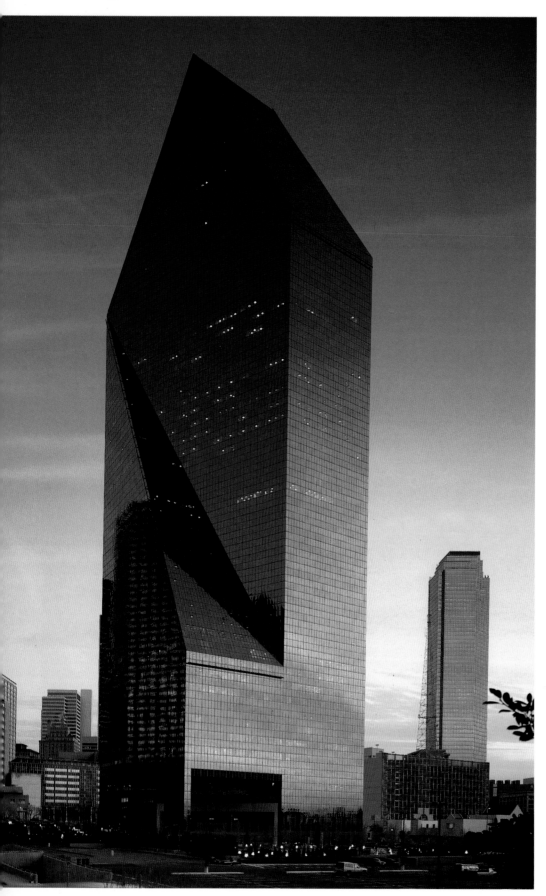

Only certain projects work well at this time of day. The right ingredients must be present. Reflective towers can be difficult to photograph, but they do offer possibilities others building surfaces may lack. I particularly like the bold shape of I.M. Pei's Allied Bank Building in Dallas, Texas. With the west facade picking up a reflection of the sunset, the north side reflects an unseen tower and dark, evening sky. Interior lights flicker on, appearing most prominent in the darkest areas of the building.

To get this particular image, I took many shots in the time before the lighting conditions were as they are seen here, as well as a few after this particular shot. I felt this photograph was the best, and the architect agreed. I used a 120mm Super Angulon lens on a Sinar F camera with Fuji 50D film.

The first time I saw the National Cathedral in Washington, D.C., lit at night (right), I knew I had to capture it on film. It was one of the best illumination projects I have ever seen. I felt it was best shown in straight elevation, but I wasn't sure I had the lens to do it. The 90mm Super Angulon F5.6 lens proved just barely adequate (the new XL would have given me a wide margin). The light falloff toward the top of the photograph just adds drama. I accepted the tree on the right but a second one above and to the left limited me as to how far back I could position my Arca Swiss camera.

I had excellent conditions with a bright sunset. Thus, I was able to get considerable natural fill light on the western facade, even after the lights began to turn on. I did a half dozen different combinations. This photo, one of the later shots in the series, was approximately 30 sec. at f/16 on Fuji 64T film. The lighting was designed by C.M. Kling and Associates, Inc.

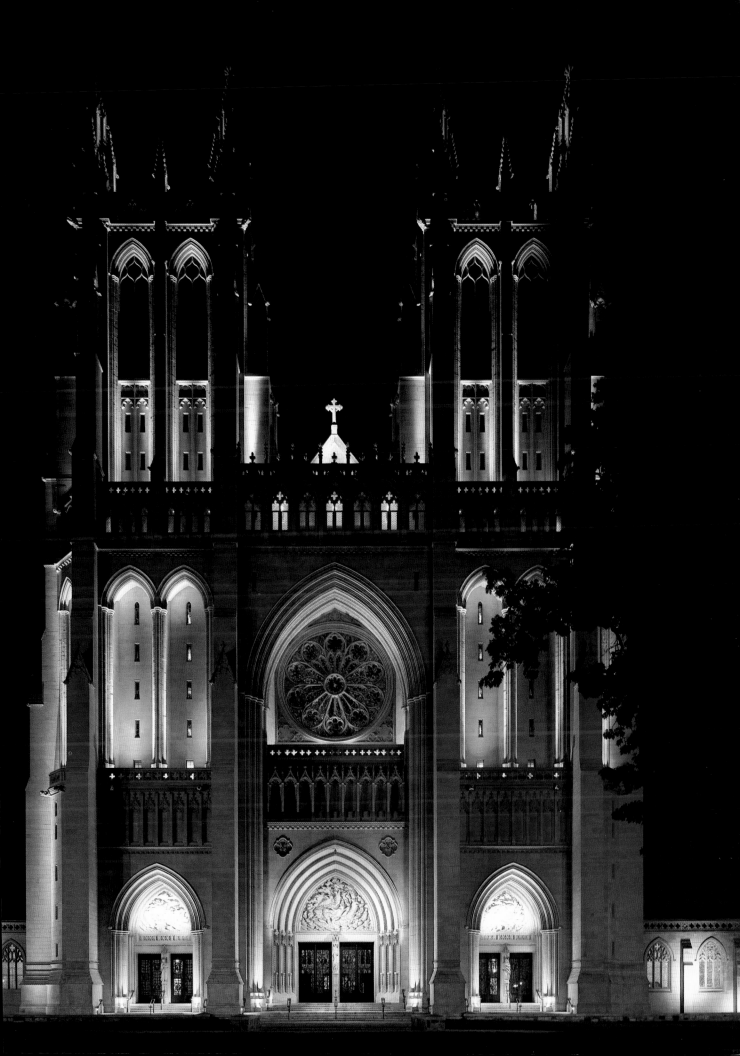

Variable Weather

Successful images can be created without sunny skies. However, the photographer has to exercise some imagination to recognize the picture that may be seized from difficult climatic conditions. Storm clouds, mist, fog, snow, rain, rainbow—all present opportunities. The fact that such situations sometimes appear quickly and unexpectedly means that the photographer needs luck and skill to be able to take advantage of them. My advice is to experiment. Film is one of the less expensive costs of photography, and wasted frames are a very small price to pay for what might be a beautiful picture.

A note about camera protection. When photographing in poor weather, the use of a skylight or 1A filter will help keep moisture from the lens. Keep the camera covered until ready to shoot. When the air is full of moisture, condensation will quickly form on cold equipment when taken inside. Use lens caps and warm the camera up slowly to avoid this.

Extremes of temperature are not good for equipment. When using a 35mm camera in low temperatures, place it under your coat so that it doesn't get too cold between shots. Conversely, protect cameras from direct sun. Black cameras, especially, heat up fast. Polaroid materials are particularly temperature-sensitive. In certain conditions, graduated color filters may be useful (but don't overuse) and always have a backup.

I arrived for the first time at this site in Nagasaki, Japan, less than half an hour before taking the photograph on the facing page. The varied cloud formations suggested good conditions for a sunset shot which, in early September, was located in just the right spot to reflect in the building's facade. With efficient assistance the equipment was unpacked and I was ready to go fifteen minutes after arrival.

Initial Polaroid tests indicated that the sky's brightness would render the building extremely dark and lacking in detail. With the aid of a neutral-density, graduated filter, I was able to sufficiently darken the spectacular sky and thus use a long enough exposure to retain adequate detail of the main entrance on the south side. Fortunately, everything worked. There was not a repeat performance the next afternoon as the skies were clear and cloudless. I used a 120mm F8 Super Angulon lens on my Sinar F. Ektachrome 64 film was exposed at 1/8 sec. at f/22 with an Ambico dark gray graduated filter, number 7783.

The Fairchild semiconductor plant was photographed for an annual report. Nikken Sekkei was responsible for the design.

The photograph of the above restaurant was taken in late afternoon under heavily overcast skies with light rain. Because interiors were my primary objective, an unfavorable weather forecast did not deter me. I had hoped for clearing skies but realized after the outside lighting had been switched on that a "wet" shot in the failing light could be quite dramatic. The "Kodak yellow" color of the awning is designed to be eye-catching from the highway. The combination of the neon-banded, stepped facade adds to the general visibility in a quite successful way for this genre. I could do nothing about the wire but figured it could be retouched.

I used a 75mm F4.5 Nikkor lens on my Sinar F. Exposure with Ektachrome 64 Daylight film was 10 sec. between f/11 and 16. This Fuddruckers Restaurant is in Westport, Connecticut. The architect/designers are James Morris.

The entrance facade of my own house, above, faces northeast. High ground to the east intercepts the early morning sun and the wooded setting doesn't make it any easier to photograph. With the deeply recessed front entrance, the ideal conditions for photographing this elevation are not obvious. The morning mist had not lifted when I took this picture, but a few rays of September sunshine did manage to penetrate the fog. I switched on interior lights to add some warmth to the house. Even in the very diffused light, I was able to capture the strong geometry of the design. I used a Nikkor 28mm F4 PC lens on a Nikon FE. Kodachrome 64 was exposed at 1/60 sec. at f/5.6 to 8.

Myron Goldfinger was the architect.

Abstraction

Certain designs lend themselves to an unusual approach, a visual point of view that might be less appropriate with more conventional subjects. Such photographs are not normally included in the documentation of a project but are, nevertheless, valuable for editorial purposes.

Abstract photographs should intrigue the viewer in purely visual terms. The accuracy of interpretation is not the most important quality here, and, obviously, a picture in this category should be considered an extra dividend rather than the major objective. Only if the subject itself is abstract might abstraction be considered a straightforward interpretation that will convey the design philosophy. Repetitive elements, in particular, lend themselves to abstract treatment.

The idea of a room photograph that shows only the ceiling and the upper walls of one corner sounds a bit bizarre, and it is. This small window is, in fact, an opening from a stair landing that permits a bird's-eye view of the living room below in this remodeled Manhattan duplex. The insertion of a new wall meant an interruption of the nice ceiling moldings. A clean cut was made through the plaster and the cross section was picked out in a contrasting color. I supplemented the room light with a bounced quartz lamp. I used a 180mm F5.6 Symar S lens on my Sinar F. Ektachrome Type B was exposed for 20 seconds at *f*/22.

The architect for the remodeling was Stephen Levine.

One rarely views a room from above, particularly from dead center. When creating this symmetrical room in a designer showcase, the architect discovered an unfloored attic space above. With considerable foresight, a removable panel was fitted into the middle of the ceiling. Inserting my camera into the confines of this opening proved quite difficult. Once set up, I had to be able to get at the lens in order to set it and cock it between exposures. The camera location was critical, as was the precise positioning of the chess set on the tabletop and the chairs. The composition looks kaleidoscopic. I was able to work with the existing lighting. I used a 65mm F4 Nikkor lens on my Sinar F.

Architect Stewart Skolnick designed this room in Irvington House, Southampton, Long Island, for a designer showcase.

This photograph is purposely ambiguous. I very carefully located my camera so that the alignment of the verticals coincides with the risers of the steps and, in addition, one of the treads becomes a continuation of the wall above the stairway. This creates a puzzle, since the viewer has difficulty distinguishing just what is in which plane. The lighting provides only hints to help determine what is being seen. Only the door handle and perhaps the two dark steps at the bottom of the photograph provide a link with reality. I suppose I broke one of my own rules in taking this picture, because I stated that abstract subject matter does not require further abstraction when recorded. I used a Nikkor 28mm PC lens on my Nikon FE camera. Ektachrome 64 film was exposed at 1/15 sec. at ƒ/8.

The architect of House Six was Peter Eisenman. The assignment was for *HG*, and this photograph is reproduced courtesy of Condé Nast.

While playing around with the image of a ceiling detail, I discovered that I could get a reflection of it in a mirror. The composition still seemed to be overly long. To add the necessary interest, I moved the mantle clock to the edge of the mantelpiece and added the candelabra on either side. I raised and lowered the camera to achieve just the right balance. I introduced only minimal bounced lighting.

This Manhattan condominium, the home of a celebrated popular composer, was photographed for *Connaissance Des Arts*.

Aerials

Aerial photography is technically specific and the approach quite different from photographing at ground level. The camera is best handheld and needs to be of a manageable size. (Early aerial cameras were large format, but cumbersome and more difficult to use.)

High-quality, medium-speed films in combination with a camera equipped with a normal lens or perhaps a short-focus telephoto lens are best. An automatic camera that selects the aperture can be very helpful because it saves having to worry about correct exposure. Be completely familiar with your equipment before attempting aerials.

I use a fast shutter speed: 1/500 or 1/1000 sec. to ensure sharpness. But because I use these settings so infrequently, I have them checked before I begin an aerial assignment. Even high-quality equipment can get surprisingly out of adjustment, cause overexposure, and ruin a take. Have more than one camera along to avoid having to reload in flight when possible. An assistant, of course, is most useful for reloading and keeping track of different films—black and white, color transparency, and color negative.

In addition to my Nikon FE-2, I use both a Hasselblad 500CM with an eye-level viewfinder and a Pentax 6 x 7, which is much like a large 35mm camera but produces a generous 2¼ and 2¾ image, which can be enlarged to 4 x 5 without cropping.

I run a Polaroid test when using the Hasselblad to confirm correct exposure. One test is usually sufficient to do this. With Kodachrome 64, I can shoot at about 1/500 sec. at ƒ/5.6 or 1/1000 sec. at ƒ/4. I wouldn't use anything slower.

What conditions are best for aerial work? Bright sun and clear atmosphere are essential for best results. Some interesting shots can be achieved with early morning or late evening light, but for documentary purposes this probably won't be successful. Backlighting or sidelighting is preferable when photographing buildings from the air. Unless the color of the building really makes it stand out from its surround, shadows are necessary to give the subject dimension. When the sun is behind the photographer, the results will be flat.

Because helicopters fly more slowly and can hover, they are frequently preferred but are usually more expensive. A small, high-wing plane may work just as well, though it will have to circle more frequently. Explain to the pilot exactly what you are trying to do and work out a communication system so that he can follow instructions when you are airborne. Also, have clear directions to the site. Things look very different from the air. Both helicopters and light planes have windows that are openable or even removable. There is a lot of wind noise when the doors are off. I don't recommend it for anyone who is the least bit uncomfortable with heights. Make sure that you and your equipment are securely fastened but free to move within limits.

Don't use a lens shade unless it is very firmly attached. A skylight filter may lessen haze and protect the front elements of the lens without reduction of film speed. Keep any extra lenses in pockets, not on the seat. Be sure to take plenty of film; it's the least expensive component of the assignment.

Beforehand, check to see if flying is banned at particular times or if there are restrictions on minimum ceiling in the location of the shoot. Ascertain that you can get a downward view that will be uninterrupted by any part of the aircraft, and decide ahead of time which side of the plane feels most comfortable to shoot from.

At ground level, both the size and layout of this complex off Long Island Sound in Stamford, Connecticut, made it possible to shoot only one section at a time. To get good overall views, I suggested aerials. I had excellent weather conditions for photographing.

The fifth and final block of the development was still under construction when I took these photographs. The eighteen-acre peninsula is the site for buildings that house corporate offices, professional suites, retail shops, restaurants, covered parking areas, and an extensive marina. The latter enables the new facility to preserve and recall something of the original character of the former boatyard.

I timed the flight so that the adjacent facades of the major blocks had good contrast with the sun coming from the southeast. I used a 35mm F2.8 Nikkor lens on my Nikon FE. Kodachrome 64 film was exposed at 1/1000 sec. at ƒ/4.

Harbor Plaza is the work of architect Do H. Chung, Yankee Planning, for the Collins Development Corporation.

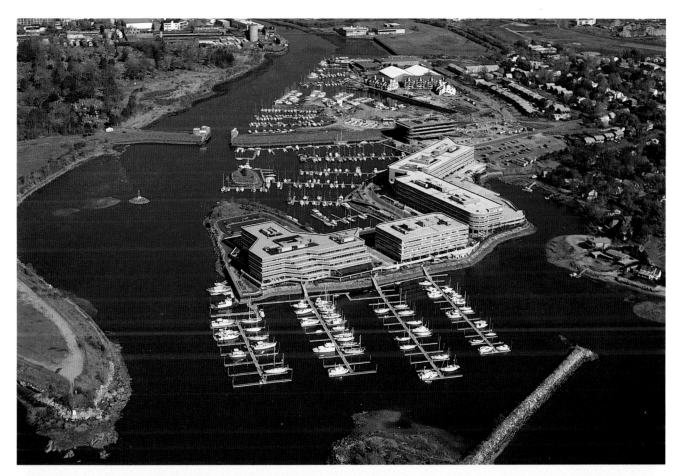

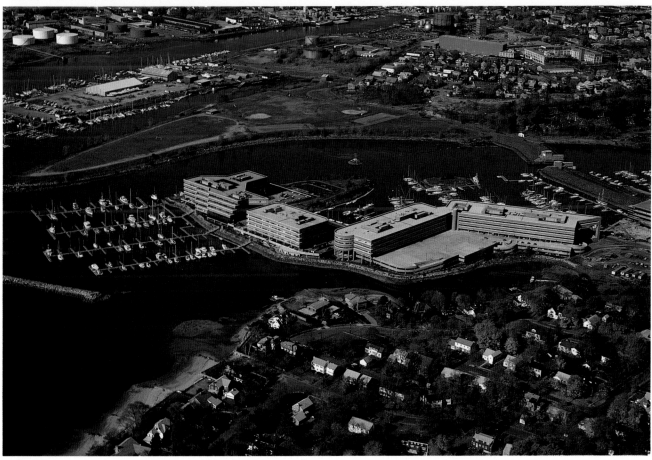

The Schlumberger Cambridge Research Center is a notable example of collaboration between the architect and the structural engineer. Seen to particularly good advantage from above, the roof material is Teflon-coated fiberglass. Its whiteness made the angle of the sun more critical.

The weather was unpredictable and my schedule tight, so I opted for an earlier flight than I had planned. At least twenty minutes were wasted waiting for clouds to pass. The viewpoints for the two top-left photos are very similar, but the backgrounds are different. In the far left image the lighting is superior, but the steel supporting frame is lost in the dark foliage behind the building, and the factory beyond. For the picture at near left, I would have preferred afternoon light; then, the sun would have thrown some light on the left, west-facing facade. The form of the roof is clearer in the view on the near left. Both these pictures were taken with a Hasselblad and the 80mm F2.8 Planar lens. I used Ektachrome 64 Professional exposed for 1/500 sec. at f/5.6.

The lower view shows the roof best of all but is less descriptive of the building. I used a 105mm F2.5 Nikkor lens on a Nikon FE-2 for this. Exposure for Kodachrome 64 was 1/1000 sec. at f/4.

The Schlumberger Cambridge Research Center was designed by architects Michael Hopkins and Partners, with structural consultants Anthony Hunt Associates and Ove Arup and Partners for the roof membrane. Photographed for the 1986 annual report, the building is seen also on pages 174 and 198.

This is an anomalous photograph. I wanted to do an aerial but no aircraft was available. Nor was there a high vantage point. To obtain this pseudo-aerial view for an annual report, I climbed up the framework of an 85-foot folding mobile crane lugging my camera. To add to my discomfort, the temperature was 110° Fahrenheit in the shade. I had the rig located to obtain the best overview, with a background typical of the Omani desert.

I used a Hasselblad 500CM with a 50mm F4 Distagon lens. Exposure with Ektachrome 64 Professional film was 1/250 sec. at f/8 to 5.6.

To house Schlumberger's field engineers, French architect Jean-Michel Regnault used prefabricated portacabin units arranged around a series of landscaped mini-courtyards, separated by shaded walkways and plantings. Schlumberger's Wireline Base is located 250 miles south of Muscat, Oman.

Other photographs of the de Menil house appear on pages 154-56. Because of the high degree of integration between the house and its landscaping, it lends itself to aerial views: The viewer has no trouble separating the built elements from the background.

I took this series early in the summer while everything was fresh and green. I feel that this three-quarter view of the ocean facade is flattering to the architecture and shows the whole lay-out well. The approach past the pond and through the pink portal to the formal, tree-lined allée is clearly illustrated. Also shown is the way the garage unit with attached apartment is integrated with the tennis court, the combination vegetable/flower garden, and the grape arbor. Details of both the roof and south facade are captured from this angle. I used an 80mm F2.8 Planar lens on a Hasselblad 500CM. Exposure with Ektachrome 64 Professional film was 1/500 sec. at ƒ/4.

This is not a good aerial photograph of the de Menil house. Taken on a low pass over the house, I was too much above it. This is closer to a plan view. The height is minimized, thus changing the proportions. The sun was directly aligned behind the helicopter, and thus there are virtually no shadows to give depth to the subject. The shadow of the plane shows on the front of the house. The result is a bit like a camera-mounted flash portrait. The figures and furniture do convey the large scale of the mansion. The camera, film,

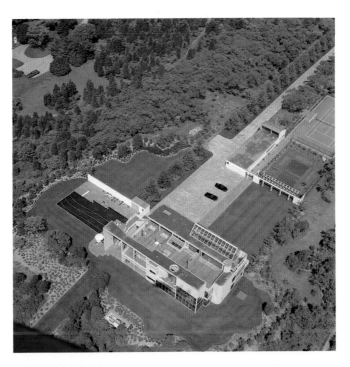

and exposure combination were similar to the one at left.

Taken from the southwest, the view below is from a much lower angle. The house and pool are clearly the focus now; the other elements are related but definitely less important. The inclusion of the horizon does provide the viewer with a greater appreciation of the basic Long Island setting. I used a Pentax 6 x 7 camera with a 75mm F4.5 Takumar lens. Exposure was 1/500 sec. at ƒ/4.5 with Ektachrome 64 Professional film.

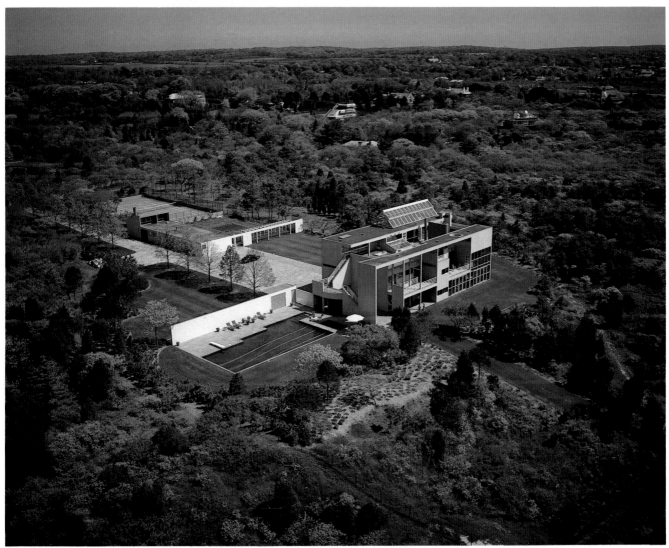

Incompatible Light Sources

Inevitably, situations arise that force the photographer to correct for one particular light source and accept the consequences of the inaccurate rendition of those remaining. Only experience can help to determine just what area to filter out and what to ignore. The lack of full control or not having a specific piece of equipment can create the necessity for compromise. As a general rule, I try to avoid a color rendition that is overly cool, that is, bluish or greenish. A photograph with an artificially green cast is unappealing and, almost equally, so is a blue one. The human eye can more readily tolerate a result that is overly warm, that is, more red or yellow than is normal. This should be kept in mind when the filter selection is made.

Dusk views of buildings with significant amounts of fluorescent lighting in combination with other sources are a problem. Almost any situation with a mixture of systems which include either mercury vapor or metal halide will be difficult to handle photographically. These two types require extended warm-up time to reach their normal operating color temperature. On page 53 you will find a table of suggested filters for use with a range of fluorescent tube types and other artificial light sources.

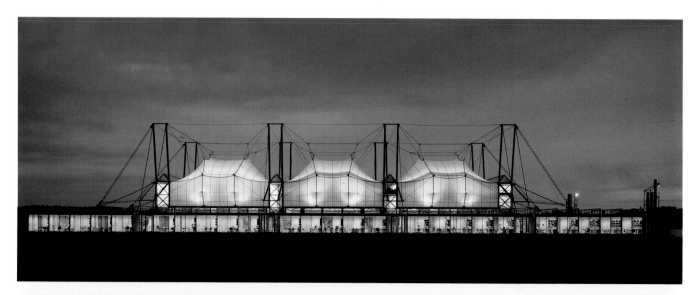

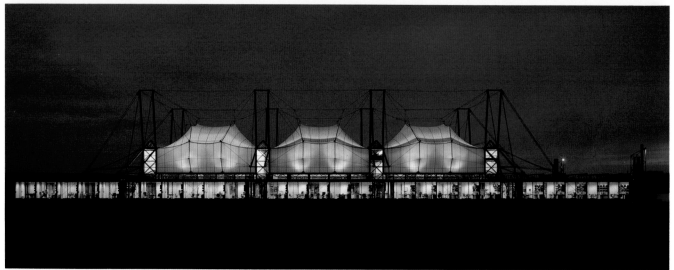

Illustrated earlier in this section as well as in the previous section, these two photographs are of the Schlumberger Cambridge Research facility. The strip of offices is lit with fluorescent illumination, and the large interior spaces behind them with quartz fixtures bounced upward into the translucent roof membrane. The whole building glows at night.

The top photograph was taken with Ektachrome Type B film with an 85B daylight correction filter. The line of offices looks as though the walls are green. For the shot below, the filtration was changed to 40R plus 10M to correct the office lighting. The penalty is the overly warm tone of the superstructure and a violet evening sky. I still prefer the lower view. I used a 120mm F8 Super Angulon lens on the Sinar F. Exposure was approximately 30 to 40 sec. at f/16.

The panels (top) in each box are illuminated by a single light source. The nine on the right are essentially incandescent, the six on the left are fluorescent. They are set up to demonstrate the variations in temperature and quality of different, widely available commercial bulbs and tubes.

The photograph is a two-part exposure with an average fluorescent source correction for the left-hand group and none for the other group, since I was using a tungsten-balanced film. The 40R plus 10M filter pack required a one-stop increase in exposure. The display is part of an experimental light room developed by Douglas Baker for the interior design department at the Fashion Institute of Technology in New York City.

The USS Intrepid is an impressive vessel. One cannot help but be in awe of a ship as large as this, particularly up close. I considered photographing it for quite a while before I decided that sunset in the summer was the right time. I set up my Arca Swiss F 4 x 5 view camera on the dockside, right on the axis of the mighty carrier, now a floating museum. I had arranged to borrow from Schneider their terrific new 58mm Super Angulon XL lens, the widest lens available that will fully cover 4 x 5.

My assistant and I started shooting while the sun was still above the horizon. The setting sun reflected off the water, bouncing light up onto the darkening hull. As the sun dropped, the computer-controlled lighting switched on, gradually. Mercury-vapor lights take some time to reach maximum output. I kept shooting.

I tried both Fuji 100D and Velvia film and, toward the end, Fuji 64T. The final shot reproduced here was taken on Velvia film and was exposed approximately 20 sec. at f/16, with no filtration.

The lens was elevated somewhat, but no vignetting is apparent, even with this ultra-wide optic. I was a bit concerned that the carrier might have moved since it floats, but apparently it didn't; even the Coca-Cola sign is sharp. This is some lens!

ELECTRONIC IMAGING: THE FUTURE

Imagine this scenario. The year is 2005. The location is a northern suburb of a large American city. The scene is the nearly completed corporate headquarters of Fujak.

A sleek, black sedan glides silently into the V.I.P. parking area. The lack of any hint of exhaust confirms that this is one of the latest high-performance electric cars from General Electric. As the two passengers get out of the car, the trunk lid slowly opens. A small folding table is withdrawn and set up a short distance away. This is followed by three squarish, steel cases and a long, thin, black one from which a sturdy tripod is removed. The photographer and his assistant set up their equipment.

A streamlined, though hefty-looking, view camera is mounted on the self-leveling head of the tripod. The camera has no apparent viewfinder system. It is obvious from the manner in which the people go about their work that they have performed this task many times before. The camera has been positioned right on axis with the main entrance to the sleek, metal-clad building. The swift selection of this viewpoint suggests that this choice was the result of advanced planning. It takes about twenty minutes to complete the setup.

Where you would expect to find a groundglass screen at the rear of the camera, there is a rectangular element with a thick, umbilical-like cord connected to a briefcase-sized unit under the table. A power cord runs from this unit to an electrical outlet that had been concealed by a discreet panel near the rear of the car, now some twenty feet away. On the table is a 20-inch monitor and a keyboard, both connected to the unit below the table. Also on the table is a hand-size controller. The monitor is shielded from the bright sun by a folding hood.

The photographer, seated on a small stool in front of the monitor screen, carefully responds to the on-screen directions and then picks up the cordless controller to activate the view camera. As the front standard of the view camera oscillates slowly, an image appears, somewhat blurred, on the monitor.

In a matter of seconds the image is sharp. The photographer examines it closely and picks up the controller. As he turns a large dial, the building on the screen appears to recede. Now the entire front facade is visible in the composition. The effective focal length of the lens has been shortened to obtain a wider view but the camera has not been touched. After continued study of the image on the screen, the photographer makes further adjustments with the controller. Some of the foreground is eliminated and more sky is added. Now satisfied, the photographer checks his watch and turns to his assistant, who goes to the car and returns with a cordless, cellular telephone. After a brief conversation, the photographer turns to re-examine the composition on the screen. As he looks on, an area of the upper part of the image is circled from some remote location. The photographer nods and picks up the controller to continue.

Slowly, the centerpost of the tripod rises and the camera is elevated approximately 18 inches from its previous position. The three skylights set back from the facade are now more fully revealed on the screen. Once again the photographer nods, and then hands the receiver back to his assistant. Now satisfied that everything is in order, the photographer picks up the remote controller and flicks a switch. The image on the screen disappears. He then types a command on the keyboard. The words *Scan in*

This is an example of my first effort at the controls of a computer equipped with Adobe Photoshop. This image represents almost three hours of work, in part due to my inexperience. I worked on this at a two-day introductory seminar sponsored by Kodak at the Apple Computer Center in New York City. This view shows the controversial recent Gwathmey Siegel tower addition to the Guggenheim Museum in New York City which permits the entire original Wright design to be opened up for public examination, uncompromised by office and storage requirements.

One might argue that the top photograph is "reality." However, in a photograph, the viewer is unable to walk around offending objects that may distract, as he or she could if truly there.

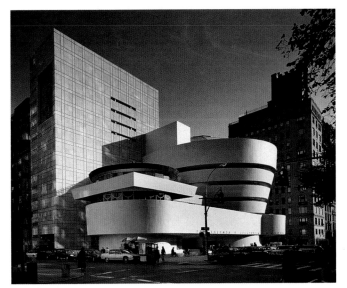

A comparison of these two photographs clearly indicates how much the photograph is "improved" by removal of the unattractive traffic control standard and the hot dog concession cart located on the street corner. The uncluttered view permits the design to be evaluated without obstructions.

The trickiest part of this "retouching" was the recreation of what was actually behind the concession cart. This includes the curved wall with the sun striking it, as well as the sidewalk and front end of the car, which still does not look quite right upon closer examination.

For the original photograph, I used a 90mm Super Angulon lens on my Arca Swiss camera with Kodak Tri-X film pack.

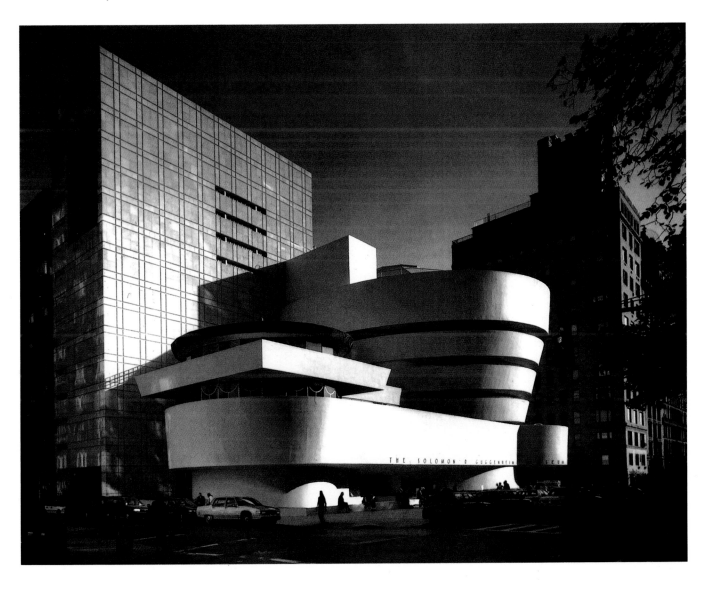

Progress flash on the screen intermittently. A time bar code indicates what percentage of the scan has been completed. After approximately ten seconds, the words *Image Capture* appear. The photographer motions to his assistant to take over. Sitting in front of the console, the assistant types some further commands on the keyboard. Thirty seconds elapse after which the now-digitized image is displayed for a final check. Satisfied that no glitches have occurred, everything is switched off, and they both begin to repack the equipment. After another twenty minutes all the equipment is stored back in the car trunk.

The photographer checks his watch. The total-elapsed time is one and a half hours. The assistant slips behind the wheel and the car hums off as silently as it arrived. Back at his studio, a closer examination of the image reveals that the skylight has a broken glass panel temporarily covered with plywood; one of the three flagpoles on the left of the entrance is missing; and a stone base on the right of the entrance lacks the sculpture that has been planned for it. With electronic imaging it will be a straightforward job for the photographer's "computer artist" to correct these problems and incorporate modifications. Following duplication, a disk of the final image will be sent to the client.

Nothing in this scenario presents a serious challenge to existing technology.

ELECTRONIC IMAGING

Electronic imaging has changed the rules. The creative potential is enormous but it is in the realm of retouching and selective color alterations that electronic imaging seems most applicable to interior and architectural documentation. What was once a lengthy and tedious process with retouching is now a snap with the aid of a computer. Recognizing the possibilities, Kodak has set up the Center for Creative Imaging in Camden, Maine. With the aid of state-of-the-art equipment and various courses offered at the center, interested people can learn how to use this new technology.

To add emphasis to the creative aspect of electronic imaging, Kodak has appointed artists-in-residence, like New England painter Alan Magee, whose reputation has been largely established by his meticulous compositions in the photo-realist style. The computer has released him from this rigid, demanding style; now he is producing works of a more cerebral content, surrealist images that are both intriguing and mysterious. The precise role of electronics in his creative process is unclear.

New questions have arisen with the advent of electronic imaging. When a respected architectural journal features a new structure, should the reader be told whether or not the images have been electronically altered? Even if the media informs its audience, there is always the possibility that the photographer has concealed the fact that indeed

Kodak's Center for Creative Imaging in Camden, Maine, is the most sophisticated facility of its kind in the United States. Converted from an old mill building by local architect Stephen Smith.

This is the interior of AAA headquarters in Orlando, Florida. The architect was Spillis, Candela and Partners. The reworking of this image was done by Stephania Serena at Ken Hansen's Imaging Center. This image represents approximately 60 to 90 minutes of work. 35 Mb original file with final image 300 dpi transposed onto an optical disk.

the images have been "enhanced." And what about the legal implications? What does electronic imaging do to the copyright law? If manipulation of a photograph is accomplished by somebody other than the original creator, who is then the copyright owner of the altered image? What about photographers whose work has been altered and changed without their consent or cooperation—even though credit is still given for that photograph? I personally have had such an experience. Fortunately, although the image was altered, the photographic integrity was uncompromised. In that case, a color change of foliage shifted a spring coverage to autumn.

Keep in mind that simply because an image is electronic, like a video image, this does not mean that the computer "understands" it. First, the image must be digitized from the analog form that makes it compatible with television. Cameras that produce truly digital images and that can be used directly by a suitably programmed computer have only recently appeared. At this point, only Kodak/Nikon, Leaf (for Hasselblad), Rollei, and Arca Swiss have produced cameras or attachments capable of producing computer-ready digital images. There are a couple of low-resolution still-video cameras capable of

producing images for speedy transmission to meet tight schedules, but anybody with moderately high standards understands the limitations of television- and VHS-level resolution. Hi-8 and SVHS have improved definition substantially, but only in comparison with broadcast standards, which are notoriously low in the United States. Even simple still cameras, used with film, can easily improve on this. Comparing resolution in different media requires explanation. In an article entitled "Resolving Resolution" (*Photo District News*, June 1991), Sam Merrell explains in a straightforward manner the pertinent factors to consider when comparing film resolution with electronically produced images. The following is a synopsis of Merrell's article.

Grain in film relates to pixels in an electronic image. A picture is divided into a grid of squares called pixels (picture elements). When an image is scanned into computer form, each pixel is given a value relating to its brightness and color. A black-and-white image has a range of up to eight values to record a continuous-tone photograph. For color material, three times the amount of information is

required (red/green/blue). Each value is termed a unit of data known as a "bit." Eight bits equal one "byte." In computer terms, it takes a capacity of one byte to record a black-and-white image and three bytes to record color.

1,000,000 bytes equals 1 megabyte. If a video camera has a resolution equivalent to 400,000 pixels (as some of the new Hi-8 models do), it requires 1,200,000 bytes of computer memory to transpose, or 1.2 megabytes.

The journey from film to print is complex. Essentially, a printed image is made up of a series of large and small dots, the number of which is termed the "screen frequency." This is expressed as the number of lines per inch (lpi). Low-grade newspaper photographs have about 85 lpi ratings, but high-quality color reproduction can be as high as 300. Working from a digital base to final print is equally complex. Two transformations occur during the process, as a result of which, four or more pixels of image data per dot of line screen are required to obtain true quality color and sharpness. Under ideal conditions, a separation needs 300 pixels per inch to print an image at 150 lpi. To produce an 8 x 10-inch printed image requires 2400 pixels (8 inches x 300 pixels per inch [p/i]) x 3000 pixels (10 inches x 300 p/i), which equals 7,200,000 pixels. At 3 bytes per pixel, this equals a requirement of 21,600,000 bytes of 24-bit digital image data or 21.6 megabytes. Just for comparison, a 35mm Kodachrome slide contains between 17 and 25 million grain particles.

Though the tools of the trade will change, I do not foresee a major revolution. The role of the photographer to document our designed environment may shift with the evolution of new promotional techniques and changing attitudes, but in the end, design professionals will need photographs of their work for a variety of purposes.

Nor do I foresee the demise of magazines. If anything, periodicals, both professional and topical, seem to proliferate and prosper. So there is likely to be a market for quality photographs, the production of which is demanding and time consuming. There may be temporary economic downturns, similar to those of the early 1990s, but design documentation will continue to play an important role in the future, as it does today.

An executive office in New York City designed by Kliment and Halsband. This image was very speedily worked over under my direction by expert Stephania Serena. The work was done at the Computer Imaging Center at Ken Hansen Photographic. Equipment there is available on an hourly rental basis, with or without instruction. They have scanners for up to 4 x 5-transparency size, as well as for larger flat art. The original photograph was taken with a 65mm Super Angulon lens and Fuji 100D film, with Balcar supplemental bounce-strobe fill light.

INDEX

Page numbers in *italics* refer to illustrations.